FACE

Jessica Helfand

FACE

A Visual Odyssey

The MIT Press
Cambridge, Massachusetts
London, England

This book was set in TheSerif, designed by
Lucas de Groot, and Neue Haas Unica Pro,
designed by Toshi Omagariby.

Designed by Jessica Helfand + Jarrett Fuller.
Printed and bound in Canada.

Library of Congress Cataloging-in-Publication
Data

Names: Helfand, Jessica, author.
Title: Face : a visual odyssey / Jessica Helfand.
Description: Cambridge, MA : The MIT Press,
2019. | Includes bibliographical
 references and index.
Identifiers: LCCN 2019013950 | ISBN
9780262043427 (hardcover : alk. paper)
Subjects: LCSH: Face perception--Miscellanea.
Classification: LCC BF242 .H45 2019 | DDC
153.7/58--dc23 LC record available at https://
lccn.loc.gov/2019013950

Cover
John Seven

Endpapers
Face-Fun Felt-o-Grams
Poster Products, Inc.
1933

Game box insert showing face variations
submitted by players around the world.

For Malcolm and Fiona. Always the We.

FACE *of* A NATION

ITALY

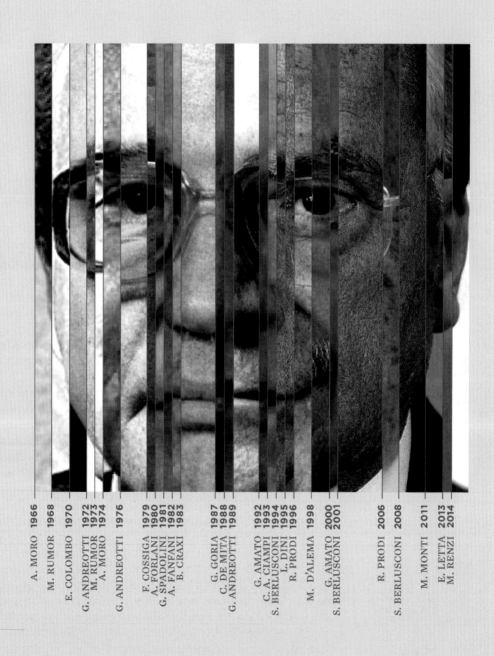

A. MORO 1966
M. RUMOR 1968
E. COLOMBO 1970
G. ANDREOTTI 1972
M. RUMOR 1973
A. MORO 1974
G. ANDREOTTI 1976
F. COSSIGA 1979
A. FORLANI 1980
G. SPADOLINI 1981
A. FANFANI 1982
B. CRAXI 1983
G. GORIA 1987
C. DE MITA 1988
G. ANDREOTTI 1989
G. AMATO 1992
C. A. CIAMPI 1993
S. BERLUSCONI 1994
L. DINI 1995
R. PRODI 1996
M. D'ALEMA 1998
G. AMATO 2000
S. BERLUSCONI 2001
R. PRODI 2006
S. BERLUSCONI 2008
M. MONTI 2011
E. LETTA 2013
M. RENZI 2014

Acknowledgments

Above
Jessica Helfand
Self-Portrait
1962

Opposite
Güney Soykan
Face of a Nation
2016

Composite images from different nations
based on individual portraits of their
leaders from the past fifty years.

I am enormously grateful to a number of colleagues, collaborators, friends, and family, beginning with my father, who died before this book was published, but whose support was an important catalyst from the start. He believed unequivocally in both this project and in me, and like many of us, he always reads the acknowledgments first. He would have laughed at being thanked in the first paragraph, and I wouldn't have it any other way.

This book would not have been possible without the herculean lift of a small but dedicated group of colleagues, beginning with my team at the MIT Press. A huge, heartfelt thank you to my editor Victoria Hindley, whose thoughtful direction and sage guidance provided a steady stream of oxygen, and to Michael Sims, whose editorial support was a godsend. In my studio, Jarrett Fuller brilliantly collaborated on the book's design, shepherded its production, and ensured its visual excellence. Kate Phillips brought a level of patience, resourcefulness, and keen detail that proved indispensable to the author and her often unwieldy process. Meredith Miller, Melissa Leone, and Maya P. Lim provided photographic and research assistance, and Susan Clements bravely took on the behemoth job of compiling the index.

My work benefited unquestionably from a number of collectors who responded enthusiastically to my queries, no matter how odd, or, for that matter, how often I sent them. Patricia Martineau kindly provided full access to her prolific holdings of nineteenth-and twentieth-century ephemera. Mark Michaelson generously shared his extraordinary examples of mugshot history. And the late Ricky Jay took me through his dazzling repository of treasures, instructing me, over the course of one memorable spring afternoon not long ago, on the finer points of the Victorian freakshow. My thanks also goes to

James Bennett, David Cohn, John Foster, Barbara Levine, Donald Lokuta, Paul Lukas, Robert E. Jackson, Anjelica Paez, Christopher B. Steiner, and Stacy Waldman.

I grew up in a decidedly bibliocentric family and learned early on that I am nothing without librarians. For their guidance, my thanks to John Bidwell at the Morgan Library, Mike Pepin at the American Film Institute Library, and Li Wei Yang at the Huntington Library. At Yale, I wish to thank Melissa Grafe and Terry Dagradi at the Cushing/Whitney Medical Library, Tess Colwell and Lindsay King at the Robert B. Haas Family Arts Library, Nancy Kuhl and Timothy Young at the Beinecke Rare Book and Manuscript Library, Elisabeth Fairman, Molly Dotson, and Laura Callery at the Yale Center for British Art, and Michael Kerbel and Archer Neilson at the Yale Film Study Center.

I am grateful, too, to a number of scholars whose work provided inspiration and grounding in some of the more historical, psychological, analytical, and even procedural aspects of this topic. My thanks in particular to Ian Alcock, Geoffrey Batchen, Chris Bonanos, Steven Heller, Pat Kirkham, Alison Langmead, Arthur Lubow, Nicole Morse, Sharrona Pearl, Lorna Roth, Shawn Michelle Smith, and Alexander Todorov.

To deliver on the promise of this material requires a visual narrative that is commensurate with the text, none of which would have been possible without the contributions from a number of artists and photographers whose remarkable work is represented in these pages. My thanks to Karl Baden, Roger Ballen, Steve Brodner, Nancy Burson, Dan Chen, Michael Cho, Mat Colishaw, Jon Corbett, Renee Cox, Jamie Diamond, Jessica Dimmock, Harold Feinstein, Nadia Gohar, Timothy Greenfield-Sanders, Leon Harmon, Adam Harvey, Richard Kalvar, Jillian Mayer, Sylvie Meunier, Trevor Paglen, Tara Pixley, Wendy Red Star, Giles Revell, Stefani Reynolds, Francois Robert, Gilles Sabrié, Diana Scheunemann, Laurie Simmons, Giuseppe Sollazzo, Rosalind Fox Solomon, Guney Soykan, John Seven, Alok Vaid-Menon, Carrie Mae Weems, Deb Willis, and Howie Woo. My own studio practice owes a huge debt of gratitude to the late David Pease, whose work lives on in anyone lucky enough to have studied with him. (This book's publication date marks the one-year anniversary of his death.)

Portions of this book were written while in residence at Civitella Ranieri in Umbria, where I spent part of the summer of 2018. My sincerest gratitude to Dana Prescott for offering me this extraordinary opportunity; to Ilaria Locchi and Diego Mencaroni for their many kindnesses; and to the gifted writers, composers, and artists I had the privilege to spend time with while I was there: A. Igoni Barrett, Vince Briffa, Dan Chaon, Alexander Hawkins, Fusun Koksal, Azar Nafisi, Celeste Oram, Pjora Paulo, Siska, Esperanza Spalding, Emily Van Kley, and Christian Vinck. For inviting me to participate in the London Design Biennale, where an early incarnation of this material was exhibited, I also wish to thank Caroline Baumann and Ellen Lupton from the Cooper Hewitt Museum, as well as my artistic colleagues, R. Luke DuBois and Zachary Lieberman.

Writing this book meant time away from other things, especially from Design Observer where my colleagues have been nothing short of spectacular. My thanks to Blake Eskin, who always makes me sound better than I am, to Betsy Vardell, who always makes me feel better than I do, and to Michael Bierut, who always knows the right thing to say to restore my faith in humanity. At Pentagram, where I am always the beneficiary of kindness I hardly deserve, huge thanks to Tamara McKenna. And at Yale, I wish to extend my appreciation to the faculty and faculty support teams at both the School of Management and the School of Art for their flexibility, understanding, and support.

Walker Percy once said we love those who know the worst of us, and don't turn their faces away. To my friends, some of whom read early drafts or troubleshot book titles, and all of whom offered support when I truly needed it, I am particularly indebted. My sincerest thanks to Kim Baer, Andrea Barnet, Jennifer Dowley, Jean Picker Firstenberg, Karin Fong, Barbara Glauber, Eliane Grigg, Melissa Harris, Jill Herzig, Kevin Hicks, Cornelia Holden, Pamela Hovland, Noreen Khawaja, Chip Kidd, Pat Fili-Krushel, Issa Lampe, Maggie Peters, Ann Prum, Joanna Radin, Jen Renninger, Chris Riley, Avery Rome, Paula Scher, Martha Rotman Snider, Rooh Steif, Lisa Strausfeld, Anne Tofflemire, Claire Weisz, and Lorraine Wild.

Finally, to my beautiful children, Malcolm and Fiona, to whom this book is lovingly dedicated, know that whatever I do and wherever I go, I will never love any faces more than I love yours.

Jessica Helfand
New Haven, CT
Summer, 2019

Contents

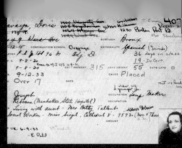

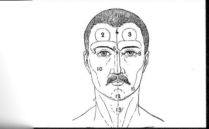

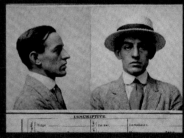

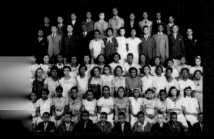

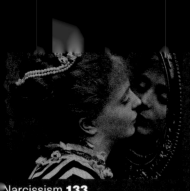

Narcissism **133**

Othering **143**

Physiognomy **153**

Quackery **163**

Relatability **171**

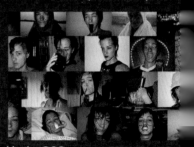

Surveillance + Spectatorship **177**

Typecasting **185**

Users + The Uncanny **195**

Vanity **203**

Wit **211**

Xenophobia **223**

You **233**

A face is a roadmap of someone's life.
Chuck Close

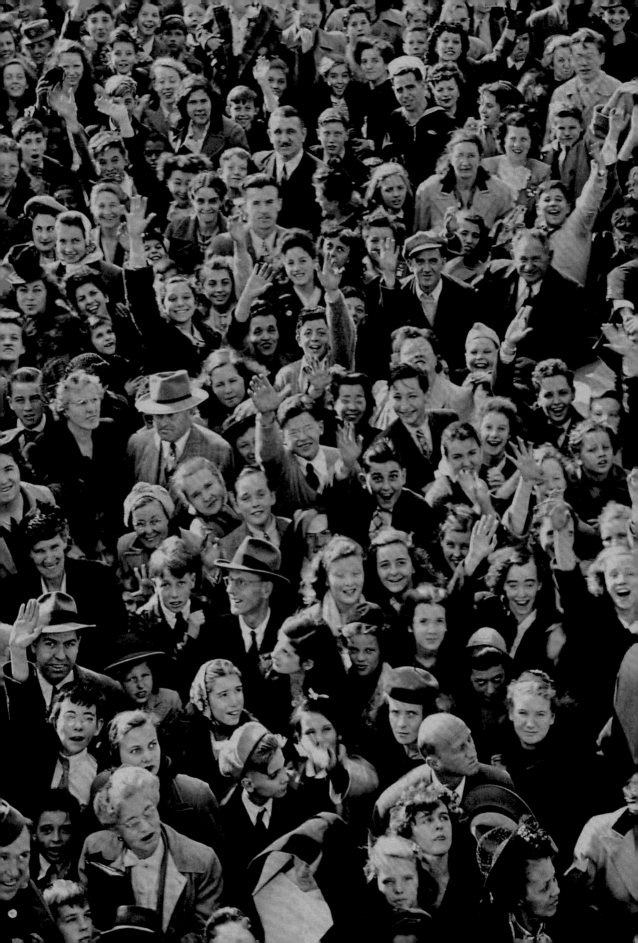

Prologue | The Mirror Is a Civil War

People! Flung wide and far, born
into toil, struggle, blood and
dreams, among lovers, eaters,
drinkers, workers, loafers, fighters,
players, gamblers. Here are iron-
workers, bridgemen, musicians,
sandhogs, miners, builders of huts
and skyscrapers, jungle hunters,
landlords and the landless, the
loved and the unloved, the lonely
and the abandoned, the brutal
and the compassionate—one big
family hugging close to the ball of
Earth for its life and being.

Carl Sandburg

A baby's face is the face of promise, but it is also the face of provenance.
To look at the face of an infant is to easily look beyond the staggering
reality of the present—the individuation of a fledgling soul, the
incomprehensibility of its biological uniqueness—and see a blank slate.
Hopeful projections are human truths: we project onto others what we
see in our own likenesses. The face is nothing if not a creature of habit.

John Seven's image on this book's cover may resemble a baby, but
that's only half true, because it's only half a baby—a bifurcated baby—
split down the center, mirrored back on itself, and flipped. If we "read"
the image as a reflection of what's real, it's because we're hardwired
to do so: we're not so much primed to anticipate cognitive dissonance
as eager to complete the picture, interpolating what's missing based
on what we think we see. (Or what we want to see.) Whether this is a
hapless gesture or a hopeful one depends on many things: context, to
be sure, but also your willingness to assess your own complicity in the
entire act of seeing. Perception may be one of the great core capacities
of the human intellect, but in an age of robotic simulation, visual
manipulation, and a seemingly unstoppable torrent of fake news,
it's also an imperiled enterprise. How do we even begin to perceive
difference, discerning the artificial from the authentic, the face from
the facsimile?

The face has always been a hieroglyph, at once an instrument of
lucidity (we all have one) and an enigmatic canvas (we're all different).
Its backstory includes misguided methodologies, implausible fictions,
and epic tales of narcissism. (Its future is no less colorful.) Writing
nearly a century ago, the Hungarian film theorist Béla Balázs described
cinema as a machine that would turn our attention back to a visual
culture and give us new faces.[1] Today, that once-new cinematic

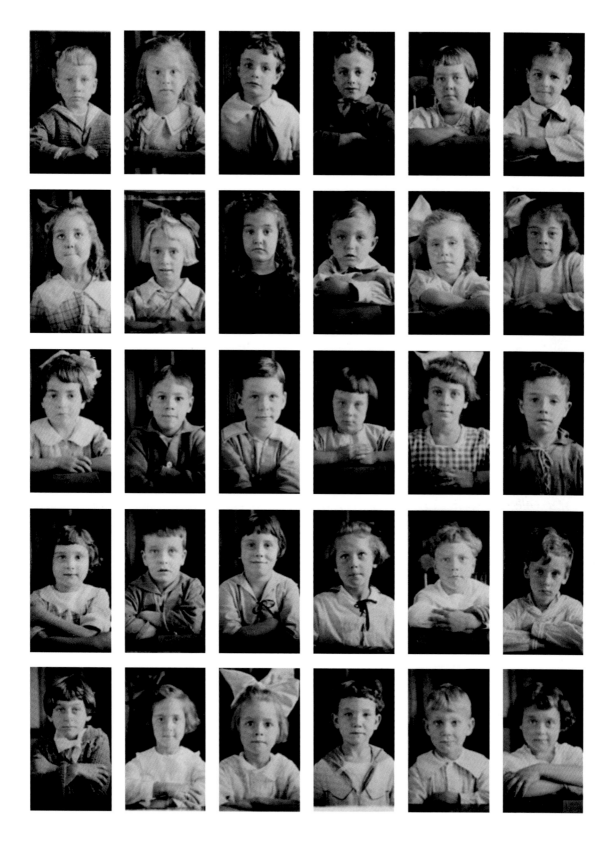

machine has expanded to include an entire spectrum of seductive technologies—mobile, social, virtual, wearable, and endlessly visual—that challenge how we see both ourselves and each other. What happened to our old faces, and how do we get them back?

The perhaps unanswerable question of who is behind the camera frames the central premise—and the core argument—for this book. It asks us to consider choice, and timing; perspective, and framing; sentiment, context, and the glare of the authentic. Most of all, it obliges us to contend with the critical, if slippery, relationship between agency and authority: who has the right to take a photo of someone else's face, and why? What are the social conventions framing that right, the societal expectations motivating us to do so, the politics and ethics guiding the publication and dissemination, over time, of *anyone's* likeness? Who decides who gets to share? The question of who owns our data all too often gets in the way of a more immediate concern: who owns our faces? Arguably the feature with which we are most highly individuated (your DNA sequence, though unique, remains hidden from public view), the face is social currency, a mashup of history, heredity, culture, posture—and pure, dumb luck. (Or, for that matter, no luck.) How we present to the world, *who* we present to the world, the way we navigate bias, calibrate judgment, and traffic in the persistent uncertainty of all that is profoundly human—these are the means by which we visually (and viscerally) scrutinize ourselves and each other. All reflections boomerang back to us. The mirror, it turns out, does not lie.

Except that it does lie—it must. It also fragments and conceals, reframes, masks, manipulates, cajoles, and labels us all. We are, at any given moment, prey to a series of ineffable (if ultimately rhetorical) classification schemes, all of us actors wearing multiple hats, playing plural roles, awash in a culture of pantomime. We smile for the camera, until we don't. (Consider passport pictures.) We hide from the camera, until we can't. (Consider candid pictures.) We turn to the camera for proof, at once a diagnostic gesture and a deceiving one: the mirror may not lie, but a picture certainly can. The photo itself can be lit, cropped, doctored, distorted, airbrushed, redacted, or refashioned to amplify (or nullify) a particular trait. Consider social platforms like Facebook and Snapchat, Pinterest and Instagram—and all that they portend. (And then consider plastic surgery. And eugenics.) Facial recognition, once a sentient behavior, is now a technological conceit. Who's behind the camera—or in it?

Where there is software there is hardware. And here, in the so-called age of personal agency, the ability to turn the camera on yourself represents a stunning reversal of authority. It bears saying that today's smartphone contains a lens pivot so graceful that your subject and object can easily share a single, fluid orbit. You may think you're the one behind the camera, but are you, really? As the pendulum of digital sophistication swings ever outward, that orbit gradually expands

Above
High School Portraits
Circa 1950

Opposite
Grammar School Portraits
Undated

Photo from a school in Massachusetts included a student with Down Syndrome.

Lawrence History Center.

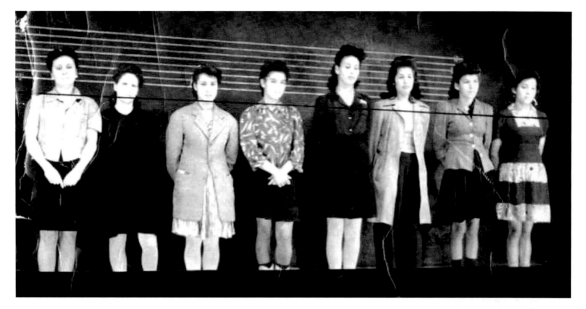

to include a host of technologically enabled deputies to do the work for you, from vigilant security cameras protecting your property to voice-activated baby monitors soothing your children. How much is too much? How fast is too fast? Now that facial recognition can unlock your phone for you—who's behind the camera, *now*?

Photographic portraiture requires, perhaps by its very nature, a certain basic interpersonal complicity, but this has not always been the case: indeed, an individual can be staged to submit to all manner of posturing. The French nineteenth-century neurologist Duchenne de Boulogne used electrical probes on his subjects' faces to elicit particular expressions that he subsequently captured on camera. (That these subjects were also day laborers illuminates, in no small way, a social manipulation that was at once deplorable and seemingly disregarded.) Later in the same century and the same country, Parisian forensic documentarian Alphonse Bertillon would measure the faces and features of criminals in an effort to introduce a systematic—and to his mind, scientific—overhaul of what was, at the time, a criminal justice system in disarray. Here, too, the question of *who* was measured, *where* their photos resided, and *how* a given suspect's data might be deployed in the service of bureaucratic superiority raises concerns about how we codify the faces of others. (Or that we do so at all.) The micro-maneuvers here—the powerful against the powerless, privacy at the hands of piracy—shed light on rather an astonishing kind of hubris. In these experiments, and at the hands of these men (self-proclaimed experts, all) the camera itself functioned rather unilaterally as an instrument of unbridled privilege.

Bertillon's anthropometric calculus combined photos and related metrics to identify criminals, and by conjecture, to anticipate nefarious activity, a practice that ignited a renewed interest in recidivism. (The introduction of frontal and side-view photographic diptychs were key

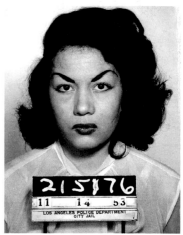

Top
The Gangsterettes
Los Angeles
1940s

The Zoot Suit Riots were a series of conflicts that occurred in June 1943 in Los Angeles between American servicemen and Mexican-American youths known for wearing zoot suits. These female hoodlums were cited for smoking marijuana, drinking alchohol—and talking back.

Top: Los Angeles Public Library.
Bottom: Mark Michaelson Collection.

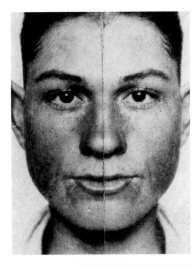

Clyde Chestnut Barrow
1930s

Barrow teamed with his partner Bonnie
Parker in a nationwide crime spree that
lasted from 1932 until their deaths in 1934.

Dallas Municipal Archives.

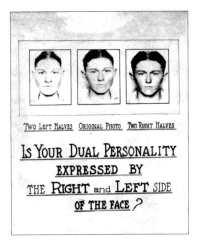

to this practice: Bertillon also famously pioneered the mug shot.) His Italian colleague, Cesare Lombroso, a physician and a criminologist, and a fervent disciple of social Darwinism, used physiognomy—or physical character assessment—to reinforce the far more pernicious theory of atavism: the assumption that a "born" criminal could be identified by his or her physical characteristics. To the degree that pictures speak louder than words, faces, in the context of these morally troubling experiments, spoke volumes.

Yet if criminology proved a fertile environment for classifying the faces of the accused, it was by no means the only discipline in which portraiture proved indispensable. Indeed, the invention—and subsequent popularization—of the camera itself made such efforts eminently achievable. Curiously, photographic experiments were common practice throughout the asylums of turn-of-the-century Europe, most regrettably among physicians for whom willful diagnostic assertions frequently trumped basic human dignity. From Paris, where the French neurologist Jean-Martin Charcot used photography to record his patients' "hysteria," to Surrey, where the British psychiatrist Hugh Welch Diamond photographed his patients' faces to confirm certain kinds of mental illness, the rights of the poor, the infirm, the racially or religiously or otherwise socially marginalized were, particularly given the context of their often involuntary captivity, sorely neglected in the service of science.

Captivity itself seems an unusually apt metaphor for experiments like these, in which patients were typically propped up in their beds, not unlike trained animals at a zoo. The idea of the patient as a kind of performative prisoner recalls the model of the police line-up (in Britain, these are somewhat lyrically referred to as "identity parades") and loosely resembles the manner in which our children are asked to congregate annually for class photos. Again, the question of who's behind the camera looms, begging the question: when did the class picture become a standard rite of back-to-school passage—and when did parents first willingly submit to the notion that this purportedly objective yearly snapshot would become part of the public record? The dilemma of whether or not to post photos of a toddler on Facebook may trigger concerns about the rights of minors, but the annual school photo normalized this behavior long before our current preoccupation with the ethics of online posting.

Those seemingly innocent class line-ups go one step further by laying bare the faces of sameness and difference. (And otherness: circus freak shows spring to mind.) Often relegated to the stuff of nostalgia—we can all marvel at the outmoded clothing and bad haircuts and mortifying orthodontia that we'd much prefer to forget— we are, at the same time, being catapulted into a game of unconscious comparison, routinely measuring ourselves against type, and, worse, against each other. Who was behind the camera, indeed: and who was behind the decision to photograph our children year after year after year? The idea that pictures of our children would inevitably come to be shared by our children might seem a foregone conclusion, but

weaponizing those photos as agents of bullying—an unfortunate, if inevitable consequence of all that sharing—stems from a kind of social one-upmanship that has a complicated history all its own. Isn't "keeping up with the Joneses" a form of human measurement? Maybe the line-up was always a freak show.

The urge to measure may well have its roots in the Renaissance, an era in which human proportion gestured to divinity, but would later fuel speculative hypotheses by anthropologists, statisticians, social scientists, and eugenicists. A century before computer software would facilitate digital methods of pictorial reconstruction, the British polymath Sir Francis Galton introduced something he dubbed "composite" portraiture, a practice whereby facial photographs could be layered, and their opacities manipulated, to gather and assess traits between families, communities, races, even civilizations. (Eugenic clinical photographs often documented faces alongside rulers, on the assumption that the undesirable—once their features had been properly clocked as aberrant—could thus be excised from history.) That the supremacist ideals of human measurement would, by the Second World War, lead to more egregious experiments at the hands of the Nazis ultimately reframed eugenic doctrine as what it always was: a

Jocelyn Elizabeth Johnson Mitchell
1929

Born in New Haven, Connecticut, Mitchell was the only woman in her graduating glass at Howard University College of Medicine, where her nickname was "Jack." Described in her yearbook as a "romantic pragmatist," she went on to become a gynecologist in Washington, DC, and lived to the age of 97.

Smithsonian National Museum of African American History and Culture.

Face: A Visual Odyssey

diabolical perversion. Here, the notion of the reflective boomerang is at once toxic and terrifying. To jettison all that is different is to privilege sameness, abolish variance, and oppose anything living outside the mirror's narrow frame. Airbrushing, fierce enemy to the authentic, may well have a sinister cultural provenance.

Nevertheless, is it not well within the human prerogative to "put your best face forward"? Selfie-taking is a booming industry supported by an ever-increasing market for beautification apps: this means airbrushing, to be sure, but also includes a dazzling suite of custom enhancements that offer radical, even racial alteration. In Asia this means smoothing the complexion, lightening the skin, and typically enlarging (or "Westernizing") the eyes. There are comical apps to make you less desirable, too: apps that fatten, disguise, cartoonify, even zombify, as well as apps to speculate on what will happen when you grow old. (Spoiler alert: you'll be wrinkled.) Meanwhile, in 2017, the American Academy of Plastic Surgeons noted a 55 percent uptick in patients requesting nose jobs: when asked why, a sizable majority cited a growing dissatisfaction with the way their noses looked in selfies.[2]

To the degree that the selfie has torpedoed itself into the visual language of contemporary culture, the need to endlessly photograph our own faces (and insinuate ourselves into all manner of images) has introduced a comparatively new form of personal measurement: it's called "relatability" and it currently vies for our attention in a climate overrun by vanity, impatience, and an ever-evolving catalogue of highly elusive beauty standards. A harmless, if popular, measure for public engagement, relatability leads with the query: am I part of the story? Can we "relate" to something only when we're embedded in its narrative? Cue the echo chamber's recursive loop: like the snapshot-obsessed before them, inveterate selfie-takers all too often conflate self-documentation with public connectedness—an entertaining, if sometimes misguided pursuit. Selfies may favor the personal, but they also feed on the endless opportunities provided by the sheer insatiability of an ever-public global arena. Insatiability may be precisely the point, here: to quote the Italian writer Italo Calvino, maybe we've all become hunters of the unattainable.[3]

On the positive side, selfies can also be seen as affirmations of agency writ large: they're entertaining, inexpensive, and (mostly) harmless. They're also valued catalysts for social engagement: to be fair, our faces are where the force field of first impressions both gestate and thrive. (Were this not the case, the entire online dating industry would instantly cease to exist.) There's a seamlessness to selfies that deserves mention, too, as well as a seemingly unlimited amount of real estate to accommodate them: taking, distributing, and archiving all those pictures—as of this writing, 417,000 of them on Instagram alone—has become effortless, so effortless, in fact, that we scarcely notice where they've gone. How to embrace these ever-increasing numbers—by logging, measuring, archiving them in pursuit of some imagined gestalt, chasing the illusion of what might constitute a complete picture? Hardly. In the end, any study of the history of the human

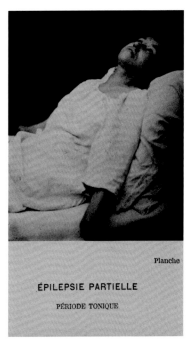

Planche

ÉPILEPSIE PARTIELLE

PÉRIODE TONIQUE

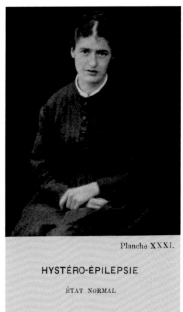

Planche XXXI.

HYSTÉRO-ÉPILEPSIE

ÉTAT NORMAL

Jean-Martin Charcot
Photographic Iconography of the Salpêtrière-Pitié Hospital, France

Confining four thousand women believed to be incurably "mad," Charcot visibly documented the evidence of his patients' ailments in a series of photographs he undertook during Paris's *belle époque*.

Harvey Cushing / John Hay Whitney Historical Medical Library, Yale University.

face is, at best, incomplete. As we cross the threshold into the age of big data and machine learning, the apparatus of the anecdotal is a decidedly messy affair. But that messiness is also what makes us human. And that is where this story begins.

What follows is neither exhaustive nor objective. It is a subjective cabinet of curiosities, a *Wunderkammer* of musings on the power and legacy of the face. How we are profiled, where our information is stored, the degree to which we choose to share our faces (or conversely, the fact that our likenesses can be siphoned off into obstreperous streams of publicly available data) are all ethical questions not easily addressed, let alone answered. Surveillance is a cultural disturbance that continues to evolve and is, consequently, impossible to fully capture in this, or frankly any, book. What matters here are the human questions, and the visual ones: how we read, react, and respond to what we see; how our cultural perceptions both fuel and frame our subsequent actions; how and why we perform and preen, judging ourselves and each other, one face at a time. The overall narrative is complicated and often contradictory, at turns dazzling and discomfiting. Scholarship in this area soon reveals institutional limitations: for generations, we failed to preserve and protect non-Western images with the care and attention they were due. That said, observations about bigotry and tolerance, dignity and privacy, and both the pursuit and defense of human rights present as an enduring, if irresolvable, theme throughout the pages that follow. I have tried, wherever possible, to embrace a spectrum of complexity and diversity, to honor indigeneity and to explore the gloriously imperfect ambiguity of human representation. That, too, remains a moving target, as indeed it must. History is uneven. Context can be slippery. In the end, all stories are subjective stories—even, and perhaps especially, this one.

Looking back, this might be shared as an empirical chronicle, seen against a backdrop of history and happenstance, our faces the calling cards of the dispossessed. Looking forward, it might be seen as a dystopian speculation, framed by the rote and the categorical, our faces dispassionately exiled from the human condition. Is a visual history of the face simply a myopic recounting of the aspirations of the vain, the powers of the powerful? Is it a reminder of the limits of class, the errors of imperialism, the fact that cultural exclusivity is both an editorial conceit—and a social epidemic? Perhaps the real story isn't so much about materiality or technology as it is about selfhood and surveillance: it's about us. (And them.) It's about how we see, and behave; what we hide from, and imagine; how we crave individuation, yet seek sameness. It's about how we value youth and beauty, fear ugliness and aging, and navigate a social climate at once intoxicating and inscrutable. It's about how we're groomed to resist otherness, to revile prejudice, and as counterintuitive as it may seem, how we routinely presume that what we see in others is what they see in us. It is not now, nor has it ever been that simple. The mirror is a civil war.

Renee Cox
Untitled, from The People's Project
(Acria)
1999

doe. Grittiches T.C. 4070
e. % Mrs. H. Sloane ress. 2 yr
foe. 1230 Boston Post Rd.
 c/o Tanchum

BOROUGH Bronx

NATIONALITY Spanish (Jewish)
 36 - days in class
 19 - Dr. Cert.
5 ─────
 DAYS ABSENT 55 DAYS LATE O

CAUSE Placed

 rent - 2 family
 house.
 1 older sis.
 2 younger br.
OCCUPATION Lamp Maker

OCCUPATION

Tallent Miss Sklar
ul 8 - 1572 (Mon. + Thur
 a. m.)
AMOUNT

A | Anthropometry

Doris Abravaya stood just over five feet tall and weighed less than one hundred pounds when she graduated from Manhattan Technical High School in 1933. Her time there was documented on a single oversized card, preprinted with basic data entry fields—school attendance logged in pencil, family facts registered in ink—alongside cryptic acronyms and earnest equations, matriculation dates, and at least seven different addresses. A tiny photo of an elfin Doris peeks out from the bottom of that card, her expression a dreamy mixture of romance and resignation. She looks little. She looks lost.

Cards like these bespeak a kind of generic authority, giving us little reason to question their veracity, yet question them we must. To begin with, she was not Doris but Dora, the second daughter of Josef (not Joseph) and Rebekah (not Rebecca), young Sephardic Jews who had emigrated to the United States together with their four children in the early years of the twentieth century. They were not Spanish but Turkish: Josef's naturalization papers suggest he worked as a barber and a restaurateur (not, as this data would suggest, a lamp maker). Rebekah's address (possibly her place of work, possibly her residence) is given as the Manhattan State Hospital, an establishment that had been previously known as the New York Asylum. At first glance, it might appear that Rebekah was employed there, but a closer read suggests that it was probably her home at the time. Further digging reveals a death notice, sometime in the 1950s, in Wingdale, New York. Until the early 1990s, this was home to a mental health facility of some renown and may well be where Rebekah spent her last years.

Confidentiality in general (and HIPAA laws in particular)[1] prevent even the most conscientious researcher from sharing Rebekah's medical history, but it is possible, even likely, that her prolonged

hospitalizations explain why Dora lived with her aunt, why she had two social workers, and why she missed fifty-five days of school in a single year. What is not mentioned is that Dora's older sister, Frida, likely lived under the jurisdiction of the Hebrew Sheltering Guardian Society: records show that Frida was sent to the convalescent home for Hebrew children, suggesting she may have been disabled. One can easily imagine that her father might have struggled to care for her as a single parent, especially with three younger children to support.

And what do we know of Dora herself? If we believe her given coordinates, she was born on June 12, 1915, on the same day—and in the same city—as David Rockefeller. Could their lives have been any more different, their destinies any more predetermined by the binary opposition of their initial, if accidental circumstances? And how do we even begin to measure that?

We are groomed, from an early age, to crave measurement. Notches on walls verify our height. Notes from doctors record our weight. We buy scales and diaries, save report cards and log achievements. As babies become toddlers become adolescents and adults, we take pictures—lots of pictures. Memories registered and milestones passed, we willingly share our data by way of a host of forms that cumulatively present, over a lifetime, as a kind of gold standard. On paper or online, they're our material witnesses, holding the temporal at bay.

Dora's material witness is typical of the sorts of records to which all of us are attached, official documents that connect faces to places, snapshots to statistics. Bureaucratic and perfunctory, we seldom stop to question the silent power of these documents, even as they transport our collective selves across time and space. Lacking nuance, devoid of emotion, they nevertheless confer a kind of keen graphic authority, begetting permission, enabling access, presupposing legitimacy, and anticipating a host of needs. Framed by the records that circumscribe that legitimacy—the records and diplomas, ID cards and passports and licenses—the playing field of difference is homogenized by numerical necessity, making all of us, in a sense, prisoners of the indexical.

Alphonse Bertillon
Indexical Records of Facial Features
1880–1914

Chins explained by their typoligies, from top: receding, flat, and ball (in French, this is known as "à bouppe.")

The pursuit of human metrics has a rich and fascinating history, dating back to the ancient Greeks, who viewed proportion itself as a physical projection of the harmony of the universe. Idealized proportion was synonymous with beauty, a physical expression of divine benevolence. ("The good, of course, is always beautiful," wrote Plato, "and the beautiful never lacks proportion.")[2] From Dürer to Da Vinci, the notion that humans might aspire to a pure and balanced ideal would find expression in everything from the writings of Vitruvius to the gardens of LeNôtre to the evolution of the humanist alphabet. To the degree that proportion itself was deemed closer to the divine when realized as an expression of balance and geometry, proportion had everything to do with mathematics in general (and the golden section in particular) and found its most profound expression in the realization of the human form.

Face: A Visual Odyssey

Plate 35

NOSES CHARACTERIZED BY THE EXTRAORDINARINESS OF ONE OF THEIR DIMENSIONS

1. Nose [con]cave elevated of very great projection.

3. Nose rectilinear elevated of very great projection.

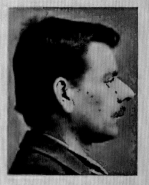

5. Nose convex elevated of very great projection.

2. Nose of the same form as No. 1, but of very little projection.

4. Nose of the same form as No. 3, but of very little projection.

6. Nose of same form as No. 5, but of very little height and medium projection.

7. Nose [con]cave (depressed) of little projection and with tip a little thick.

8. Nose slightly convex horizontal of very great height.

9. Nose of same shape as No. 8, but of very little height.

FIGURE VUE DE FACE (a)

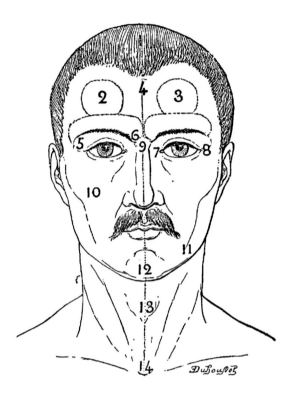

Désignation des parties :

1 — cuir chevelu ; 2 — bosse frontale droite ; 3 — bosse frontale gauche ; 4 — ligne médiane (représentée par une droite pointillée allant du sommet de la tête au bas du cou) ; 5 — pointe externe (ou queue) du sourcil droit et angle externe de l'œil droit ; 6 — pointe interne (ou tête) du sourcil droit ; 7 — angle interne de l'œil gauche ; 8 — angle externe de l'œil gauche et pointe externe du sourcil gauche ; 9 — racine du nez ; 10 — pommette ; 11 — maxillaire gauche ; 12 — bout du menton ; 13 — larynx ; 14 — fourchette sternale.

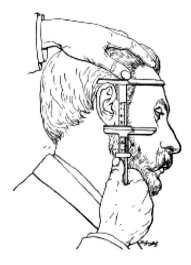

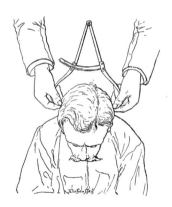

Alphonse Bertillon
*Signaletic Instructions Including the
Theory and Practice of Anthropometrical
Identification*
1896

Also known as the Bertillon System of
Identification, this nearly five-hundred-
page book includes diagrams, checklists,
and detailed instructions for identifying
criminals—dead or alive. "How much more
precious would such means of identifica-
tion be," notes the preface, "if it could be
applied not only to the living man, but to his
dead body—even when crushed, mangled,
or dismembered beyond recognition?"

While there is ample evidence to suggest that the urge to
measure had its origins in ancient civilizations, the science of
bodily measurement was not recognized as a proper professional
pursuit until the nineteenth century. With the advent of industry
and the pragmatic concerns with which it was associated—growth
projections, profit motives, numerical evidence as approved metrics
for evaluation—certain public institutions were perhaps uniquely
sensitized to appreciate the value of quantitative data. Statistics as a
field of mathematical inquiry gained traction as a discipline thanks in
no small part to the scholarship of Sir Francis Galton, whose obsession
with counting and measuring everything imaginable (but especially
human beings) warrants mention here. His 1891 "Anthropometric
Laboratory"—which was included in the International Health
Exhibition held in London in 1885—was an attempt to show the public
how human characteristics could be both measured and recorded.[3]
Add to this the rise in photography as a promising new technology
and the idea of capturing evidence via methodical efforts in data
mining was an idea whose time had clearly come.

To measure was to apprehend and be made accountable, and
nowhere was this more resonant than in the identification and
classification of criminals, led by the efforts of one particularly
dedicated officer in Paris at the end of the nineteenth century.
Alphonse Bertillon was the black sheep of his largely intellectual
family, many of whom were physicians and statisticians. A weak
student with a reputedly obstinate manner, he flunked out of school
twice, and found only entry-level work in the Paris Police Station,
following a singularly unimpressive tour in the army as a bugle
player, at the relatively advanced age of twenty-six. Unceremoniously
relegated to the basement, where he was charged with the laborious
process of hand-copying prisoners' admission forms, Bertillon
soon began to notice a number of key discrepancies—in language,
description, order, and detail—that caught his attention. There
was too much reliance on eyewitness accounts, he believed, a poor
organizational system, and a surprising scarcity of consistent input
criteria. The idea that increasing rates of recidivism might bear a
direct relationship to these ineffectual methods gave Bertillon cause
for concern, and he set out to remedy what he perceived to be a deeply
flawed system, one that failed to recognize, among other things, the
specifics of facial discrepancy.[4]

Bertillon understood that the study of evolutionary biology is
based upon a careful examination of difference, noting in particular
that difference itself is best understood (and ideally more accurate)
when measured in a controlled environment. By reducing the variables
and streamlining the input process itself, he wondered if there might
not be a more effective system for identifying—and by conjecture,
capturing—repeat criminals. Inspired by the writings of Adolphe
Quetelet, a Belgian statistician who had introduced the concept, in 1835,
of what he termed *l'homme moyen* (the average man)—a standard-
bearer against which the general population might be effectively

REPRODUCTION PAR LA PHOTOGRAVURE

d'une photographie judiciaire (profil et face) avec notice signalétique y relative combinée en vue
du **portrait parlé.**

La fiche, du format dit à classer alphabétiquement (161ᵐᵐ sur 142ᵐᵐ), est disposée de façon à ce que, pliée en deux
en dessous de la photographie,
elle puisse être facilement introduite dans une poche de redingote.

(*Recto.*)

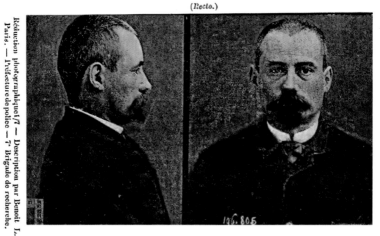

Réduction photographique 1/7. — Description par Benoit L.
Paris. — Préfecture de police. — 1ʳᵉ Brigade de recherche.

Cliché nº 196.805 fait le 10 décembre 1890, il y a 2 ans,
le sujet alors âgé de 28 ans en paraissait 32.

Observations anthropométriques. Renseignements chromatiques. (1)

taille 1ᵐ, (54.1) Oreille dr. Tête { longʳ 18.5 pied g. 24.1 dʳ/4 Coulʳ de l'Iris { nº de cl. 3 barbe *chât. roux m.*
voûte 1 largʳ 15.6 médius g. (10.0) aurⁱ *τ oz m* cheveux *chât. m. gris.*
envergᵗ 1ᵐ, 50ʷ longʳ 6.2 auricᵗ g. 7.9 périⁱ *ard. j. v. m* { (Pig⁻ p
buste 0, 89.2 largʳ 3.8 coudée g. (38.8) partⁱ⁻ Color { (Sang⁻ (d)

Renseignⁱˢ descriptifs analysés de profil : Contour Gᵃˡ *occiput* nes proeplat

Front { Arcᵗ p. / inclⁱⁿⁱ (*fuy*) / Hautʳ m. / Largʳ m. / partⁱ⁻ *découvert à profil courbe*

Nez { Racine (profʳ) m / dos rectˡ s. base relevée / Hautʳ Saillie Largʳ / m. l m. l m / partⁱ⁻ *lég.* dévié à drⁱ

Oreille droite { bord. Origⁱ Supʳ p. Postʳ p., ouvⁱ⁻ / lob.contⁱ *équerre* adhⁱ *fondue mod.* uni Dimⁱ *tc. p.* / a. trg. inclⁱ profⁱ renvⁱ Dimⁱ / pli. infⁱ supᵗ *tc.* *haute* forme ; ecⁱ / partⁱ⁻

Lèvres { hʳ labiale p. / partⁱ⁻ *minces* (!) / Menton { inclⁱⁿ *saillante* / Hautʳ p. / partⁱ⁻ *à houppel*

Renseignⁱˢ descriptifs analysés de face : Contour Gᵃˡ *pommettes* lég. *saillantes.*

Cheveux { implⁱ *chvx. en pointes.* / barbe *fer à cheval* / emplⁱ *bas* / volume *courts* / partⁱ⁻ *en brosse*

Paupⁱ { ouverture *peu fendues* / modelé spⁱ *presque recouverte* / Saillie du globe / Interoculaire / partⁱ⁻ ocul⁻

Bouche { Dimension *cachée par une moustache* / tracé *longue et descend.* / partⁱ⁻ *2c lui manquait les deux incisives médianes* / rides / expression

Corpulence { cou *larynx saill.* / Carrure *L. p. i. oll* / Ceinture m. / habillement *col droit.* / divers (1) *touffe de cheveux blancs, net au milieu, sur le devant*

attitude / allure / acc⁻ *croix méridional*

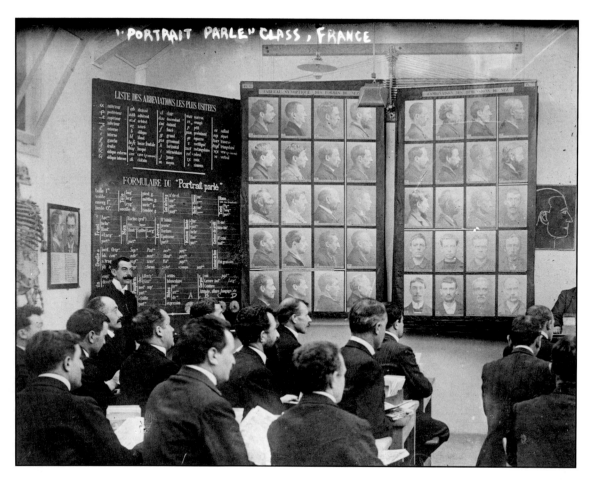

Alphonse Bertillon
Class on the Spoken Portrait
1911

Bertillon's notion of the spoken portrait
(or "portrait parlé") embraced a method
of physical description that demanded
precise, detailed measurements of both
body and face. His index cards (opposite)
allowed for this documentation to be
logged and filed for easy retrieval by and
between police precincts.

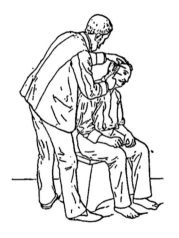

compared—the young Bertillon chose to devote himself to the study
of more precise visual observation.[5] His system, which would become
known as Bertillonage, revolutionized the field of criminal justice and
lay the groundwork for what would emerge as a more efficient method
for criminal management.[6] And, as it happened, a more teachable one.

If Quetelet's focus was on the average man, the Italian
criminologist Cesare Lombroso focused on a more delinquent model.
Born to a wealthy Jewish family in 1835 (the same year Quetelet
published his principal work, *A Treatise of Man and the Development
of His Faculties*), Lombroso was trained as a physician, and later
became a professor of forensic medicine. (He published his own
book on human delinquency in 1878.)[7] Over time, Lombroso would
come to be known for his staunch belief in biological determinism:
notably, the supposition that mental illness was genetic, and that
criminals were born, not made. A fervent believer in atavism, he was
particularly drawn to the fine-tuned measurement of the skull as an
indicator of the savage proclivities of man. (Thieves had small eyes, for
example, and rapists could be identified by their big ears.)[8] Lombroso's
unconventional methods ultimately proved wildly inconsistent, his
conclusions far more quixotic than reliable. Though popular in his day,

ANTHROPOMETRIC
LABORATORY

For the measurement in various ways of Human Form and Faculty.

Entered from the Science Collection of the S. Kensington Museum.

This laboratory is established by Mr. Francis Galton for the following purposes:—

1. For the use of those who desire to be accurately measured in many ways, either to obtain timely warning of remediable faults in development, or to learn their powers.

2. For keeping a methodical register of the principal measurements of each person, of which he may at any future time obtain a copy under reasonable restrictions. His initials and date of birth will be entered in the register, but not his name. The names are indexed in a separate book.

3. For supplying information on the methods, practice, and uses of human measurement.

4. For anthropometric experiment and research, and for obtaining data for statistical discussion.

Charges for making the principal measurements:
THREEPENCE each, to those who are already on the Register.
FOURPENCE each, to those who are not:— one page of the Register will thenceforward be assigned to them, and a few extra measurements will be made, chiefly for future identification.

The Superintendent is charged with the control of the laboratory and with determining in each case, which, if any, of the extra measurements may be made, and under what conditions.

H. & W. Brown, Printers, 20 Fulham Road, S.W.

his controversial doctrines were ultimately discounted as ineffectual, inappropriate, and prejudicial.

For his part, Bertillon's methodology was exacting, quantitative, and rigorous. He toured prisons, where he undertook measurements with calipers that allowed him to record his subjects with the utmost precision. ("Every measurement slowly reveals the workings of the criminal," Bertillon would later write. "Careful observation and patience will reveal the truth.")[9] Head circumference and chin angle were more critical determinants than, for instance, a suspect's surname, and over time, Bertillon compiled what was, in essence, a comparatively early (and radically inventive) database in which data was searchable by the metrics themselves. (The unusually time-consuming nature of this type of work eventually obliged the young criminologist to seek assistance: he later hired a young female helper, and—once she proved her dedication by personally filling out more than seven thousand ID cards—he married her.)

By 1888, the Paris prefecture had created an identification bureau helmed by Bertillon. Within a few short years, he'd inaugurated an even more sophisticated system, which would become widely known as the *portrait parlé*—the speaking portrait. Parsed into descriptive sections with exhaustive notational criteria, the idea was that the face could be deconstructed by any intaking officer. In addition to racial determinants that included skin tone and hair color, Bertillon parsed the face itself into compartmentalized subsections allowing officers to log every possible mark, blemish, and visual detail. Such detailed analog input ultimately proved both time-consuming and inefficient, a slippery system for capturing the subtlety of facial variables. By the early 1900s, Bertillon's once-innovative system had begun to fail.

The desire to measure the face has continued to remain a critical function in law enforcement, albeit a controversial one. Today, an increasingly more adept and agile machine landscape has reframed the once-flawed act of analog human measurement. Algorithms now do the work for us, but algorithms can often be wrong. (Such bias in machine learning is often referred to as a "coded" gaze.)[10] When leveraged against the intricacies of biology, humanity, and personhood, the mechanical application of statistical analysis can easily miss the mark. Like Dora, whose truncated biography so poorly represented who she truly was, such documents often favor the format over the content, missing the bigger and more complex story—a story that is, by its very nature, impossible to capture, let along deliver, on an index card.

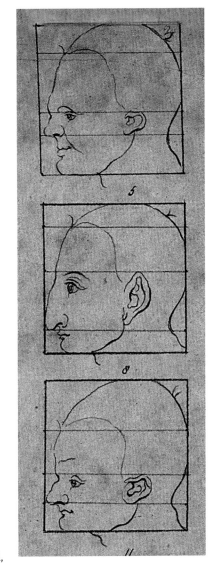

Opposite
Sir Francis Galton
Anthropometry Laboratory Poster
1851

Above
Albrecht Dürer
Facial Proportion Studies
Sixteenth Century

Wellcome Collection.

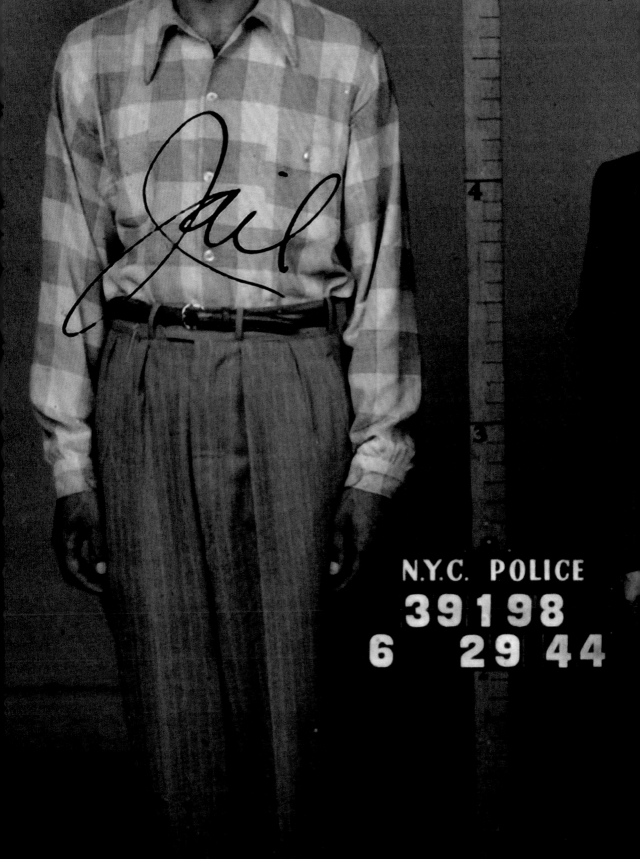

B | Biometrics + Bias

When I sing, I don't want them to see that my face is black. I don't want them to see that my face is white. I want them to see my soul. And that is colorless.

Marian Anderson

In 2010, a group of British roboticists proposed a more expedient system for facial recognition based on, of all things, the nose. Brilliant—or biased? Observing that there is no one magic biometric, PhotoFace takes a 3-D image of a nose, then analyzes it computationally against six main nose shapes: Roman, Greek, Nubian, Hawk, Snub, and Turn-up.[1] If that sounds comical, well—it is. (Shnozz as sundial!) But it's also pragmatic. Consider the degree to which the practice of criminal identification demands accuracy as well as expediency. To that end, parsing all that is photographic—from the casual and blurry snapshot to the staged and seated mugshot—may benefit from the pure dimensionality the nose delivers. Set against the relative flatness of the facial plane, the proboscis is actually a perfect slice of geometry.

Facial detection today is a serious industry, fueled by robust efforts in visual analytics that include tracking, sensors, encryption, security protocols, massive databases, and phenomenally complex algorithms—all of which lie well beyond the purview of this book. But the human ethics surrounding this issue are precisely within its purview. The degree to which a "subject" does not actively participate in the acquisition of his or her own likeness raises complicated questions about privacy, individuality, compliance, fairness, and the far more philosophical human spectrum of free will. If successful biometrics are guided by the promise of computational accuracy at the expense of human cooperation it is because we have so objectified the face that we scarcely notice that it is attached to a sentient being. Were this not the case, we might more judiciously consider the language we use to describe these efforts. Consider the fact that, in the robotics world, the coordination of the static and the active

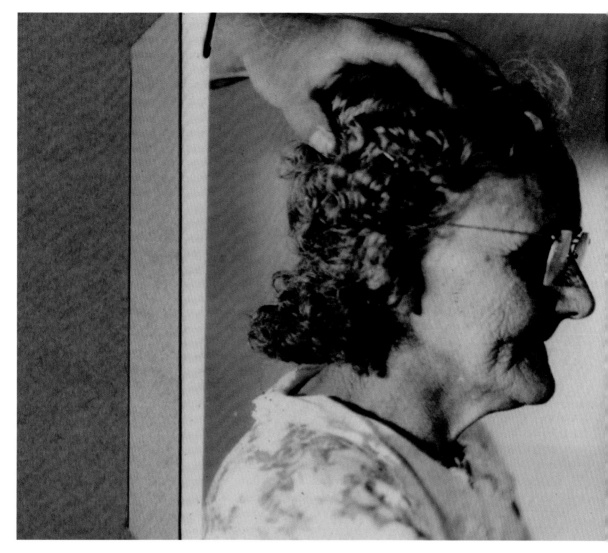

May Taylor Arrest Photos
1940

Arrested for shoplifting, fifty-seven-year-old
Philadelphia resident May Taylor's head was
physically held in place so that her coordinates
could be properly measured.

Mark Michaelson Collection.

camera—co-calibrated for security purposes to detect peoples' faces
as they move—is rather horrifyingly referred to as the "master/
slave" approach.[2] And no: the fact that this language has its origins in
Hegelian dialectic neither forgives nor excuses it. As the virtual slips
into the real, and the word "artificial" is joined ever so casually with the
word "intelligence," language that references such regrettable human
atrocity only serves to further drive bias into a more permanent state
of cultural malignancy. We can do better, and we should.

Under contract to the US government in the 1960s, Woodrow Wilson
Bledsoe, an early pioneer in pattern recognition, developed a system
that set out to classify photos of faces using something called a RAND
tablet, a somewhat primitive incarnation of the iPad that allowed
for the manual recording of facial coordinates: eyes, nose, hairline,

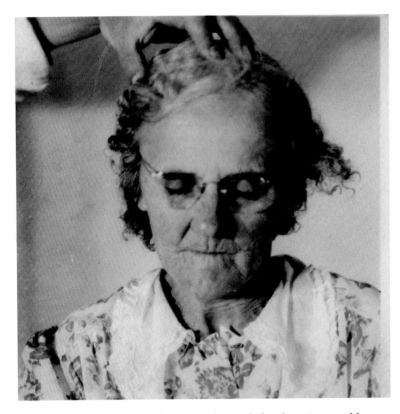

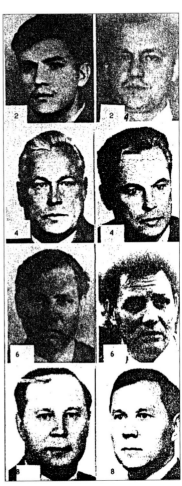

The Model Method of Facial Identification
W. W. Bledsoe
1964

What Bledsoe termed the "recognition problem" was a function of human variation. "Some other attempts at facial recognition by machine have allowed for little or no variability in these quantities," he wrote in his 1964 study, noting that optical date pattern matching was certain to fail in cases where the variability is great. (The poor image quality reflects the nature of the typical mimeographed office copy.) "In particular," he noted, "the correlation is very low between two pictures of the same person with two different head rotations."

and mouth. Once inserted into a database, Bledsoe's system could retrieve images and compare them with subsequent ones, thereby allowing for more efficient, and ideally more accurate, comparisons.[3] Between 1955 and 1969, Bledsoe published two papers on this subject for an organization called the King-Hurley Research Group (which was later revealed to be a front for the CIA)[4] in which he concluded that the technology did not yet exist to deploy picture recognition in concert with the human face. Nevertheless, his work paved the way for several subsequent studies, at least two of which—Eigenfaces and Fisherfaces—would go on to focus on how data might be maximized to better analyze facial features and focal differentials.[5] Bledsoe, who died in the late 1990s (only a few short years before the global war on terrorism would shift biometrics into critical focus with regard to national security) rightly predicted the degree to which this kind of systematized acuity would become imperative. The global market in biometrics grew from $400 million in 2000 to $5 billion in 2011 and is projected to increase to $23 billion by 2019.[6] What Bledsoe could not accurately predict, however, was the rise of social media: specifically, that photos of our faces would come to be so randomly shared and identified. True, your face is yours and yours alone, but what happens when it can so effortlessly migrate elsewhere, trafficking in the relative ambiguity of all that is so disorientingly digital?

Established in the United States a decade ago, the Biometric Information Privacy Act—or BIPA—was a landmark bill that set

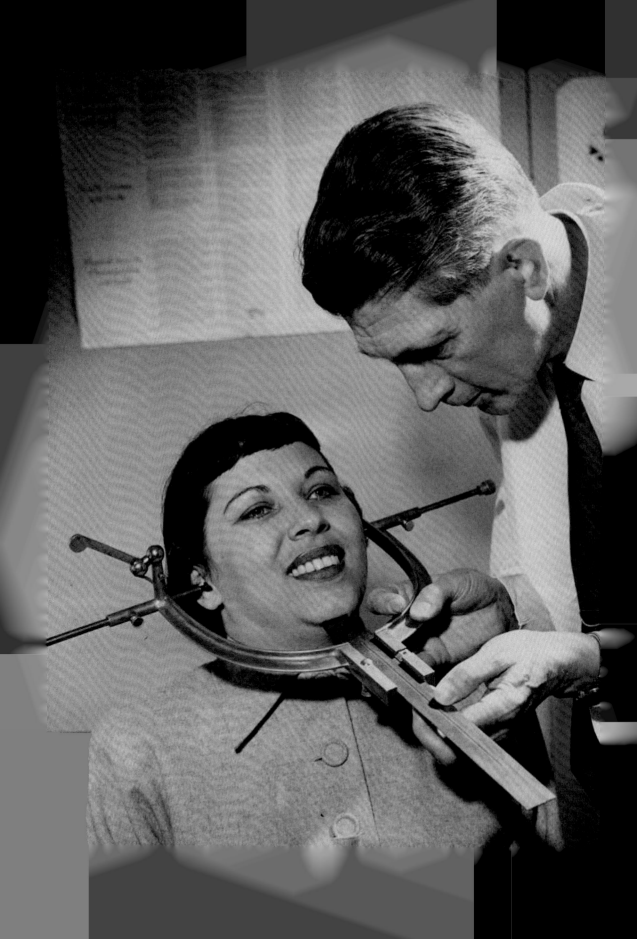

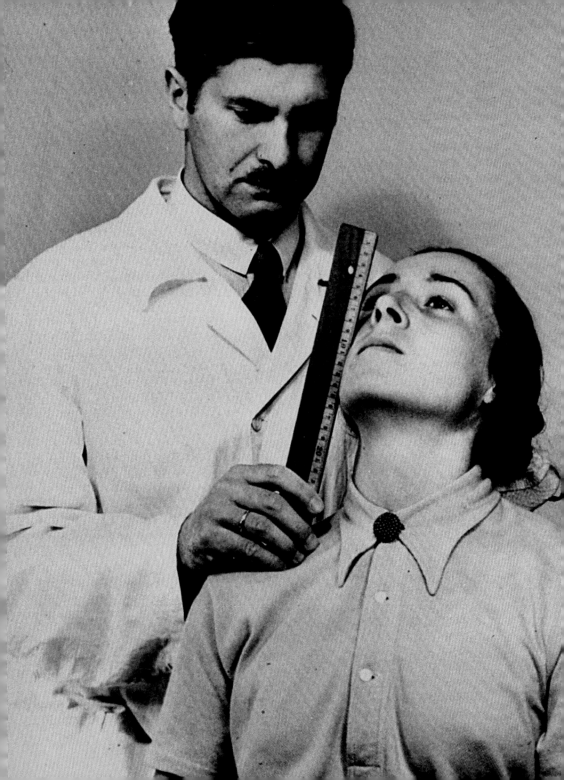

Previous Page, left
Head Spanner
1952

An Open House at the Philadelphia Center for Research in Child Growth invited visitors to measure their faces. In this photo, a "senior anthropometrist" measures a volunteer.

Temple University Libraries.

Previous Page, right
Racial Examination
Circa 1933–1939

Not all face measurement was as benign. Here, the facial dimensions of a young German woman are measured during a racial examination.

United States Holocaust Memorial Museum.

Below
Bertillon Measurement System
Taking Bertillon measurements at the 1904 St. Louis World's Fair: mapping the body against a geometric device oddly evocative of a crucifix.

Missouri Historical Society.

out to define and defend the coordinates framing biometric data access, privacy, and everything in between. Today, it's under attack for numerous reasons, not least because biometric data is so easy to capture (and even easier to share)—something no bill in Congress can manage to regulate. Not long ago, when Facebook first introduced facial recognition technology, a seemingly innocuous feature that allowed users to identify both themselves and each other, the idea of "tagging" your friends hardly seemed a violation of privacy.[7] While it may present as a useful ID metric, personal picture tagging, by its very nature, does not require consent, and can thus easily lead to naming, shaming, finger-pointing, cyberbullying—and bias.

By all rights, bias is a deeply human prerogative, albeit one that is ever-shadowed by dark associations and unbidden assumptions. On a cognitive level, what we like can be influenced by any of a number of factors including, but not limited to, climate, context, nature, nurture, gender, advertising, peer pressure, and some degree of genetic predisposition, but mostly it begins with what we see in ourselves. What Jacques Lacan called the mirror stage—the age at which we recognize our own reflections (about six months) reflects an evolutionary bias that is not unique to humans. (It's also not unique

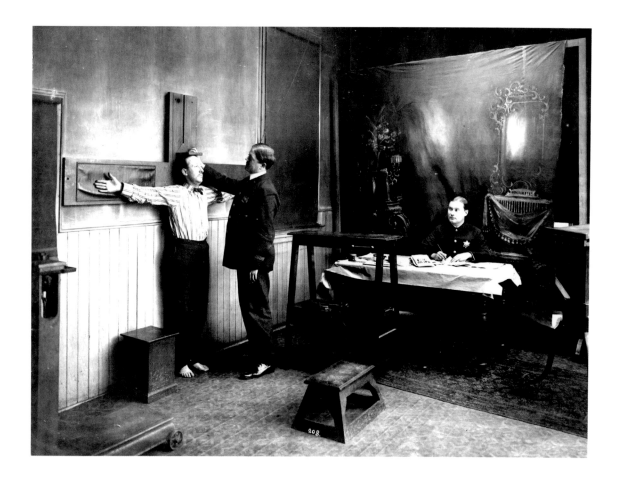

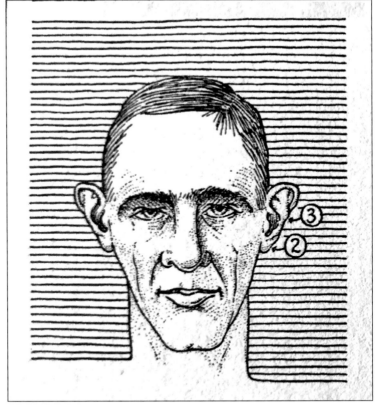

Above
Crime and the Man
Earnest A. Hooton
1939

A twelve-year study of the anthropology of the American criminal. Known for his work in racial classification and primatology, Hooton shared Lombroso's view of the "born" criminal, and was particularly drawn to measuring things: his "Harvard Fanny Study," for example, involved measuring buttock spread and buttock-knee lengths to design more comfortable car seating for Pennsylvania Railroad.

to Lacan: Charles Darwin wrote about babies and their reflections as early as 1877.)[8] Infants, beyond recognizing their own mothers, are said to prefer what are called "own race faces"—sociologists call this "the mirror effect"—which posits the power of presumed reciprocity: you see yourself through the gaze of others, and you tend to view others more favorably if they resemble you in some way. Similarly, the idea of "like begets like" speaks to an implicit, and seemingly harmless, subjectivity that may not be surprising—until it is. But when does subjectivity become narrow-mindedness, and to what degree does repressed bias lead to involuntary, or even willful generalizations, particularly as we age?

Being a baby is one thing—being baby-faced, another. As it happens, adults with round baby-like faces are perceived to have more childlike traits—to be naive, submissive, weak, and warm—and are often passed over for mentally challenging tasks and leadership positions.[9] Likewise, we tend to believe that attractive people are more trustworthy and reliable than those who are less attractive. (Experts sometimes refer to this as an "attractiveness" halo.) But to what extent do we unwittingly project our preferences onto the faces of others? And how deep does that bias go in driving perception? A reliance on biometric data can dangerously skew narratives by privileging its own disciplinary authority:[10] stories thus become over-rationalized by data, wrongly contextualizing historical, cultural, even personal fact.

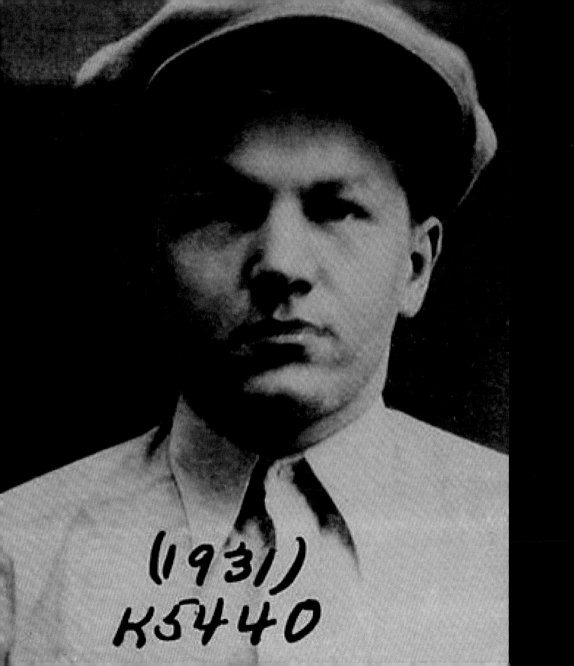

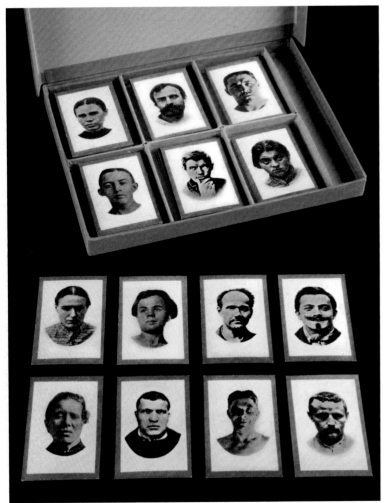

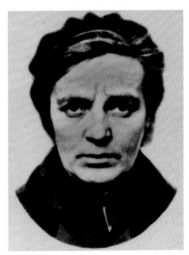

Genotropism—a doctrine first introduced by Hungarian geneticist Léopold Szondi in 1938—suggested that a predisposition for attraction is shared by people who are genetically linked. His controversial Szondi test of 1935 was a travesty of bias: using photographs of faces of both genders, the idea was to trigger responses that revealed a viewer's own repressed psychological impulses. (Your sympathy or aversion to a given image was meant to indicate your true sentiments.)[11] Szondi himself believed that faces were physical manifestations of genetic aberrations including, but not limited to, mental illness and homosexuality. That he used these images as the basis for a kind of bespoke psychological target practice did little more than reassert the willful distortion of the cultural stereotype. In so doing, his eponymous test reframed facial identification as a prejudicial social platform—pictures pegged as friendly or unfriendly, pleasant or unpleasant—binary judgment the unspoken guide. The face in this context was not so much a canvas for clinical study as a forum for cultural manipulation, each likeness a victim of bias, each a caricature of itself.

Opposite
Baby Face Nelson
(Lester Joseph Gillis)
1931

The Federal Bureau of Investigation.

Above
Szondi Test
Léopold Szondi
1935

The Morgan Library and Museum.

C | Caricature + Close-ups

However regular we may imagine a face to be, however harmonious its lines and supple its movements, their adjustment is never altogether perfect: there will always be discovered the signs of some impending bias, the vague suggestion of a possible grimace, in short, some favorite distortion towards which nature seems to be particularly inclined.

Henri Bergson

In Italian, the verb *caricare* means "to load," making the word caricature literally a loaded portrait. But loaded with what, and by whom? Ironically, the opposite is much closer to the truth: the caricature wields its principal power by removing all superfluous detail. Consider the oversized ears of Prince Charles, the oversized hair of Donald Trump, the oversized nose of any of a host of political figures throughout history (occasionally, a not-so-subtle Pinocchio reference), all of them reductive, pared-down incarnations of their subjects' most pronounced physical characteristics. Exaggeration, the life blood of all caricature, functions best when it is the subject of keen distillation.

And yet exaggeration itself is meaningless without an anchor of individuation: simply put, the caricaturist must simultaneously deviate from accuracy while capturing and carefully preserving a sense of core identity.[1] (A big nose alone does not a caricature make.) While entertaining, the caricature also be injurious, migrating effortlessly from skewering depiction to full-blown mockery. Consider Leonardo Da Vinci, whose obsession with ugliness emerged in drawings that were brazenly unkind, even salacious. ("The drawings of hideous, deformed faces with sagging skin, bulbous noses and elephantine jaws," explains Jonathan Jones, an art critic for the *Guardian*, "were the cruel and dubiously comic portraits of freaks.")[2] That this work was seen as permissible in its day (and long admired) sheds light on a lamentable aspect of caricature: the idea that it serves to entertain the populace at the expense of the person. Public figures might be excused on the assumption that they willingly sign on for such visual derision, but to ridicule civilians (or the unfortunate, or the infirm) shifts the art of caricature into an act of shame. Willful facial distortion can be comical, but it can also be barbaric.

The OP Spectacles

George Cruikshank
The OP Spectacles
1809

Library of Congress.

Cruikshank's print shows a horrified John Philip Kemble looking at the world through O.P. spectacles—signifying "old price" and referencing the elitist uptick in pricing for private boxes at Covent Garden.

The theatergoing public protested because the cost for entry was prohibitive. Kemble later publically apologized: it was agreed that the private boxes would be returned to public use, with the pit priced accordingly.

CHART A
Characterological Disarticulated Head

CHARACTEROLOGY

AN EXACT SCIENCE

EMBRACING PHYSIOGNOMY, PHRENOLOGY AND
PATHOGNOMY, RECONSTRUCTED, AMPLIFIED
AND AMALGAMATED, AND INCLUDING
VIEWS CONCERNING MEMORY AND
REASON AND THE LOCATION
OF THESE FACULTIES
WITHIN THE BRAIN
LIKEWISE
FACIAL AND CRANIAL
INDICATIONS OF
LONGEVITY

BY

L. HAMILTON McCORMICK

ILLUSTRATED

Chicago · RAND McNALLY & COMPANY · New York
1920

Top
Characterology : An Exact Science
L. Hamilton McCormick
1920

Below
**How to Study Strangers by
Temperament, Face and Head**
Nelson Sizer
1895

Historically, caricature was a fundamentally political enterprise, the expert domain of artists such as George Cruikshank, James Gillray, William Hogarth, and Thomas Nast, among many others—white men who saw it as their right to poke fun at the principles and policies of, frankly, other white men. That they viewed their role as social critics of the patriarchy meant that they used visual, in addition to (and sometimes instead of) verbal exaggeration as a tool for commentary. Yet if they were keen chroniclers of social performance, they were also trenchant observers of visual form: to see the circle as a set of spectacles, in the case of Hogarth, or a bloated body, in the case of Gillray, demonstrates the degree to which caricature, though prone to the exaggerated, is also an art of sublime minimalism.

But that doesn't suggest it couldn't be malicious, and it was. Both Leonardo Da Vinci and Cruikshank, among others, were given to labeling faces they drew as "grotesque." Much has been written about these artists (and about that word, more a gibe than a gesture of equanimity) which may have fueled their artistic inquiry. Leonardo, for example, wrote in his diaries[3] about the act of deliberately situating the ugly next to the beautiful. Perhaps he saw the portrayal of human difference as kind of social experiment, a binary representation of

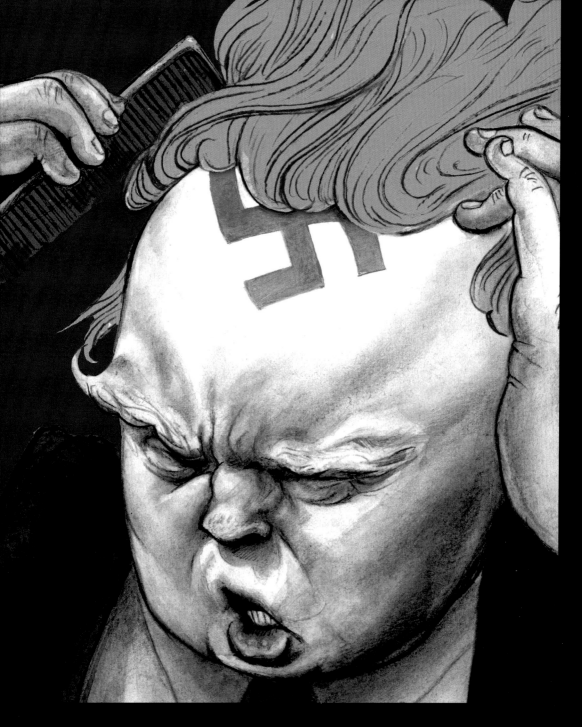

Donald Trump
Steve Brodner
2017

The Passion of Joan of Arc
Directed by Carl Theodor Dreyer
1928

"You cannot know the history of silent film," wrote the American critic Roger Ebert, "unless you know the face of Renee Maria Falconetti."

physical extremism as a way of mapping sameness against difference. The distance between bias and bigotry here is scarce, subjective, even somewhat random—but it's there.

If the facial caricature exaggerates by satire, the filmic close-up exaggerates by scale—a gesture of forced intimacy, and a dramatic maneuver on the screen. In the early days of the silent film, the close-up functioned largely as an expository gesture, facial expressions deployed to telegraph verbal ones. ("Early close-ups were often seen as grotesque, obscene, and in bad taste," writes historian Margaret Werth, "breaking the continuity of the film.")[4] Jacques Tati is rumored to have hated them, thinking them crude, dramatically indulgent, even gratuitous. Nevertheless, their power as emotional accelerants remains indisputable, in film as well as in theater.[5] From D. W. Griffith to Luis Buñuel, Sergio Leone to Spike Lee, the framing of the face is a powerful testament to emotion[6] as one of film's greatest dramatic assets, pulling viewers in, holding on tight, and not letting go.

While not limited to the actor on the screen, this kind of dramatic magnification was also evident in the oversized and often dramatically cropped printed likeness. Posters—themselves prone to a certain basic drama—invited the face to take over and colonize the frame, boosting emotional impact at the pedestrian level. Early movie posters were like theatrical trailers, teasing the story without giving too much away,

Poster for The Traitor (Detail)
Directed by Abram Room
Stenberg Brothers
1926

The Moscow-born brothers Vladimir and Georgii Stenberg were Soviet artists and designers whose film work embodied a sense of expanded movement, distorted perspective, and exaggerated scale.

Artist's Rights Society.

and often using the expanded scale of the broadside or tabloid to gesture to the drama of the main event. Michael Kimmelman once observed the impact that early twentieth century posters might have had in the age of early monochromatic films, particularly in war-torn Eastern Europe, where "the sight of a poster, bright and jazzy, must have been almost as dazzling as the starlets it advertised, who, after all, were only black-and-white in the movies."[7]

Opposite and above
L'Ecran (The Screen)
Magazine Covers
1930s and 1940s

Promotional vehicles for studios and stars alike, film magazines typically lead with the faces of the stars themselves, as in this series from an early twentieth century film periodical in France.

Patricia Martineau Collection.

The rhythm of the camera—how and when it cuts, zooms in, holds its focus on the character and does not veer away—gestures to the close-up as an act of authorship, the director guiding the camera, the camera itself a kind of sentinel. How the lens is wielded (to focus or blur, to linger or retreat) becomes as powerful as the face itself: in the case of silent films, perhaps even more so. And here the range of examples is vast. In Carl Theodore Dreyer's 1928 classic *The Passion of Joan of Arc*, the face is a symbol of martyrdom. In John Cassavetes's 1968 film *Faces*, it is an expression of ennui. For Ingmar Bergman in *The Seventh Seal*, the face is pale and bloodless—the very personification of death itself—and for a young Zelda Harris in Spike Lee's 1994 film *Crooklyn*, it is the face of focus, presence, and quiet determination. More aggressive cuts using the facial close-up are often the stuff of horror movies, or the occasional art film (Luis Buñuel and Salvador Dali's *Un Chien Andalou* comes to mind) while Norma Desmond's parting monologue in *Sunset Boulevard*—I'm ready for my close-up, Mr. De Mille—reminds us that facial scrutiny itself confers a kind of regal, if evanescent star status. In that single close-up, Desmond's character conflates celebrity with criminality, the famous giving way to the infamous as she sweeps down the staircase.

Is the close-up a tease, a perceptual trigger? Does it stage itself like a kind of cultural shorthand, a caricature of the normative? Both Jean Baudrillard and Walter Benjamin wrote critically about the hyper-reality of magnification as a particular kind of scrutiny.[8] For Baudrillard, what he termed the "zoom-in" was an expression of prurient and promiscuous detail, while to Benjamin, the challenge, for the actor in particular, was to preserve one's humanity in the face of the apparatus.[9] Long before issues of privacy would present themselves as the harbingers of concern (raising questions about how our faces migrate across the public sphere) both critics rightly observed that the close-up hinted at a newly modern mode of human scrutiny, all of us subject to a far more expansive, way more secretive, and increasingly more covert magnifying glass.

D | Diagnosis

In his face there came to be a brooding peace that is seen most often in the faces of the very sorrowful or the very wise. But still he wandered through the streets of the town, always silent and alone.

Carson McCullers

Measuring the spectrum of human emotion has always been an ambiguous enterprise. It is one thing to deploy a picture to visually represent an external physical condition, quite another to bestow upon it the far more intangible qualities of emotion, expression, even—and perhaps especially—the assessment of mental stability. Yet if the empiricism of the seventeenth and eighteenth centuries served, at least in part, to elevate both the importance of observation and the value of sensory experience, photography helped to inaugurate a comparatively radical new set of opportunities for doctors seeking scientific confirmation. For some of these doctors, the implicit seduction of the image (Walter Benjamin's "optical unconscious" comes to mind) led to questionable experiments with human beings whose faces served as blank surfaces for projection.[1] Today, in an era that is likely to be remembered for its media assault on veracity, the alleged innovations of a number of Victorian physicians remind us that photography in general (and posed portraiture, specifically) was, at least initially, seen as a reliable formal armature upon which to assess psychological health.

Since the age of Pericles, physicians have relied on the act of observation as an essential part of clinical practice. But for the French nineteenth-century neurologist Duchenne de Boulogne, photography offered a particularly compelling form of visual ratification: for Duchenne, the photo was a reflection of truth itself. ("Only photography as truthful mirror could attain such desirable perfection," he wrote.)[2] In an effort to improve on the physiognomic canon, the neurologist developed a controversial practice that combined staged portraiture with shock therapy: using small electrical probes applied

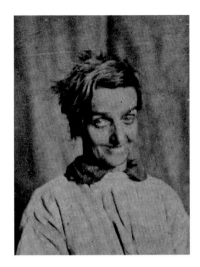

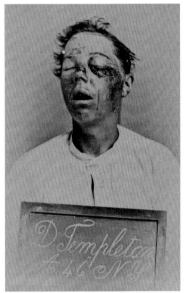

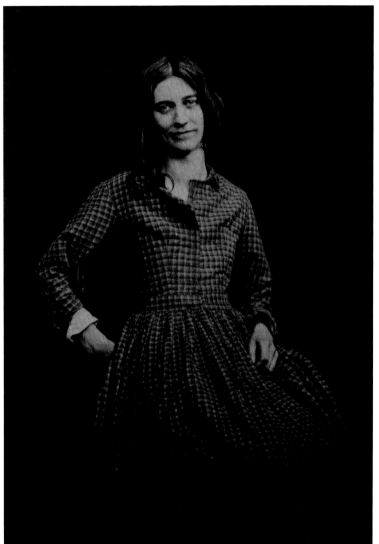

Top and Right
Dr. Hugh Welch Diamond
Patients
Surrey County Lunatic Asylum
1850–1858

Diamond wanted to "catch in a moment the permanent cloud, or the passing storm or sunshine of the soul." An early adopter of photography, he hoped to better understand the realtionship between demeanor and emotion, between the visible and the invisible.

Victoria and Albert Museum.

Below
Reed Bontecou
Civil War Trauma Photography
Harewood Hopsital, Washington, DC
Circa 1863

Harvey Cushing / John Hay Whitney Historical Medical Library, Yale University.

to various regions of the face, his idea was to intentionally trigger particular expressions that could then be captured on camera. The comparatively maudlin result succeeded in producing what was, at least as for Duchenne, "an accurate rendering of the emotions."[3] Regrettably, the photographs in question viewed "accuracy" through the troubling lens of physical manipulation, thus subverting the very essence of the Hippocratic oath. (First, do no harm.) The notion of the physician as tormenter, cinematographer, and sole arbiter of emotion testifies, in no small way, to a man whose thirst for control was exceeded only by his rather stunningly inflated ego. The resulting pictures, entertaining though they may seem, do little more than trade ethics for evil.

The ill-concealed power dynamic here is considerable. Duchenne deployed photography, in the interest of science, as a not-so-subtle form

of cultural capital. (The camera itself, still in its relative infancy and therefore costly to own and operate, functioned here as an extension of his own stature, a token of elitism.) Equally insidious, Duchenne was a master manipulator of those less fortunate: while he initially employed volunteer actors to carry out his experiments, he quickly found them insufficiently pliable for his purposes. Turning to civilians, his male subjects—recruited from working-class backgrounds—were never identified. (The most photographed among them is dubbed "old man" and is only occasionally labeled as a shoemaker.) Women were more scantily clad than their male counterparts, and their photos were less rigorously cropped, resulting in portraits far more burlesque than clinical. All of his subjects were white.

The desire to dramatize here, too, was not insignificant: in an effort to maximize the lighting and tonality for his "electro-physiological" portraits, Duchenne collaborated with a young photographer named Adrien Tournachon. Skilled, if less professionally adept than his more celebrated older brother—the portraitist Nadar—the younger Tournachon made images that revealed exposed wires and poles, with hands deliberately shifting faces into position before administering the electric stimuli that resulted in the desired expressions. Though his 1862 masterwork—*The Mechanism of Human Physiognomy*—was the first book on the human expression to contain real photographs, these photos tell a different story. Duchenne may have been a respected physician in his day, but he was also, it now seems clear, a master puppeteer.

Like Duchenne, Jean-Martin Charcot was a pioneer in modern neurology, a physician who used his power and position to orchestrate human subjects in light of his own questionable interests. Under Duchenne's tutelage at the Pitié-Salpêtrière Hospital in Paris (which had originally been built in the seventeenth century as a prison and orphanage, only to be transformed into a medical establishment during the years of the Enlightenment), Charcot produced a now-famous series of photographs in which he deliberately hypnotized women until they reached some demonstrably hallucinatory state. Volumes have been written on how this came to be—why it happened, to whom it happened, why it was tolerated not only in the academy but touted as a public form of entertainment for the rising class of the Bourgeoisie—but the painfully objectified pictures that remain both deserve and demand their own accounting.

The Charcot photographs illustrate a particularly intrusive kind of gendered pantomime: paroxysm as porn, a pictorial conceit all the more eroticized by wild hair and exposed skin. More lamentable still, it has been suggested that the women Charcot featured in his public performances were later re-hypnotized in private, so that they could properly hold these poses for the camera.[4] These images extended his influence far beyond the spectacle of the stage: in this context, the photograph itself becomes not so much a scientific form of documentation as a social vehicle for voyeurism. Charcot himself—a mentor of Sigmund Freud's—apparently possessed the swagger of a

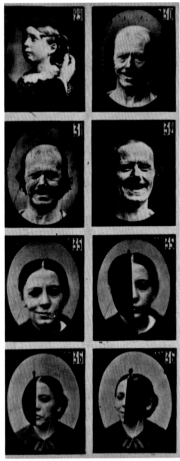

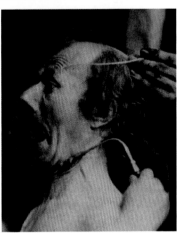

Duchenne de Boulogne
Electrophysiological Studies of the Face
1854–1856

An effort to determine how the muscles in the human face work to produce facial expressions: Duchenne's studies were published in *The Mechanism of Human Physiognomy* in 1862. (Bottom: terror.)

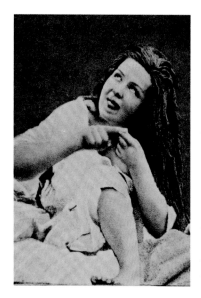

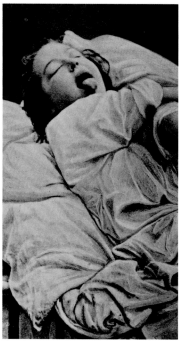

Jean-Martin Charcot
Photographs from the Salpêtrière
Hospital, France
1880s

Charcot established a neurology clinic
at Salpêtrière in 1882. He believed
that the ability to be hypnotized was a
clinical feature of hysteria; the so-called
Salpêtrière school of hypnosis, as it
would become known, would become
controversial over the coming years.

*Harvey Cushing / John Hay Whitney
Historical Medical Library, Yale University.*

carnival impresario and was consequently nicknamed the "Napoleon of Neurosis": indeed, so determined was he to dramatize his patients' neuroses that he was said to literally have mocked their tremors and facial tics in his lectures. [5] There may be no more unfortunate evidence of the abuse of privilege—and the expression of patriarchal superiority—than this: the drugged faces of Charcot's patients, calcified into collective cultural memory since their inception more than a century ago, providing an involuntary iconography for a skewed and sexualized representation of mental illness.

The French philosopher Georges Didi-Huberman, who has written extensively on Charcot's legacy, has suggested that photography, in a clinical context, surfaced as a privileged practice that aimed to crystallize the link between the fantasy of hysteria and the fantasy for knowledge. [6] If the physical evidence of delirium was captured in the face, the photograph became one way of pathologizing all that was visibly symptomatic—eyes at half-mast, jawlines slack— which Charcot reframed into a mesmerizing, if woefully misguided, *mise-en-scène*: doctor as director, patient as performer. [7] And he was not alone: the irresistible allure of the visual spectacle, made possible at least in part by the camera, would go on to influence others at the Salpêtrière, most notably the neurologist Jules Bernard Luys, whose own obsession with the photographic portrayal of hysteria led him to host predatory sessions in his own home, where, among other things, he experimented with odd physiological triggers. Luys recorded, for example, how patients under hypnosis could reveal physical changes simply at the sight of test tubes containing drugs. [8] (Pavlov's experiments in classical conditioning would come later.)

In an address before the Royal Society of Medicine in 1856, Hugh Welch Diamond—a British psychiatrist who was for a decade the Resident Superintendent of the Female Department at the Surrey County Lunatic Asylum in the UK—argued that photography itself might be used in the treatment of the mentally ill by helping people achieve a more accurate sense of their own bearing. Diamond found that showing his patients their own portraits had therapeutic benefits, helping them see themselves with greater objectivity. The images he took were simply framed and devoid of embellishment. (In an era characterized by the ornamental extravagance of Victorian excess, his was a prescient nod to a kind of pared-down modernity.) Highly respected as both a seasoned physician and a skilled, if amateur, photographer, Diamond used photography to study, rather than stage his patients, hoping to catch, as he lyrically described it, "the permanent cloud, or the passing storm or sunshine of the soul." [9]

The idea that the diagnostic image benefitted from such formal simplicity was not lost on Dr. Harvey Cushing, a pioneer in neurosurgery who incorporated photography, in his clinical work, as a form of keen observational triage. In his practice at Brigham and Women's Hospital in Boston, and later at the Yale University School of Medicine in the early years of the twentieth century, Cushing took before-and-after photos of his patients (shot, and magnificently

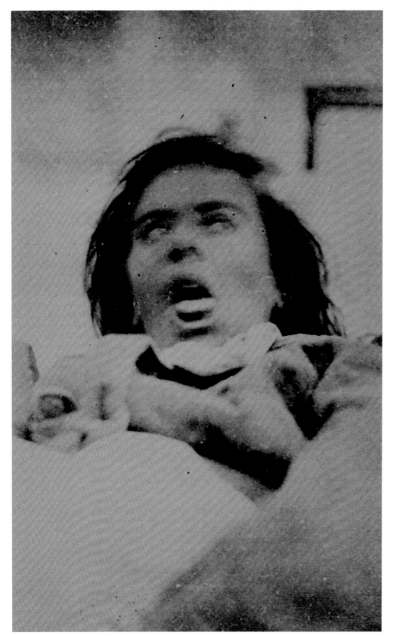

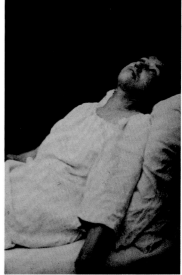

preserved, on 8 x 10 glass negatives) that provided not only visible proof of illness but offered additional and seemingly superfluous details—patterns on bathrobes, girls with hair ribbons, nurses in uniform—emblems of a visual vernacular now long gone. (Cushing's photographs have a kind of *cinema verité* quality to them, direct and frontal and clear.) Unlike his drama-seeking predecessors at the Salpêtrière, Cushing—a consummate man of science—had a documentarian's view of the image: by all indications, his patients were not victims, but willing participants in the process. Some 10,000 of these photographs

Jean-Martin Charcot
Photographs from the Salpêtrière Hospital, France
1880s

Charcot believed in the value of images, both as a clinician and with regard to his own pedagogy, and used photos, like those shown here, when he presented to students and to the general public.

Harvey Cushing / John Hay Whitney Historical Medical Library, Yale University.

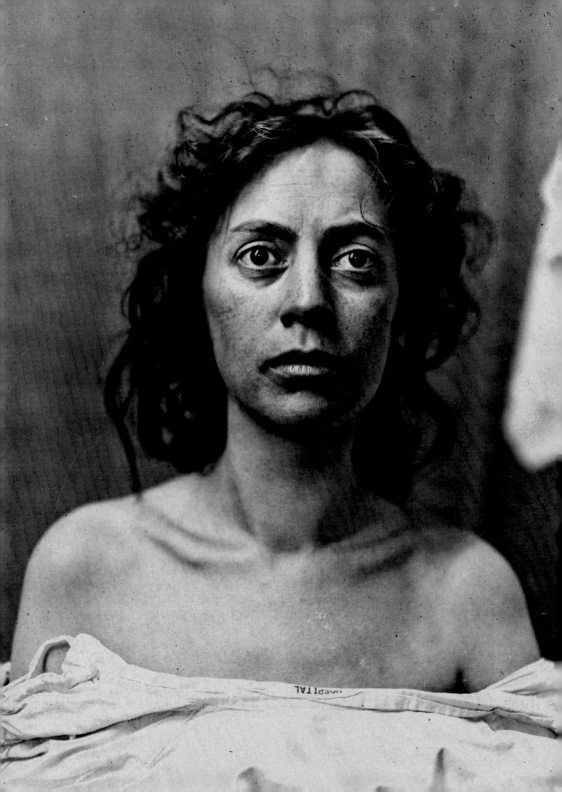

Utrechtse Krop
Naevus pigmentosis pylosis
Date unknown

During the nineteenth century in the
Netherlands, the drinking water in the city
of Utrecht was as so deficient in iodine,
many people suffered a thyroid condition
known as "Utrechtse Krop," or Utrecht
goiter.

From the book **Utrecht Goitre** *edited and*
composed by Troost/Van Zoetendaal.

have been magnificently archived at the Yale School of Medicine, a
selection of which remain on view in a permanent installation that
includes, among other things, his subjects' preserved brains.

The reality of "shell shock"—a harrowing casualty of World War I—was
to some extent eclipsed by the more obvious physical consequences of
battle. Curiously, the term itself was not even invented until 1915—a
good six months after wartime fighting had begun—but long before
neurasthenia would surface as one of the most enduring casualties
of the Great War. By 1929, some seventy-five thousand men claimed
to be afflicted.[10] These men sustained injuries that were not easily
diagnosed, struggling with behavioral, psychological, and emotional
changes long after they'd returned home. Nearly a century before the
DSM would identify a diagnostic spectrum of trauma-induced disorders
(shell shock among them), those afflicted endured crippling challenges
that limited their ability to function socially, thus further distancing
them from successful repatriation. Photographs of their faces— inert,
distant, often unresponsive—are especially heartbreaking because
this underlying psychological trauma was largely unspoken, and
consequently, remained for misunderstood for so long.

If, by the Second World War, the camera had come of age, so, too,
had the exigencies of political correctness. The patriotic values of
1940s wartime culture, a temperament perhaps best characterized by
the can-do spirit of Rosie the Riveter, firmly disavowed the realities of
wartime melancholia. The phrases "stiff upper lip" and "keep your chin
up" (both, as it turns out, curiously face-specific) embraced the tacit
belief that weakness, particularly of the emotional variety, could not be
tolerated. ("Saving face," a core conceit in many Asian cultures, brings a
parallel reading to this conceit, albeit one more focused on maintaining
dignity than concealing depression.) Curiously, even in the aftermath
of World War II, public health communications continued this kind of
oddly optimistic posturing. Many mid-century training films produced
by, among others, the US Coast Guard, focused on postwar distress (as
painfully indicated on a soldier's face) and shied away from explaining
its deeply human genesis, choosing to do so, instead, from the safe
distance of animation.

A postwar rise in aspirational consumerism helped boost a
then-weakened economy, but also led to new kinds of anxieties for
many, an invitation to a burgeoning pharmaceutical industry eager
to satisfy those fearing the stigma of silent suffering. In the years
directly following World War II, the development of psychotropic drugs
gave birth to an entire range of social stereotypes (targeted to army
veterans, yes, but also to anxious housewives, children with attention
deficits, and the disorienting conditions plaguing the elderly, among
others) for whom drug marketing opportunities surged. Subsequent
advertisements featured campaigns filled with pictures of people onto
whom were projected the presumed curative prospect of chemical
rescue, turnkey solutions, one pill—and one happy face—at a time.

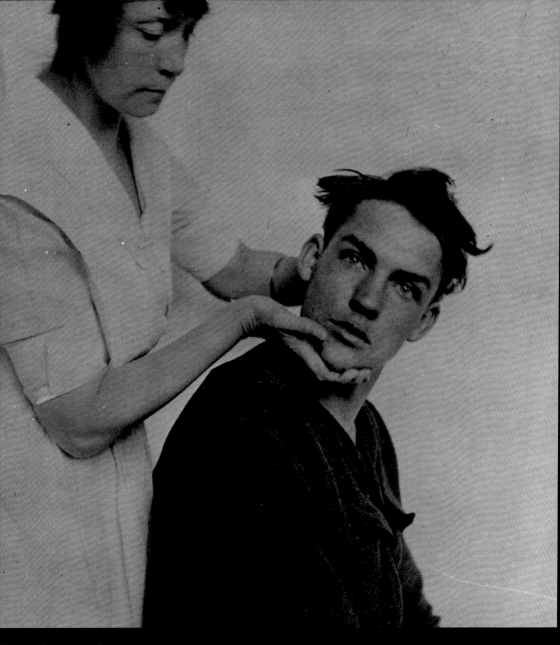

Physical Reconstruction
Circa 1918

A nurse rehabilitates a young patient's neck
during World War I.

*Reeve Photograph Collection, Otis Historical
Archives, National Museum of Health and
Medicine.*

Tyrant in the House
Thorazine Advertisement
1960s

Thorazine can "control the agitated, belligerent senile" boasted this advertisement from GlaxoSmithKline, labeling this face a tyrant.

Was this meant to constitute progress? Were such portrayals believed to be less egregious because they were cast by actors—not actual patients—played out across the pages of medical magazines rather than the vaudevillian arena of the asylum? The implied sexism in so many of these ads (women cast as victims of domestic ennui, requiring the reboot only a chemical stimulant could provide) tell their own story, not so much a tale of imposed hysteria as a story of manufactured mood: the patient posed, the face exposed, the Hippocratic oath nowhere in sight.

Today, the use of the facial photograph in the service of medicine is both less predatory and less performative. (It's also a great deal subtler.) Privacy laws now protect the infirm from being exhibited as live specimens, and mobile technology narrows the communicative gap between doctor and patient: you can take a selfie of a rash with your smartphone and message it to your dermatologist, arguably

Stellazine + Nervine Advertisements
1960s

Stellazine, an antipsychotic drug made by the Philadelphia-based Smith Kline and French, and Nervine, a bromide, or sedative made by Miles Laboratories in Indiana, were commonly prescribed throughout the mid-1970s for anxiety and agitation—particularly for women.

Thorazine Advertisement
GlaxoSmithKline
1960s

Still used today to treat psychotic disorders including schizophrenia, this 1960s advertisement used a dramatically oversized eye to represent psychotic outbursts addressed by this drug.

accelerating the diagnostic process itself with both speed and ideally, some modicum of privacy. Even the primitively rendered smiley face plays a role in modern triage, as patients are routinely asked to point at faces that resemble their pain thresholds. (Chernoff faces, in which the shape and location of facial features are used to represent data variables, are not dissimilar.) Both systems are sketchy and illustrative, descriptive but benign: you can point to a face indicating your pain threshold, but nobody is going to be hurt when you do so. Mercifully, the era of what Charcot called the "museum of living pathology"[11] is now a relic from a distant era. Part cautionary tale, part social allegory, the real story lives on in the faces of those who endured what was, without question, a crucible of deep injustice at the hands of a number of medical professionals whose practices, we now know, were far more corrupt than clinical.

E | Eugenics

While any word ... may have a different character in different contexts, all the same there is one character—a face—that it always has. It looks at us.

Ludwig Wittgenstein

The idea that photography allowed for the demonstration and distribution of objective visual evidence was a striking development for clinicians. Unlike the interpretive transference of a drawing, or the abstract data of a diagram, the camera was clear and direct, a vehicle for proof. Yet the visual efficiency that photography lent to the sciences was in many ways more seductive than sound. Moreover, the process itself allowed for a kind of massive stockpiling—pictures compared to one another, minutiae contrasted, hypotheses often mistakenly corroborated—which, while arguably rooted in scientific inquiry, led to a stunning degree of generalization in the name of fact.

If evolution is seen as the study of unseen development—biological, generational, temporal, and by definition intangible—the camera provided the illusion of quantifiable benchmarks, an irresistible proposition for the proponents of theoretical ideas. Such notions fascinated Charles Darwin, whose *Expression of the Emotions in Man and Animals* was published in the early 1870s, only a decade after Duchenne de Boulogne's own research, which had proved inspirational. Darwin claimed to be the first to use photographs in a scientific publication to actually document the expressive spectrum of the face: he famously logged diagrams of facial musculature, along with drawings of sulky chimpanzees, and photographs of weeping infants to create a study that spanned species, temperament, age, and gender.[1] But what really interested him was not so much the specificity of the individual as the universality of the tribe: if expressions could, as Duchenne had suggested, be physically localized—could they also be culturally generalized?

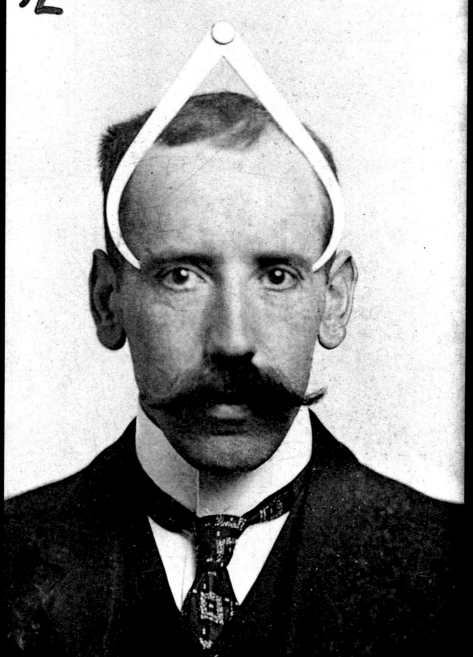

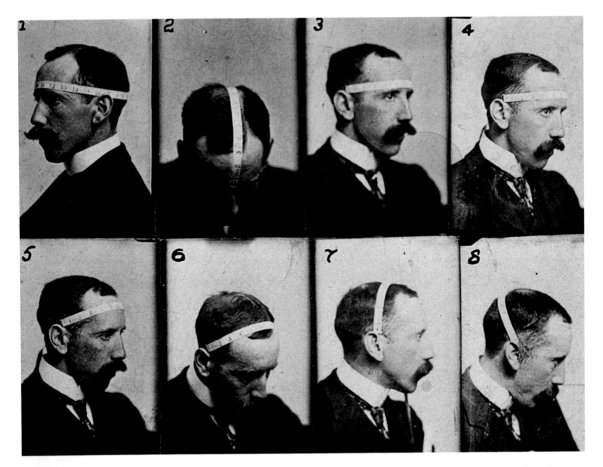

Bernard Hollander
Cranial Measurement
1902

The Austrian-born Hollander favored a quantitative approach to phrenological diagnosis, and is shown here methodically measuring his own skull. His meticulous view of the critical role of cranial measurement mirrored Galton's in its obsessive assessment of statistical averages.

Wellcome Collection.

In his 1859 classic, *On the Origin of Species*, Darwin introduced notions of diversity and evolution, which, while theologically controversial at the time of their publication (and to a fair degree since), introduced an analytical framework for assessing the spectrum of the human condition. Twelve years later, in *The Descent of Man*, he examined evolutionary difference as a fundamentally biological conceit. But it is in this third book that Darwin really went rogue, combining speculation about raised eyebrows and flushed skin with vile commentary about the mentally ill. As a man of science, he set out to analyze the visual difference between types, which is to say races, which is to say that while Darwin's scientific contributions remain ever significant, he was also a man of his era—privileged, white, affluent, commanding—who generalized as much as, if not more than, he analyzed, especially when it came to objectifying people's looks. In spite of his influence on evolutionary biology and his role in the scientific study of emotion, Darwin's prognostications read today as remarkably prejudicial. ("No determined man," he writes, "probably ever had an habitually gaping mouth.")[2] This urge to label "types"—a loaded and unfortunate term—would essentially go viral in the early years of the coming century, with such assumptions reasserting themselves as dogmatic, even axiomatic, fact.

Hardly the first to postulate on the graphic evidence of the grimace, Darwin hoped to introduce a system by which facial expressions might be properly evaluated. He shared with many of his generation a predisposition toward history: simply put, the idea that certain facial traits might have a basis in evolution. Could noses be compared, foreheads aligned, hereditary features extrapolated to cue a bigger pool—features as reliable markers for more expansive cultures, even civilizations? Was that what Darwin meant by suggesting that facial expression was a universal language? Empirically, the idea itself is not unreasonable. We are, after all, genetically predisposed to share traits with those in our familial line, occasionally by virtue of our geographic vicinity. At the same time, certain specimens, when classified by visual genre, become the easy targets of discrimination. In so doing, comparisons can—and do—glide effortlessly from hypothesis to hyperbole, particularly when images are in play. The moon may have four faces, but the human countenance is not so easily compartmentalized. Or is it? The real seduction here lies in the notion that pictures—and especially pictures of our faces—are remarkably powerful tools of persuasion and do, in so many instances, speak louder than words.

In 1978, Paul Ekman, a psychologist at the University of California, published a study in which he determined that there were seven principal facial expressions deemed universal across all cultures: anger, contempt, fear, happiness, interest, sadness, and surprise. His Facial Action Coding System (FACS) supported many of Darwin's

Sir Francis Galton
The Jewish Type
1885

In his study of boys from the Jews' Free School in Bell Lane, Galton laid the foundation for his Jewish type. "What struck me," Galton would later write, after driving through the Jewish neighborhood in Stepney, East London, was their "cold, scanning gaze."

Wellcome Collection.

Face: A Visual Odyssey

THE JEWISH TYPE.

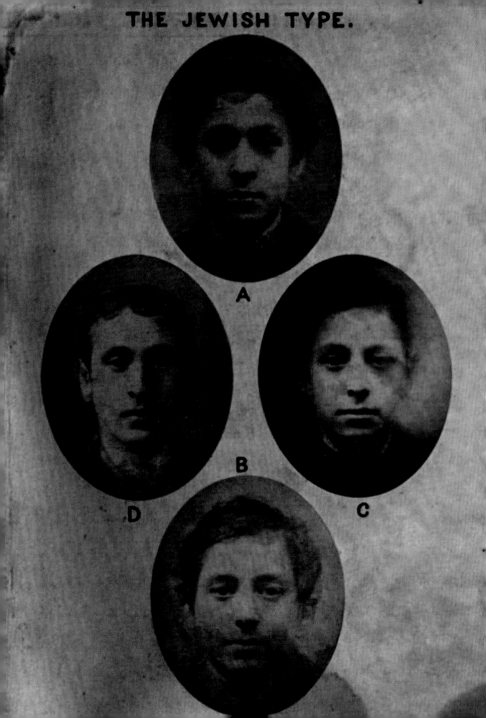

A

D

B

C

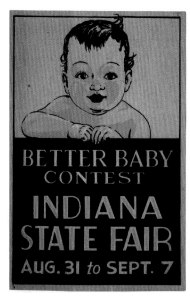

Better Baby Contest
Indiana State Fair
1930

Indiana State Library.

(1) (2)

Your Friends' True Character
Martin Whittington
1925

Left, figure 1 shows the "Semitic" line
of face, while figure 2 shows the Caucasian
line of face. "Individualism marks the
Aryan," writes the author, "and he is
responsible for all the revolutions in the
world's history which have been of the
intellect." Whittington referred to the
Semitic profile as "predatory."

earlier findings and remains, to date, the gold standard for identifying any movement the face can make.[3] As a methodology for parsing facial expression, Ekman's work provides a practical rubric for understanding these distinctions: it's logical, codified, and clear. But what happens to such comparative practices when supposition trumps proposition, when the science of scrutiny is eclipsed by the lure of a bigger, messier, more global extrapolation? When does the quest for the universal backfire—and become a discriminatory practice?

Darwin's cousin, the noted statistician Francis Galton, saw such generalizations as precisely the point. Long before computer software would make such computational practice commonplace, he introduced not a lateral but a synthetic system for facial comparison: what he termed "composite portraiture" was, in fact, a neologism for pictorial averaging. Galton's objective was to identify deviation and, in so doing, to reverse-engineer an ideal "type," which he did by repeat printing—upon a single photographic plate and within the same vicinity to one another—thereby creating a force-amalgamated portrait of multiple faces. At once besotted with mechanical certainty and mesmerized by the scope of visual wonder before him, Galton thrilled to the notion of mathematical precision—the lockup on the photographic plate, the reckoning of the binomial curve—but appeared uninterested in actual details unless they could help reaffirm his suppositions about averages, about types, even about the photomechanical process itself. (The late American photo theorist Alan Sekula referred to Galton as an "artist manqué,"[4] and saw him as someone who randomly invoked a kind of artistic alchemy in a way that was far more speculative than scientific.) That Galton drew upon the language of statistical fact—and benefited from the presumed sovereignty of his own exalted social position—to become an evangelist for the camera is questionable in itself, but the fact that he viewed his composite photographs as plausible evidence for an unforgiving sociocultural rationale shifts the legacy of his scholarship into far more pernicious territory.

At once driven by claims of biological determinism and supported by the authoritarian heft of British empiricism, Francis Galton pioneered an insidious form of human scrutiny that would come to be known as *eugenics*. The word itself comes from the Greek word *eugenes* (noble, well-born, and "good in stock"), though Galton's own definition is a bit more sinister: for him it was a science addressing "all influences that improve the inborn qualities of a race, also with those that develop them to the utmost advantage."[5] The idea of social betterment through better breeding (indeed, the notion of better *anything* through breeding) led to a horrifying era of social supremacism in which "deviation" would come to be classified across a broad spectrum of race, religion, health, wealth, and every imaginable kind of human infirmity. Grossly and idiosyncratically defined—even a "propensity" for carpentry or dress-making was considered a genetically inherited trait—Galton's remarkably flawed (and deeply racist) ideology soon found favor with a public eager to assert, if nothing else, its own vile claims to vanity.

Formen: Großwüchfig, fchlank; langköpfig, fchmalgefichtig; Nafe fchmal; Haar wellig.

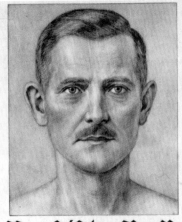

Nordifche Raffe

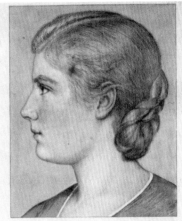

Farben: Sehr hell, Haar goldblond, Augen blau bis grau, Haut rofig-weiß.

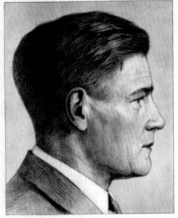

Formen: Sehr großwüchfig, wuchtig; langköpfig, breitgefichtig; Nafe ziemlich fchmal; Haar wellig oder lockig.

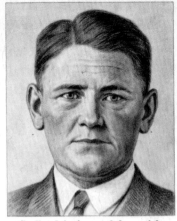

Fälifche Raffe

Farben: Hell, Haar blond, Augen blau bis grau, Haut rofig-weiß.

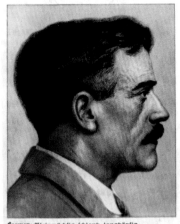

Formen: Kleinwüchfig, fchlank; langköpfig, mittelbreitgefichtig; Nafe ziemlich fchmal; Haar wellig oder lockig.

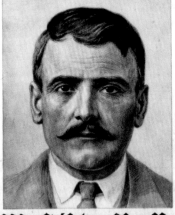

Weftifche Raffe

Farben: Sehr dunkel, Haar fchwarz, Augen fchwarz, Haut hellbraun.

Pictures of German Races
1935

Eugenic practice in Germany depended upon clarifying racial affiliation. Racial hygiene criteria classified and evaluated hair, eye, and skin color. Display boards for racial theory lessons were designed to give students the basics of "racial science" as desired by the state and required by the Nazi party.

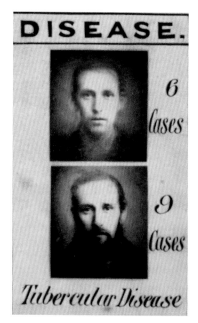

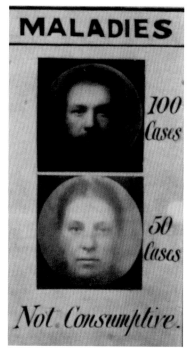

Sir Francis Galton
Consumptive Predictions
1883

Ever the statistician, Galton believed averaging facial features held diagnostic value. The frequency of consumption in England rendered it an appropriate subject for statistics, made into a kind of cautionary tale through composite portraits.

Wellcome Collection.

The social climate into which eugenic doctrine inserted itself appealed to precisely this fantasy, beginning with "Better Baby" and "Fitter Family" contests, an unfortunate staple of recreational entertainment that emerged across the regional United States during the early years of the twentieth century. Widely promoted as a wholesome public health initiative, the idea of parading good-looking children for prizes[6] (a practice that essentially likened kids to livestock) was one of a number of practices predicated on the notion that better breeding outcomes were in everyone's best interest. As a comparatively early experiment in social media, the resulting photos conferred bragging rights on the winning (read "white") contestants, but the broader message—framing beauty, but especially facial beauty, as a scientifically sanctioned community aspiration—implicitly suggests that the inverse was also true: that to be found "unfit" was to be doomed to social exile and thus restricted, among other things, by fierce reproductive protocols. In twenty-nine states—beginning in 1907 and until the laws were repealed in the 1940s—those deemed socially inferior (an inexcusable euphemism for what was then defined as physically "inadequate") were subject to compulsory sterilization.[7] From asthma to scoliosis, mental disability to moral delinquency, eugenicists denounced difference in light of a presumed cultural superiority, a skewed imperialism that found its most nefarious expression during the Third Reich. To measure difference was to eradicate it, exterminate it, excise it from evolutionary fact. Though ultimately discredited following the atrocities endured during multiple years of Nazi reign, eugenic theory was steeped in this sinister view of genetic governance, manifest destiny run amok.

Later, once detached from Galton's maniacal gaze, the composite portrait would inspire others to play with the optics of the amalgamated image. The nineteenth-century French photographer Arthur Batut—known for being one of the first aerial photographers (he shot from a kite)—may have been drawn to the hints of movement generated by a portrait's animated edges.[8] American photographer Nancy Burson has experimented with composite photography to merge black, Asian, and Caucasian faces against population statistics: introduced in 2000, her *Human Race Machine* lets you see how you would look as another race. The artist Richard Prince flattened every one of Jerry Seinfeld's fifty-seven TV love interests into a 2013 composite he called "Jerry's Girls," while in 2017, data scientist Giuseppe Sollazzo created a blended face for the BBC that used a carefully plotted algorithm to combine every face in the US Senate.

Galton would have appreciated the speed of the software and the advantages of the algorithm: but what of the ethics of the very act of image capture and comparison, of the ethics of pictorial appropriation itself? There's an implicit generalization to this kind of image production and indeed, seen over time, composite portraiture would become a way to amalgamate and assess an entire culture, even an era. In a 1931 radio interview, the German portraitist August Sander claimed he wanted to "capture and communicate in photography the physiognomic time exposure of a whole generation,"[9] an observation

Face: A Visual Odyssey

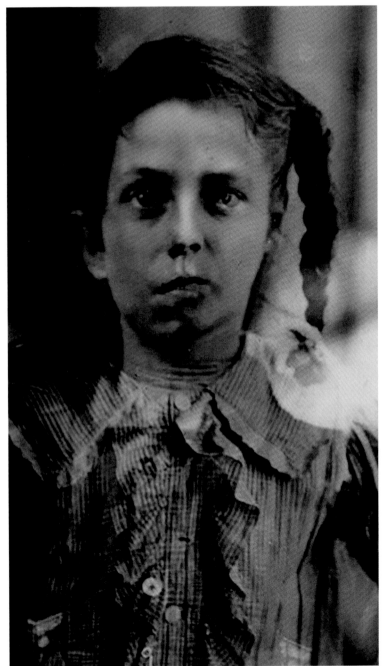

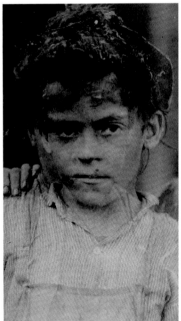

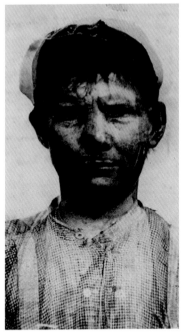

that reframes the composite as a kind of collected census, or population survey. The camera, after all, bears witness over time, its outcome an extension of the eye, the mind, the soul of the photographer. Sander was right. (So was Susan Sontag: "Humanity," she once wrote, "is not one.") [10] With the advent of better, cheaper, faster, and more mobile technologies for capturing our faces, the time exposure of a whole generation was about to become a great deal more achievable.

Lewis Hine
Child Labor Portraits
1908–1911

Under the aegis of the National Child Labor Committee—where he worked as an investigative photographer—Hine captured images of countless children who were exploited by their employers.

Library of Congress.

F | Facsimilies + Fragility

As a material document, the photograph bequeaths a kind of visible certainty that is, paradoxically, both amplified and diminished by its replication. From forgery and fakery to the aspirational wonders of airbrushing, pictorial engineering allows the digital copy to multiply, even colonize as it careens ever outward—a particularly slippery slope for the facial photograph in the context of all that is networked. Is your face protected once it is stored in the cloud—or not?

Curiously, while the culture of the copy seemingly embraces the democratic ideals of equitable distribution, it also raises questions about the origin and ownership of the image itself, particularly in the age of instantly renewable digital transference. What Google does for the inquisitive—and Instagram does for the acquisitive—Pinterest does for both, appealing to both the hunter and the gatherer in each of us. You may not be able to afford a Diane Arbus photograph, but you can search and find (and screenshoot and save) every single last one of them. You can even share your collection with others: civilian as connoisseur, aspiring collector as accidental curator. Whither the original? Where are all those copies? And why should you care?

The word "facsimile"—to make *alike*—beautifully embeds in its root form the idea of production itself (*fac* from the Latin *facere*, to make) but also cops to mimicry: it is not only to make, but to make *similar*. In so doing, the facsimile honors both the original and its replica, simultaneously laying claim to the authentic and its simulacra. Yet even though the camera, as a physical object, may produce a single initial image, the broader cultural system—a system of software and networks and endless editorial contrivances in the form of shares, comments, retweets, and more—inevitably discharges its offspring

> Everyday the urge grows stronger to get hold of an object at very close range by way of its likeness, its reproduction.
>
> **Walter Benjamin**

with tumultuous abandon. To control a picture's dissemination is to police its capacity to be shared, which raises the question: if taking photographs is a constitutional right, is sharing them protected by the same civil liberties? Where the face is concerned, who gets to choose where a picture goes, where it resurfaces, and how it is thus perceived? When the German political artist John Heartfield first exhibited his photomontages—skewering critiques of the Nazi regime, often focused on faces that he routinely extracted from daily news coverage—the actual newspapers were exhibited too, on the assumption that the public required a contextual explanation in order to assess what they were actually seeing. A face clipped from a newspaper may well reframe our ability to see it in a different light, but what happens when that face travels solo, untethered to the context within which it was initially intended to operate?

In an era that is likely to be remembered for its love affair with speed, where the acronym F2F, or "Face to Face," suggests that actual human contact is the exception rather than the rule, the facial facsimile occupies a particularly liminal space. On a practical level, digital photography means that you can easily self-duplicate, iterate, even manipulate both yourself and others. At the same time, the highly controversial "right to be forgotten" suggests, in principle, that we each retain the right to scrub our own faces from the public arena should we choose to do so. Nevertheless, and much as we may applaud

Top Left
Half-length Portrait of a Young Boy

Top Right
Young Boy with Boutonnière

Above
Edward V. Richardson + **Fannie Sturgis**
Former slaves from Maryland

Randolph Linsly Simpson African-American Collection, Beinecke Rare Book and Manuscript Library, Yale University.

Face: A Visual Odyssey

Frances Benjamin Johnston
County Fair Tintype Booth
1903

Frances "Fannie" Benjamin Johnston
(1864–1952), an early American female
photographer, set up her own tintype
studio outdoors in a tent, at a county fair,
in the spring of 1903. The tintype—the
iPhone photo of its day—liberated the
photographer from the studio and enabled
more impromptu sittings.

Library of Congress.

the presumed agency of social media, there remains no reliable way to
prevent your likeness from being copied—by anyone, anywhere, at any
time, across media and in perpetuity—unless you insist on living a life
of self-imposed digital exile. (Good luck with that.) Tagging, posting,
sharing, and re-sharing are all colloquial euphemisms for agreeing
to distribute pictures of ourselves, none of which seems particularly
ill-intentioned, until it is. Once replicated, splintered into multiples, and
jettisoned across time and space (where your likeness is relegated—if
you're lucky—to a distant cloud), the copy trades the evidentiary for
the elusive. In so doing, it becomes fragile.

That fragility—of the face, to be sure, but also of its formal
manifestations—raises fascinating questions about rights, about loss,
even about impunity. In 2011, a British nature photographer named
David Slater was out in the Indonesian jungle when he casually
abandoned his camera one morning, thus inviting a Sulawesi crested
macaque to take, of all things, a picture of itself. The resulting and
rather hilarious selfie instantly went viral, yet Slater himself was
later sued by People for the Ethical Treatment of Animals (PETA) for
allegedly using an animal to advance his own "human" agenda. The
saga has dragged through the courts for nearly a decade, at once a
legal conundrum ("monkey can see but monkey can't sue") [1] and a
cautionary tale: man against monkey, self against society.

Fragile, too, is our understanding of our own relationship to the faces we see lauded as examples of the human ideal: not as reflections of racial or cultural supremacy, but as expressions of consumer aspiration. Historically, the copied image was the commodified image, linking methods of production to modes of persuasion. Commodified faces were iconic faces, performative visual archetypes projected on screens, in newspapers, on posters, and across all manner of pictorial propaganda. Their ubiquitous presence served, if nothing else, to provide a kind of quotidian legitimacy for passersby[2] while ironically, those same passersby were, in a sense, primed to become replicas themselves. Before theatrical trailers became the teased overtures of the movie-going experience, newsreels showed faces in the context of the everyday: by conjecture, they became visual simulations of those seated in the theater: part mirror, part magnifier.

If scientists like Galton believed that legitimacy was a kind of objective truth protected by the mechanics of the camera[3]—physical proof trumping psychological intuition—it was also true that as the photograph came of age, its consumer patterns caused that objectivity to dissipate. Mobility and migration, the twin gifts of human progress, ultimately led to cheaper cameras, fewer chemicals, faster developing time, and generally speaking, a more generous and robust appetite for

Left
Polaroid Test Photograph
1950

Baker Library, Harvard Business School.

Above
Polaroid One Step 2
1977

Opposite
John Heartfield
Whoever Reads Bourgeois Newspapers Becomes Blind and Deaf: Away with These Stultifying Bandages!
1930

Metropolitan Museum of Art, New York.

Face: A Visual Odyssey

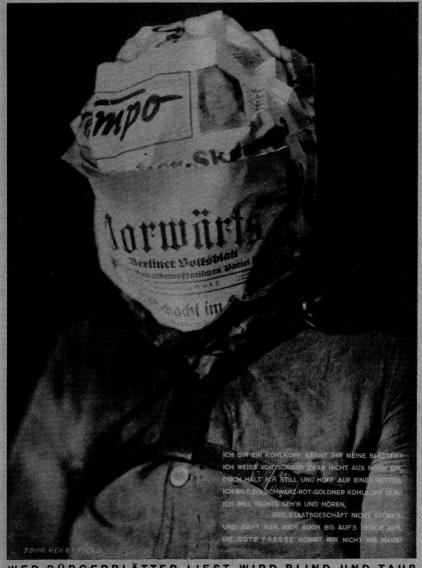

ICH BIN EIN KOHLKOPF. KENNT IHR MEINE BLÄTTER?
ICH WEISS VOR SORGEN ZWAR NICHT AUS NOCH EIN,
DOCH HALT ICH STILL UND HOFF AUF EINEN RETTER.
ICH WILL EIN SCHWARZ-ROT-GOLDNER KOHLKOPF SEIN!
ICH WILL NICHTS SEH'N UND HÖREN,
 DAS STAATSGESCHÄFT NICHT STÖREN,
UND ZIEHT MAN MICH AUCH BIS AUF'S HEMDE AUS,
DIE ROTE PRESSE KOMMT MIR NICHT INS HAUS!

JOHN HEARTFIELD

**WER BÜRGERBLÄTTER LIEST WIRD BLIND UND TAUB.
WEG MIT DEN VERDUMMUNGSBANDAGEN!**

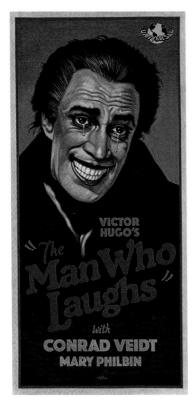

The Man Who Laughs
Directed by Paul Leni
1928

In Victor Hugo's original novel, a group of child snatchers perform plastic surgery on a young boy, leaving him with a permanent freak-like grin. Later, this character would inspire Batman's Joker.

The Joker
Art by Michael Cho
2013

picture-taking as a social activity, all of which helped pave the way for apps that make the act of taking a picture an entirely new experience. (Snapchat takes the amphetamine rush one step further, with photographs that deliberately self-destruct after a requisite amount of time, a far different response to objective truth than Galton could have ever imagined.) Implicit in the novel peregrinations of picture-making was the idea that time might become so effortlessly compressed as to result in a single fleeting moment of optical capture. If photography is, as Susan Sontag once wrote, an expression of the American impatience with reality, it equally true that once it shed its gestational devotion to chemical reproduction, it could deliver on what it had always aspired to be. And that was magic.

Edwin Land's Polaroid SX-70 camera was just that. Brilliantly code-named "Aladdin," it debuted in 1972, boasting instant, chemical-free, no-wait-time pictures. While quickie photography was not, in and of itself, a novelty at that time (Land had been experimenting with so-called instamatic cameras since the late 1940s), this new model was different: a sleek flip-top box, spitting out elegant square pictures that developed in real time and in broad daylight. Equally alluring was the publicity that accompanied this novelty, from the print campaign by Helmut Krone and Doyle Dayne Bernbach, to an exquisite short film by Charles and Ray Eames, to a television commercial voiced by Laurence Olivier that literally cast the camera as an extension of the body. *"It becomes almost part of you, this camera. You focus, frame, press the electric button... the camera seems alive, like an extension of yourself. You watch your creation come to life, and minutes later you're looking at a print almost as real as life itself."* [4] This promise of realistic simulation (the idea of collapsing the time between clicking the shutter and viewing the resulting image) presaged the speed of digital photography, but more critically, appealed to both the artistic aspiration (you as superstar) and personal vanity (you as unicorn) of the amateur photographer. Did Krone's famous faces campaign mean to suggest that you, with your little SX-70 in tow, might produce equally iconic pictures? Was the star-studded tone—the famous portraits, the seductive voice-overs—meant to imply a kind of human transference—*the camera as you*—and you, by association, as Olivier? Magic, or marketing?

Most fragile of all are the vicissitudes of time's passage. ("Nature gives you the face you have at twenty, and life shapes the face you have at thirty," Coco Chanel once famously observed. "But at fifty you get the face you deserve.") But what if you get the face you don't deserve? The acknowledgment of *that* essential fragility is as mesmerizing as is the capacity to endlessly self-replicate, a territory inherently more accessible in fiction than in fact. Films, and especially horror films, deploy methods of visual dislocation to pique public curiosity about the very nature of facial otherness—faces excavated, identities snatched—stories lodged safely behind the fourth wall, thus permitting even

more persuasive illusions of human savagery. Here, we are invited to imagine, even flirt with, the unthinkable psychological disorientation of facial reconstruction and presumed rebirth. But what happens when the facsimile functions as a prosthetic device, the face remade and reattached, even reverse-engineered?

In her excellent book, *Face/On*, historian Sharrona Pearl observes that the maneuvers in many horror films view physical appropriation as a kind of a zero-sum game. "In other words, for one person to gain a face," Pearl writes, "another must lose one, usually violently."[5] Not surprisingly, this is precisely the kind of violent gesture that ignites a film's dramatic arc. Delmer Daves's 1947 film *Dark Passage*—which starred Humphrey Bogart as a man who changed his face to clear his name—shot from the actor's own perspective to strategically conceal

Snapchat
Ghosting Icon
2019

If Polaroid once touted "fun that developed instantly," Snapchat lets you "capture the moment"—but it also lets you destroy it. The idea of planned obsolescence is now firmly part of modern facsimile culture.

his pre-surgery likeness from the audience. Rod Serling's famous 1960 *Twilight Zone* episode "Eye of the Beholder" reframed the facial narrative so that when the once-bandaged patient is uncovered (to the viewer, as a magnificent beauty) her surgery is deemed a failure by her team of physicians—who are themselves disfigured. John Frankenheimer's thriller *Seconds* merged disassembled features with the even creepier idea of eviscerated identity to create a sinister story about the face as a function of eminently forgettable attributes. (The opening titles by Saul Bass—in which the features themselves are isolated, blurred, dislocated, and spun—is a visual overture of pure genius.) Jean Redon's acclaimed novel *Eyes Without a Face*, dramatized in 1960 under the direction of the French filmmaker Georges Franju, made use of the surgical mask to both professionalize and conceal the medical team, inserting a deliberately sterile division between the doctors and the facial looting that cues the film's focus. In each of these films and in countless examples since, the face trades on its inherent frailty as an uneasy yet supremely powerful—and memorable—dramatic conceit.

G | The Gaze

And then—oh, marvelous independence of the human gaze, tied to the human face by a cord so loose, so long, so elastic that it can stray, alone, as far as it may choose.

Marcel Proust

The idea that duplication would lead to commodification seems easily one of the foregone conclusions of the modern age. Yet the cultural framework surrounding the picture in general—and the facial likeness in particular—is only partially defined by its mechanical capacity to replicate: reproduction, as it happens, occurs in every glance. The question here is one of perception: do we not vote for politicians, select physicians, choose partners because of what we see in their faces—or don't see? Put another way: when we look, who looks back?

To the extent that human beings are wired to transmit as well as receive, that implied reciprocity seems perfectly logical—until it isn't. Gazing is an ambiguous enterprise, less a core function of equitable exchange than a peripatetic gesture of willful engagement. What the French psychoanalyst Jacques Lacan dubbed the gaze (*le regard*) is the act of seeing as well as *being seen*, a core behavioral exchange common among all sentient beings. In film, it is the perspective of the camera— an extension of the director's gaze. In medicine, it is the perspective of the pathologist—an extension of the physician's gaze. But between them lies a host of other, more mercurial gazes in which the face torpedoes itself across time and space to represent more than the sum of its countless parts.

The American theorist E. Ann Kaplan writes about what she calls the imperial gaze: racially biased, cosmetically belittling, authenticity imperiled by the drive to assimilate. Author and social activist bell hooks's notion of the oppositional gaze critiques an implicit culture of repression, for (and about) black women across a range of media. (In a parallel vein, the Ghanaian-American computer scientist Joy Buolamwini studies algorithmic bias, which she terms a "coded

DONT'S

DON'T apply rouge in a circle or a dab.

DON'T blend rouge too close to nose.

DON'T draw eyebrows too thin.

DON'T draw eyebrows too square.

DON'T draw eyebrows too heavy.

DON'T start accentuating eyebrows too far back from nose.

DON'T draw in a cupid bow or rosebud mouth.

DON'T part hair low on side, or draw it back tight from forehead. Don't hide 'widow's peak'.

DO'S

DO start placing rouge near center of cheek.

DO blend rouge up over cheekbone toward temple.

DO carry rouge lightly up under eye especially if you have dark circles—this helps to erase them.

DO keep natural eyebrow line.

DO start eyebrow accent on line directly above inside corner of eye.

DO outline and fill in mouth full, following natural line and adding curves to thin lips.

DO retain oval outline in hair style. Draw hair back from forehead keeping it full and soft at cheekbones.

The Charles Antell Glamour-Graph
Ern Westmore
1960s

Along with his twin brother, Perc, Ernest Henry Westmore was a Hollywood makeup artist of great renown. A salon owner, occasional actor, and voice-over artist on his own LPs, Ern coauthored the idea that people possessed one of only seven basic face shapes; Oval, Round, Oblong, Square, Triangle, Inverted Triangle, and Diamond-shaped.

James Bennett Collection.

gaze.") The idea of the colonial gaze speaks to imperial supremacy: in the context of the recording of faces, the camera becomes what the Zimbabwean novelist Yvonne Vera calls a "dire instrument," which she likens to the gun and the bible. Marianne Hirsch's concept of the familial gaze reflects the dominant, enduring ideologies represented by the iconic family photo. And the Austrian scholars Bernadette Wegenstein and Nora Ruck write about the entrenched gaze of makeover culture—the cosmetic gaze—which has a complex and layered social history dating back to the age of Aristotle. (The cosmetic gaze, they explain, "is also and perhaps most importantly a moralizing gaze.")[1] The gaze can thus be a gesture of power, an expression of love, a reflection of judgment, an amplification of privilege, or an adumbration of totality.

It is no accident that all of the theorists and artists cited here are women. To understand the gaze is to unearth its point of origin, which has proven, more often than not, to originate with a perspective that is predominantly male. (We might also posit this is a predominantly Western, and an overwhelmingly white, gaze.) To be legitimized by the gaze of another is to be invisible in its absence—a behavior that demands to be questioned. On a purely material level, that inherent power imbalance is intensified by the procurement and dissemination of images, where the viewer becomes, perhaps almost by definition, a voyeur. To gaze at another person is to seek a kind of silent verification, a proposition made infinitely more difficult in the age of virtual replication, where multiplicity trumps simplicity at every turn.

The very act of photographic capture (an act of disturbance for Benjamin, of violence for Sontag) abstracts the gaze by stopping time, shifting focus, and disrupting the call and response dynamic between the image and us. What might now be termed the kaleidoscopic gaze is a uniquely modern condition, a function of the multiple opportunities to seize upon and capture any of a number of random glimpses of the same thing. (Some professional photographers, whose scrutiny typically results in more considered images, refer to this kind of pictorial randomness as "fire-hosing.") Online, we gaze by tagging:

Face: A Visual Odyssey

enter the words "Pope Paul IV" or "The Artist Formerly Known as Prince" into the search engine of your choice and you'll be rewarded by a plethora of options. Yet in spite of its speed and efficiency, online searching also neutralizes by volume, making the *specificity* of the gaze something you have to really work hard to achieve. Tags are tools that guide and locate—but do not in principle reflect—the gaze itself. Where faces are concerned, that guidance is driven by a far more internal and idiosyncratic engine that resides in each of us. It's called preference.

Preferences are framed by the exigencies of social interaction, and what (and who) we look at drives everything from technology to economics to population growth. On a consumer level, faces are primed to promote sales, work-for-hire models representing a kind of condensed cultural sediment: personification as commodification. That face you see on a billboard reflects a strategic past (marketing research, product positioning) and optimistically predicts a profitable future, but at that precise moment in which you lock eyes, well, it's really just the two of you. Who is that woman looking back, conflating the acts of staring—and selling? Magnified beyond reason, airbrushed to perfection, she's a modern-day Helen of Troy, her perfect face a marketing proxy for repeat transactions. Is an author's intention, a director's mindset, a nation's leadership any different? The gaze seduces by pulling you in, mesmerizing you with promise, and maybe loving you just a little too much.

The consumer gaze only hints at one way in which looking is an act of seduction. Freud's concept of *scopophilia*—literally deriving pleasure from looking—is a prurient conceit that overtly sexualizes the gaze, but points to the very act of looking as a deeply human endeavor, which is to say individual, intentional, and never indifferent. [2] That "pleasure" may explain the draw (and profitability) of the pornography market, wherein bodily objectification seemingly disposes with—indeed, obviates—the need for a two-way gaze. But what happens when the face is a recognizable one, offering a presumably enhanced experience at the expense of the other? A relatively new digital impersonation technique called Deepfake allows for faces to be swapped onto alternate bodies, including those of pornographic actors. As of this writing, there is no law prohibiting the harvesting of available images of well-known people from being reverse engineered into X-rated films. While consensual cyber-porn may exist (and will likely persist), there's nothing about this kind of face-hijacking that suggests a gaze that's anything but unilateral.

Equally one-sided, the largely amateur parade of profile pictures on dating websites embraces both the universal (people want to fit in) and the unique (people want to stand out). Here, it bears saying that gaze is perhaps more rote than romantic, fueled by a never-ending slideshow of facial propaganda. A man on a boat holds a fish up to his face to show what—his prowess as a fisherman? A woman in a restaurant shows herself surrounded by friends to show what—that she has friends?

Photofit : Self-Portraits
Gilles Revell and Matt Willey
2007

Originally designed by Jacques Penry,
Photofit comes in a wooden box outfitted
with paper strips printed with forty different
sets of eyes, noses, mouths, haircuts,
and chins, as well as transparencies for
add-ons including glasses, facial hairs, and
wrinkles for both men and women.

In 2007, the photographers Gilles Revell
and Matt Willey borrowed a male and a
female kit from a police museum in Kent,
and invited a number of people to come
and assemble their self-portraits and
comment on the process. Some of these
are shown on the following pages.

Rajnaara C. Akhtar
Lawyer

After I started to wear the veil, I just found that boys paid me that little bit more respect. When they did look at me, they would look me in the eyes. I don't wear the niqab, but I disagree with the view that wearing a full veil is a barrier to communication. In this day and age, face to face communication happens so infrequently—most conversations are done over the phone or email—and we manage to express our feelings and opinions perfectly well that way.

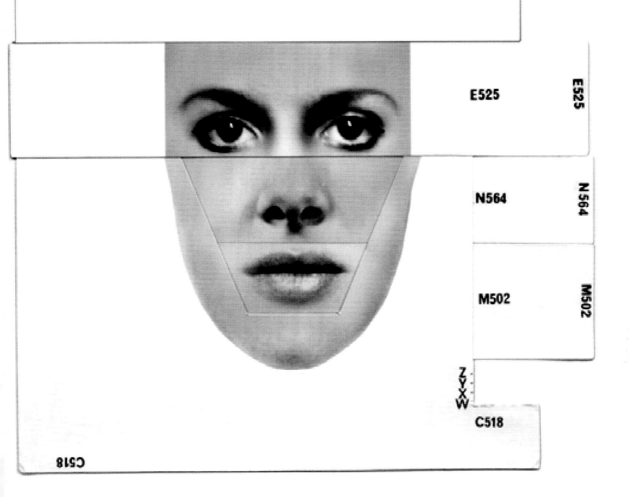

E525

E525

N564

N564

M502

M502

C518

C518

Contextual information is random information, but in the orbit of hopeful digital romance, it's expository information—from bathroom mirror selfies that reflect not only the face in question but the oversized bottle of mouthwash on the counter, to interior car selfies that reveal the ho-hum banality of a Prius, to sports-inflected selfies that reference the due diligence of time presumably logged in the weight room—all framing faces positioned against a host of ancillary information about money and privilege and taste (or lack thereof). Ironically, the gaze here is at once self-directed and sensational: self-portrait as homespun advertising campaign.

Ultimately, while the power seemingly resides in the supplicant, every dating site wannabe remains inert until chosen, each aspiring suitor at the mercy of the unseen gazes of others. But that doesn't mean the gaze cannot become socially generalized. Much has been written on the male gaze (and by conjecture, the female gaze), a theory first proposed by the British film theorist Laura Mulvey back in the mid-1970s, suggesting that a filmmaker's gendered perspective, by implication, expands to include the principal male characters and creators of the film in question.[3] It's subtle—dangerously so—this idea that we unwittingly buy into visual strategies within which women are positioned, like mindless mannequins, to smile and perform. If, at one extreme, the male gaze expands to the patriarchal gaze (relegating women to positions of lesser status or achievement) the female gaze reframes that position by lingering less on archetypes. "Whatever precautions you take so the photograph will look like this or that, there comes a moment when the photograph surprises you," wrote the French deconstructionist Jacques Derrida. "It is the other's gaze that wins out and decides."[4] Curiously, the female gaze implicitly grasps this unfortunate, if somewhat common human dynamic. It's the ambiguous gaze of pluralism.

The idea that the gaze shifts the boundaries framing our understanding of others is, perhaps not surprisingly, highly prone to misperception, even error. Sociologists refer to something called "heritage commodification," or heritage tourism, the idea that local populations reflect back the "gaze" of tourists' expectations in order to benefit financially.[5] The tourist gaze itself is framed by privileged mobility, a one-sided kind of looking in which visitors are primed to glamorize what they perceive as foreign in unfamiliar cultures. In this context, the tourist harvests foreign experiences to archive and share, a practice made decidedly more awkward with the widespread availability of social media. In the quest to serve up "authentic" experiences, some modern hotels have begun to hire Instagram concierges to identify the perfect time and place for picture-taking. Such morally misguided voyeurism detaches the viewer from the viewed, reinforces the chasm between class and culture, reframes the normative as the performative, and reasserts indigeneity as a distant, artificial, and exotic ideal.

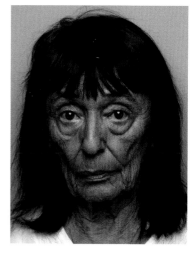

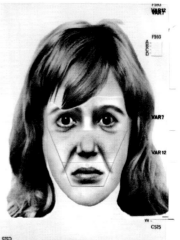

Beryl Bainbridge
Writer

Putting together your own face is much easier when you are young. When you're old, your face is no longer the same. It's gone, in a funny sort of way. There are bits there, but it's not the way it used to be. Are there features of mine that have improved with age? No, nothing ever changes for the better. The wrinkles just arrived—I guess I got more because I smoked. Having spots was worse. The daft thing about faces is that when you are young, you are never completely satisfied with the way you look. And that continues right until you get old, and then you look back at photographs.

Face: A Visual Odyssey

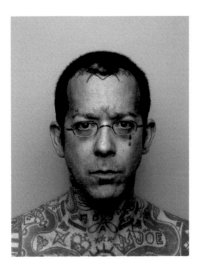

Duncan X
Tatooist

When I am out on the street, having a tattoo across my face seems to work in my favour. I know it can look quite threatening, and that was probably my intention to begin with, but if anything I tend to get nice comments these days. I would tattoo the face of somebody who is in my profession, but I'd feel funny about doing it to somebody else. It has got to be acceptable. Once a girl came into my shop: she was a really angry person, and she wanted "Fuck Off" tattooed across her neck. I wouldn't do it. I said to her, "You're not always going to feel like that, my love." She told me to fuck off.

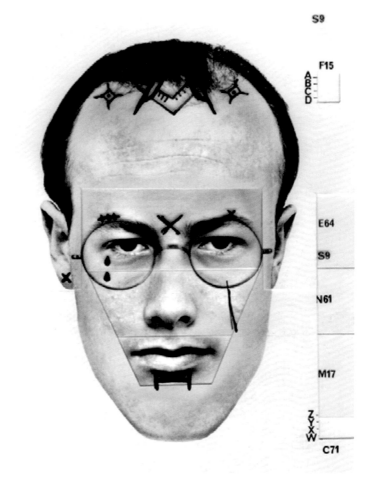

Rachel / Robin
Music Promoter

I am happy being either Rachel or Robin depending on what mood I am in. I have never been into the girly thing—I don't speak with a shrill voice or do the overly camp body language. I've not had any operations, and I have no intention to. With transsexuals, it's a case of you feeling that you are born in the wrong body—with transvestites it is easier. Occasionally, I will get stares, but I've never had anyone being rude to me in public. I guess Rachel has changed over the years. You've got to dress your age—even in drag.

THE
girl watcher

**A GUIDE TO
GIRL WATCHING**

MARCH 1959 PRICE 50¢

Tired of Collecting Bottle Tops, Race Horses

Start a Girl Collection

SOME ADVANCED FIELD NOTES ON:

STALKING THE GIRL

A GIRL WATCHER WITH A PURPOSE is the photographer who has been handed what looks like an easy assignment. After all, the memo is only two lines long:

"We want the youngish girl, reflecting all the buoyancy of today's womanhood. Most of all, she must reflect the spirit of the client's product."

And what is the client's product? A do-it-yourself shim replacement for valve seats in leaky faucets.

But you're a photographer and a *Girl Watcher*, too, and a challenge is a challenge. You remind yourself that most any AGWA member would envy you for getting paid for doing what they do for free, adjust your cornea and attack the happy task of trailing the quail.

Such a search is likely to take you into some school districts and a number of malt shops. As the full-blown delights geekle around in their sweaters and the young bucks concentrate on discussion of their fuel-injection jobs, you tend to parrot the pundit who observed that youth is wasted on the young.

A hypo hipster on a picture assignment for a magazine confesses to a bit of chicanery no one ever plumbed. Seeking the exact qualities in one girl, he had almost given up after a week of sherlocking when he chanced upon a pair of twins who, between them, had it all. He used one for frontal assaults, the other to bring up the rear. He speaks of it as sort of pre-emulsion composition work. His only complaint was that he had to pay two model fees.

The Girl Watcher
Men's Magazine
1959

Intended as a humor magazine for men, the editorial tone of *Girl Watcher* is disturbing for its language, perspective, and unabashedly sexist imagery. Articles on the practice of pursuit are in ample supply here, from fictionalized accounts of panty raids, to stories on the hunter and the hunted, to tips on the finer points of building collections of exotic girls.

Curiously, that kind of targeted looking invites a focused gaze that can seem oddly prejudicial: here, tourism operates as an underlying framework in which human specimens are brazenly objectified. Within that value system lies the scientific gaze, in which the gazer seeks validation for something external and evidentiary. This is the territory of the notably dispassionate medical gaze, introduced by Michel Foucault in his landmark 1963 book, *The Birth of the Clinic*. Here, the presumed inequities framing the doctor-patient divide underscore an imbalanced power dynamic that reinforces a very particular kind of scrutiny—analytical, objective, and detached. "A gaze and a face," Foucault explains, "or a glance and a silent body ... free of the burdens of language, by which two living individuals are 'trapped' in a common, but non-reciprocal situation." With a subtle nod to modernism by way of minimalist thrift (Foucault calls the clinical gaze the "gaze that burns things to their furthest truth")[6] such reductive diagnostic vocabularies identify an issue even as they rob the person of his or her actual identity, pathology trumping personhood.

If the medical gaze dehumanizes its subject by separating the body from the self, that imposed chasm is further reinforced by the tyranny of power systems that define what's known as the imperial gaze, postcolonial, intractably hierarchical, a system privileged by privilege itself. Consider any system in which racial ideal is represented by facial ideal—Aryan supremacy, white supremacy—cultural systems that position the white western subject at the epicenter of an uneven power dynamic. The idea of this sort of predictive gaze was nowhere more toxic than at the hands of the SS party during World War II, where the prevailing dogma promoting "race consciousness" led to practices intended to promote and protect German nationalism, including, at the bequest of Heinrich Himmler, a document establishing the health of one's family line. [7] That heredity itself would soon be imperiled reframed the gaze as an act of terrorism and torture. Looking would never be indifferent again.

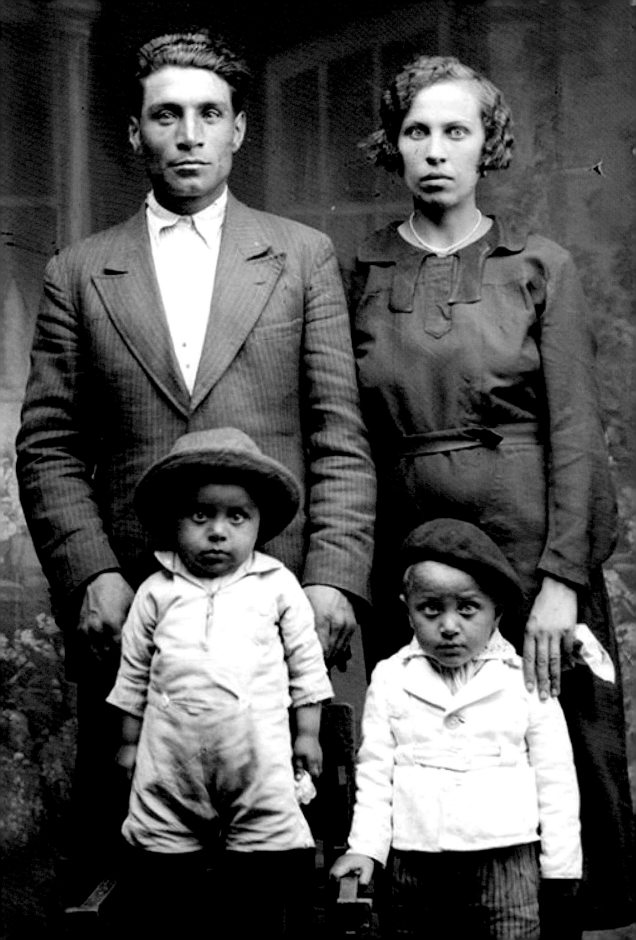

H | Heredity

I am the family face;
Flesh perishes, I live on.

Thomas Hardy

In the spring of 2018, Alexandria Ocasio-Cortez won the Democratic primary in New York's 14th congressional district, defeating the incumbent, Joseph Crowley, who had run unopposed since 2004. Like Barack Obama before her, Ocasio-Cortez was a spirited community organizer with an unusual last name. Like Amal Alamuddin before her, she was a stunning human rights activist with a decidedly nonwhite complexion. The twenty-eight-year old Ocasio—poised and articulate, a third-generation Bronx native—was attacked for her evident youth, critiqued for her relative inexperience, and judged for her unconventional grass-roots campaign, which was, in the words of one reporter, "emphatically and unapologetically multicultural."[1] What was even more unconventional was that she accepted no cash donations, opting instead to establish her platform by going door to door, campaigning the old-fashioned way—literally, face to face.

Arguably, that face may have helped win her the election. Ocasio-Cortez was a highly photogenic, bright-red lipstick-wearing Latina whose heritage was her ticket. True, her democratic message resonated with disappointed Hillary supporters, her socialist mission appealed to progressives, and her mixed pedigree reflected the essential diversity of her multicultural constituents, but it was her movie-star good looks—olive skin, dark eyes, and that million-dollar smile framed by candy cane-red lips—that likely helped catapult her story far beyond her own relatively small congressional district.

Framed by a helmet of slick brown hair, Ocasio-Cortez's official campaign portrait calls to mind a number of iconic faces, from the Mexican artist Frida Kahlo, to the Mexican activist Dolores Huerta, to the American actress-turned-British-aristocrat Meghan Markle. (Ocasio-Cortez's coif also nods to another aristocrat, one Lady Ann

THESE PARENTS:

Can Have *ONLY*
Blond, Straight-Haired, Blue-Eyed Children

BUT THESE PARENTS:

May Have Various Types of Children,
Including

(For Results of Other Matings, See Text)

You and Heredity
Amram Scheinfeld
Frederick A. Stokes Company
1939

Clifford, a seventeenth-century baroness who was also a somewhat improbable early feminist.) Comparisons to Naomi Parker Fraley—the inspiration for Rosie the Riveter—and to Soviet siren and poetic muse Lilya Brik also deserve mention here, reminding us that while heredity may reveal itself as a cultural conceit, it summons no shortage of pictorial comparisons as well. In her official portrait, Ocasio-Cortez looks away from the direction in which she is seated—a classic triangulation often used for campaign portraits. Susan Sontag called this kind of three-quarter profile "the politician's gaze." It was, she famously wrote, "the gaze that soars."[2]

This kind of professional portrait is typically known as a headshot, a standard-issue kind of imprimatur for politicians but also for actors,

Clockwise, from top left
Alexandra Ocasio-Cortez
Photograph by Stefani Reynolds
2018

Lady Ann Clifford
Countess of Dorset, Pembroke,
and Montgomery
Portrait by William Larkin
Circa 1618

National Portrait Gallery, London.

Lilya Brik
Photograph by Alexander Rodchenko
1924

Frida Kahlo
Photograph by Guillermo Kahlo
1932

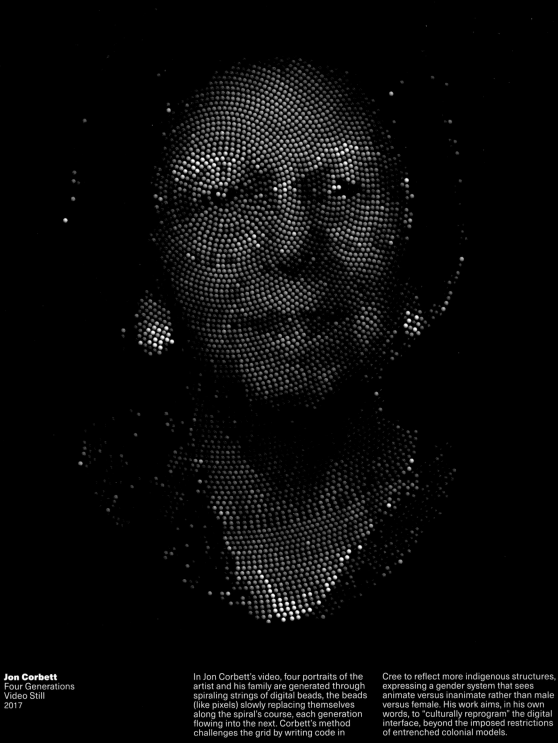

Jon Corbett
Four Generations
Video Still
2017

In Jon Corbett's video, four portraits of the artist and his family are generated through spiraling strings of digital beads, the beads (like pixels) slowly replacing themselves along the spiral's course, each generation flowing into the next. Corbett's method challenges the grid by writing code in Cree to reflect more indigenous structures, expressing a gender system that sees animate versus inanimate rather than male versus female. His work aims, in his own words, to "culturally reprogram" the digital interface, beyond the imposed restrictions of entrenched colonial models.

Deb Willis + Hank Willis Thomas
Sometimes I See Myself in You
2008

Starting at center of crown

Starting at temples

Over whole top of head

You and Heredity
Amram Scheinfeld
Frederick A. Stokes Company
1939

realtors, executives, doctors, and virtually anyone with a serious online profile. Headshots serve to confer a kind of baseline realism, a humanizing presence that puts a face to a name, providing a tacit kind of legitimacy that varies, stylistically at least, by discipline. Executives tend to favor coats and ties. Soldiers are mostly shown in uniform. Physicians wear standard-issue lab coats. Actors sometimes demonstrate their performative flexibility by sharing multiple facial expressions on a single sheet. A longtime staple of Hollywood celebrity culture, the once-formal studio portrait has become far more simplified in recent years. Faster shutter speeds, simpler set-ups, and a more generous use of natural light have, in addition to the freedom of smartphones and the platforms of social media, helped to relax the overall formality of the headshot, but its essential purpose has remained unchanged. Now as ever, headshots serve as proxies for personal promotion.

If the headshot is the crystallization of an ideal likeness—chiseled and tweaked, primed to an external audience—the family photo album provides the opposite view, providing an accidental compendium of mostly amateur images that collectively narrate the ancestral saga. Such books provide one-of-a-kind repositories for studying the art of intergenerational similarity, reminding us that while fashion may change, and cameras may improve, a receding hairline is destined to reassert itself with each passing generation. Family albums are raw material writ large: they're brutally honest, sometimes inescapably so.

The formal evidence of heredity, however, is no longer limited to the photographer, nor, for that matter, to the album. Websites like Ancestry, GenealogyBank, and FamilySearch connect people, pictures, and all kinds of data points that collectively serve to identify individuals and confirm linkages. Genealogical databases—many of which offer premium access to photographic archives—contain additional resources including yearbooks, scrapbooks, and remarkably clear facsimiles of census records. Consumer DNA testing kits like MyHeritage and 23andMe analyze microscopic samples of saliva against thousands of genetic markers to detect staggeringly specific traits including, but not limited to, cleft chins, earlobe types, skin pigmentation, and whether or not your widow's peak was inherited from your grandfather. That receding hairline, as it turns out, has a clear and traceable provenance, and it's firmly embedded in your DNA.

And if that DNA allows for the excavation of data pools that preceded you, technology catapults it all forward: the digital headshot today is a blank canvas for all kinds of experiments in visual hybridity. Contemporary face apps invite you to select, match, and ape a likeness by morphing it onto another one, a practice that invites fascinating, if unsettling, experiments in hairstyle, fashion, height, weight, even race and gender transformation. Face Story produces a step-by-step animation that dissolves one face into another. Morph Thing lets you speculate on what your offspring might look like if you procreated with a celebrity. FaceFilm, Face Fusion, and Face Blender perform

7 x **3**
1935, 1967, and 2005

Portraits of the author's mother, the author,
and her daughter, all photographed at the
age of seven.

similar services: you can even combine with a nonhuman face—a face
in a painting, for instance, or an animal. It's all harmless, of course,
except that such casual pixel-play can slip easily into expressions of
pronounced, and rather public-facing, hypocrisy. (Imagined celebrity
progeny is one thing—using your artificially tricked-out likeness as
your preferred profile picture, quite another.) True, the ethics of photo
retouching have always raised questions about the veracity of the
image, but where faces are concerned, we are psychologically primed
to believe what we see. And here, the increasing sophistication with
which digital technology makes facial modification possible means
that your visual legacy can be swiftly and effortlessly manipulated.
Which means that it won't remain harmless for very long.

At the more serious end of the heredity spectrum is the study of
facial morphology, reliable because it is biological and grounded, as it
happens, in genetic fact. [3] We now know, for instance, that the tip of
the nose is the most inherited trait. After that come the cheekbones,
the inner corners of the eyes, and the area just above and below the
lips. Facial width-to-height ratio is often seen as a metric for social
dominance in humans (and in certain animals) [4] and face shape itself is
critical to security measures and surveillance: yet because these studies
are by definition targeted, they're also somewhat limited. The idea
that facial characteristics are genetically predictive may underscore
heredity's epic reach, but it fails to recognize what is, unquestionably, a
more nuanced spectrum of racially diverse, geographically distributed,
culturally nuanced, and/or gender nonconforming faces that might
(and will) deviate from any presumed biological norm. Genetic markers
never tell the whole story. Nor should they.

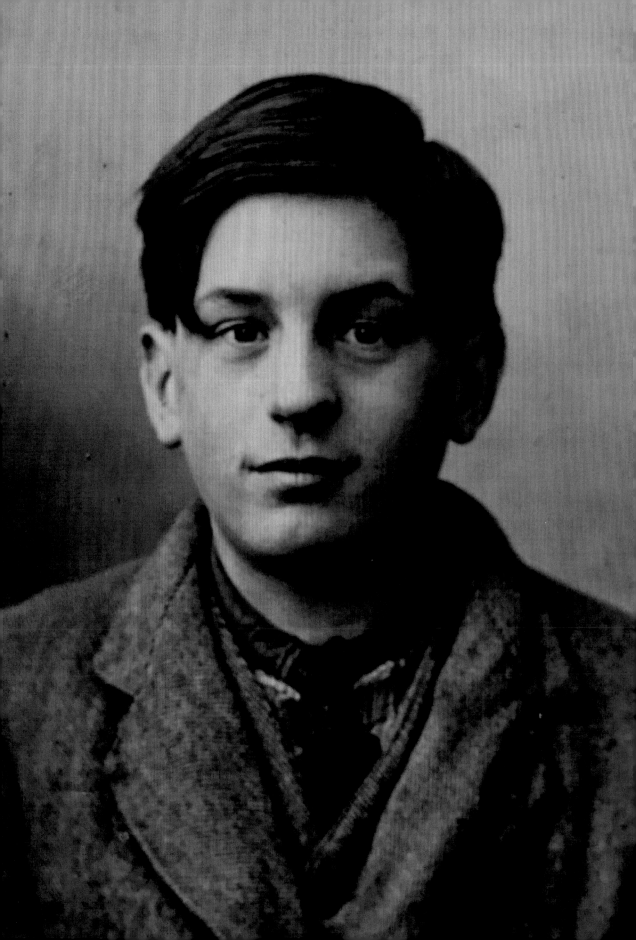

▋ | Identity

A man finds room in the few square inches of the face for the traits of all his ancestors; for the expression of all his history, and his wants.

Ralph Waldo Emerson

In Paris, not far from the Marais, there is a small shop filled with old photographs, many, if not most, of anonymous provenance. There are vintage Polaroids and vernacular snapshots, beauty pinups and theatrical portraits, shiny pictures of old cars and panoramic scenes of bygone splendor. Nostalgia isn't cheap, and many of these images are priced accordingly (which is to say astronomically), but the real treasures, as it happens, sit outside in a small bin—hundreds of postage-stamp-sized portraits originally intended for purposes of identification. Who were these people, their lives lost to time, each a casualty of pictorial free-fall?

There are laborers, photographed in coveralls. There are ladies, photographed in finery. There are portly businessmen and pimply teenagers and there are swarms of innocent children—anonymous faces decontextualized from history, untethered to the multiple alliances that once circumscribed their lives. Having seceded from the narratives within which their lives were once formally embedded, each is a photographic orphan, unwittingly cast adrift by time's unruly passage. Curiously, what they share, if anything, is the rarified paradox of their very survival. They're visual oxymorons: identification pictures that are unidentifiable.

In France, the history of personal identification is physical, mechanical, and endlessly political. (And in some cases, shockingly inhuman: branding by hot iron was only abolished by law in 1832, but it wasn't until 1872 that photography was instituted in the Paris prefecture where it joined with descriptive practices to yield more reliable dossiers for tracking criminals.)[1] Yet if pictorial identification stems from the

requirements of bureaucratic order, its function is by no means limited to the organizational demands of criminology. Generally speaking, the use of the face as a locus for identification can be traced to the origins of commercial photography, but in France, its genesis can be traced to the first French Republic, when Napoleon introduced the *livret* or worker's passbook, a kind of internal passport primarily intended for regulation by employers. Under the tightly controlled regime of his newly minted Empire, Napoleon hoped to restrict both personal migration and wage inflation.[2] (Another paradox: here, the goal was to impede movement sooner than sanction it.) The *livret* was, in a sense, a tracking device: your identification papers proved you could be easily located, which refuted, most notably at that time, the highly stigmatized suggestion of vagrancy. French ID card regulations evolved over the course of the ensuing centuries to include more detailed coordinates including occupation, nationality, civil status, signature, and—by the late nineteenth century—a standard-issue headshot. By 1917, ID cards were compulsory for anyone over the age of fifteen and by 1940, after the fall of France to the Germans, both the occupying power and the Vichy regime imposed a system of identity cards requiring photographs for the entire population.[3]

Portuguese Identity Cards
Porto, Portugal
1935, 1937

Collection of the Author.

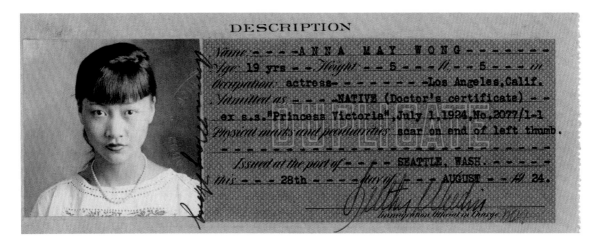

Anna May Wong
Certificate of Identity
1924

Born in Los Angeles in 1905, Wong traveled internationally during the 1920s and 1930s for film roles. The complexity of her travel papers reflect the scrutiny leveled toward Asian Americans following the enactment of the 1882 Chinese Exclusion Act, which banned all immigration from China for a period of ten years. Despite repeals, anti-Chinese sentiment prevailed throughout the early years of the twentieth century.

National Archives.

Portuguese Transit Passes
Porto, Portugal
1944, 1947

Collection of the Author.

But if government-mandated registries demonstrate, from an aerial perspective, how peoples' identities were methodically parsed, the documents themselves reveal a force field of personal, emotional, and social history that collectively tell a far more interesting story about who we were, where we went—and why it may have mattered. There is the loopy handwriting. There are the frequent misspellings. There are self-identifying details: "widowhood" as social status, confirming a woman's right to her husband's pension, for instance. For anyone whose face revealed a foreign culture, there are inventive surname adjustments—Anglicized, Westernized—creatively tweaked patronymics intended to disguise what might otherwise be viewed as an imperiled provenance. There are official stamps and authoritative signatures, formal notarizations and elaborate seals, and, finally, there are the photographs, redolent in their utter specificity, with rakish hats and retro hairstyles and all kinds of subtle (and not-so-subtle) hints of sartorial vanity. The poor often look timid, while the wealthy sometimes pose with a kind of stiff, pompous swagger. Those over a certain age—the clear technophobes of their era—reveal a visible discomfort that is at once unmistakable and endearing. Children are often blurry, because when do children ever willingly sit still?

There is something about the face of a child that stands apart from the others, frozen in time, suspended in cultural memory. Serge Klarsfeld's extraordinary account of Jewish children deported during the Second World War shows, over the course of more than 1,800 pages, how certain identifying documents seize our attention in particular by conflating the perfunctory with the personal. Of the 11,402 children who were deported, only about 300 survived, and Klarsfeld bears witness to every last story he can find. ("I would have wanted a book of 11,000 pages," Klarsfeld once said. "Of 11,000 faces.") [4] Those children, their innocent lives lost to the atrocities awaiting them in places like Auschwitz and Bergen-Belsen, Buchenwald and Dachau and Treblinka, persist silently in those tiny photographs, stamped to cards, lost to time, involuntary effigies all.

In France, as elsewhere, the very concept of "lost" operates as a euphemism for "missing"—a word that sooner conjures the wandering gait of the dreamy *flâneur* than the mysterious casualties of political subterfuge. Yet the use of the facial photo as a way to locate missing persons (*les disparus*) holds a unique power in the sense that it has, over time, led to a crowdsourced outlet for citizen activism, a now-common practice in which faces are deployed, on public walls, as an ad-hoc finding aid. Hardly limited to France, such makeshift exhibits would surface with grim insistence (and brutal regularity) in the wake of all kinds of demonstrations of civic unrest, all over the world, for generations to come. From the forced disappearances at the hands of paramilitary groups in Guatemala, to those missing as a consequence of human rights violations during the years of Pinochet's rule in Chile, to the nearly 3,000 victims of the 9/11 terrorist attacks in New York, face-laden walls have become a universal visual trope. When people go missing, the burden of recognition falls, as it must, to all of us.

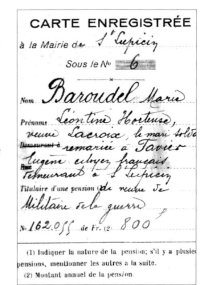

Prior to the advent of photography, identifying documents generally depended upon written descriptions: officials were asked to note all peculiarities—freckles, scars, odd blemishes, moles, marks, and tattoos—as well as any related details that might additionally serve to further flag a person's physical demeanor. If this process demanded a certain consistency of input, it was, in the tradition of Bertillon, intended to streamline the promise of efficient data retrieval: simply put, people could be more easily tracked if their identifying criteria were systematic, especially where official papers were concerned. Such alleged consistency was perhaps less evident in the context of more informal documents—transportation passes, for example, or membership cards—forms that, in principle, were less obligated to comply with the imposed didacticism of official standards required at the government level. Here, the visual language of personal identification typically reveals a more stylistically nuanced imprimatur, with composition, typography, ornament, and even color palettes varying by country, by institution, and by year.

When, in certain cases, civilians were offered the opportunity to fill in their own information, words themselves became evocative descriptors, with language at once lyrical (in his 1926 passport, the American poet Ezra Pound boldly described his own chin as "imperial") and cryptic (on an ID card from the same era, a black vendor noted his race simply by adding the letters "ed" after the word "color"). These kinds of tiny expressions of personal idiosyncrasy read like grace notes among the dispassionate metrics that frame these imperious documents: you have to look carefully, patiently, even microscopically to find them—but they're there.

In his excellent book on the history of the passport, British author Martin Lloyd observes that the social contrivances of Victorian photography—the way people were posed, dressed, lit, and so forth—resulted in pictures that sooner resembled the classic *carte de visite*

Marie Baroudel Identity Card
Circa 1920

This card clearly establishes Baroudel's identity as seen through the eyes of the state: she is a widow whose late husband served in combat, thereby entitling her to his survivor benefits. Her own profession and age are not given.

Collection of the Author.

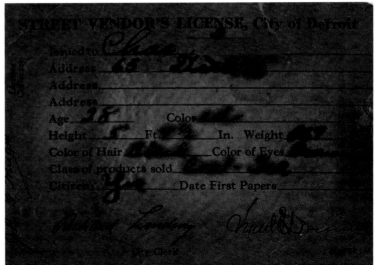

Detroit Street Vendor's License
1932

The licensee, known only as Charlie
(or "Chas"), elected to register his race by
adding the letters "ed" to the word "color."

Anjelica Paez Collection.

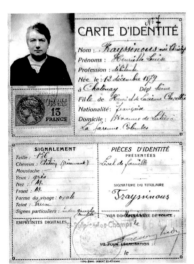

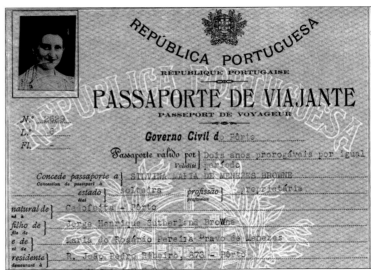

French ID Card + Portguese Passport
Early Twentieth Century

European identification documents
showing stamps, seals, and other markings
as required by national governments.

Collection of the Author.

than the perfunctory IDs that would replace them a century later.[5]
The economics of commercial photography made the acquisition of
the headshot something of an economic hardship in the early days of
photography, but the popularity of the *carte de visite*, and in particular,
the invention by the French photographer André-Adolphe-Eugène
Disdéri (who realized it was possible to take multiple photos on a single
plate) was both a technological innovation and a boon to citizen access.
By the First World War, photographs would be required on all passports,
even though the realities of wartime rationing made the acquisition of
the actual picture something many found to be a financial hardship.
(Crafty passport supplicants would sometimes harvest their likenesses
from personal albums, avoiding the necessity for a commercial portrait
sitting.) The first British passport, issued in 1915, had not yet specified
a particular pose for portraits, and the images are consequently more

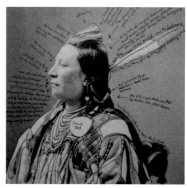
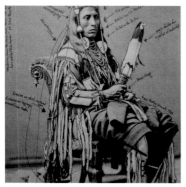
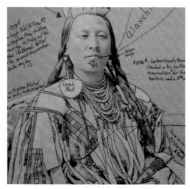
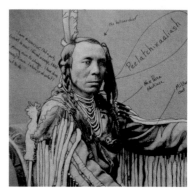
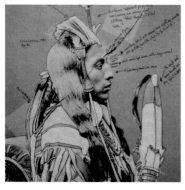
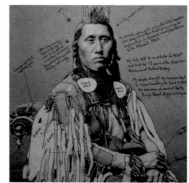
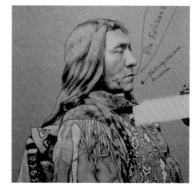

varied, in professionalism as well as in pose. By the Second World War, booklets had replaced single sheets, and both picture sizes (and poses) had become largely standardized.

The ID photo itself comes from a staunch tradition of external authority, a punctilious, and by necessity, a surveillant order. Bowing to what is, fundamentally, a culture of interrogation (whether that border crossing is Checkpoint Charlie or your child's public school is, in a sense, immaterial) the framework is a simple one. People are catalogued by their geographic coordinates (which, by their very nature, may change) and their physical coordinates (which, in principle, do not, although today, in an age in which genetic engineering, cosmetic surgery, and expressions of gender nonconformism no longer bear the stigma of social resistance, this can no longer be considered a foregone

Wendy Red Star
Medicine Crow and The 1880 Crow
Peace Delegation
2016

Red Star uses a red pen to both
excavate and annotate the symbolism
behind a series of iconic portraits of
late-nineteenth-century Crow leaders.

Face: A Visual Odyssey

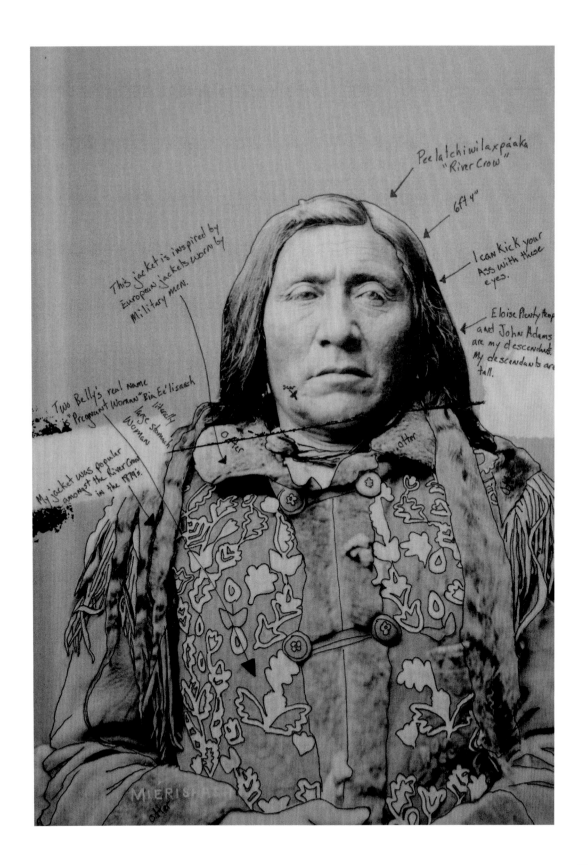

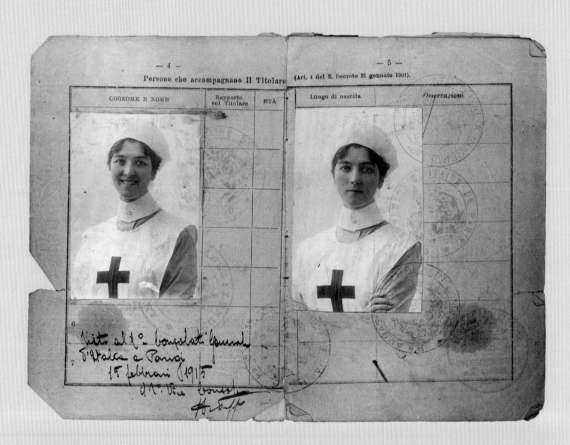

Chiquita "Chick" Mazzuchi
Passport
1915

*American National Red Cross Photograph
Collection, Library of Congress.*

Mazzuchi was born in Singapore, claimed
to be a countess, and traveled in the
same social circles as Stanford White.
She volunteered for the war effort, though
the content of her relief work was the
subject of some scrutiny. (The "countess"
performed for soldiers, whereupon she
passed a collection cup.) During the War,
she was rumored to be living in a villa in
San Remo: her second husband divorced
her and found her an unfit mother. Their
child was raised in an Italian convent.

conclusion). Far less flexible are the government-sanctioned guidelines for ID photos that require a kind of dispassionate, almost affectless demeanor, which is often referred to as "facial neutrality." Passport-seekers in many countries (including, notably, the United States and the United Kingdom) are advised, for example, to provide portraits that are devoid of expression: no grinning, no frowning, no raised eyebrows. Smiles—particularly those showing teeth—are classified as unusual, even unnatural. Curiously, to neutralize emotion is, in a sense, to revoke a kind of baseline personality from the person being photographed,[6] and herein lies perhaps the greatest paradox of all. The idea that external authority overrides personal agency essentially means promoting artificially inclusive practices (let's all look alike) that are by their very nature exclusionary (let's ignore the fact that we don't, we can't, and we shouldn't try to look alike).

Long ago, the standard-issue ID badge was a small metal disk fitted with a pin, stamped with a company's logo and branded with an employee ID number. Today, electronic sign-ins allow digitally protected access to all kinds of public and corporate environments, with employee identification sooner hung from disposable lanyards than pinned to a lapel. Tags can operate equally as keys, our faces multitasking as passwords to unlock access (and ideally, one imagines, to prevent identity theft). Beyond cards and tags lie a world of mobile, screen-based technologies inviting even speedier access. Surveillance-driven, they can be archived and summoned after the fact; Snapchat-like, they can disappear once they're no longer needed. Facial recognition software makes all of this an almost automatic proposition—and for many, an unsettling one. (Identical twins, it is believed, can unlock each other's iPhones just by holding their screens up to their faces: an innocent gesture, until someone finds a way to undermine it.) Moving in even closer, retina scanning is a biometric technique that captures the patterns produced by the eye's blood vessels to ascertain identity. Someday very soon, RFID implants may allow for an even more seamless transference of proof.

But what is it, exactly, that we are trying to prove: that we are who we say we are, that we look like we're supposed to look? The face may function as a proxy for regulatory control, but we are invariably evaluated by a host of assessments that scarcely reflect who we are (particularly if we are forbidden—as in the case of the standardized passport photo—to express the emotions that constitute what should, by all accounts, remain an inalienable human right). Promises of prevention and protection aside, the bureaucratic cataloguing of the world does not, indeed *cannot*, favor the kinds of sentient proclivities that make us who we are. ("Attention without feeling," the American poet Mary Oliver once observed, "is merely a report.")[7] By privileging the objectivity of the system over the subjectivity of the individual, we are sooner classified by our data points than by our personhood. Branding by hot iron may reside in the distant past, but in matters of identification we nevertheless remain the outsiders, mere subjects awaiting admission, approval, and judgment.

Top
Fairchild Aircraft, Ltd.
Identification badge
Circa 1940

Smithsonian National Air and Space Museum.

Below
ID Badge Cutouts
1940s

Stacy Waldman Collection, House of Mirth.

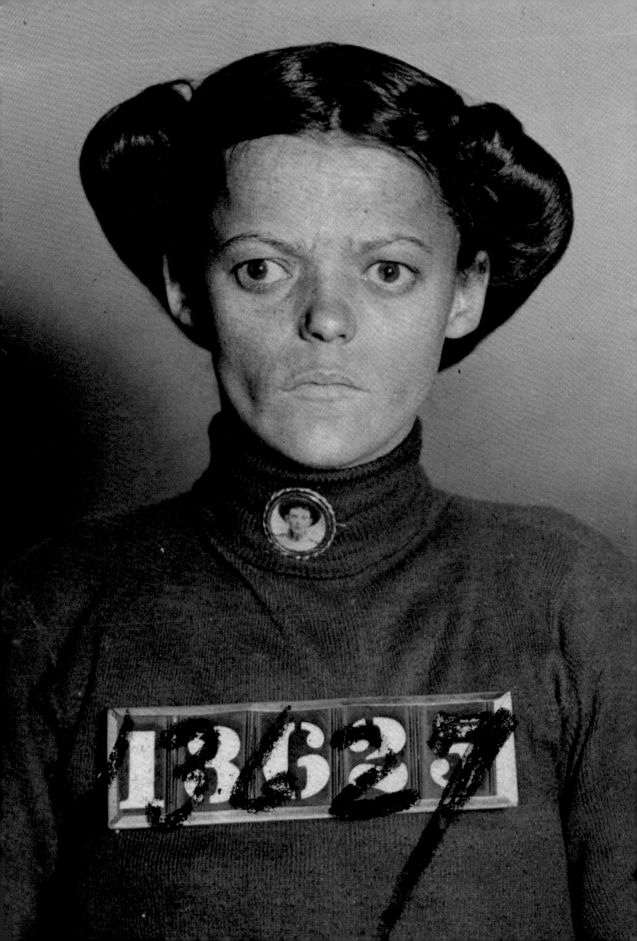

J | Judgment

Raya is an international platform for romantic, and to a lesser extent, work-related networking that targets the creative industries, a group of people whose interest in visual form makes them particularly predisposed to pretty things, and to pretty people. The site—which boasts a waiting list purportedly in the hundreds of thousands— believes that exclusivity breeds trust. True, it also breeds some less benevolent behaviors like snobbery and privilege, but the fundamental axiom at the core of its strategy is unabashedly transparent. (Raya doesn't deny its superficiality, but reframes it, instead, as a core marketing conceit.)

On the arguably slender precept that what community members share is a fundamental appreciation for beauty, the site not only trades in the social media currency of "likes," but favors the even more performative exposition of Instagram likes, and by conjecture, of Instagram followers. Simply put: your Instagram feed not only says a lot about you (what you look like, what you do, how and with what frequency you've chosen to depict both as a matter of public record) but is amplified by your followers, which is to say your friends, but also your fans, all part of that amorphous, adoring public who claim to want to look at you, too. This curious blend of quality (given the implications of desired exclusivity) and quantity (given the immensity of your presumed following) is where Raya marks its core territory. Call them elitists if you wish, but their basic demographic is patently clear. What Raya's core constituents really are—and unapologetically so—are lookists.

In a sense, all dating apps subscribe to the tenets of lookism. You shop for partners like you're browsing for bananas, a behavior sooner informed by the metrics of the hunt than the mysteries of

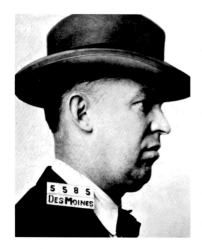

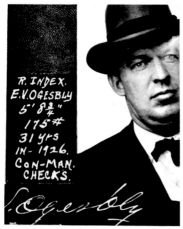

Check Forger
Bertillon Card
1926

The kinds of crimes logged by police were often entered longhand on index cards, thus providing all kinds of forensic detail. Height, weight, age, race, and signature— all combined to tell a particular story.

Mark Michaelson Collection.

Opposite
Laura Bullion
1893

Posing as a war widow and using assumed names (she personally chose the nickname Della Rose), Laura Bullion was an outlaw and a member—along with the Sundance Kid—of Butch Cassidy's Wild Bunch gang.

Library of Congress.

desire. Transactional though it may appear, it's also fairly truthful— the face as the portal for primary engagement, attractiveness as visual stimulant—we judge, after all, based on what we like, reason be damned. There's a clear philosophical precedent to lookism, as it turns out: it was Socrates, in Plato's *Phaedrus*, who noted that the irrational desire leading us to beauty overpowers all judgment,[1] and Blaise Pascal, the seventeenth-century French theologian, who lyrically observed its circular logic. ("The heart has its reasons," Pascal famously wrote, "of which reason knows nothing.")[2]

If a face that begets love drives us to abandon reason, beauty remains, as ever, an aspirational ideal, something to be objectified, valued, and judged. Sociologists often refer to something called the "beauty premium"—the notion that better-looking people are believed to be more trustworthy or likable, a supposition long believed to carry with it a tangible economic benefit. Ironically, it may turn out that the beauty premium's opposite (sometimes called the "ugliness penalty") has proven its own enduring value with regard to wage growth: a 2006 study suggesting that attractive people were likely to earn more than their less comely counterparts was disputed a dozen years later, when it was revealed that certain compensatory factors (intelligence, discipline, and patience, among others) resulted in a greater long-term financial yield.[3]

What is wage-worthy? Who is professional-looking? Why do we place our trust in faces that smile back? How do we assess suppliers, gauge colleagues, elect leaders, even (and especially) fall in love because of what we see—or do not see—in another person's face? As idiosyncratic as that may seem, there's a fair amount of empirical evidence suggesting that some of what we judge is rather universal. We now know, for instance, that men with wider faces tend to be more socially (and often sexually) aggressive.[4] Researchers have isolated portions of the faces of leaders to map the ways facial inflections read to the public, where they are evaluated against perceptions of strength, leadership, and competence. On the personal end of the spectrum, neurologists can monitor activity in the brain to see where that dopamine dance is happening when you like someone's face (you can thank the amygdala) while psychologists map our readings of faces to something called the "Big Five," a handful of essential expressions against which all humans can be assessed equally. These are: extraversion, agreeableness, conscientiousness, neuroticism (defined as the opposite of emotional stability), and openness to experience, otherwise known as intellect.[5] In his superb book *Face Value*, Princeton psychologist Alexander Todorov—perhaps the world's expert on first impressions—masterfully explains the degree to which face signals are illusory, prone to perceptual difference, and contextualized by culture.[6] Certain facial responses are triggered neurobiologically: dissent, as it turns out, is a fairly global phenomenon (there's literally something called the "not" face that's biologically predetermined) and facial-triggered love, whether romantic or maternal, appears to embrace gender distribution fairly equally.[7] (This is a factor of

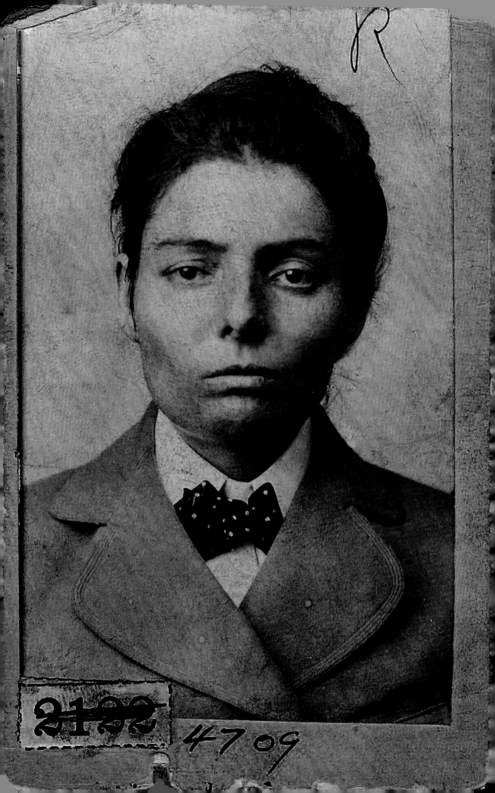

		Dates.	Offence.	Sentence.	Where Tried.
Emanuel Jack Cohen		8-07	Frequenting	2 months	Mansion Hse
Alias Jack Cohen		8-08	"	3 "	Guildhall
Trade Bookmakers Clerk		6-09	Stealing Watch	6 "	West London
Where Born Stepney		11-09	Frequenting	3 "	Watford
Age 34 yrs Height 5-7		1-13	Revolution Crime	6 "	Clerkenwell
Hair Black Eyes Grey		6-07	Frequenting	1 "	Epsom
Marks Scar on forehead		2-12	Larceny from person	12 "	London City
Left forearm I.L.J.C &		6-14	P.E. Act	10 "	Clerkenwell
Jessie, Hand Heart		9-19	Loitering	3 "	Nott—
Solomon Cohen		8-01	Stealing Pouch	4 months	North London
Alias John Harris		1-02	Frequenting	3 "	Mansion Hse
Trade Traveller		4-03	do	3 "	"
Where Born Spitalfields		7-03	Stealing Purse	6 "	Guildhall
Age 41 yrs Height 5-6"		4-05	" Watch	6 weeks	Worship St
Hair D. Brown Eyes Grey		1-1a	Incorrigible Rogue	12 months	Middlesex
Marks Walks with limp		10-11	Attempt Larceny	12 "	London City
Lame left leg		2-15	do "	3 "	Tower Bridge
		9-19	Loitering	3 "	Nott—
Michael Charles Hollick		8-89	Suspected person	7 days	Stratford
Alias Maloney, Goddard &		7-90	Larceny	6 months	Thames P.E.
Trade Tailor		6-94	Stealing Watch	12 "	North London
Where Born London		10-98	Larceny from person	6 "	Leeds
Age 46 yrs Height 5-10		3-00	do "	12 "	E. E. Court
Hair Dark brown Eyes Grey curly, thin on top		4-13	do "	6 "	Guildhall
Marks		3-18	Attempt Larceny	Bound over	"
		12-04	Robbery	7 years	Drogheda
		9-19	Loitering	3 months	Nott—

Above
Jack Cohen + Solomon Cohen
Jewish Gangsters
1919

The Cohens may, or may not have been brothers, but their probable mob affiliation (the Aldgate Mob and the Bessarabian Tigers were two of a number of Jewish mobs in east London around the time of the First World War) likely connected them in some manner. While crimes logged in this book include larceny and loitering, there's a record of at least one "incorrigible rogue." M.C. Hollick shares a page in the log book because he was arrested on the same day: books like these create impromptu communities at once materially ephemeral and socially permanent.

Yale Center for British Art.

Opposite
Franz Mraček
The Atlas of Syphillis and Venereal Diseases
1898

The outbreak of small pustules telegraphs the nature of this illness, which, because it is typically transmitted via sexual contact, would have been seen as shameful.

Wellcome Collection.

cognition—not gender—common to all human beings.) All of us judge books, as it turns out, by their covers. On a fundamental level, we're all lookists.

Still, to judge a person for being ugly—indeed, to even try to define what constitutes ugly—carries with it a host of didactic social assessments that read, by contemporary standards, as alarmingly biased. Yet the values framing public opinion were not always thus: in the Middle Ages there was a law by which, when two persons were suspected of a crime, the uglier was to be selected for punishment.[8] (Homeliness as punitive.) A late nineteenth century illustration of a syphilitic man shows what was then seen as "the horrible results of vicious indulgence."[9] (Promiscuity as pox.) The classic "before and after" face altered by weight loss or skin care or even surgical intervention suggests that there is an ugly-to-beautiful spectrum of choice, a set of valences to which we're meant to willingly subscribe, as though beauty is a matter of will, a function of active achievement. Evaluating difference through the distorted lens of binary judgment suggests you're either good looking—or you're not.

Being judged for having a face deemed "ugly" may seem churlish (and it is) but for those on the receiving end, the emotional impact of

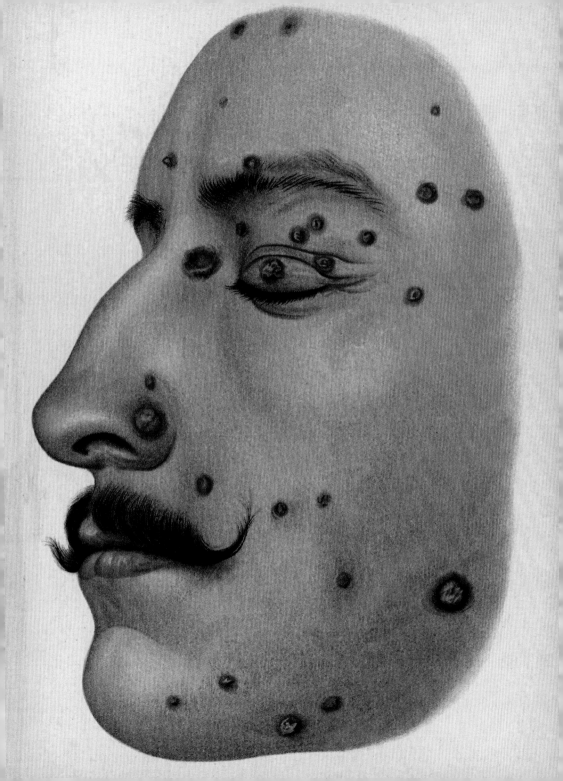

THINKING AHEAD

The Roman Nose indicates more or less Will Power and Aggressiveness. But, two in one family, where the wife and husband each have one, may prove to be one too many.

CLEAR SAILING

The Concave Type Nose, which represents Receptiveness and Gentleness, and the Roman Nose, Will Power and Aggressiveness, suggests the most preferable mating.

Girls with small Upturned Noses make good wives of the clinging vine type—but must be handled with kid gloves to get the best results.

Character Reading by Observation
Character Chart Sales Company
1939

Detailed in its judgment of facial characteristics, this chart, endorsed by the National Recovery Administration (a prominent feature of Roosevelt's New Deal), suggested that qualities of endurance and dependability could be gleaned through the chin, shrewdness and opportunism could be seen in the eyes, generosity and kindness could be found in the ears, and marital suitability was best measured by the nose.

such derision can be cataclysmic. A national study on child safety in schools [10] found that 27 percent of the students polled cited appearance as the primary cause of bullying, but the overlap with other quasi-visible characteristics—ethnicity, race, gender, even religion (difference revealed through headscarves, facial hair, and non-Western attire)—elevates that number to an alarming degree.

Within the realm of appearance-based difference lies the issue of facial difference, a handicap all its own. (It is bad enough to be paid more because you are pretty, but to be rejected because of deviation from a questionable physical norm is particularly egregious.) To those for whom congenital abnormality manifests as visual difference, public scrutiny is simply and undeniable cruel. Mercifully, today there appears to be an increasing amount of public support for those navigating the complexities of this kind of devastating—and to a certain extent, inescapable—discrimination. AboutFace is a Canadian nonprofit focused on promoting positive mental and emotional well-being for individuals with facial differences (and their families) through social support and educational programs. Changing Faces is a UK-based charity that campaigns for what they call "facial equality," lobbying for policies and protections, challenging discriminatory practices, and reaffirming equitable opportunities for children and adults who self-identify as facially different.

Like body-shaming, face-shaming thrives on social media platforms where the accuser can be effortlessly concealed, ironically shifting into facelessness by hiding behind a cryptic handle or a goofy avatar. (Or both.) So-called appearance-based bullying is amplified by the extraordinary reach of popular sites like Facebook, Twitter, and Instagram, where kids can be mean and where—under the aegis of free expression—First Amendment rights can just as easily shield the bully as defend the victim. But for those unfortunate enough to find themselves in the crosshairs, the net effect can be dire: cyberbullicide, defined as "suicide indirectly or directly influenced by experiences with online aggression" [11] is a social epidemic that turns trolling into tragedy. Here, faces are frequently the prime targets for all kinds of vitriol: invoking abstract notions of facial beauty as an absolute and using social media platforms as stages for publically shaming others, visual judgment quickly grows toxic, even lethal.

Poor judgment is made infinitely worse by the visual evidence that follows in its wake. Beyond the irredeemably tone-deaf stupidity that leads someone to photograph themselves, say, preening at Auschwitz [12] there is another kind of judgment in which faces are curiously primed for public view, a strangely counterintuitive kind of self-portraiture known as the daredevil selfie. (Colloquially: a "killfie.") For those ending in fatality, as far too many do, the question here is perhaps so heart-breaking as to be unanswerable. Having arrived at a moment in history where we share portions of ourselves through online platforms—platforms that disseminate our likenesses with reckless abandon—how is it that such recklessness has come to colonize our own unassailable capacity for self-protection? This is the territory

Face: A Visual Odyssey

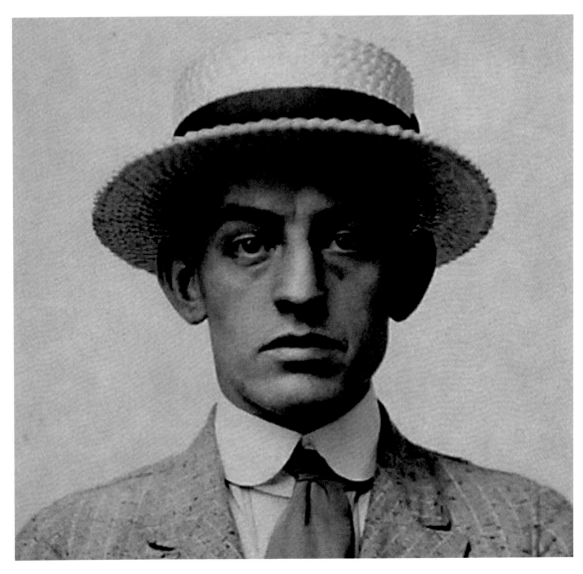

of the maddeningly impulsive snap judgment, but also speaks to questions of ego, and to the exceptionalism brought about by self-love.

Ironically, love may lie at the core of it all. We now know, for example, that the experience of visual beauty engages the part of the brain known as the orbitofrontal cortex, and that love itself (romantic, parental) is cued by the face of the love object (the lover, the child) which is the one place where judgment is blithely suspended. Does such suspended judgment extend, in these cases, to one's own likeness, love for one's own face refuting logic, ignoring consequence? To be enamored of yourself death-defyingly captured on camera effectively means you're simultaneously living in the moment and glorifying its afterlife. (Selfie as souvenir.) How tragic that the pursuit of the killer shot should commemorate that fleeting image for eternity as your single, and most irrevocable act.

George J. Ellis
War Deserter
1919

Ellis, a soldier, was arrested and charged with desertion on July 16, 1919, in Worcester, Massachusetts. With no prior criminal record, his narrative is purely observational: Ellis is described simply by his marks, moles, and scars.

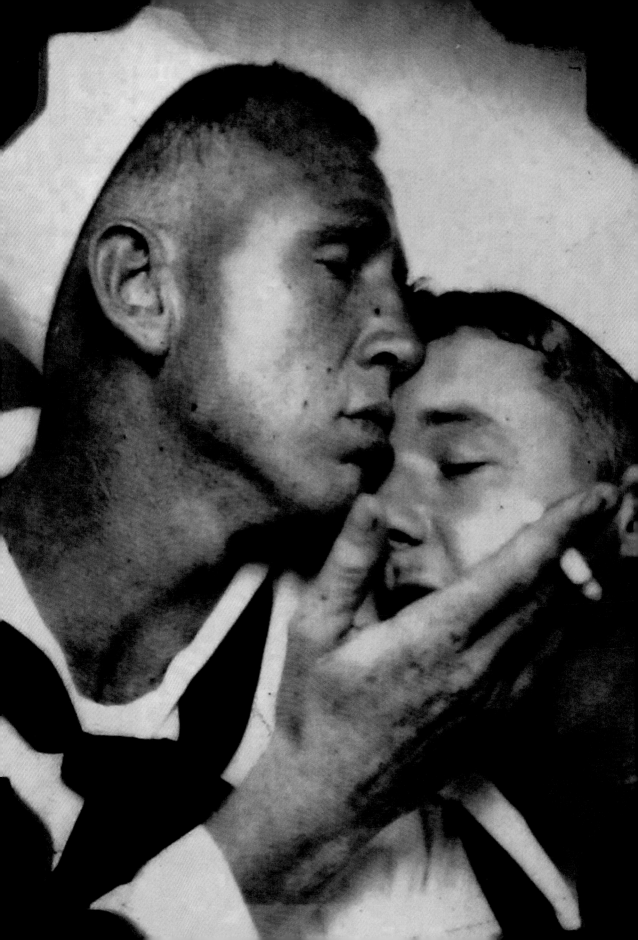

K | Keepsakes

In the fleeting expression of
a human face, the aura beckons
from early photographs for the
last time.

Walter Benjamin

As a material artifact, the facial snapshot is a study in paradox, at once
an expression of the ephemeral and a claim to perpetuity. It's also the
flimsiest of trinkets, a disingenuous testament to truth: once snapped,
you'll never look the same again. The camera, by its very nature,
preserves the moment yet simultaneously persecutes its subject: it's
a fool's errand—snapshot as theft.[1] Just as your new car loses value the
instant you drive it off the showroom floor, you've aged, technically
speaking, before that photograph will ever actually be seen.

How have we come to be so besotted by our faces, harboring them
like would-be fugitives? Do we cling to them because they function as
mnemonic devices, glimpses of who we were, teasers for who we'll be?
And why do we crave such image-driven acquisition, if not to actively
participate in the faithful recording of our own imagined narratives?
Seventeenth-century Puritans in North America frowned upon art in
general because they believed it distracted from religious worship, yet
willingly embraced portraits, which they viewed as reliable historical
records. What makes something a portrait? Who decides if it's reliable?
And why do we care?

History and Puritan doctrine notwithstanding, the story of our
obsession with pictorial captivity follows a more circuitous path. It
might track to the amulet (a wearable artifact that promised protection
from danger) or the talisman (a good-luck charm believed to convey
magical powers)—both symbolic practices that can be traced as far
back as the Roman Empire. For centuries, we visited faces in churches
and in museums, where portraits of deities, dignitaries, monarchs, and
even mythological figures were displayed as both vessels for worship
and conduits for prayer. Later, the rise of the miniature—which both
emanated from the golden age of the illuminated manuscript and

Top
**Postmortem Portrait of
an Infant and Mother**
Ambrotype
Circa 1850

*Paul Mellon Fund
Yale Center for British Art.*

Below
Postmortem Portrait
Photographed by
Charles DeForest Fredricks
Circa 1857

Houghton Library, Harvard University.

beckoned to the early days of the daguerreotype—transformed these trinkets into more personal curiosities like broadsides, books, and jewelry. At once decorative and devotional, jewelry in general (and the facial locket in particular) flourished in sixteenth-century Europe, expanded in popularity with the rise of the cameo during the reign of Elizabeth I, and found its most poignant expression in the art of *memento mori*, Latin for "remember you must die," a solemn Victorian practice in which photographs of the departed would be kept—and often embellished by—their grieving survivors.

If such rituals seem ghoulish or even overly sentimental by contemporary standards, make no mistake: modern selfie-takers are no less facially preoccupied than their album-obsessed forebears. Less overt hoarding. (More obsessive hashtags.) Where our faces are concerned, we're all nostalgia-seekers, longing for a glimpse of the familiar. And what could be more familiar to us than our own reflections? Perhaps this explains why faces are so endlessly seductive. We see ourselves in them, measure ourselves against them, and cling to their mesmerizing, if not always cogent narratives.

That we keep them is clear. But for whose sake do we do so?

Rescuing images—and cementing them to the page—is a social convention that gained particular traction during the volatile years that followed the Civil War. The idea that you might refute a sense of heightened personal vulnerability by barricading yourself with stockpiles of material evidence was, at least initially, an antebellum conceit: refreshingly, it was neither a gendered nor a privileged nor a racially divided activity: Thomas Jefferson kept scrapbooks and so did Mark Twain and Frederick Douglass. (The American historian Ellen Gruber Garvey has written extensively about William Dorsey, an escaped slave whose more than 400 scrapbooks documented black life, black history, and the stunning hostility of the white press.) Keeping a scrapbook is about saving that which is only ostensibly ephemeral: it's the art of *carpe diem*.

Later, photo albums would give rise to the production of memory books for soldiers and their families; postwar printers would publish similar volumes for war-weary baby boomers (literally anticipating memories on behalf of their future progeny); and a global market for scrapbook paraphernalia soared in the wake of 9/11. Over time, the value we placed upon saving photos of ourselves and each other would essentially parallel the rise of industrialization, the expansiveness of commercialization, and the realities of emotional hardship brought about by wartime loss. The act of holding onto that picture was both a gesture of self-preservation and a way of resisting tumult, of steeling yourself against the fragility—and inevitability—of all that lay beyond your control.

It is one thing to save something, quite another to record it for subsequent retrieval. Long before tagging enabled us to track a picture's path and popularity by "following" a photographer, how did we come

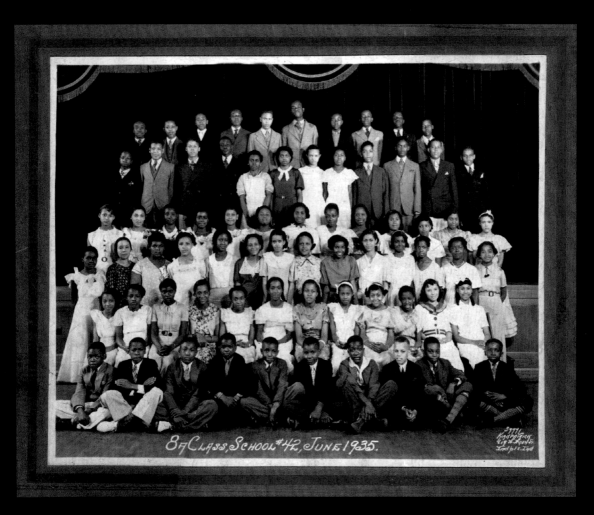

Eighth Grade Class Photo
Indianapolis, IN
1935

The Indiana Album,
Joan Hostetler Collection.

to label things—indeed, to label *ourselves*? It was customary, for a time, for the author of a photo album to self-identify as just that: *self*. (To share one's own name was likely deemed either too obvious—or too boastful.) Photographs sent out to be processed were flagged by dates, either stamped on their borders or entered manually on the reverse of the print, a somewhat unreliable proposition, particularly when it involved spelling. Newspaper picture morgues housed repositories within which a photograph could be shared by multiple authors, its history mapped, like geological strata from an archaeological dig, on its reverse. At once formally sloppy and factually specific, those annotations read as dazzling gems of analogue beauty, formal mashups that don't quite align, like police reports rendered in graffiti.

The contextualizing caption is, of course, by no means the only way we decipher found photos. We willingly attach our own contexts, navigating by speculation, reverse-engineering stories, connecting all kinds of endearing, if elusive dots. We may interpolate detail or excavate meaning or even choose to recalibrate history—all social conventions we're groomed to perform when looking at the image to which we have, for whatever reason, ascribed keepsake status. Yet while our perceptions may be deeply informed by our own familial experiences, they are equally, if not more, prone to cultural predisposition. (And bias.) Walker Evans's classic depiction of a sharecropper's family during the Depression is just as formally posed as a staged gathering of the British monarchy, yet its overwhelmingly somber mood recently led several of my Asian students to recently ask why nobody was smiling. That these sharecroppers did not have much to smile about was seemingly of little consequence to them. ("You smile for a portrait," one of them insisted, "and that is that.") Saving face, the idea of protecting your reputation (and by association, upholding that of your family) is a core conceit in Asian culture, as is its opposite—*giving face*—in which you humbly deflect the attention away from yourself. (Labeling yourself as "self," for instance.)

While "kinship" may suggest connectivity by bloodline, commemorative portraiture extends far beyond the confines of the ancestral pack. Consider sports teams, school reunions, social clubs, even summer camps—all social amalgamations that willingly cop to a certain "smile for the camera" rubric, as though a picture's future value hinges on such demonstrable, if fatuous proof. Posed, stilted, and generally predictable (even the non-uniformed wear a certain uniform) such pictures remind us of where—if not exactly who—we once were.[2] Oddly, in their inherent nod to a kind of stiff external authority, school photos sooner resemble passport photos than personal ones, even though the familial posse that is your intended audience could not be more different than your own personal clan. (Who is going to keep those school photos besides your family?) There's a visual *patois* to school pictures, with poses we can parse, in retrospect, with painful and granular accuracy: the tilted head, the wooden grin, the angled shoulders—all of us amputated, as if by scholastic decree, at the clavicle. Because they are so normalized by convention, so neutralized

Delegate Badges
New York and Pennsylania
1901, 1907

Glass-fronted portraits with ornate typography and embellishments were standard fare for political delegates in the United States throughout the late nineteenth and early twentieth centuries.

Collection of the Author.

Face: A Visual Odyssey

Rebekah Assembly Badges
Indiana
1910–1911, 1916–1917

The International Association of Rebekah
Assemblies is a service-oriented
organization as well as a branch of the
Independent Order of Odd Fellows, whose
badges often used photographic portraits.

Collection of the Author.

by social codes, they lend themselves to multiple kinds of formal comparisons, from hemlines to hairlines to a host of feature-specific details including, not surprisingly, that culturally mandated smile. (One study deployed a "lip-curvature metric" to measure this exact detail, concluding that girls, on average, smile more than boys.)[4] Bound by the unimaginative limitations of the institution at hand, you smiled for the camera, and that was that.

A decade ago, the *New York Times* reported that parents were beginning to pay to have their childrens' school photos doctored[4]— blemishes blurred, skin tones brightened, flyaway hairs magically erased—which raises curious questions about the veracity of the commemorative photo and the ethics of the edit (to say nothing of parental judgment). Does staging our children send the message that they're only as good as they look? Are children themselves increasingly primed to replicate one-too-many celebrity poses, thus projecting themselves, with diva-like determination, as their own nascent brands? The British psychologist Oliver James suggests that these kinds of portraits are the first step in the commodification of future workers as they prepare to sell themselves to employers,[5] a chilling thought.

Still, if the cultural restrictions of the commemorative portrait imposed their own visual vernacular, this was by no means the only method for determining pictures worth keeping. The rise of the commercially available camera during the early years of the twentieth century allowed for a host of then-new social opportunities that reframed the practice of civilian photography as a leisure activity, or sport. Kodak, for a time, turned its brand into a verb: you went out "Kodaking" with your friends, and the physical proof of your escapades lived on in the pages of your albums. That you clicked the shutter was not the real issue: what mattered was that you could produce memories on your own, and that you could save and share them. By inventing the inexpensive box camera and introducing roll film, Kodak endeared itself to a public eager to both produce and publish its own pictures— and by conjecture, to visualize and retain its own memories.

And here, there is a long-lasting history of entrenched racial bias. By mid-century, Kodak had introduced a color matching system that would become known as the "Shirley Card." Originally named for a Kodak employee, "Shirley" became synonymous with a cultural shorthand, an anonymous (but ever-light-skinned) *Caucasian* woman who would, for generations, serve as the approved benchmark for calibrating skin tones in printing. The Canadian scholar Lorna Roth writes about the cultural implications of Shirley's reign as the undisputed standard-bearer for what was would, for more than half a century, be egregiously termed "normal." "Peoples of color," she explains, "whose embodied imagery would have benefited from a more sensitive chemical emulsion in the case of still photography and a more dynamic range in the case of digital technology, were not the constituency group leading the visual engineers and scientists to further explore the dynamic range of their company's film products."[6] In spite of a system that easily could have expanded to encompass

Above
Nick DeWolf
Color Correction Collage
1970s

Computer engineer Nick DeWolf took
upwards of 40,000 photographs during his
lifetime, including examples of how color
tests (like the Shirley Card) were put to use.

Nick DeWolf Photo Archive.

Opposite
Leader Ladies Project
Chicago Film Society
2019

In the film era, lab technicians would
splice two or three frames from a properly
exposed negative into the leader of a
finished negative to reconcile color
densities. Since 2011, the Chicago Film
Society has been creating a digital archive
of these frames as they are discovered by
librarians, archivists, film projectionists,
and conservators all over the world. Like
the Shirley Card, these were almost always
Caucasian women. Sometimes, they were
lab employees themselves.

Chicago Film Society.

a true racial spectrum, these cards remained unchallenged well
throughout the 1970s and 1980s. Shirleys came and went, exclusively
female and always white. It would take until the 1990s for Kodak to
introduce multiracial standards for color calibration. By 2012, the
once-popular company would file for bankruptcy.

If the portable box camera allowed for picture-taking to become a
more casual enterprise, the rise of the Photo Booth took it all one
step further by reframing picture-taking as experimental, playful,
and endlessly repeatable. Patented by a Siberian immigrant named
Anatol Josepho, the Photo Booth (originally called the *Photomaton*)
arrived in the United States in 1925 to rousing success, conflating the
twin lures of vanity and entertainment. [7] What was it, exactly, that
made those pictures so enchanting? For one thing, they offered four
consecutively captured shots that together hinted at a kinetic ideal,
a subtle gesture of incipient modernity. The idea of multiples (itself a
modern conceit) meant you could share and vary them, shifting poses,
adding friends, even importing props to mark them as your own.
Perhaps most critically, the Photo Booth offered the aspiring photo-
taker an unprecedented amount of privacy: once unmoored from the
judgmental glare of the commercial portrait studio, you could pull

Harold Feinstein
Army Draftee in Photobooth
1952

Harold Feinstein Photography Trust.

Opposite
Two Women Kissing
Found Photograph
Undated

a curtain and go rogue. (Or go incognito.) The seclusion of the Photo Booth's curtain likely appealed to anyone who self-identified as socially different—from mixed race couples, to same sex couples, to anyone seeking a temporary respite from the unforgiving scrutiny of the status quo. (This also led to a fair amount of artistic and—perhaps not surprisingly—sexual experimentation.) It was fun, it was fast, it was social, it was personal, and it was powerful, because it provided what was, in retrospect, a comparatively radical kind of personal agency. Simply put, it made you the *de facto* author of your own keepsakes.

That a face could exist as a picture on a wall meant it could be revisited at will, but once it was glued to an album, or captured in a locket, or delivered onto that damp paper rectangle and spit out, midwifery-style, by the Photo Booth, it was capable of migrating far beyond its locus of inception. Once the focus shifted from the producer of the photograph to the owner of the photograph, its emotional resonance shifted, too. [8] Appealing paradoxically to both our nomadic tendencies and our enduring need for emotional anchor, the facial souvenir beckoned as a pastime with benefits. In a sense, the face would come to reveal itself as the ultimate keepsake because it can't easily be contained. Maybe we hold onto pictures because we can't hold onto each other.

L | Likenesses + Lies

It is not really the perception of likeness for which we are originally programmed, but the noticing of unlikeness, the departure from the norm which stands out and sticks in the mind.

E.H. Gombrich

In his classic treatise on prognosis, Hippocrates suggested that physicians would be well advised to begin their evaluations by taking notice of whether a particular patient's face was normal: whether, in fact, it resembled its "usual self." ("Such likeness will be the best sign," he wrote, "and the greatest unlikeness will be the most dangerous sign.")[1] Good advice for the clinician, but on a basic level, who is to say what is usual, what is normal, what is like—or unlike—you? The small chin and flat nasal bridge characteristic of those with Down syndrome might provide one kind of "usual," providing a different baseline, say, from the dysmorphic facial features occasionally present in dwarfism. Both occur by way of genetic mutations, but biology only accounts for part of the story: there are countless other factors that serve to locate us in our own norm—each to ourselves, but also to each other. The face, after all, is only the serial number of a specimen:[2] bloated by illness, ravaged by war, exaggerated by age, torqued by circumstance, your usual may not be so very usual after all, but it is, at the very least, your own. Until, of course, it isn't.

Artistic fidelity to the likeness is a thorny, if fascinating topic. If a painting can aspire to likeness as a gesture of verisimilitude, a photograph captures that veracity in split-second slices. Eddie Adams's iconic photo of Brigadier General Nguyen Ngoc Loan shooting a Viet Cong prisoner literally reveals the instant the bullet entered the prisoner's skull. Tara Pixley's exquisite portrait of a young woman in motion exquisitely captures her as though her hair has its own energy source. And Rosalind Solomon's portrait of a young man's face brutally colonized by Kaposi sarcoma is a searing reminder of an entire generation of epic, unbearable loss. Framed—like a medieval doge—by the circular halo of his straw boater, the arrow on his "Silence = Death"

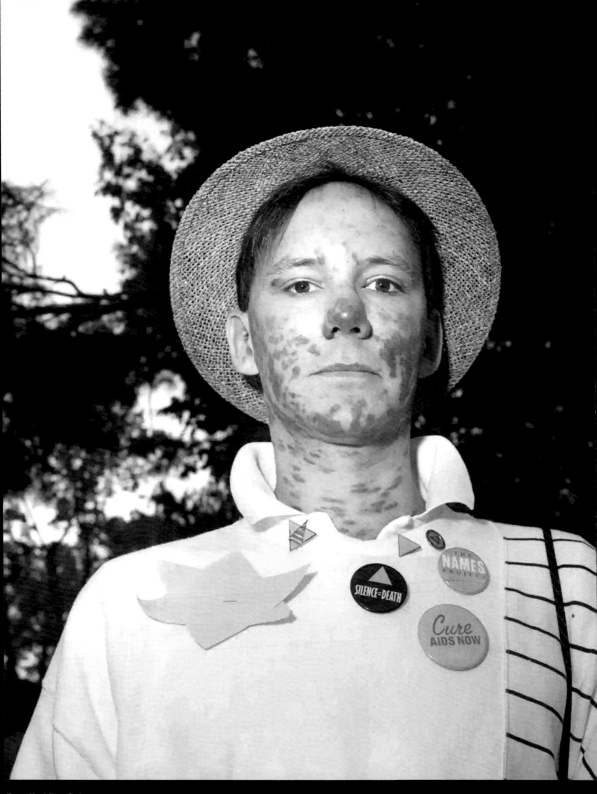

Rosalind Fox Solomon
Silence = Death
1987

button pointing upward, his is the face not only of an individual, but of a shattering global health epidemic that claimed countless lives.

Mortality is nothing if not equitable. Doctors refer to the "Hippocratic" face as that which directly precedes death—eyes sunken, cheeks sallow—a likeness invaded by illness that sooner resembles death, in the absolute, than it resembles the person. Death masks, literally molded from our inert faces after we no longer draw breath, capture our likenesses with unforgiving truth simply because of their infallible anatomical accuracy. Perhaps death is the ultimate likeness.

At its core, a likeness is a resemblance, a replica, an expression of truth. Galton saw likeness as typecasting. Charcot saw it as objectification. The Renaissance scholar Petrarch used the term "air" to suggest a certain kind of likeness brought about by similarity, preferring to interpret form rather than to mimic it; likeness as "a certain shadow ... perceptible above all in the face and eyes ... even though if the matter were put to measurement all parts would be found to be different."[3] In an effort to parse the actual components of the likeness, the eighteenth-century Swiss theologian Johann Kaspar Lavater labeled features as what he termed the "firm" parts. "The eye, the look, the cheeks, the mouth, the forehead ... are the most expressive," he wrote, adding that these were "the most convincing picture[s] of interior sensation, desires, passions, will, and of all those properties which so much exalt moral above animal life.[4] That an appeal to moral life might be cued by facial likeness would fuel the imaginations of poets and philosophers for centuries to come.

For Plato, likeness meant nearness to God (and by conjecture, proximity to virtue). For Milton, that very claim to godly proximity was a gesture of divine similitude. Indeed, the term *simulacrum* originally surfaced in the sixteenth century to describe the physical representation of deities and would later invite considerable philosophical inquiry by scholars and theorists eager to define likeness in the absolute. Aristotle (and a good while later, Adorno) among others would wrestle with the idea of mimesis—likeness as imitation— questioning the relationship between nature and art, the real versus the represented, likeness as a way to convey truth—but whose truth? The sitter or the self? The viewer, or the viewed? Us or them?

Our origin stories—and we all have them—begin in utero, where we ride passively through the gestational sojourn that confers likeness upon us. Family resemblance, a visual amalgamation of anatomical and accidental properties, imposes its latent ancestral authority upon us all, cross-generational traits reasserting themselves with every throw of the genetic dice. To share a family likeness is to inherit it (or be its source of conveyance), which may reveal itself in appreciation— or, for that matter, in apology. "I remembered how, an infant, his face was too dark," writes the American poet Toi Derricotte, describing her infant son. "Nose too broad, mouth too wide / I did not look in that mirror / and see the face that could save me / from my own

darkness."[5] Perhaps this is what it means to be framed by the likeness of our yesterdays: whoever you are, those genetic dice have their own game plan, which may seem, for the most part, to be irrefutable. (One is reminded of Philip Larkin's own skewering take on the family elliptical: "They fuck you up, your mum and dad. They may not mean to, but they do.")[6]

But ancestral affiliation is far from the only way we acknowledge likeness: on the contrary, we see faces reflected in a range of places and spaces, many of them rather unusual, even random. Pareidolia is a psychological phenomenon in which we perceive patterns in inanimate objects, gestures executed by way of the visual cortex, which is where we process visual information. And they're everywhere: the man in the moon, a face in the clouds, a designer teakettle that looks rather disturbingly like a cartoon version of Adolf Hitler. ("Faces in Things" devotes an entire Twitter feed to this trope: car grilles, house facades, door handles, even pet fur.) Sometimes, the appeal is simple—the accidental likeness as a token of natural charm. In the spirit of Shakespeare ("a woman's face with nature's own hand painted")[7] the late Shozo Hayama spent fifty years collecting rocks that looked like faces: some 1,700 of them are on display in a museum called the Hall of Curious Rocks in Chichibu, Japan. Sometimes the similarity is comical: food portraiture aficionados share videos online to instruct in the finer points of sushi (President Obama) and pancakes (the Beatles), while "faces in food" is its own collectible genre, the likeness sought in everything from chicken nuggets to cheese puffs to rounds of pastry that look like Mother Teresa. (In 2004, an alleged likeness of the Virgin Mary singed onto a piece of toast brought close to $30,000 on eBay.) And sometimes it is simply whimsical: the Italian mannerist painter Arcimboldo constructed collaged portraits using natural elements like flower petals and fishbones to create what he termed *teste composte*—or composed heads—all of them constructed from found objects.

John Singer Sargent once described a portrait as "a likeness in which there is something wrong about the mouth."[8] He was likely referring to the artist's prerogative as biographical interpreter, extracting from the sitter the juiciest, if not always the most desirable, visual details. Sitter vanity may be the true culprit here (a topic worthy of a volume all its own) replete with stories of commissioned portraits in which flattery for the subject easily trumps the faithfulness of the artist's rendering. Iconic leaders were often depicted as taller, their wives prettier, and their children far better behaved than they probably were, which begs the question: if a likeness fails to render its replica with the utmost veracity, does that mean it is lying?

Hardly. For all our presumed interest in the truthful likeness, the lie is, as Nietzsche long asserted, a basic condition of life. Portraits themselves are deceptions. ("A likeness, any likeness," wrote Gertrude Stein, "... has blisters.")[9] Darting eyes, rapid blinking, facial scratching, eyebrows raised—these are the telltale signs of lying, we are told— but what if the lie is etched in the physical apparatus of the likeness

itself, in the portraits that outlive us? Consider that rogue's gallery of psychologically toxic offenders, whose faces betray us with their sheer capacity for trickery: likeness can also proffer itself as a searing kind of seduction. The handsome yet philandering spouse. The composed yet cunning thief. The hypocritical yet airbrushed politician. If deception is a human conceit, do we obviate it by turning to avatars—computational constructions into which we embed our own curated, even sanitized choices?

In Cambridge, a group of research scientists recently collaborated on a digital facial likeness that hopes to one day serve as your assistant—or as your caregiver.[10] To be sure, the ethics of appropriation may seem less pernicious in the context of a digital simulation, but the core question remains: why is this screen-based she (and make no mistake—it is always a she) modeled after a human likeness if not to map to that essential Hippocratic norm? And what of appropriating another person's identity—is that not also a lie? So-called borrowed likenesses are deceptions of a very particular sort, falling under the rubric of what legal experts call personality rights: the protection, by statute, of any unbidden appropriation, reproduction, or distribution

François Robert
Faces
2000–2018

Chicago-based photographer Francois Robert has been shooting pictures of faces in objects for more than two decades.

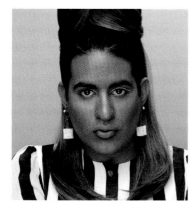
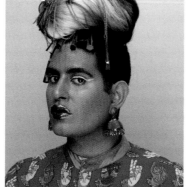
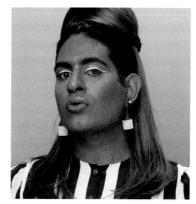
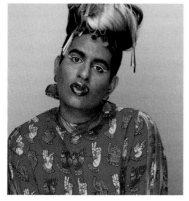
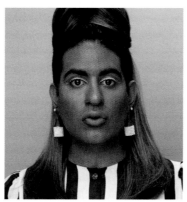
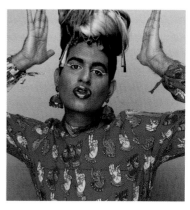

of your identity without your explicit consent. We may elect to remove the capacity for deceit by turning our attentions to digital replicas, but it's not clear that this even begins to address the real issue, which is how we define privacy.

Beyond the rapacious reach of identity theft, there's an even stranger conflation between the likeness and the lie, reserved for those who, for whatever reason, elect to go under the knife in an effort to ape someone else's looks. Whether your goal is to look like a Barbie doll or a movie star or even Nefertiti, the idol in question is not really the issue, here. What *is* at stake are the lengths you are willing to go to reset your coordinates, crafting a likeness that scarcely resembles you at all. Does the agency with which we now approach personal expression mean that we can redirect those coordinates at will—reframing the likeness, reclaiming our own sense of what constitutes that norm, diverting the "usual" in favor of an alternate self? One need only consider the triumphant stories of transgendered people—who've overturned the onerous deceptions of their own biological origins by bravely reasserting their true identities—to realize that "likeness" should be a personal, protected, and inalienable right.

Such agency, however, seldom presents itself as actionable. What happens when the choice to resemble yourself is no longer yours to make? Medically necessitated cosmetic surgery tells a different story. At its most extreme level, recipients of facial transplants struggle, as

Alok Vaid-Menon
Selfie Series
2018

Alok Vaid-Menon is a non-binary transgender femme writer, LGBTQ rights activist and performance artist whose work explores topics including gender, race, trauma, and belonging. "What selfies allow me to do," they explain, "is to remember who I am, what I am fighting for, and what the world I want to create looks like."

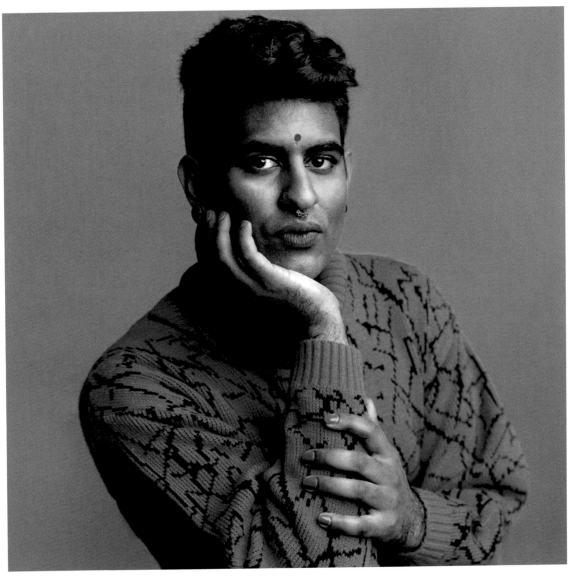

they must, with questions of effaced identity. To the degree that their own likenesses have been eviscerated, they must import new faces, recalibrate new identities to go with them, and adapt to new ideas of what constitutes a revised, arguably alien baseline—a "usual" that is anything *but* usual. Navigating the psychological dislocations brought about by such extreme facial overhaul is nothing short of cataclysmic for the recipient, but what of the rest of us—what is it we see, and respond to, and judge? ("God hath given you one face," Hamlet tells Ophelia, "and you make yourself another.")[11] Who is to say what it means to conceal or reveal a face, to question in ourselves the reflection of someone else's countenance against our own self-image, as though that provides an objective—or, for that matter, subjective—measure of anyone's worth?

Timothy Greenfield-Sanders
Portrait of Alok Vaid-Menon
2016

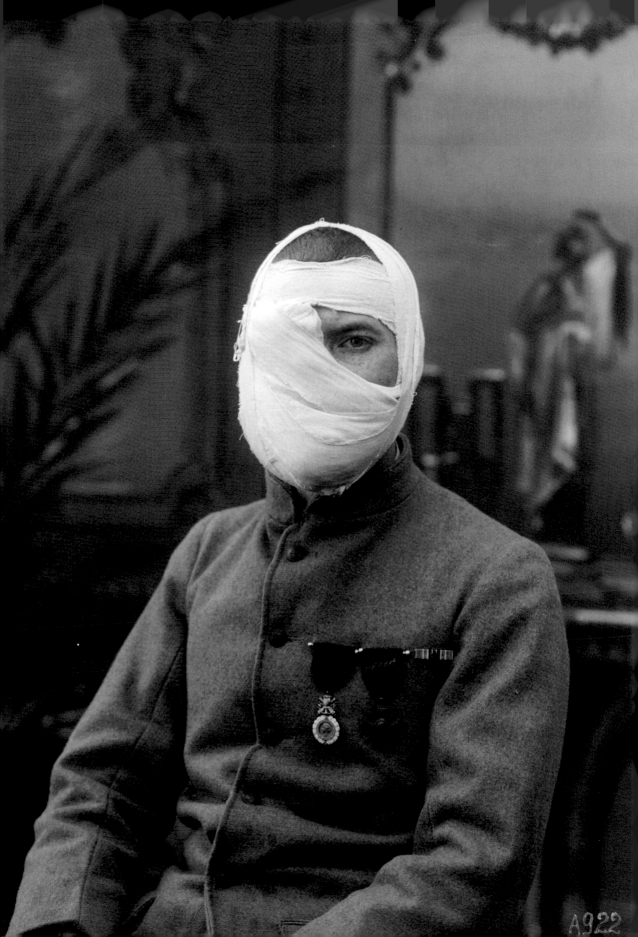

M | Masks + Mirrors

Mirror, mirror, on the wall
Who is falsest of us all?
He who wears a mask so well?
If you cannot, he can tell.

Peter Davison

Three days after Kennedy defeated Nixon to become the forty-fourth president of the United States, Rod Serling's now-classic episode of *The Twilight Zone* first aired on American television. Titled "Eye of the Beholder," its implied message—a cautionary tale about public approval and the perils of social conformity—remains as trenchant today as it once was (in the age of peer pressure and screen-based "likes," perhaps more so). In his inaugural address, Kennedy would speak to the promises of a new frontier, his handsome face an iconic symbol for a renewed era of American hope. Optimism, or conformism?

The same might be said of this now-classic episode. The plot is simple: a group of physicians, their faces concealed behind rigid white surgical masks, are examining a patient lying on a gurney. Shrouded by a massive web of bandages, "Patient 307" is described simply as a "pitiful twisted lump of flesh." Her "hideous disfigurement" is meant to explain her social disgrace and consequent exile. "If the procedure fails," we are told, "state officials will relegate her to a special village with others of her kind."[1] As the bandages are removed, the camera cuts back to reveal the patient, who turns out to be a vision of Hollywood loveliness. Only then do we see that the surgeons have removed their own masks—and they're aliens.

Interchangeable as both noun and verb, a mask is equally an extension of a likeness and its unruly, camouflaged alter ego. (The word *proposon* was used in ancient Greece to describe both face and mask, thus to wear a mask was literally to double your face.) Curiously, the word's Latin root, *masca* (ghost) points to the Italian *maschera* (fiction) and can mean anything from erasure to ridicule to pretense. (In Arabic, the word *maskara* is translated rather deliciously as "buffoon.") The American poet Paul Laurence Dunbar saw masks as inevitable features

Above
Painted Wooden Ritual Masks
Sri Lanka
1771–1860

Opposite
Scold's Bridle
Belgium
1550–1775

Science Museum, London.

of modern social posture. ("We wear the mask that grins and lies / it hides our cheeks and shades our eyes.") For Emily Dickinson, masking itself presented as a kind of curtain, a mashup of subterfuge and sex. ("A charm invests a face," she wrote, "Imperfectly beheld / The lady dare not lift her veil / For fear it be dispelled.") In C. S. Lewis's last book—the exquisitely titled *Till We Have Faces*—the character of Orual sees her ugliness as a facial deformity, which she hides with a mask.

Conversely, the very notion of a beauty mask can symbolize a kind of gendered emptiness. ("Some women," wrote Nietzsche, possessed no content and were "purely masks.")[2] In Shakespeare's *Romeo and Juliet*, Mercutio describes the mask as a visor, shielding the eyes from blinding light, a metaphor for resistance—a way to divert truth. (Italo Calvino once described it as a silent shroud for psychological pain, describing a friend "masking" his feelings so as to conceal the darkness of the soul.)[3] Ezra Pound's early poem *Masks* speaks to precisely this sentiment: that "strange sadness in their eyes" its own kind of cover-up. Or absence: in his 1992 novel *The English Patient*, Michael Ondaatje describes his fully bandaged protagonist as a man with no face, "an ebony pool."[4] At once a barrier to entry and a protective cover, masks offer a way of both standing out and fitting in. Hidden or veiled, disguised or bandaged, they're mercurial tools of facial redaction that both ensure anonymity and advance our capacity for deceit. Masks can be used to decorate, to interrogate, but most of all, they're used to obfuscate: they occlude vision, and thus revoke identity. They erase us.

In the early days of Greek theater, Dionysian masks served as flexible aliases for multiple stage identities: the actor did not need to leave the stage, but donned a different mask, instead, to signal each change in role. The ever-twinned comedy and tragedy masks are, in fact, modeled after the original Greek muses Melpomene and Thalia. (The god of theater and of "enthusiasms," Dionysus himself was a virtual chameleon of characters, and is often referred to, for that reason among others, as the masked god.) The Romans would later use them on stages and in festivals, while a commercial market for masks grew, as both craft and commodity, reaching its apex in Venice during the masquerade-rich years of the Renaissance. *Commedia dell'arte* masks were elaborate constructions, highly specific to character delineation and thus easily recognizable by the audience. Such masks persist today, in Venice, as decorative souvenirs.

Over time, the entire notion of the masquerade would extend beyond the confines of the stage, into the carnivals and onto the streets, to a populace eager to experiment with different personas. Channeling alternate roles, invoking ancient ancestors, and gesturing to any number of aspirational selves, you could be anything behind your mask, and you were. Arthur Schnitzler's 1926 *Rhapsody: A Dream Novel*— adapted for the screen by Stanley Kubrick for his 1999 thriller *Eyes Wide Shut*—dramatizes the mask, during sex play, as a barrier to exposed identity. The idea of a facial barrier concealing your identity while your naked body is on public display in an orgy may seem counterintuitive, but that barrier is a facial fortress all its own.

Photo-Multigraph
1900–1910

A photo-multigraph is created by placing the sitter between two mirrors which are then angled to produce four separate reflections of the subject. By exposing the face from multiple perspectives,the process allegedly allowed participants to "see ourselves as others see us."

"It will be impossible to make our faces appear to the most advantage by a clever pose," opined a critic in *Scientific American* in 1894, "for the latest innovation in photography, the multiphotograph, which is destined to become the photographic portrait of the future, will reveal all our defects and crudities."

Collection of Christopher B. Steiner.

Throughout history, across multiple cultures, masks have always held symbolic, even shamanic qualities. In Bulgaria, they were constructed from flowers and feathers and used to adorn the blushing bride. (The blush itself is a kind of mask.) African masks, which predate the Paleolithic era, were traditionally used in ceremonies to summon the spirits of ancestors. The ancient Aztecs used masks as trophies, and in India and Indonesia, they've long been used ceremonially to represent a wide range of mystics and deities. Asian and Inuit masks have classically been believed to hold spiritual properties: the fascinating, if somewhat controversial Iroquois practice of "False Faces," is still used in healing rituals[5] and should not be confused with the 1932 Lowell Sherman film, the 1943 George Sherman film, or the 1919 silent Lon Chaney film that share similar titles. (The idea of the mask as a physical representation of facial falsification was, understandably, an irresistible "get" for Hollywood: consider the mask of Zorro, of Darth Vader, of the Phantom of the Opera, of Superman and Batman and most, if not all of their bandit enemies.)

If masks confer evil upon the bad guys, they have served equally as tokens for punishment. Medieval masks were occasionally used as devices for physical and even social torture. In the sixteenth century, a woman reviled for what was believed to be immodest or inappropriate behavior (gossiping, for instance) might be paraded through the streets by way of something called a scold's bridle, a metal muzzle scaled to an adult face. Referred to as a mask of shame, it served to telegraph a woman's dishonor: mask as stigmata. Today, in some parts of culinary-mad France, tiny songbirds called ortolans are slaughtered by drowning—in a vat of Armagnac—whereupon they are served, and meant to be eaten whole, a practice so controversial that the very act demands putting your napkin over your head, a modern-day mask of shame. And then, what? After the napkin comes off, after the bandages are removed, after the carnival is over—who is left? *Eripitur persona, manet res*, wrote Lucretius. *The mask is torn off: the person remains.* [6] What then?

To see the mask as a theatrical prop tells only part of the story. Masks have served equally as prosthetic devices, concealing injury but also extending the optical regions of countless faces marred by warfare, most notably during the First World War. Physical wounds—by gunshot, by chemical gas—were to some degree treatable in the trenches, but those suffering facial damage endured far more egregious and enduring hardships. Eyewitness accounts tell only part of the story, and it is a highly sanitized one. "The ambulance takes these men, mutilated beings, without any faces, who would otherwise be unbearably repulsive and almost certainly economically dependent, and makes them over," wrote the socialite Mrs. William Vanderbilt in 1916. [7] It is both impossible to grasp the numbers of men whose faces were irrevocably damaged in battle and to estimate the attendant emotional distress that followed them through their remaining days. Ebony pools, indeed.

The idea that a mask might mollify the public display of facial mutilation was made possible by a number of devoted physicians, particularly one particularly determined American artist called Anna Coleman Ladd. Having served at the 3rd General Hospital in London where she trained in the Masks for Facial Disfigurement Department, Ladd founded her own studio in Paris in 1917: she called it the Studio for Portrait Masks. (Soldiers called it the Tin Noses Shop.) [9] Using plaster casts, plasticine molds, and thin sheets of galvanized metal, Ladd created prosthetics for soldiers whose facial disfigurements were so profound that many were unable to go out in public. She experimented with enamels and oils to match skin tone, slivered and painted tin foil to create brows and lashes, but operated only at a topical level, meaning that facial nerves remained dormant: the masks she produced were, by definition, destined to remain expressionless and inert. Striving for a kind of simulation that was likely impossible to regulate—somewhere between human familiarity and anatomical precision—Ladd nevertheless produced remarkable replicas of noses, jaws, and ears. Still, and in spite of her notable efforts, her patients scarcely

The False Faces
Directed by Irvin V. Willat
1919

Magazine advertisement (top) and poster for the silent film starring Lon Chaney.

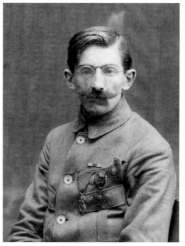
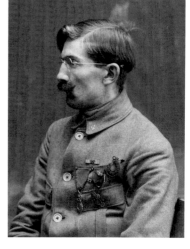

resembled their prewar selves, and in many cases, so devastating was the experience of seeing the reflection of their own compromised faces, mirrors were banned in most medical wards.[9]

But spectatorship is its own kind of mirror. Writing about the perception of faces in art and photography, Ernst Gombrich brilliantly described the human reflex when responding to such facial inertia. (He called it "the torpor of the arrested effigy.") What Gombrich termed "the beholder's share"[10] was, in effect, a compensatory behavior: the eye unwittingly completes the picture, meaning that we project our own associations onto the surface of the two-dimensional image itself. To the extent that these men harbored facial injuries that eviscerated their muscles, rendering their faces immobile, their capacity for demonstrable feeling forever compromised, our own expressions would have delivered the most unforgiving reflections. Did our still-intact faces serve as cruel reminders of their own irreparable losses? Did we look—and look away?

Ironically, in those early years of the new century, the proliferation of the mirror in both residential and commercial spaces offered a feedback loop that would forever change the way we saw ourselves and each other. While the mirror had figured prominently in French culture since the reign of Louis XIV, and in England since the days of the Crystal Palace, the notion of personal reflection would find profound resonance in the early twentieth century, particularly in the United States, once mirrors became cheaper, lighter, and more portable. Women carried mirror compacts, cars concealed them in their visors, and they served equally as vehicles for entertainment, from funhouse mirrors to trick mirrors to something called photo-multigraphs—carefully positioned tabletop devices creating the optical illusion of seeing yourself in multiple positions at once—a popular form of entertainment at fairs and festivals that appealed to a visual appetite for both novelty and vanity.

Anna Coleman Ladd
Studio for Portrait Masks
Paris, 1918

Portraits of some of the men treated by Ladd in her Paris studio, where she devoted her time both during and after World War I to creating cosmetic masks for those with significant facial injury.

American National Red Cross Photograph Collection, Library of Congress.

Face: A Visual Odyssey

Anna Coleman Ladd
Studio for Portrait Masks
Paris, 1918

Each of Ladd's masks took about a month to fit, engineer, and produce. Completed masks were often held together by spectacles, as shown in these photos.

American National Red Cross Photograph Collection, Library of Congress.

Yet just as the portable mirror transformed our ability to secure regular facial check-ins, it proliferated equally as a material innovation across the built environment. In 1928, the American retailer Macy's featured a sample room completely lined with mirrors: so enthralled was the public by the sheer magnitude of this spectacle, the *New York Times* later reported that the crowds needed to be held back.[11] By all accounts, what was most beguiling was the presence of an endless series of cascading reflections. Visitors could see themselves from ten angles at once (an impromptu sort of micrograph). The very idea nods uncomfortably to selfies—equally endless evocations of our vanity reverberating in digital space—much as those Macy's mirrors did nearly a century ago. Curiously, the need to endlessly self-document may manifest as a modern conceit, but the human urge to do so predates us all. Behavior, as Goethe once wrote, is the mirror in which everyone shows their image.

N | Narcissism

In 2014, a British teenager named Danny Bowman was hospitalized after a failed suicide attempt. Bowman—who claimed to take upward of 200 pictures of himself every day—was addicted to his smartphone with which he obsessed over capturing the perfect self-likeness. For four years, beginning at the age of fifteen, he spent the majority of his time trying to do just that: along the way he lost twenty-eight pounds, stopped going to school, and didn't leave his house for six months. "I was constantly in search of taking the perfect selfie," he later confessed. "And when I realized I couldn't, I wanted to die."[2]

In Ovid's classic myth, Narcissus was so besotted with his own reflection that he renounced all earthly pleasures, including—and especially—the plaintive calls from the mostly invisible wood-nymph, Echo. (One can imagine Bowman's helpless parents feeling just as invisible.) Just as the ripples in the water recalibrated each intoxicating glimpse for Narcissus, so, too, did every one of those selfies spur Bowman to keep on keeping on. That he was later diagnosed with technology addiction, body dysmorphia, and a pretty serious case of OCD provided a reasonably happy ending for what so clearly might have ended in tragedy.

Narcissus, as we know, was not so fortunate, gazing deliriously into that evanescent pool, only to be greeted by his own shadow. (*A form, a face, and loved with leaping heart,* writes Ovid.)[3] Punished for his pride, Narcissus soon withers away by the side of the water, suicide by self-love.

By 2019, the number of smartphones in use worldwide is expected to surpass five billion units. Approximately two billion images are

Above, Top
Mat Collishaw
Narcissus (Self-portrait)
1990

The Tate, London.

Above, Bottom
Jean Marais
Orpheus
Directed by Jean Cocteau
1950

Opposite
Michelangelo Merisi da Caravaggio
Narcissus
1597–1599

Galleria Nazionale d'Arte Antica, Rome.

uploaded every day to social media—Facebook, Instagram, Flickr, Snapchat, and WhatsApp, among others—nearly 100 million of which are estimated to be selfies. Teenagers are predicted to post some twenty-five thousand selfies during their lifetimes, though by all accounts, Bowman easily took three times as many in a single year, and to what end? A water reflection differs from a screen-based one only in materiality (or lack thereof). Both are surfaces. Neither is physical. Kim Kardashian West has more than one hundred million followers on Instagram, most of whom just want to look at pictures of Kim Kardashian West. How does that not signal its own kind of death knell, all of us grasping repeatedly at all what is, by its very nature, destined to disappear?

Reflection itself plays a quixotic role in the depiction of the face. You are "reflecting," of course, as a function of sentiment, considering your pictorial duplication in some physical, external form. The image itself "reflects" you, but inverts itself (this is, after all, the operational dynamic of the mirror) so that you cannot possibly see yourself as others see you. (This may explain why most people prefer a facial photograph corresponding to their mirror image over their true image.) [4] The implicit trickery in that very notion of reflection—yours with the mirror, the artist's with the canvas, the viewer's with the resulting image—speaks to the essential phenomenology of transformation. The cycle is elliptical and unyielding: myth into reality, life into death, being into nothingness.

Face: A Visual Odyssey

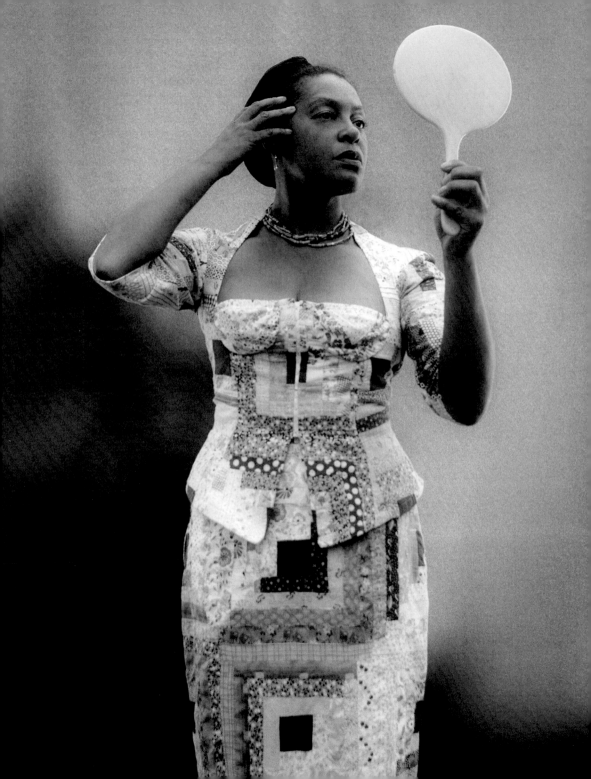

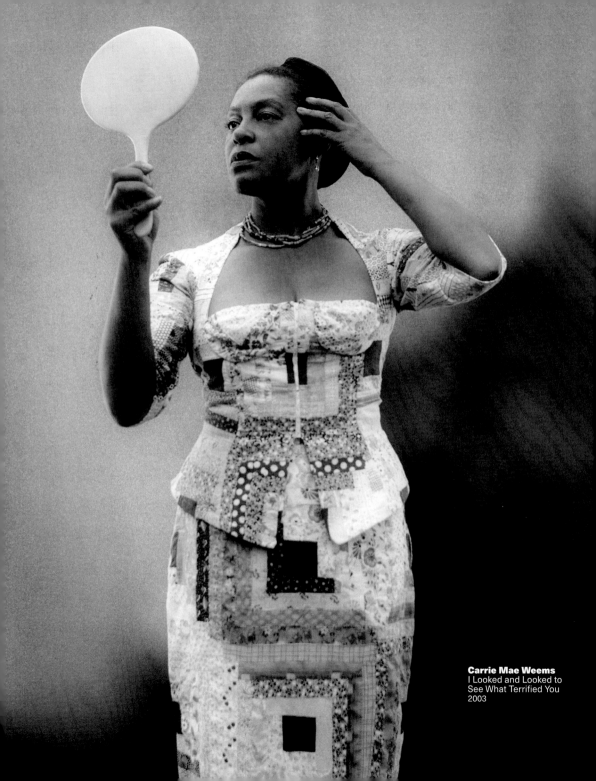

Carrie Mae Weems
I Looked and Looked to
See What Terrified You
2003

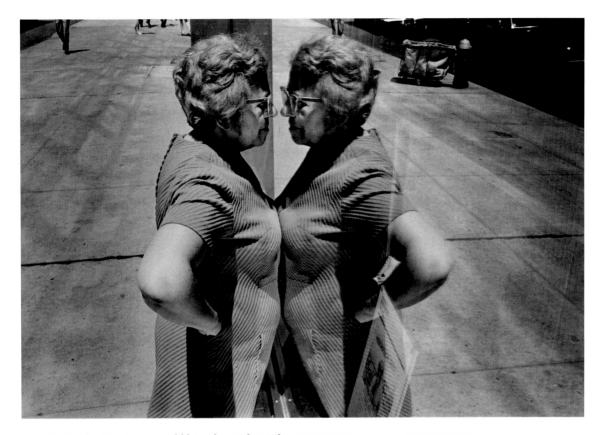

Richard Kalvar
Woman Looking at Herself in Store
Window
New York City
1969

Magnum Photos.

Curiously, Narcissus would have been about the same age as
Danny when his descent into myopic obsession began, but that doesn't
mean that narcissism is merely a young man's game. A 1967 book
published in Sweden catalogued every literary reference of narcissism
from Ovid to Shelley, while the idea itself has spawned movies,
inspired operas, and provided epic material for artists, novelists, and
poets. ("I rhyme / To see myself," wrote Seamus Heaney, "To set the
darkness echoing.")[5] Freud wrote about the idea of narcissism in the
context of the developing ego, and the Jewish theologian Martin Buber
contextualized it as a fascinating, if fraught, social construct that had
less to do with us as individuals, and more to do with the world we
inhabit. Artists in particular have long been fascinated with visual
interpretations of Ovid's classic myth, and the Italian Renaissance
polymath Leon Battista Alberti believed that the desire to visualize
this essential narrative—and mimic this exact pose—was a perfect
metaphor for art. ("What is painting," wrote Alberti, "but the act of
embracing by means of art the surface of the pool?")[6] A beautiful
young man, a gleaming pool of water, a face glimmeringly reflected
(or, in the case of Salvador Dali's 1937 version—created during what
he called his "paranoiac critical method"—a hand and an egg), all of
them iconic interpretations of history's most self-obsessed mythical
archetype. Dali's obsession went even further: he wrote a poem about
Narcissus and photographed himself, in the late 1930s, staring into

 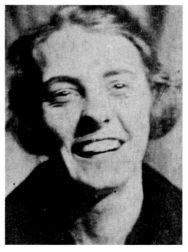

a mountain stream. Mat Colishaw's 1990 photograph of himself as a slim, shirtless man staring into a mud puddle pays delightful homage to Dali's version. (Both are at the Tate in London.)

Photographers would later explore this narrative by shifting the balance of foreground and background, playing with scale and context, and reasserting the reading of the self through the fragmented physicality of the built environment: glass = mirror = window = water. An early Vivian Maier self-portrait positions the camera in such a way that it (and not Maier) is the subject, a series of repeat mirrors echoing the angular geometry of her beloved Rolleiflex. Carrie Mae Weems's exquisite diptych from 2003, *I Looked and Looked and Failed to See what So Terrified You,* mirrors a woman holding a mirror, a split perspective on the transparency and opacity of the fragmented self. And a 1969 photo by Richard Kalvar performs a similar gesture: the bifurcation of a woman's reflection, like the wings of a butterfly, rendering her both as an extension of the window and—not unlike John Seven's baby on this book's cover—a conjoined twin of herself.

Lisette Model, Lee Friedlander, Imogen Cunningham, and Weegee, among many others, produced similar images capturing the accidental reflections of faces and figures in shop windows—the shop, in a way, a crude symbol for both the insatiability of Narcissus's pool and his own unyielding rapacity. As a modern, and decidedly urban, conceit, the shop window cues a very particular form of vanity, embedding the viewer in an unspoken narrative of random, commercial consumption. Émile Zola saw the store as a site of worship, the lure of commerce replacing the liturgy of the church. (Today, we might say the same of Instagram.) "What a stinging, quivering zest they display," wrote the American novelist Theodore Dreiser, "stirring up in onlookers a desire to secure but a part of what they see, the taste of a vibrating presence, and the picture that it makes."[7]

Long before the rise of computers, a good half-century before smartphone cameras and social media and selfie-obsessed teenagers, the American historian Daniel Boorstin predicted the degree to which

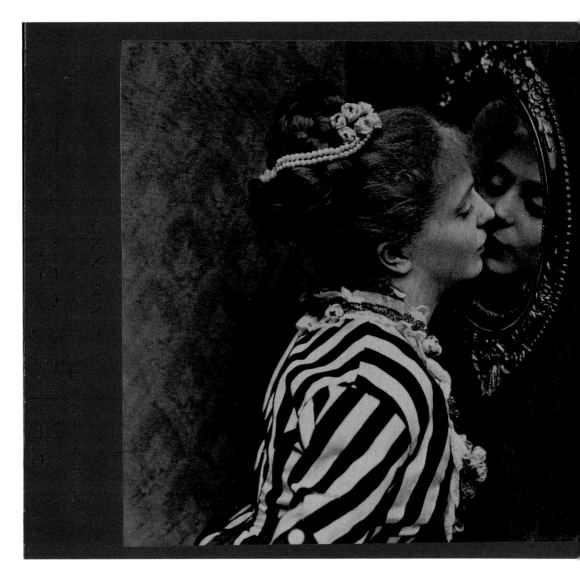

Fritz Luckhardt
Stereoscope Card:
Woman Kissing Her Reflection
in a Looking Glass
Circa 1895

Boston Public Library.

we would come to be infatuated with our own images. ("We have now fallen in love with our own image," he wrote, "with images of our making, which turn out to be images of ourselves.")[8] Way back in 1960, Boorstin wrote with acute, prescient wisdom about the preoccupying degree to which our self-reflections would come to consume us. A decade later, Italo Calvino would nod to the same premise, a foreshadowing, perhaps, of the sovereignty of social media. "In order really to live, you must photograph as much as you can, and to photograph as much as you can you must either live in the most photograph-able way possible, or else consider photographable every moment of your life," he wrote. "The first course leads to stupidity; the second, to madness."[9]

Is narcissism a form of madness? Since 1980, the *Diagnostic and Statistical Manual of Mental Disorders,* or DSM, has recognized it as pathology defined by traits that include, among others, a tendency

Face: A Visual Odyssey

toward grandiosity, arrogance, and envy; an acute need for admiration; and a proneness to shame. What killed Narcissus—and nearly killed young Danny Bowman—was the idea of unrequited approval: a young man falls in love with his own reflection, fails to find the approval he craves, and responds to the anguish of defeat with a bid for self-annihilation. For others, it is enough to peer into the pool of their likenesses, rather than your own, or to see an amplified, magnified image of the aspirational you. "There was a freshness to my image, a kind of mild glow that I had never seen before," notes the protagonist in Steven Millhauser's short story "Miracle Polish," a man whose obsession with his own reflection soon turns violent. "Some people added windows to brighten their homes—I bought mirrors. Was it such a bad thing?"[10] Easier to gaze at what you see reflected before you than consider what might lie on the other side of that reflection, inside the darkness, beyond the light.

O | Othering

A tiny bracelet circles a chubby wrist. A pressed cotton dress falls over ankle-free legs. A pillowy tuft of blond hair crowns a head that balloons up high and wide over a minuscule face, two small, innocent eyes torqued in terror. There is no name—not of the child, nor of the photographer—nothing but a single sentence on the picture's reverse.

Saw the Baby in White River Jct., VT Fair, Sept., 1922

The camera has the power to catch so-called normal people in such a way as to make them look abnormal. The photographer chooses oddity, chases it, names it, elects it, frames it, develops it, titles it.

Susan Sontag

Someone dressed this child beautifully the day her picture was taken. Was it a parent, a caregiver, a steward of the fair? Who was she, this nameless child, her face bloated by illness—a prisoner in her own body, a prisoner in the photograph itself? Why as she put on exhibit simply because she was different?

Difference, when it manifests as anomaly, pulls the viewer in two different directions. The mind wants at once to connect—to familiarity, to some kind of parallel understanding—yet is simultaneously repelled by its opposite. Lured by the binary opposition of fascination and revulsion, you can't quite look—but you can't quite turn away, either. Your mind ricochets between curiosity and compassion, sorrow and relief.

Searching "facial disfigurement" on any search engine quickly retrieves a host of physical afflictions, each with its own photo—and its own story to tell. There is cherubism, a rare genetic disorder caused by abnormal fibrous tissue in the lower part of the face that manifests with enlarged cheek and chin proportions. Goldenhar syndrome results in unilateral facial asymmetry, typically seen in incomplete development of facial features—the bridge of the nose, for instance,

or a missing ear. Moebius Syndrome is evidenced by weakness or paralysis of the facial muscles (not unlike Bell's palsy, except that it is permanent) resulting in a face that is, to some, disorientingly expression-free. Add to these any number of conditions brought about by accident, and it quickly becomes clear how personal this is, yet equally how public and therefore socially punitive. It is one thing to peer at photographs of facial difference, quite another to consider the degree to which these images, unmoored from the dispassionate objectivity of clinical observation, each belongs to an actual person. Disconnected from biographical context and detached from temporal specificity, such likenesses do battle in a social landscape where physical difference is pure handicap, inviting ridicule, caricature, scorn—and othering.

To be "othered" simply because of difference is a complicated topic, but to be ostracized because of physical disability is particularly heinous. By contemporary standards, the notion of isolating, let alone profiting from, the disability of someone else, seems antediluvian—and it is. Sadly, though, it's not *that* antediluvian: if the pageantry of the Victorian sideshow looms as a distant mirror on public values, the work of photographers like Diane Arbus, among others, reminds us that even now, the idea of staring at faces other than our own still preys upon that distance in countless ways. Voyeurism may seem marginally more palatable when you are concealed behind a one-way window (this is, after all, the great privilege of the photograph, where you can gape all you want) but remains a prurient practice, nonetheless.

Although she is frequently (and to some, mistakenly) appraised as someone who benefited from the misfortune of others, Arbus is said to have approached her subjects with poignancy, even pathos. She spent time with them, traveled with them, got to know their friends and their families and over time, grew close to them—or so she believed. Richard Del Bourgo, a magician who toured the American carnival circuit in the 1960s as Richard the Great—and who knew and admired Arbus—believed it, too. ("Nobody saw themselves as freaks," Del Bourgo later observed, "even the freaks.")[1] Far from seeing her subjects as objectified, Arbus herself came to believe that being born a freak eliminated a certain kind of anxiety. "They know that nothing much worse or frightening can happen to them, so they don't have to go through life dreading what may happen," she once observed. "It's already happened. They've passed their tests. They're aristocrats."[2]

The idea of an aristocracy framed by physical difference may have reflected the photographer's own skewed optimism, but Arbus stood by her position, even if generations of critics (Susan Sontag among them) believed that her images were more exploitative than empowering, questioning the degree to which the photograph itself functioned as a tool for provocation: simply put, whether these pictures invited even more objectification. What remains indisputable is the fact that in many cases these are disquieting images: dwarves and giants, lonely drifters, mongoloid children, men in drag. In some ways, and for some viewers, the tacit agreement underlying each photograph (Arbus

Roger Ballen
Lunchtime
2001

Head Below Wires
1999

Roger Ballen
Dresie and Casie, Twins
Western Transvaal
1993

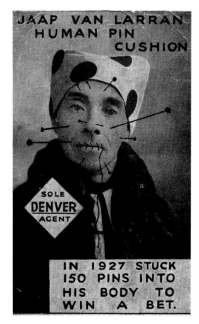

JAAP VAN LARRAN
HUMAN PIN
CUSHION

SOLE
DENVER
AGENT

IN 1927 STUCK
150 PINS INTO
HIS BODY TO
WIN A BET.

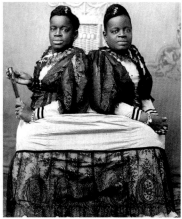

Opposite
Jo-Jo the Dog-Faced Boy
Early Twentieth Century

Fedor Adrianovich Jeftichew was a Russian
sideshow performer brought to the United
States by P. T. Barnum in 1884.

Above, Top
Jaap Van Larran
1927

The Ricky Jay Collection.

Above, Bottom
Millie + **Christine McCoy**
Michael A. Wesner
Late Nineteenth Century

Millie and Christine McCoy were American
conjoined twins, who toured as The Carolina
Twins, The Two-Headed Nightingale, and
The Eighth Wonder of the World.

allegedly worked in tandem with her subjects, not candidly, as a street photographer) made them even more unsettling. It is difficult, perhaps impossible, to parse the complex social frequencies at play in her photographs, which may have been the entire point.

At an extreme level, this is the territory of the freak show—the intentional, unexpurgated display of human difference—where visual anomaly is primed for public view. Such spectacles date back to the reign of Elizabeth I, but the sideshow as a social construct reached its peak in the early nineteenth century (and its economic nadir at the end of it) when it afforded certain profiteering showmen like P. T. Barnum to recruit anyone whose physical deformity could be easily monetized. "The Greatest Show on Earth" was a migratory empire featuring a range of exotic animals, daredevil performers, and human curiosities—blockheads, bearded ladies, and microcephalic "pinheads," to name a few—whose likenesses graced promotional materials that included, among other things, posters, broadsides, and the production of cabinet cards. Barnum's main photographer during the height of his reign was the German-born Charles Eisenmann, who prided himself on shooting his carnival subjects in the same regal poses that he reserved for his society clients. Whether Eisenmann's insistence upon an elitist gaze further objectified these performers or not mattered little at the time, and his work remained in great demand for a number of years. Cabinet cards were both a huge source of revenue and a clever marketing ploy, and these photographs undoubtedly served both men, commercially speaking, extremely well. As morally repugnant as it was to objectify human beings in this way, any pity leveled against the infirm was one way of elevating the viewer to a position of presumed superiority, thus invoking the specter of schadenfreude (a core capacity of the voyeur), which was, arguably, the primary social currency of the freak show itself.

To the degree that the circus served to colonize difference by treating it as a theatrical commodity, it was by no means the only vehicle for sharing images of the disabled. Tod Browning's 1932 film *Freaks* (based on a 1923 short story by Tod Robbins) was initially met with negative reviews because—although billed as a horror film— it featured real people whose disfiguring qualities made viewers uneasy. (Writing in the *Kansas City Star*, one critic noted: "There is no excuse for this picture. It took a weak mind to produce it and it takes a strong stomach to look at it.") [3] Still, if "othering" suggests that men like Barnum exploited his performers (which he undoubtedly did) it is equally true that the complex economics of carnival management— salaries and fees, rentals and rights, taxes and travel—meant that some of the more prominent circus performers managed to be surprisingly well-compensated. The Bangkok-born brothers Chang and Eng Bunker (still the most famous pair of conjoined twins in history) were discovered in the 1830s by a Scottish merchant who paid their parents to tour them as a curiosity. Within a decade they had emigrated to the United States and become successful businessmen and landowners, profiting handsomely from their own story.

Not all sideshow performers attained such success, however, nor did their lives reflect the kind of social agency modeled, improbably perhaps, by the entrepreneurial Bunkers. James Morris, who later toured as the India Rubber Man and the Elastic Skin Wonder, suffered from something called Ehlers-Danlos syndrome, a genetic condition that allowed his skin to stretch to remarkable lengths. Stefan Bibrowsky, who had an extreme case of hypertrichosis, was known as Lionel the Lion Boy. Krao Farini was discovered in Southeast Asia at the age of six, and was later employed by Barnum for more than three decades: her small stature combined with what was clearly an extreme case of hypertrichosis led to her billing as the Ape Woman—and worse, as the Missing Link—as though she herself provided living proof for the claims of Darwinian evolution. (An epic demonstration of othering: an 1887 broadside touted her as a "perfect specimen of the step between man and monkey.") William Durks—with a cleft face, split nose, and a third eye painted in the hole where the bridge of his nose should have been—was also tied to a larger historical narrative: he was known as the Man from World War Zero. There were the two-faced men—Sam Alexander and Robert Melvin—and the tragic, if likely apocryphal tale of Edward Mordake, whose facial abnormality was accompanied by an unusual behavioral tic: when he wept, the "face" imprinted upon the back of his skull is believed to have laughed in response. That Mordake was said to have been born into the peerage further distanced him from once-exalted social position, and he allegedly took his own life at the age of twenty-three.

Unlike Mordake—and not the least bit apocryphal—the tragic tale of Joseph Carey Merrick (known colloquially as the Elephant Man) ended in a natural death by asphyxiation, likely the result of his extreme head weight. Long thought to have suffered from neurofibromatosis, pathologists now believe Merrick suffered from Proteus syndrome, an extremely rare genetic disease that manifests with thickened skin and subcutaneous masses on the head and body. Genetic aberration was often responsible for such physical displays of difference: Grace McDaniels, for example, suffered from something called elephantiasis, which was regrettably localized in the face, particularly in her lower lip, which was brutally distended. (Today, lymphatic anomalies that lead to tissue overproduction may be no less common but are occasionally more treatable.) Initially billed as the Ugliest Woman in the World, McDaniels nevertheless married, had two children, and toured the American carnival circuit throughout the 1940s as the Mule Woman.

To be "two-faced" is, of course, a euphemism for hypocrisy, and the inherent tension in this dual reading may have served, if nothing else, to increase audience engagement in the carnival's heyday. (This is prime Jekyll and Hyde territory.) Today, circuses frame entertainment as a more wholesome enterprise, and freak shows have been mercifully relegated to the annals of history. Objectifying faces that differ from our own no longer requires a sideshow: for that, we have the carnival known as social media.

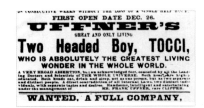

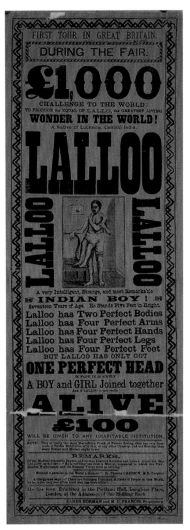

Top
The Tocci Twins
1891

Below
Lalloo the Indian Boy
Greatest Living Wonder in the World
1887

Connected to a parasitic twin and possessing "one perfect head," Lalloo, born in 1874, was often billed as the "Handsome, Healthy, Happy Hindoo."

The British Library.

Face: A Visual Odyssey

WONDERFUL NATURAL PHENOMENON!

TO BE SEEN

At N°· 107, Regent Street,

A CHILD

With Two Faces, Four Eyes, Two Mouths, Two Noses, Two Ears, and Two Chins,

All in perfect Nature; different coloured Hair, with only one Head and Body; Hands and Feet as exact as any other Child, and there is nothing in it unpleasant to the sight of any beholder. The said Child was born at TAUNTON, in the County of Somerset, on the 23d of December, 1827.

The Child is the Daughter of JOSEPH and ELIZABETH VERRIER, who will exhibit it at the place above-mentioned, or at any Lady's or Gentleman's House, if required.

Admittance—ONE SHILLING.

J. BALE, Printer, 65, Union Street, Hoxton New Town.

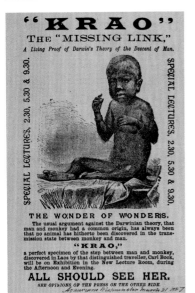

Sideshow Broadsides
1827 (top) and about 1882

Born in 1876 in Laos, Krao had a severe case of hypertrichiosis (excessive hair growth) and toured the US and Europe advertised as "The Missing Link."

Wellcome Collection.

If physical difference has found itself, more often than not, at the unfortunate center of public spectacle, it is by no means the only affliction under scrutiny. The portrayal of mental illness might be said to carry equally objectionable visual referents—asylums, straightjackets, caricature at the hands of fiction and film—none of which appears safe from derision. Historically, language was also complicit in our efforts to codify people into heartless taxonomies. A widely adopted classification system from the early twentieth century listed, for example, five major types of mental deficiency: idiot, idio-imbecile, imbecile, moral imbecile, and backward or mentally feeble. If clinicians routinely used this language (and they did), the institutions they served were eager to comply, producing marketing materials that included drawings, photographs, and other forms of visual propaganda that further alienated those afflicted.

Some decades later, the 1957 film *The Three Faces of Eve* was based on the true story of a woman who possessed multiple personalities. (Today this is known as dissociative personality disorder.) Eve's "faces" were not physical, but psychological, surfacing as three totally separate full-blown personas, magnificently portrayed on screen by Joanne Woodward, who won an Academy Award for her performance. The film itself told a highly edited version of the real story, and here, on the topic of omission, it bears saying that the physicians who cowrote the book upon which this film was adapted later sold the rights to Twentieth Century Fox—*without* consulting Chris Costner Sizemore,

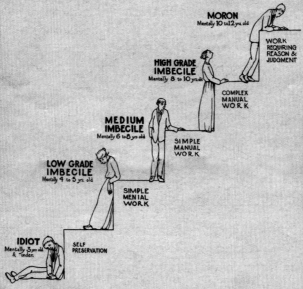

STEPS OF MENTAL DEVELOPMENT

Types
of
Mental
Defective

Steps
of
Development

MORON
Mentally 10 to 12 yrs old

WORK
REQUIRING
REASON &
JUDGMENT

HIGH GRADE
IMBECILE
Mentally 8 to 10 yrs old

COMPLEX
MANUAL
WORK

MEDIUM
IMBECILE
Mentally 6 to 8 yrs old

SIMPLE
MANUAL
WORK

LOW GRADE
IMBECILE
Mentally 4 to 5 yrs old

SIMPLE
MENTAL
WORK

IDIOT
Mentally 3 yrs old
& under

SELF
PRESERVATION

WHERE THEY STUMBLE
The Limit of Development of Each Type

THE Clearing House for Mental Defectives holds daily clinics from 9 a. m. to 12 noon.

Trained physicians and social workers spend their time helping these socially unfit up the steps.

Why not give them your help too?

"Every
Little
Helps"

Come and
See What
Your Money
Can Do

Clearing House for Mental Defectives
Circa 1913

The Clearing House for Mental Defectives
was a public clinic housed at the Post
Graduate Hospital in New York City.

Robert Bogdan Disability Collection,
Yale University.

Ernst Heinrich Philipp Haeckel
Development of the Face
1874

Haeckel believed that embryos resembled
one another and that humans were derived
from fish. His oversimplified drawings
led to distortions rendered in the name
of science that proposed deformed and
biologically predetermined facial norms.

whose story they had chosen to tell. (Sizemore, who took the writers to
court, reportedly had twenty different personalities—not three.) From
the viewer's perspective, mental illness was the stuff of theater. From
Sizemore's, it was a mutiny.

The British psychiatrist Hugh Welch Diamond, a leader in the
use of the photograph for psychiatric assessment, may have helped
usher in a more humane vocabulary for the treatment of individuals.
(Previously labeled as "lunatics," Welch called them "mental patients.")[4]
But the prejudicial materials circumscribing the story of mental illness
have long remained controversial. Nearly a century later, Burton Blatt
and Fred Kaplan's 1966 spectacular photographic essay "Christmas in
Purgatory" revealed the neglected conditions of five unnamed state
institutions that together housed some hundreds of individuals whose
conditions spanned the spectrum of intellectual disability. Not unlike
James Agee and Walker Evans's canonical 1941 work, *Let Us Now Praise
Famous Men* in its verité rawness, there is a palpable tone here of both
personal dismay and public remorse. ("There is a hell on earth," explain
the coauthors, "and in America there is a special inferno.")[5]

Using photographs of people as a tool for social reform meant that
the pictures themselves were often blurry or poorly lit, neither of which
really mattered. If Arbus shot her subjects with presumed compassion,
and Eisenmann portrayed Barnum's "freaks" as royalty, Kaplan's
photographs did neither—and are equally, if not more harrowing
as a result. The resulting story is a kind of communal othering:
eyes redacted to protect the innocent, these people are the faceless
ambassadors of a marginalized subculture—a confederacy of others.

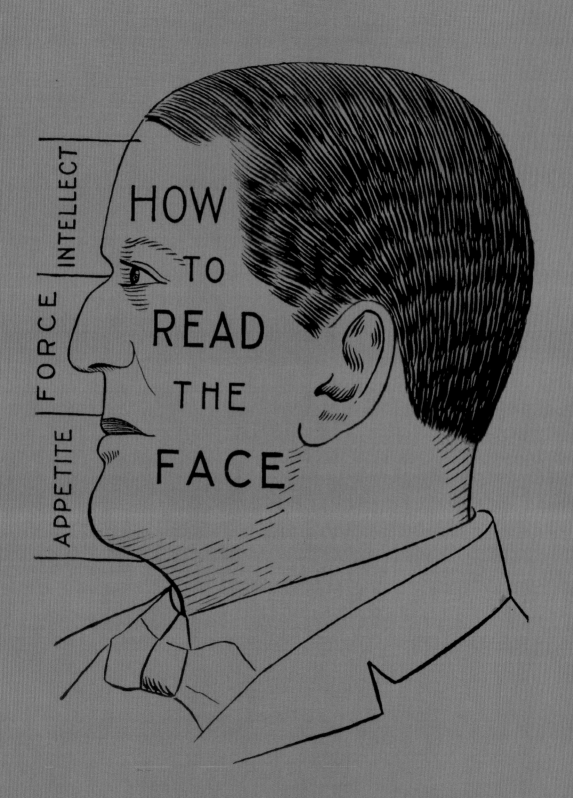

INTELLECT

FORCE

APPETITE

HOW
TO
READ
THE
FACE

P | Physiognomy

Physiognomy, the practice of reading the face, dates back to the
Paleo-Babylonian period in Mesopotamia. Scholarly references can
be found as early as the eighth century BC (Homer) and the fifth
century BC (Hippocrates), and social references can, too: Pythagoras
reportedly used it as an interviewing technique, claiming to have his
potential students *physiognomized* before agreeing to be their tutor.
Aristotle wrote about it some two centuries later, citing a litany of
so-called physiognomic "rules" that linked facial features to individual
expressions of character: a pale complexion meant you were fickle, a
flat face indicated that you were faithful, and a sweaty face suggested
you were probably a poor conversationalist.[1] Both Albertus Magnus
and Saint Thomas Aquinas saw physiognomy as a vehicle for moral
reckoning: the former as a companion to chiromancy and the latter an
expression of his own taxonomy of truth, a physiognomic code of the
emotions. (There were fourteen of them.)[2]

Not unlike the pseudoscience of phrenology (which differs
by privileging cranial over facial measurement), physiognomy's
credibility would swing wildly over the course of the ensuing
centuries, from studies on comparative anatomy that paralleled the
Age of Discovery, to treatises on astrology and mysticism throughout
the Middle Ages, to the analysis of facial gesture in the royal courts of
the Renaissance. Leonardo DaVinci notably disputed its importance,
calling it a "false" science, but a century later, the English physician
Sir Thomas Browne praised its virtue, claiming that "there are
mystically in our faces certain characters that carry in them the motto

Wide Triangular,

Circular Vital,

*Ligamentous
Sodium type.*

*Carbon type,
Nitrogen type,
Hydrogen type,
Oxygen type.*

Bengamin Gayelord Hauser
Types and Temperaments
1930

Hauser's theory was rooted in
facial contours that emanated from
temperaments, which were (oddly)
correlated to chemical properties.

Oblong Bone,

Oval Muscular,

*Calcium type,
Silicon type.*

*Potassium type,
Chlorine type.*

of our souls."[3] (Browne also believed in angels and witchcraft, and thought that eyes and noses had tongues.) In late eighteenth century Britain under the reign of King George II, physiognomy was publicly denounced as a criminal act: those committed to its practice were deemed rogues and vagabonds and could be sent to prison.

Claiming a certain scientific objectivity, the methodology itself has always been oddly indexical, almost brutally so. But it served equally, for a time, as a form of entertainment, particularly toward the end of the last century, for a then newly minted bourgeoisie. Montaigne, among others, saw physiognomy as both a social skill and an art form, priding himself on distinguishing, for instance, "affable from simple faces, severe from rude, malicious from pensive, scornful from melancholic,"[4] a sensibility that foreshadowed the sorts of post-Napoleonic social values so brilliantly satirized, a century later, by Balzac. Arguably, such facial scrutiny may have served as a welcome civilian counterbalance to those witnessing Haussmann's epic reconstruction of Paris: dwarfed by urban boundlessness, pedestrians could, at a minimum, size each other up by their faces. Curiously, Haussmann was later nicknamed "the demolisher," an assaultive handle that echoes the vitriol harbored by the keen physiognomist. People-watching, as it happens, has both an illustrious and an infinitely cruel history, an involuntary behavior to which few are immune. "We are all of us, more or less, active physiognomists," wrote Thoreau.[5]

Thoreau wasn't alone. There are references to face-reading throughout literature, from Brontë to Chaucer to Dickens to Emerson, observations ranging from the dreamy optimist, Walt Whitman, describing Americans (he writes of "the freshness and candor of their physiognomy") to the sly satirist, Oscar Wilde, describing his iconic protagonist, Dorian Gray. ("Sin is a thing that writes itself across a man's face," he wrote. "It cannot be concealed.")[6] Emily Dickinson, like many of her generation, often used the words "physiognomy" and "face" interchangeably, and not only with regard to humans. Her exquisite poem "A Spider Sewed at Night" takes physiognomy into a lyrical, almost liturgical space, linking the solitary artist to the lone artwork, the arthropod to the Anthropocene.

The earliest examples of physiognomy point to the lure of divination: birthmarks and moles were sometimes seen as morality markers, physical aberrations thought to be tied to personality flaws. The ancient Greeks took this one step further and approached such scrutiny as a form of clinical diagnosis. Hippocrates parsed the human temperaments—also known as the dominant "humors"—into a collection of four. (One was either sanguineous, bilious, melancholic, or phlegmatic.) At the same time, the allegorical stirrings of typecasting were taking root, likely with the publication of *The Iliad*, where Homer likens heroes to predators, men to beasts. (The judgment of the physiognomist figures prominently for Homer in *The Odyssey*, as it does for Socrates.) And here—where animal comparisons are concerned—the entire issue of rational judgment is upended.

Face: A Visual Odyssey

Fig. 4
The Pure Mental Type

Fig. 9
Pure Vital Type

Fig. 7
Pure Motive Type

Fig. 5
The Pure Mental Type

Fig. 7
Pure Motive Type

Fig. 6
Pure Motive Type

Georges Henri LeBarr
Why You Are What You Are
1922

Many books on face reading label specific "types" (mental types and vital types, among others) related primarily to face shape. There's no indication that these needed to be exclusively Caucasian faces, but they always were just that. Nonwhite faces appeared infrequently, or were added to display deviation from a baseline that was, at the time, narrowly defined around white-dominated values.

That there is a link between primates and people is an evolutionary narrative, not a social one.

Initially, physiognomy found its most visual expression in the work of Giambattista della Porta, an Italian writer who published his noted work, *De humana physiognomonia*, during the early years of the Reformation. Theorist, playwright, and a noted polymath, Della Porta was also a collector: it is rumored that he influenced Athanasius Kircher and, by association, may have inspired what would become Kircher's celebrated *Wunderkammer* (believed to have included, among other oddities, preserved animal skulls). And what is physiognomy if not a collection? Della Porta—who also wrote about cryptography and optics—mostly collected ways to look, by contextualizing but also by correlating: animals to people, outside to inside, faces to faces. His work later found its principal "modern" expression in the work of Johann Casper Lavater, the eighteenth-century Swiss theologian who

"Constancy"
comes at the back
of the head.

The Bump of
"Reason."

"Love of child-
ren" is shown
here.

Right
V. G. Rocine
Napoleon Phrenological Diagram
Heads, Faces, Types, Races
1910

Above
Allied Newspapers, Limited
Fortune Telling for Everyone
Circa 1930

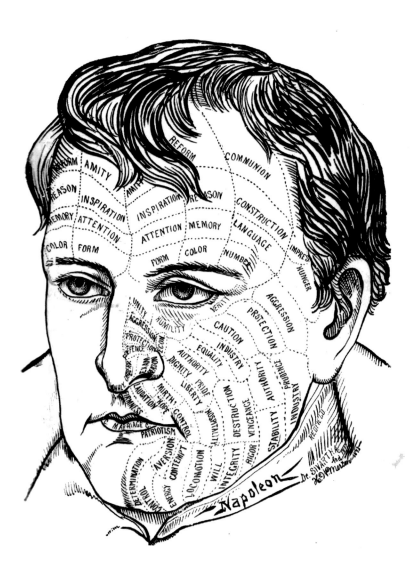

famously mapped physical attributes to human qualities: beauty to morality, for instance, and ugliness to misery. Lavater produced four volumes of essays on physiognomy that offered, in his words "the most convincing picture of interior sensation." More spiritual than scientific, Lavater was at once a scholar and a preacher, an individualist and a bit of a softy. ("Each man," he wrote, "is an individual self, with as little ability to become another self as to become an angel.")[7] That his theories would later be discredited on the basis of their mostly prejudicial claims was perhaps inevitable. His fall from grace happened largely at the insistence of the German physicist, atheist and (curiously), hypochondriac Georg Christoph Lichtenberg who—in spite of being revered by such noted thinkers as Kierkegaard and Goethe— may merely just been jealous. Lichtenberg was also, in the spirit of Montaigne, a born flâneur. "The chief enjoyment of my life," he would later confess in his diary, "is to observe people's faces."[8]

If physiognomy has a disreputable provenance, it was no doubt shepherded by the less well known (but arguably more inventive) work of Petrus Camper, a Dutch anatomist who developed what he termed the "facial angle," a geometric armature upon which to assess the relative positions of the features. Ironically, Camper may have held a more reasonable view of human evolution than some of his peers (refuting the idea, for example, that blacks came from apes or that Jews were indistinguishable from one another), yet nevertheless produced a gradual spectrum that would establish a kind of baseline for subsequent, and far more abhorrent, examples of racial profiling. Although he distinguished animals from humans, Camper's theory of the facial angle still led to stunning prejudicial assessments—he believed, for example, that African faces were positioned furthest from "canonical" ideals of classical beauty—which ultimately led to his work being classified firmly within the realm of scientific racism.[9] As a philosophical tenet, a biometric practice, and a highly questionable visual method, physiognomy would ultimately lead to an era of remarkably unapologetic racist speculation, fortifying the very essence of eugenic doctrine: labeling as both a facial metric and a social epithet.

As an ever-fascinating example of pseudoscience, physiognomy would surface once again in the late nineteenth and early twentieth centuries as part of what might be considered, in retrospect, a kind of nascent self-help movement. Joseph Simms's 1872 *Physiognomy Illustrated (Or, Nature's Revelations of Character—A Description of the Mental, Moral, and Volitive Dispositions of Mankind as Manifested in Human Form and Countenance)* begins with a frontispiece showing famous men in profile—Lord Byron, James Boswell, and John Locke, among others—and sandwiched between them, a Tasmanian aborigine whose face is noted for his "cruel and cannibal habits." Written in turgid prose, Simms's textbook—which clocks in at a staggering 670 pages—proposes that physiognomic study be introduced in grammar school curricula to teach face-reading as a vehicle for truth. He proposes it equally as a beneficial tool in business, allowing honest men to "steer clear of the shoals of insolvency and bankruptcy" by becoming more discerning observers of the face.

Others would soon concur. "The study of the human countenance should form part of every man's and woman's education," writes Professor A. E. Willis in his 1884 book *The Human Face*. Five years later, in *Descriptive Mentality*, author Holmes Whittier Merton describes its benefits to businessmen, parents, and paramours alike, noting the importance of studying types, temperaments, signs, and signals, and the need to do so in the order they are presented. (Merton, who also wrote books on vocational counseling and heliocentric astrology, also produced the illustrations.) Fellow vocational expert Marie Rasher's more amateur offering—*Character Analysis* (1919)—also includes her own (primitive) illustrations, but both Merton and Rasher are eclipsed in their entirety by Katherine Blackford's *The Job, The Man, The Boss* (1915), which combines the corporate authority of vocational training with the specious snark of privileged distance. American Indians are

Georges Henri LeBarr
Why You Are What You Are
1922

An example of the extremely convex, or "impulsive" type.

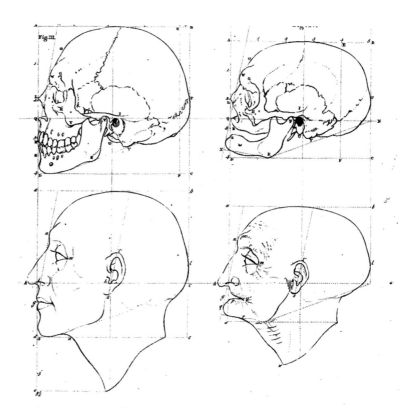

Above
Johann Kaspar Lavater
Essays on Physiognomy
1853

Right
Petrus Camper
Illustration of Facial Angles
18th century

Wellcome Collection.

observed to have "strong chins," Negro boys to possess "flat noses," and Filipino girls are characterized by their "concave foreheads and convex mouths." Savage in its disregard for all manner of human difference, Blackford's book is both hollow and hyperbolic, physiognomy in its purest form: a propagandistic vehicle for intolerance, xenophobia, and racism.

L. A. Vaught—a self-proclaimed "phrenologist" who published his eponymous character reader in Chicago in 1902—claimed there were forty-two known elements of human nature, all of which could be tagged to the face. From deceitful chins to honest noses to cruel eyes, his detailed explanations for mapping features and skull shapes led to a plethora of bizarre and irrational judgments. (Perpendicular heads made unreliable fathers, the author proposed, and moral "pluck"—whatever that was—could be gauged from a man's hairline.) Vaught's facial renderings, which are exquisite, together with his eager, if hapless, observations, are made considerably more comical by the stilted lexicon of his era: under his tutelage, one learns to discern qualities including approbativeness (vanity), amativeness (love), and pugnacity (belligerence).

The perhaps equally strident Bill Ryan (known by his pen name, Jacques Penry) was a self-proclaimed "facial topographer" who made several films for British Pathé in the 1940s, in which he literally drew "types" on a blackboard, describing how facial flaws could be viewed as moral determinants. In addition to publishing two books on the subject, the Canadian-born Penry created a parlor game in 1939 called Physogs in which players could test their physiognomic literacy

PERSISTENCE

SELF-CON-FIDENCE

TACT

PRACTICALITY

OBSER-VATION

ACQ.

COMB

DEST.

FORCE

CENTER
OF
VITALITY

FIRMNESS

WILL

MUSCULAR
CO-ORDINATION

L. A. Vaught
Vaught's Practical Character Reader
1902

Fig. 1

The Balanced Type in Color Form and Structure.
An Ideal Type.

against a series of flash cards and photographic portraits. (He later created a version for children—The Physog Family—that used jigsaw-like illustrations instead of photographs.) In the 1970s, Penry became a consultant to the British Home Office and produced two systems for police purposes, to help witnesses reconstruct the faces of suspects following crime incidents. Identikit was soon replaced by PhotoFit, a mix-and-match identity game, which came packaged with interchangeable photographs of mustaches, beards, eyeglasses, and headwear, along with 162 pairs of eyes, 151 noses, 159 mouths, 112 chin and cheek outlines, and 261 foreheads.[10] In the spirit of both Bertillon and Lombroso and building on the misguided constabulary premise that facial "types" functioned as pre-emptive templates for assessing criminals, Penry's contributions were stunningly and unapologetically atavistic.

Ultimately, if the idea that the face was a kit of parts awaiting reassembly was ultimately discredited, its fallout was not without considerable ideological consequence. Philosophers from Jean Merleau-Ponty to Ludwig Wittgenstein would later question the face as a surface upon which aspects of the self might—or might not—be aptly represented. Wittgenstein, for example, believed that emotion itself was visual ("We do not see facial contortions and make inferences from them")[11] proposing that facial comparison was sooner achieved by observing overlapping similarities, rather than seeking parity through a single point of reference. Merleau-Ponty's concept of *écart*—a gap, or distance—considered, with a slightly more nuanced lens, the notion of the viewer and the viewed, the self and the other. ("Resemblance is the result of perception," he famously wrote, "not its basis.")[12]

Such ontological questions would not erode the tenets of physiognomy so much as parallel their evolution. If Descartes identified the dualism between mind and body, Emanuel Levinas questioned the ethics by which we look and respond to faces as portals into deeper engagement with one another. With his coauthor, Félix Guattari, Deleuze would later deconstruct the face as a surface through what he termed "Faciality," examining the substance of facial expression and critiquing Levinas's ethical mandate as he did so, a position that was, to be fair, not entirely antithetical to the physiognomic canon. (Labeling is labeling.)

To the degree that the focus here is on the face as a material presence, the Deleuzian premise reads as both dispassionate (white wall, black holes) and somewhat disheartening (who's behind that wall and those holes?) Faciality was—and remains—a work of great philosophical merit but is equally a reminder that such binary reduction refutes the very notion of our greatest human prerogative—our capacity for reason, reflection, and, most critically, for perceptual nuance. Even Montaigne, in the end, understood the moral limitations of physiognomy. ("A man's look," he wrote, "is but a feeble warranty.")[13] That the face, as an extension of the person, should be subject to such indexical assessment also meant that it was a prime target for all manner of persuasion. Physiognomy would not be the only pseudoscience claiming implausible and divisive promises with regard to the face. For that, we have quackery.

SCIENTIFIC TRUTH

OPTOMISTIC and DRAMATIC ENTERTAINMENT

CRAFTY TREACHERY

PESSIMISTIC GLOOM

Opposite
Georges Henri LeBarr
Why You Are What You Are
1922

Above
V. G. Rocine
Heads, Faces, Types, Races
1910

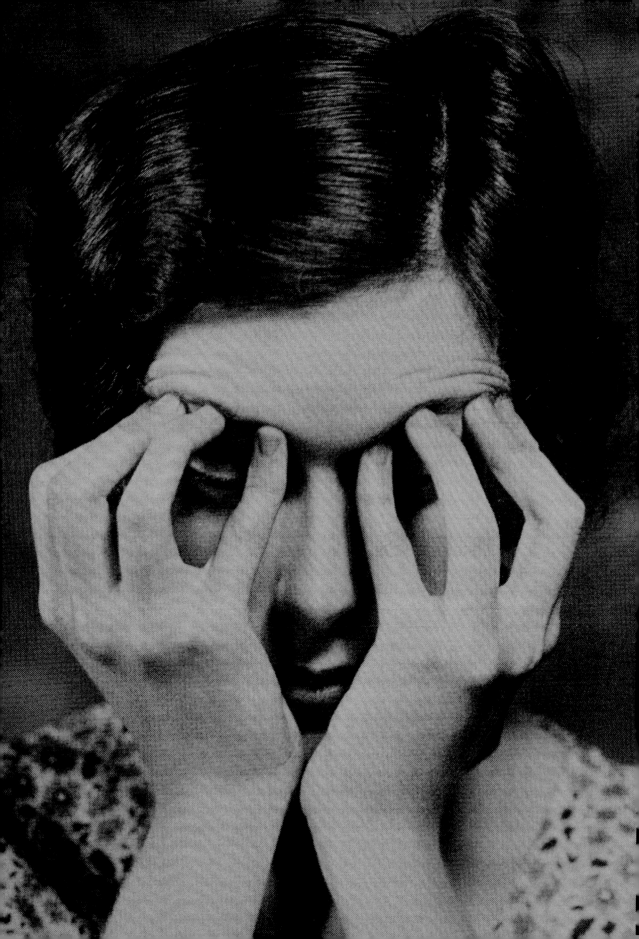

Q | Quackery

The soul establishes itself.
But how far can it swim out
through the eyes
And still return safely to its nest?

John Ashbery

It is 1939. Germany invades Poland. A newspaper in America costs about a nickel. Batman makes his first appearance in the comics. And as New York opens its World's Fair, all eyes are on the future—the "world of tomorrow," as it is whimsically called. Edward Steichen captures the theme—indeed, its very ethos—in *Vogue* that year, with a photo-essay titled "Tomorrow's Daughter," in which a woman is presented as both iconic and robotic, her face described as a carefully calibrated machine: "The tilt of her eyes, the curve of her chin, the shade of her hair, ordered like crackers from the grocer." [1] Tomorrow must have seemed as thrilling as it was terrifying: curiously, *Vogue's* aspirational beauty ideal is virtually effaced by the sheer magnitude of the unknown. "She exists in time, somewhere beyond the powdered-glass—the Woman of To-Morrow," Steichen proclaims. "We shall never see her face."

As the nation headed into its second war in less than half a century, the lure of aspirational beauty assumed a curious, somewhat opportunistic position in public life, with morale-inflating marketers making outlandish, even spurious claims. Pills and powders promoted smoother complexions. Exercises and massages promised restorative youth. Books and brochures offering detailed instruction on the proper care of the face were anchored by an enduring, if weak, assumption that all of it was scientifically sound. And nearly all product promotion was targeted to a white—and predominantly middle-aged—middle class.

Throughout the materials dominating beauty advertising both during and between the wars, there is an astonishing amount of hubris focusing on the face, and with it, predictions of restored health, wealth, even happier marriages. In New York, "Primrose House" touted a diagrammatic method called "Face Moulding" that promised to restore a woman's youthful countenance. In St. Paul, entrepreneur Alfred

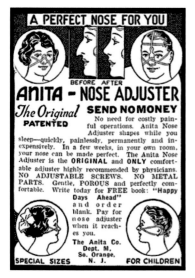

Anita Nose Adjuster
Circa 1910

Promising results while you sleep, the Anita Nose Adjuster was marketed not only to men and women, but to children, too.

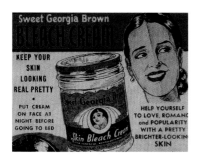

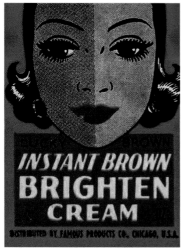

Bleaching Cream Advertisements
Skin Lighteners
1940s

Krank proposed that face shapes could be adjusted by different kinds of self-massage. Shaving and hair products marketed to men were only marginally less extreme in their effort to link beauty to lifestyle, product usage to personal success, the face at the center of everything.

Where there was hyperbole, there was also hypocrisy. Billed as "Every Woman's Right," promotional materials by English cosmetic entrepreneur Marie Earle (whose Parisian empire made no mention of her modest Liverpudlian origins) focused on the skin and offered facial maps to indicate how best to reduce the regrettable evidence of drooping facial muscles. Philadelphia-born perfumer Richard Hudnut's Madame du Barry line of cosmetics populated department stores across the nation, invoking a narrative of bygone European charm that was inversely proportionate to his decidedly ruthless business practices. And Hollywood titan Max Factor promoted what he saw as irrefutable color principles (touted as scientific principles) enhanced by celebrity endorsements to hawk his own eponymous product line. If the pretense and the palettes relaxed over time, the basic intent did not: a Max Factor brochure from the 1950s is only slightly less strident than its earlier incarnations, but still reads as a hyperbolic sales tool. ("Your rouge," notes Factor in one advertisement, "is another name for magic.") Some eighty years later, the bombast may have diminished, but the basic marketing premise has not: consumers today are likely to be just as lured by the exalted promises of beauty products, perhaps even more so. A two-billion-dollar-a-year business in the 1930s, the global cosmetics industry is estimated to reach nearly four hundred million dollars in annual revenue by 2020.[2]

In hindsight, the ersatz tone of all this pablum seems both clumsy and quaint, but today, as digital practices insinuate themselves into consumer culture, it is no less intrusive. Is it still quackery if there's no money directly changing hands? Where the face is concerned, the virtual trumps the emotional, which soon trumps the logical. The Ontario-based Modiface—as of this writing, the leading supplier of augmented reality beauty in the world—provides beauty try-on simulations via live video, with tracking software to render the face and its features in precise detail. (Virtual beauty apps also track user preference and retail behavior.) To the degree that virtuality is itself a mode of persuasion, simulation becomes a highly seductive enterprise, an aspirational practice, rather than an authentic one—a question of what if, not what is.

Simulation also reminds us that elective improvements by way of cosmetic surgery are eminently achievable, letting you look before you leap. And where's the harm in that? Chins can be lifted, brows lowered, lashes lengthened, teeth whitened, hair darkened, noses straightened, and skin peeled, plucked, bleached, waxed, polished, shaved, or bronzed. If surgery seems a bridge too far, certain alchemical measures—Botox, chemical fillers, and a range of related injectables, for instance—still require a licensed practitioner but hold the appeal of requiring little to no recovery time. (Such procedures are sometimes referred to, in beauty industry parlance, as tweakments.)

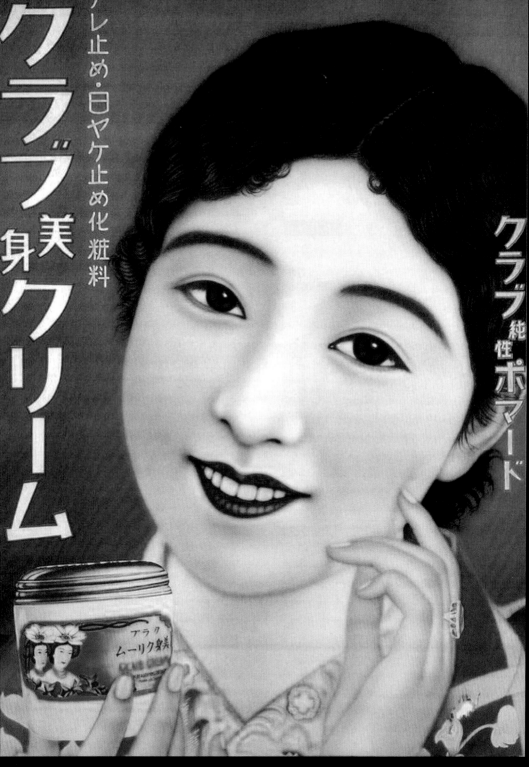

アレ止め・日ヤケ止め化粧料

クラブ美身クリーム

クラブ純性ポマード

Advertisement for Japanese Skin Lightening Cream
1930s

Japanese skin cream advertisement, promising to protect your hands from the staining of chemicals and sunlight.

Above
Holiday Magic Informative Cosmetics
BGP Enterprises
1966

A grid of facial exercises printed on the inside of an LP, narrated by Ernest Henry Westmore—known as Ern—a Hollywood make-up artist who created the Los Angeles–based House of Westmore with his three brothers. "There isn't a woman in the world," Westmore once said, "who can not be made to be more beautiful."

Opposite
Kathryn Murray System of Facial Exercises
1920s

Below
The Dimple Maker
Modeled by Erma Schnitter
1947

Invented by Isabella Gilbert in 1936, the dimple maker came with instructions to wear five minutes at a time, two or three times a day, while dressing, resting, reading, or writing.

Robert E. Jackson Collection.

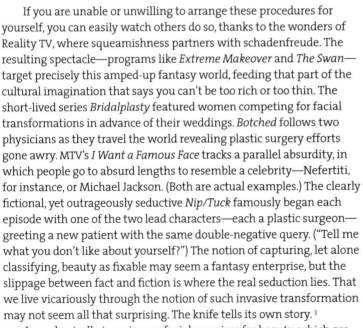

If you are unable or unwilling to arrange these procedures for yourself, you can easily watch others do so, thanks to the wonders of Reality TV, where squeamishness partners with schadenfreude. The resulting spectacle—programs like *Extreme Makeover* and *The Swan*—target precisely this amped-up fantasy world, feeding that part of the cultural imagination that says you can't be too rich or too thin. The short-lived series *Bridalplasty* featured women competing for facial transformations in advance of their weddings. *Botched* follows two physicians as they travel the world revealing plastic surgery efforts gone awry. MTV's *I Want a Famous Face* tracks a parallel absurdity, in which people go to absurd lengths to resemble a celebrity—Nefertiti, for instance, or Michael Jackson. (Both are actual examples.) The clearly fictional, yet outrageously seductive *Nip/Tuck* famously began each episode with one of the two lead characters—each a plastic surgeon—greeting a new patient with the same double-negative query. ("Tell me what you don't like about yourself?") The notion of capturing, let alone classifying, beauty as fixable may seem a fantasy enterprise, but the slippage between fact and fiction is where the real seduction lies. That we live vicariously through the notion of such invasive transformation may not seem all that surprising. The knife tells its own story. [3]

Less physically invasive are facial exercises for beauty, which are historically difficult to date with any accuracy. (It is rumored that Cleopatra was vexed about her jawline and may well have engaged

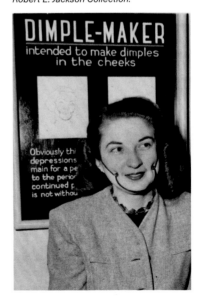

Face: A Visual Odyssey

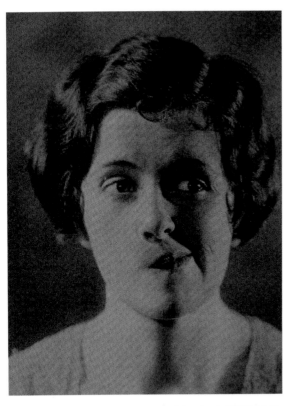
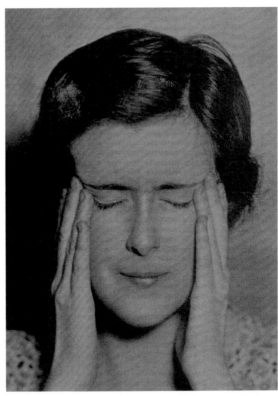

Caput zygomaticum

Corrugator supercilii

Digastricus

Platysma

Buruburu Smile Lifter
Made in Japan
2017

An anti-aging device for the mouth that works with vibration to exercise and stimulate the facial muscles. Recommended for use three times a day.

in face-specific workouts as a result.) But if sartorial taste ebbed and flowed over time as popular appreciations of the physique itself evolved (it was Shakespeare, after all, who observed that "clothes make the man") the face was not as easily modifiable as the body accompanying it— which may explain, at least in part, the emergence of facial calisthenics. Long before Jack LaLanne made body workouts socially acceptable, Sanford Bennett's 1907 *Exercising in Bed* opined upon time's passage by bemoaning the physical inevitability of gravity. ("The face and the neck," wrote Sandow, "may show the wear and deterioration of years, in marked contrast to the apparently more youthful body.")[4] Indeed, the idea of stretching the muscles of the face with an eye to minimizing lines and wrinkles would find an enthusiastic, and, to some degree, captive audience over the years to come. Along with recommended exercises came certain cosmetic enhancements—creams, tonics, emollients, vitamin-enriched butters—as well as a market for targeted facial devices, many of them rather ludicrous. There were dimple machines, cheek vibrators, breathing balloons, and an extraordinary range of gadgets to reshape your nose—the length of which, according to Max Factor, was optimally the same as the depth of your forehead. His so-called "beauty micrometer"—initially designed for Hollywood make-up artists—may appear comical by contemporary standards but needn't be. The 1999 *Rejuvenique* facial mask is no less spooky, and can, as of this writing, still be purchased online.

Postwar publications touting the presumed benefits of facial exercise expanded, at least initially, with the arrival of cheaper printing. There were subscription services, mail-order clubs, and other personalized offers that operated on a premise of modesty—curiously, the inverse of social media showmanship. The 1933 Kathryn Murray *System of Facial Exercises* urged users to "bathe" the face, to use "skin food" (a lubricant) for many of them, and to remember to breathe. Joyce Lee's method was deemed "scientific" and was only meant to take ten minutes a day. Her 1965 book credited the photographer, John Engstead (a Hollywood celebrity portraitist of some renown) whose testimonial sits squarely by that of a plastic surgeon and a dermatologist: art and science, side by side, beauty staged as serious

Orbicularis oculi

Triangularis

Zygomaticus

business. Senta Maria Runge's 1974 *Face Lifting by Exercise* suggested sketching on your face with eyebrow pencil so you could see where your muscles were located, thus determining whether or not you were performing the exercises properly. While books on improved youth via the facial workout continue to be published, the popular practice of "Face Yoga" endures, touted as a reputable antidote for aging.

Meanwhile, an ongoing market for the exercise device persists—particularly in Japan, where at least one popular e-commerce website boasts numerous options including a face iron, a face expander, a mouthpiece slimmer, a laugh lines lifter, a chin hammock, a cheek belt, and a butterfly beauty nose clip (not to be confused with the nose straightener or the nose adjuster or—for the truly determined—the nasolabial fold booster). Some of these items are costly, and many are often sold out, as are a wide range of topical elixirs, many of them useless, yet all of them successfully marketed to people all over the world, people who crave beauty, youth, approval, and acceptance, but who, most of all, just want to fit in.

Above
Miss Craig's Face-Saving Exercises
Marjorie Craig
1970

Marjorie Craig trained as a physical therapist before becoming director of the body department for Elizabeth Arden, and a best-selling author.

Below, left
Wrinkle Up Tape
Made in Japan
2017

A fifteen-minute regimen per day claims to be useful in stretching the skin back to its once-buoyant state.

Below, right
Taruman Mouth Training Figure
Made in Japan
2017

To help train underused portions of the face, this device works to tighten the muscles around the mouth and jaw, fighting sagging skin and other visible signs of aging.

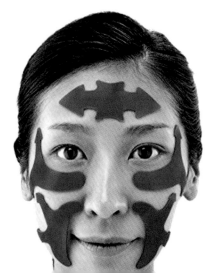

R | Relatability

There is no longer a public self, even a rhetorical one. There are only lots of people protecting their privacy, while watching themselves, and one another, refracted, endlessly, through a prism of absurd design.

Jill Lepore

In Budd Schulberg's 1953 short story "Your Arkansas Traveler," Lonesome Rhodes is a down-on-his-luck drifter, doing time in a rural prison when he's randomly discovered by one Marsha Jeffries, an attractive East-coast journalist. Operating on a simple editorial conceit—finding unknown people and harvesting their personal stories—Jeffries shepherds Rhodes to overnight fame, first on the radio and, soon after, on television. The fact that his rugged good looks belie a fractured psyche is just one evocation of the fissures on display, here: this is a story about the chasm between the image and the truth, the person versus the persona. Rhodes is ultimately his producers' pawn, and it is *they*—not Rhodes—who both predict and provoke (and ultimately orchestrate) his tragic downfall. Working off-camera and behind the scenes, these producers are, to quote Schulberg, the lepers of the television industry. They're men without faces.[1]

Schulberg wrote about all kinds of archetypes. There were belligerent prize fighters, slimy executives, clueless drudges seeking fame, lonely outcasts seeking redemption—all of them "faces in the crowd,"[2] lyrically plucked from the oppressive banality of the everyday. Preying on the public's fascination with fame as a kind of fantasy lottery, Schulberg was compelled by the notion that faces provided escape, became brands, and personified popularity, particularly when twinned with the epic lure of stardom. In classic Hollywood parlance, the very idea of the "face" was a euphemism for fame—a synonym for iconic stature and recognizability. ("We didn't need dialogue. We had faces," notes *Sunset Boulevard*'s Norma Desmond, referring to a time before "talkies.") Though fictional, both stories are hauntingly allegorical—each character a misbegotten pop-culture remnant—reminders to the rest of us that once you trade privacy for publicity,

Zachary Lieberman
Illustrator exploration for
Más Que la Cara Installation
2016

Más Que la Cara, a Spanish phrase that
means, "more than the face," was an
interactive installation Lieberman installed
in downtown Houston in 2016. Shown
here are some of the studies for the
project: the artist found inspiration in many
things, including the facial investigations
produced in the 1960s by the Italian
designer Bruno Munari.

Bruno Munari
Facial Studies from
Design As Art
1966

you become a marketable vessel for the exalted expectations of the
populace. The instant your face goes public, you belong to everyone—
and you become, in a sense, *everyone's* pawn.

Facial recognition initially presented as a survival tactic. Historians
posit that our earliest ancestors navigated the wilderness by making
visual associations: how else to resist predators if not by perceiving
a resemblance to your own kind as a marker for protection? If there's
strength in numbers, it likely began right there, in those initial
reconnaissance missions. Our faces served as safe havens, the shelter of
the pack operating as a social construct born of both physical
and protective necessity.

Fast-forward through several action-packed millennia, and
the concept of relatability (a word synonymous with resemblance,
to be sure, but also with likability) is an all-too-common refrain in
contemporary culture, and why? Perhaps it's a defense against the
social dislocation brought on by digital distance. (I relate as an *antidote*
to my loneliness.) Maybe it reduces the entropy of the universe by
tethering us to something specific and real. (I relate as an *extension*
of my loneliness.) But if we primarily self-identify by connecting to
what is already familiar to us, social connectivity becomes little more
than tautological reinforcement. And if we primarily relate to what we
resemble, and we resemble what we already know, how does that even
begin to generate human progress?

At its core, to navigate through a sea of faces by virtue of
what you already know is a deeply primal gesture: that aboriginal
ancestor sought visual confirmation in the wild just as a baby seeks
a glimpse of reassuring sameness in its mother's face. It's reflexive:
you unconsciously read—and retrofit—the faces of others through the
familiar lens of your own world view, a perspective seeded in your
heritage and lodged in your psyche. It's relational: you subconsciously
relate to others by invoking a kind of parallel emotional processing
framed by your experience of kinship. ("The face speaks to me," wrote

Emmanuel Levinas, "and thereby invites me to a relation.")[3] It's robotic: you look in the mirror and see your own face, notes W. J. T. Mitchell, "but somebody could recognize in it the features of a friend, or a relative, or a public figure."[4] Finally, it's recursive: that which any of us deem worthy of being "relatable" originates in the mind (and eye) of the beholder, meaning that what's not immediately identifiable is likely perceived as foreign, even dangerous. Hunter to the pack, infant to the parent, one to the many—this is a proposition made decidedly more complex (and increasingly less comprehensible) with the insistence of social media, where what we "relate" to is, by its very nature, so mercurial. Faces frame the core vernacular, here: if we recognize someone in the crowd, it is because we recognize them in ourselves. If relatability is safe, it's also restrictive.

The urge to "relate" might be said to have underscored Lombroso's atavistic dogma, prompted Galton's eugenic typologies, framed segregation in the antebellum south, fueled the lunacy of the Chinese Exclusion Act, and denied equitable access to the disabled. (Susan Sontag once called communism "fascism with a human face.")[5] To privilege familiarity is to resist the other, which is, at its core, a rather stunning form of visual sectarianism. If your own likeness stands, sentinel-like, as the primary lens through which you read the faces of others, why stop there? Relatability stems from recognition. To see a face that you note as familiar connects you instantly to the broader spectrum of human experience by purely visual means. That a baby recognizes its mother is one thing; that we see in a political candidate a shadow of anticipatory hopefulness, quite another. Must we recognize kinship in order to cultivate appreciation for the face of someone else? To reject what we do not recognize is to succumb not only to bias, but to the failure of the human imagination.

Relatability is also a kind of reflection. Aristotle believed that it was through mimesis—or simulated representation—that we could most empathically respond to theatrical portrayals, silently mapping our own selves onto the faces of others. We "relate" to canonical representations as expressions of self-love, our heroes/heroines a performative extension of our own presumed identities. Reflection pulls focus by tethering us to the familiar, thus occluding the healthy

ARMOURER—*L'Armurier.*

FLORIST—*La Bouquetière.*

MUSICIAN—*Le Musicien.*

FRUITERER—*La Fruitière.*

BLACKSMITH—*Le Forgeron.*

distance between reality and illusion. (Arguably, another failure of the imagination.) But mirrors present equally as metaphors, reminding us that relatability is ultimately a synonym for resemblance. Writing in the *New Yorker* in 2014, British journalist Rebecca Mead's skewering essay "The Scourge of Relatability" illuminated the degree to which we so easily dislocate self-awareness by way of sheer flattery.[6] "The notion of relatability implies that the work in question serves like a selfie," Mead wrote, "a flattering confirmation of an individual's solipsism." Flattery—as in thumbs-up emoticons, retweets, and likes—is feel-good social currency, but that doesn't mean it's authentic, or original, or, for that matter, even remotely actionable.

What it *is* is reassuring. Online searches for "relatable memes" primarily serve up affirmations for the socially disenfranchised. If you're having a bad hair day, chances are in your favor that someone else is having one, too. (Connecting via complaint might make you feel better, even if your hair disagrees.) On the plus side, relatable faces can be helpful faces: when *Sesame Street* introduced Lily, in 2011, the fact that she was homeless was a reference to the fact that national statistics for homeless children are not insignificant: giving homeless kids a character to relate to was both timely and smart. (Lily's is a fuchsia and orange and Muppet face—not the face of an actual child—thus providing a cartoon relatability, rather than a comparative human one.) It's not the idea that seeking relatability through shared experience is so objectionable: it's the supposition that sameness breeds acceptability, and that such vanity prioritizes a kind of indulgent self-love. "The life that you live in order to photograph it," wrote Calvino, "is already, at the outset, a commemoration of itself."[7]

In the end, this urge to relate—face to fame, self to star—is nothing if not rhetorical. Lonesome Rhodes is at once a free agent and a doomed archetype. He's Icarus: his sun his public, his greed his undoing. He's Narcissus: his reflection his public, his vanity his undoing. In the story's final denouement, we see him signing off, smiling as he lampoons his adoring fans while the sound is secretly turned up, and

THE WRITER — *L'Écrivain.*

COOPER — *Le Tonnelier.*

FISHERMAN — *Le Pêcheur.*

his true character is brutally revealed. The threat, if not the reality, of such cataclysmic public exposure itself might prove relatability's true undoing: some fifty years after Schulberg published his collected stories, a then-twenty-something Mark Zuckerberg mocked his early adopters for sharing their faces on his then-nascent site, then called The Facebook. "They 'trust me,' dumb fucks," he wrote, examining some of what was posted in those initial hours in his Harvard dorm, peering at the faces populating his newly-minted database. "I almost want to put some of these faces next to pictures of some farm animals and have people vote on which is more attractive."[8] Rhodes went down in flames, while Zuckerberg is currently the third wealthiest person on the planet: today, a mere fifteen years after its inception, Facebook claims as many adherents as Christianity.[9] Schulberg's fable was at once a cautionary tale (be careful what you wish for) and a work of prescient genius (are we not all faces in a crowd?). Maybe solipsism is the real scourge, here. If we can relate to anything, we can probably all relate to that.

Samuel William Fores
Portraits of Trades
Circa 1800

This nineteenth century example of rendering a portrait through a trade recalls the work of the sixteenth-century Italian painter Giuseppe Arcimboldo. Playfully rendered and bilingually labeled, the trades themselves offer their own social narrative: coopers, joiners, black-smiths, florists—and writers.

Wellcome Collection.

S | Surveillance + Spectatorship

Nothing and nobody exists
in this world whose very
being does not presuppose
a spectator.

Hannah Arendt

We have always watched each other, and ourselves, through lenses
of questionable authority. Do we snap, store, and share pictures of our
faces as a social gesture? (For denizens of social media, the answer
is yes.) Do we agree to be photographed in order to be afforded what
is presumed to be equitable access? (For carriers of passports and ID
cards, the answer is also yes.) Do we have any idea about the scope
and sophistication of the cameras watching us over the course of a
single day? As sensors grow smaller, databases grow bigger, security
measures grow stronger, and mobile technologies makes everything
faster and more fluid, the answer, most likely, is no.

Surveillance itself can be sophisticated, even systematic, but it
can also be surreptitious. That we are identified by the contours of our
faces is not, in and of itself, a complicated idea. But the fact that we can
be verified by those contours equally suggests that we can be vilified
by them, raising serious questions about freedom, ethics, and the
promises and limits of protection. And this is where things get slippery.

Over the course of the past two decades, the question of what
constitutes protection has become hotly contested with regard to the
very definition of civil liberties. Terrorist attacks have led to more
enforced policing, which in turn has led to more robust methods
of scrutiny, and thus to more widespread surveillance protocols.
Surveillance itself has now become synonymous with public safety,
which is to say the safeguarding of public space: lobbies, streets,
airports, even (and especially) schools, which makes the very issue
of how we define public and private space suddenly unclear. So
sophisticated are our current methods for pictorial capture that your
face can be swiftly extracted from a blurry crowd and identified with
a fair degree of accuracy. Whether this is a measure of public oversight

Above
Howie Woo
Video Stills
2016

Facial camouflage experiment
using crocheted yarn.

Opposite
Adam Harvey
CV Dazzle
2018
Photographed by Cha Hyun-Seok
Modeled by Kim Jeong Eun

CV Dazzle is a project that deconstructs
facial continuity through cosmetics,
clothing, and embellishments, exploring
how fashion can be used as form of
camouflage. The artist considers this
a kind of "anti-face."

or an expression of Orwellian lunacy depends on the circumstances, on your perspective, and quite possibly on your skin color, but the technologies that provide facial recognition have raised the bar for us all (and lowered it). In a sense, we have all submitted to something, for the good of everyone, far beyond the reach and control of any individual, even as the enduring impact of that reality remains highly uncertain. Our faces may brand us as individuals, but the democratization of technology has flattened the playing field to such an extent that we have largely abdicated the very agency that was once, arguably, our principal and most precious human right. While everyone—from federal agencies to watchdog groups, legislators to lobbyists—seeks to create better policies and practices, to date, no US laws exist to regulate the private use of face recognition: not how it is gathered, nor how it is distributed, nor where, or how (or for how long) it is stored, shared, or simulated. It's not so much a question of who's out there watching you, but the fact that you probably can't stop them from doing so.

Without laws governing restrictions for facial recognition, and because the technology itself is becoming so widely available, facial data mining has migrated from public means to private methods. Our faces now circulate as points of data marked for use by anyone and are especially coveted by anyone capable of understanding how they might be best engineered for greater commercial gain. Microsoft's Project Oxford is geared to developers eager to understand consumer emotion. Recognizr (née Augmented ID) allows you to use your phone to "see" who a person is and what web services and social networks they're connected to. PittPatt, short for "Pittsburgh Pattern Recognition," developed at Carnegie Mellon and later acquired by Google, was funded by DARPA, not because the government is out to get you but because defense researchers invest in universities, believe in research, and are hoping to fund the next generation of artificial intelligence. Or so we're told.

Conspiracy theory or consumer reality? After Facebook created its Facial Profiler app in 2009 to promote Coca-Cola, nearly 300,000 people downloaded it, willingly sharing their faces with the hope of locating their digital doubles. Facebook's own tagging feature, a source of considerable controversy since its inception more than a decade ago (the cause of so much litigation that it has been periodically banned in Europe) has been recently reframed as protective aid: your face, claims Facebook, offers you a bespoke "template" lest you fall prey to impersonation by someone else. (The idea that a publicly traded company harvests your likeness as a template for anything is perhaps the more critical question.) Indeed, when the social media giant came under attack, in 2018, for storing facial recognition data without consent[1] it was not so much surprising as it was inevitable. Facebook's then-public mission—to "Move Fast and Break Things"—was as much a rallying anthem for technology as it was a death cry for humanism.

To be fair, Facebook is hardly alone in this perspective: companies—indeed, entire countries—view the acquisition of facial

data as a logical step in both corporate growth and civil governance. To many of them, it's progressive. (To most of us, it's predatory.) The degree to which facial recognition practices are now considered useful to consumer-based operations takes the face, transforms it into a form of currency, and both traffics in and trades upon the buzz that ensues— even when it is flawed. To wit: Apple's Face ID, a technology introduced in 2015 with the iPhone X, allows users to bypass password protection by holding their faces up to their phones. This now-common feature is said to perform most reliably for those for whom the facial musculature has been clearly set (generally speaking, this means postpubescent faces). Curiously, Face ID works interchangeably between most, though not all pairs of, identical twins, yet has proven highly inconsistent with regard to discerning certain Asian faces, which it often recognizes as visually indistinguishable.

As flaws go, this one is egregious, yet the practice of facial surveillance has been enthusiastically embraced in China, where it is evident in everything from scanners installed in public restrooms in Beijing to catch toilet paper thieves, to a Kentucky Fried Chicken franchise in Hangzhou where you plug into Alibaba's "smile to pay" online paywall, to a rise in supermarkets so certain of their surveillant skills that they are increasingly free of clerical staff. And China's exuberance with regard to facial capture and big data doesn't stop there: *xue liang* (which roughly translates to "sharp eyes") is a massive plan to use facial recognition and artificial intelligence to analyze video, track suspicious behavior, and anticipate nefarious activity.[2] As of this writing, more than 170 million closed-circuit television cameras have been installed in China, a number expected to grow exponentially over the course of the coming decade.

It bears saying that facial surveillance can be equally tricky at the micro level. As recently as 2016, two facial recognition researchers in Taiwan published a paper in which they claimed to believe that computers were capable of scanning images of your lips, eyes, and nose to detect future criminality.[3] That the response to this research was controversial speaks, at least in part, to an implied tone of recidivism— but that doesn't mean that the technology does not continue to power on, eager to classify, codify, and compartmentalize us all. With the rise of artificial intelligence, virtual reality, and all kinds of machine learning, many are wary of something called algorithmic bias—a relatively new field of study that examines how people are themselves trained when creating code for all sorts of decision-making including, notably, the sorts of biometric systems that record our faces, where inference (and not interpretation) is the baseline. Unlike interpretation—which speaks to the nuances of the human intellect— inference is a mechanical conceit, sooner based on dispassionate metrics than sentient behaviors. ("A machine," writes the American writer and photographer Teju Cole, "sees without sympathy.")[4]

Should we be concerned? Today, facial recognition data sets are widely available, from the 10K US Adult Faces Database (based on the 1990 US Census, host to more than 10,000 faces) to the 3D-focused

Bosphorous Database (105 subjects and 4,666 faces) to countless examples used by field researchers to capture everything from tracking emotion to quantifying pain to assessing humor. Once a dataset has been populated with multiple examples of the face, algorithms can plug into that data to infer information that may be useful—or, for that matter, discriminatory. Collectively, this feeds a newly ubiquitous surveillant language that embeds itself in services, systems, spaces, experiences, and no shortage of products, where the tricky promise of accuracy is framed by the hope, if not the tacit expectation that we are protected by protocols that identify us properly. Under the aegis of that supposition, we trade privacy for protection: to be face-scanned is to be

Leon Harmon
The Recognition of Faces
Published in *Scientific American*
1973

As early as the mid-1960s, Harmon, while working as a researcher in mental and neural processing at Bell Labs, was conducting studies on facial recognition, using a mosaic process we would come to understand many years later as pixelization.

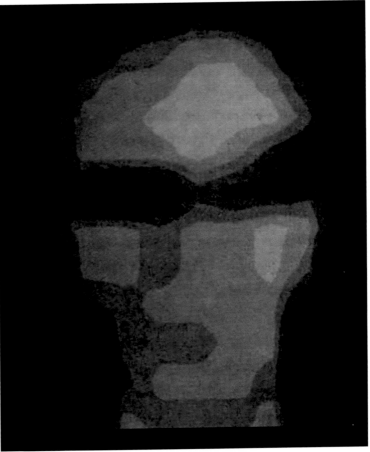

counted, your likeness a specimen to be logged into a database—but whose database? To be authenticated by the idiosyncratic likeness that is yours and yours alone is one thing. The fact that one in two American adults is in a law enforcement face recognition network, quite another. [5] There is, at present, no federal law that prohibits your face from inclusion among more than 52 million faces currently registered in the FBI's database, where the mere fact that you hold a driver's license renders you automatically eligible for inclusion.

My expressions are a calculable system of metrics.
You don't have to try and figure out what I am thinking anymore, I'll make it easy for you.
What decision I might make, where I look next and how.
You can sense my heart rate, and I see yours.
It's like you know the real me.

Above
Jillian Mayer
David Castillo Gallery
Bas Fisher Invitational
2016

In the face of ever-present surveillance, Mayer questions the ways we are followed, objectified, even quantified, subverting technological practices in an effort to locate the private in the public.

Opposite
Giles Sabrié
2018

CCTV footage taken in Beijing uses the facial-recognition system Face++.

The ever-shrinking sensor also means that surveillance can be just as easily lodged in stuff. Micro-surveillance is a niche market that sells to the presumably paranoid: today, you can purchase everything from a pen to a watch to a pair of sunglasses to a toilet brush with a hidden camera. Samsung's Family Hub refrigerator features three interior cameras to tell you what you have on hand for dinner, and when you might need to replace it. The idea of your produce being monitored may seem less objectionable than having your face logged into a law enforcement database, but these are not mutually exclusive: the question is not about where these sensors lie, but the fact that they're there at all. Who gets to determine who leverages these tools, and for what end? While the US Department of Commerce drafts "best practices" with regard to the commercial use of facial recognition technology, who is to say what's best, and for whom?

Of course, some of this seems rather innocuous. One might argue that trawling your friends' likenesses on Facebook lies somewhere between spectatorship and sport, framed by the social transactions of personal agency (your friend, after all, elected to share that photo) and supported by the digital patois that has us participating in an outward-facing show of public engagement. Here the focus is squarely on the face: tagging it, but also retouching it, and for that we have an entire market of options. Microsoft Selfie uses computer vision technology to detect your age, gender, skin tone, and more. FindFace will pick a person out of a crowd and link you to their social media profile. Photo Makeover lets you embellish your face using all kinds of templates, including one for animal faces that allows you to adopt the face of, say, a koala or a monkey, and Doppelgänger will match you with your ideal pet. Face Tune smooths your complexion, Springg makes you leaner, and for less than a dollar, Beauty Mirror expertly remodels your nose. Looksery—acquired by Snapchat for 150 million dollars in 2015—enables the facial modification of photos in real time on mobile platforms. Because these tools are positioned as playful, it would be easy to imagine that they are harmless. But the premise isn't at all harmless: as facial capture becomes commonplace, it's terrifying.

Increasingly, the swiftness and ease with which visual trickery embeds itself in everyday life blurs the detection of truth in ways that are at once stunning and stultifying. In the spring of 2018, the American Civil Liberties Union gathered signatures from a host of companies and individuals urging Amazon's chief executive officer, Jeff Bezos, to stop powering facial surveillance systems. Soon after, they set out to test Amazon's signature system—called Rekognition—by using it on the faces of members of Congress, where it proved to be remarkably flawed, particularly with women and especially with people of color.[7] Even when detectable, the seeds of dazzling inaccuracy have been sewn. From there, we're all capable of being lulled by all manner of extreme fiction: this is the power of the so-called liar's dividend[8] and it's a serious, embedded part of surveillance culture. The idea that our faces fuel its engine, providing the raw material making all of this possible? There's nothing harmless at all about that.

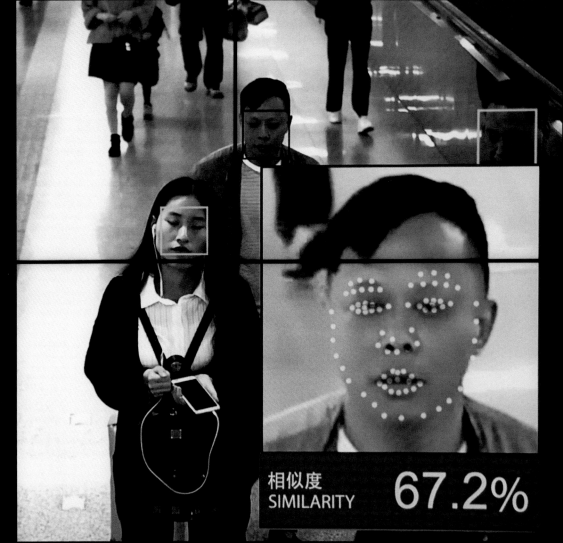

相似度
SIMILARITY 67.2%

T | Typecasting

At the corner of an exit ramp stands a man, holding a piece of stained cardboard. On it, he's written a single word—*veteran*—in scratchy lines that ape the striations etched across his face. A cleft slashes unforgivingly across his forehead. Another crevice scars his cheek. His matted hair topples over an angular brow, pale gray eyes locked in steely determination. He's motionless. And so are you.

No man for any considerable period can wear one face to himself and another to the multitude, without finally getting bewildered as to which may be the true.

Nathaniel Hawthorne

The similarity ends there. You're seeing all this because you're blessedly captive, distanced by fortune, sheltered by the sheer physical sanctuary of your vehicle. You, the viewer, remain safe in the protected embrace of some three thousand pounds of steel, the beneficiary of whatever accidental fate landed you on one side of the road, while he—a man who fought for his country—ended up on the other. He shivers in his tattered coat, modestly barricaded by a piece of paper detritus onto which he's scrawled a rather trenchant outline of his own autobiography. (Veteran as keyword.) But this is not a LinkedIn profile: it's a cardboard sign. He's not posing for maximum viewership: he's just standing there. There is nothing airbrushed or whitewashed or edited about his presence to make you pay attention. You just do.

You consider for an instant whether he might be an actor prepping for a role. You imagine that he's a drunkard or a drug addict, a panhandler or a petty thief, a loiterer, a truant, a bum. In which war did he serve, you ask yourself? (As if that matters.) Veteran, you wonder, or vagabond? He's too young to be homeless, too old not to know better, too fit not to be employed by someone, somewhere, doing something other than standing out there in the cold, making you feel guilty. (Because it really is all about you, isn't it?) If you manage to abandon all those reverse-engineered narratives it is only due to another stroke of fortune, because by now, the light has miraculously changed. Time— like so many things in your favor just now—stands firmly on your side.

Bobby

Beau

Mitch

Trevor

Opposite
Mary Pickford
Circa 1910

Known as America's Sweetheart, the Canadian-born Pickford was a classic ingenue. With a career that spanned half a century, she was also one of the original thirty-six founders of the Academy of Motion Picture Arts and Sciences.

Above
Heartthrobs
The Dream Date Game
Milton Bradley, Inc.
1988

A game for teenage girls in which players are asked to choose pretend boyfriends based on looks alone, later weighing them against potentially annoying personality traits like nail-biting.

It is so easy to reassure yourself with assumptions, to stake your superiority with a familiar narrative, to cocoon yourself within the methodical affirmations of your own ineffable privilege. It is so easy to typecast someone else, especially when your mind drives so much faster than your car.

To typecast is to color inside the lines, to proceed within expectations—the heroine as the perky blonde, the villain as the tattooed thug—a time-tested Hollywood recipe for success at the box office. Or at least it used to be. If we are to be judged by our faces, to what extent do we lean into the obvious, embracing those strident extremes within the force field of the familiar? Habit is an unforgiving teacher. Even now, as mobile technologies afford a level of unprecedented agency in the mining and maneuvering of the facial likeness, we are primed to see faces within the territory of the obvious. This is what it means to pigeonhole someone. We've even typecast the pigeon: who is to say whether she or he or it (or they) even have a hole?

Facial typologies may well originate in Hollywood yet distribute themselves with furious insistence throughout the many visual portals of popular culture—from fashion to advertising, film to television, video games to graphic novels—where cultural stereotypes metastasize in an environment marked by pictorial captivity. By the time they've implanted themselves within social media platforms, the social etiquette has been firmly established. There's an entrenched interpersonal choreography, here: you know what to do, and you do it. Cued by the now-familiar behavior of checking our "feeds" (which makes us all sound like poultry) we graze the news of others by parsing data through an artificial orchestration of pantomimed performance. Such is the new modern condition: what you see and respond to is the simulacrum, not the soul; the posture, not the person.

True, pictures often speak louder than words, but in online venues, to trust in the likeness is to give in to an entire set of behaviors, ignoring the far more pressing, if largely concealed emotional subtexts

that underlie them. Here's the truncated cultural shorthand at play:

Look at how happy I am!

(Fair enough, for who does not deserve to be happy?)

Now for the full-blown back story:

Look at how happy I am surrounded by my photogenic posse of carefree pals, whose utter devotion to my happiness is demonstrated by the sheer Bacchanalian display of our communal revelry!

Yes, it is far easier to post than to pontificate—but the subtext here is real, perpetuated by habit and populated by all those randomly repeating faces that blanket our daily online peregrinations. And they repeat because we choose to repeat then, promulgating their potency by liking and thumbs-upping everyone else's, and yes, *sharing them,* because that is typecasting's current drug of choice. Your participation in this curious yet all-too-common enterprise essentially makes you complicit as both a dealer and an addict. Sharing, the social albatross of our era, is the world's creepiest popularity contest. If it feeds on typecasting as a native form of cultural exchange, it is because we've all grasped the agenda and gained fluency with the codes. You can tell yourself that posting is an expression of personal agency, but the more you share, the more you actively contribute to this broader visual tapestry of type-reinforcing homogeneity. Social media may present as an open-source democracy, but it's also a flatland of sameness, a bastion of visual uniformity, a colony of transactional passivity. (Little boxes on the hillside, little boxes all the same.)[1] Agency? Perhaps not so much. Much easier to share, to stay put, to fit in. Unwittingly perhaps, you've just typecast yourself.

Typecasting gets thorny when we play *against* type—but isn't that very capacity a core expression of free will? We can dress the part, or fake the look, or hide our less appealing attributes, but where our faces are concerned, what you see is pretty much what you get. Or is it? For those who self-identify as gender nonconforming, the question of what constitutes "type" traffics in the uncertain language of biology, genetics, and—shockingly—politics. Scientists posit the question of identity as one that originates not so much as between the legs as between the ears,[2] but in truth it mostly manifests right between the eyes. (The visual cortex is like a locomotive: seeing may not always mean believing, but first impressions are indelible impressions.)[3] And here, there's substantial research suggesting that the neural pathways guiding our sight (and by conjecture, our assumptions) about others originate in a part of the brain that labels us, at least primarily, through a racial and sexual lens.[4] That urge to label may present as an involuntary reflex, not necessarily forgivable, but human. Regrettably, it is the visual ambiguity of someone else's countenance that can pique controversy, challenge understanding, and, all too often, invite paroxysms of civil unrest. Typecasting is a referendum on sameness, difference be damned.

Such restrictive notions are intensified in an age in which faces navigate in online venues, divorced from their owners, detached from their own rightful claims of authenticity. Nathan Jurgenson is a social

Karl Baden
Every Day
1987–Present

Standing in the same position, Baden has posed for his own camera nearly 10,000 times since February 1987, embracing his own typecasting even as the inevitable temporal changes evolve. "The impulse for this work originates in the vectors of curiosity and distress tied to four factors affecting my life," Baden explains. "Mortality, incremental change, obsession (its relation to both the psyche and art-making) and the difference between attempting to be Perfect—and being human."

Face: A Visual Odyssey

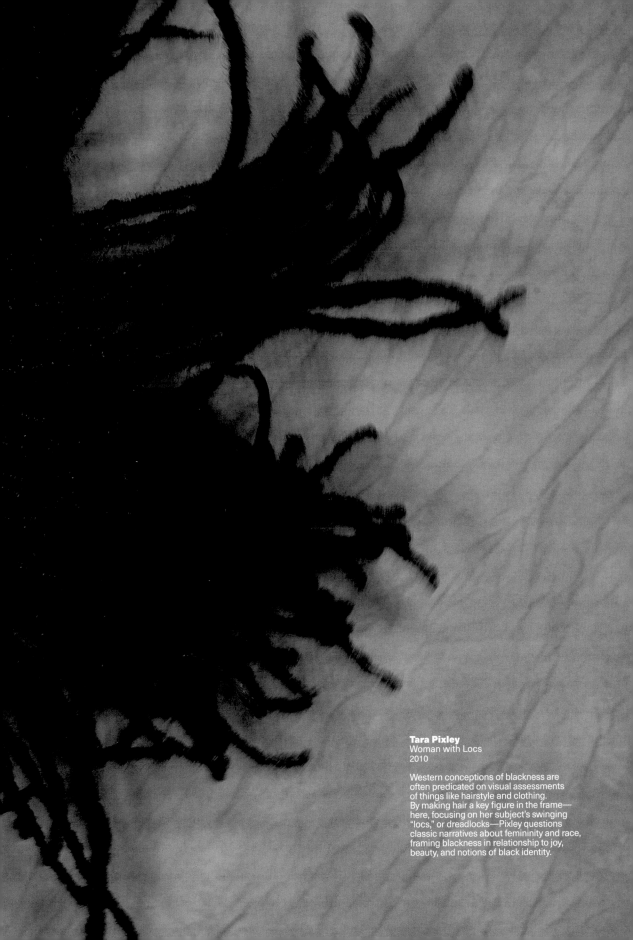

Tara Pixley
Woman with Locs
2010

Western conceptions of blackness are
often predicated on visual assessments
of things like hairstyle and clothing.
By making hair a key figure in the frame—
here, focusing on her subject's swinging
"locs," or dreadlocks—Pixley questions
classic narratives about femininity and race,
framing blackness in relationship to joy,
beauty, and notions of black identity.

media theorist who writes about what he calls "social" photography: the idea that your interaction with many, if not most, of the people you come into contact with happens largely by way of alternate digital channels, which is to say that you see an *image* of a person before (and often instead of) the actual person.[5] Unlike photography as a form of documentary or artistic expression, social photography torpedoes itself through time and space where it deposits itself in fragments, landing at different intervals and across different time zones, spewing all sorts of secondary and tertiary narratives. Untethered to its locus of inception, a secondary story can veer irrevocably from its origin, but, more often than not, it just succumbs to the broader taxonomy from which it is imagined to belong: we're sooner willing to classify *within* type than to consider the kinds of deviating details or visual inflections that might require actual time, attention, even (and especially) reflection. Impatience, that supreme condition of modern life, favors the speedy, and the speedy get typecast.

Nevertheless, our faces can occasionally transmit their own stories of resistance. The Oxford-educated, Muslim-identifying, British-Pakistani actor Riz Ahmed explains the stunning immediacy with which, for example, a brown-skinned person becomes the face of "the minicab driver / terrorist / cornershop owner"[6]—theatrical roles he elected, professionally, to oppose, even as the fundamental nature of getting through airport security obliged him to contend with a far more entrenched series of cultural assumptions. (You don't have to be a bigot to make them: consider our homeless veteran.) Those assumptions might equally prompt us to see someone physically disabled as mentally unfit (wrong) or someone with thick eyeglasses as incapable of perceptual acuity (also wrong) or someone who is beautiful as kind and gentle (cataclysmically wrong, despite multiple sociological studies suggesting that we generally trust good-looking people more than their homely counterparts).[7]

For those who self-identify as nonbinary, typecasting can manifest as a particularly punitive kind of personal oppression. Even though there may be more flexibility today with how you choose to present to the world—a woman shaves her head, a man wears eyeliner, a teenager embraces any number of ways to express his or her or their desire for visual androgyny—those on the receiving end are prone to a crippling demonstration of resistance and dissent. (Certain new parents—concerned over precisely this tendency toward gendered labeling—have recently taken to referring to their newly minted offspring as "theybies.") While it is true that the spectrum of possibility is better served by the availability of alternate descriptors, language can get you only so far. What you see when you look at someone else's face lends itself to far more immediate response mechanisms that can, by their nature, prove resistant to a more nuanced perceptual spectrum.

The question of your own agency in light of the authority thrust upon you by some random biological lottery introduces the perhaps deeper question of moral typecasting, a sociological theory that positions us either as agents or patients, rescuers or receivers. The idea

Jessica Dimmock
Still from *The Convention*
2016

I've felt different ever since I was nine. I always questioned myself, because I didn't know if I was, you know—I didn't know about transgender at the time. And I thought, well, am I a cross-dresser? Am I gay? Am I this, am I that? On almost a daily basis, I was praying to God to let me wake up as a woman. I was confused about myself, with my mind saying I should be a girl, while having this boy body. And God never did let me wake up a woman.

Gina-Marie, 60

itself proposes a clear polarity stretching between good and evil: simply put, you can't be both the villain and the victim. If we are incapable of seeing more than one thing at a time, are we hardwired, by conjecture, to resist ambiguity? What, then, of the essential hybridity of our robotic future, where human features are grafted onto mechanical capacities to accelerate our productivity and advance our species? Future historians may one day view typecasting as a curious kind of life raft, one that offered us a kind of temporary, if ultimately false stability as we navigated an emerging landscape of visual and social difference. Far more difficult to grasp a world in which facial ambiguity is, as it should be, the new normal.

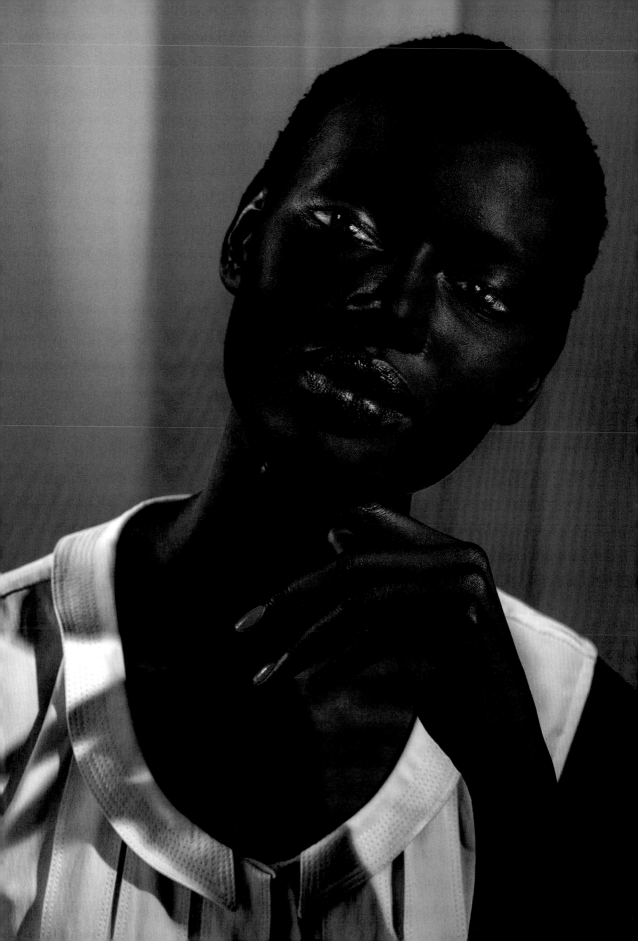

U | Users + The Uncanny

But even the ugliness of faces, which of course were mostly familiar to him, seemed something new and uncanny, now that their features—instead of being to him symbols of practical utility in the identification of this or that man, who until then had represented merely so many pleasures to be sought after, boredoms to be avoided, or courtesies to be acknowledged— were at rest, measurable by aesthetic coordinates alone, in the autonomy of their curves and angles.

Marcel Proust

A logical fallacy is a flaw in reasoning. We believe something because we want to believe it, because it is far easier to follow than to flee. Social psychologists call this pluralistic ignorance: the notion that we're fundamentally predisposed toward going along with the group. This is not unlike confirmation bias—interpreting information in a manner that merely confirms your preconceptions—something, it bears saying, that is considerably more seductive when it's visual. (If something *looks* good, we're more likely to assume that it *is* good.) Hans Christian Andersen's classic fable *The Emperor's New Clothes* is a perfect example of a logical fallacy: a cautionary tale of intellectual vanity, illuminating the laziness reflex that begets social sheepishness. No one dares speak the truth for fear of an unfavorable reprisal (social exile?) which, in turn, fuels the fable's epic pantomime.

But this chasm between what is real (the logic) and what is fake (the fallacy) also hints at far more immediate kinds of oppositions both grounded in—and amplified by—the sly trickery of language. Take the now-common verbal refrain "user friendly." What's so friendly about the word "user"? "Friendly" suggests affability, camaraderie, even a kind of freewheeling social serendipity, while the mechanically awkward "user" is workmanlike, robotic, and inert. The same might be said of any one of a number of polarizing mashups—artificial intelligence, machine learning, digital insights—all of which follow a familiar pattern. (One word is synthetic, the other, sentient.) Together, each is an expression of a kind of intimate detachment, a dispassionate proximity.[1] Human capital. Sanity check. Brain dump. How have these come to be the go-to aphorisms of our day? You can point to all that's social and viral, accuse big business or lambast big data, blame it on the promises of marketers or rebuke the tech evangelists, but the problem

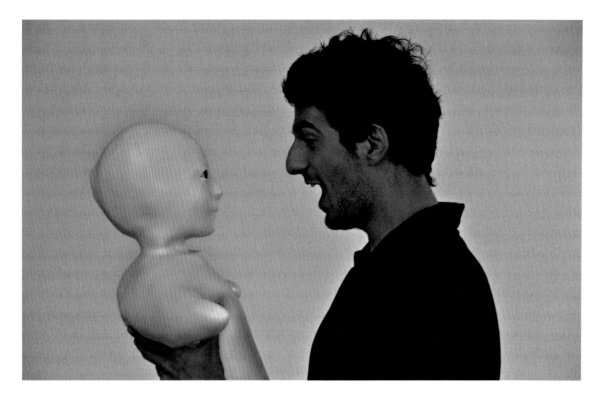

Hiroshi Ishiguro Laboratory, ATR
Telenoid R1 Robot
2010

Intelligent Robotics Laboratory at Osaka
University in Japan created this robot that
can be operated remotely by someone in
another room. It has flexible skin encasing
a set of curiously amputated limbs and an
only slightly more detailed face.

Hiroshi Ishiguro Laboratories, ATR.

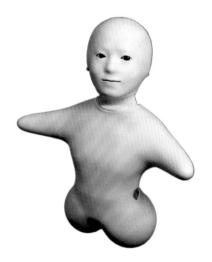

here originates with the words we deliberately and actively choose to describe who we are, what we believe, what is real—and what isn't.

This sort of axiomatic language holds firm throughout the tech sector but is especially resonant in the field of something called people analytics, a discipline that addresses the so-called science of emotion measurement: much of this work originates, perhaps not surprisingly, in the face. A company called Affectiva has developed a technology that tracks a person's smirks, smiles, frowns, and furrows, thus reading "the user's levels of surprise, amusement or confusion." Intraface, which originated at Carnegie Mellon's Robotics Institute, is an open-source platform offering automated facial feature tracking, facial attribute recognition, and something called head pose estimation, which it does by extracting faces from video footage. Also video-based, Adobe's Project Puppetron focuses on mapping style synthesis against something called temporal coherence. (As if the passage of time was ever coherent.) And Emotient, a self-labeled "expression analysis engine" acquired by Apple in 2016, claims to reduce the tedium of manual coding by "automatically extracting action units."

It remains unclear as to when we actually went from having faces to serving as "action units," but let's begin with the fact that a person, whose capacity to express emotion resides in the heart and the soul, and whose mind is nourished by a presumably healthy dose of oxygen flow to the brain, is now routinely referred to as a user. That user (née person) has the capacity to produce a series of facial expressions that can now be computationally harvested and batch uploaded as a series

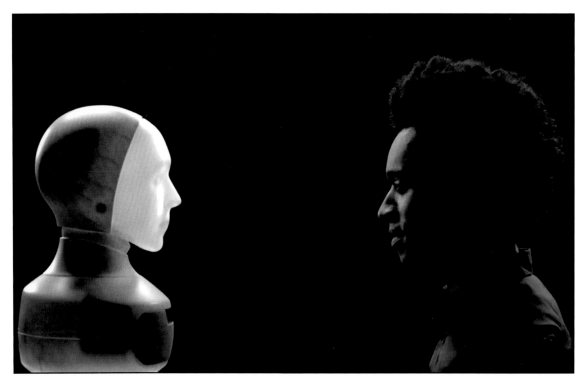

Furhat Robotics
Face-Swapping Robot
2010

Furhat robots use what their creators call situational awareness, which is intended to naturalize head movement and reduce mechanical oddity—a departure from the creepiness of the uncanny valley. This method involves a projection system that beams a face on to an opaque mask, while a flexible neck enables head movement. The back-end technology registers where you're looking and how you're standing, so that the "bust" responds when being addressed. At present, Furhat is one of the very few robotics companies working with nonwhite facial simulation.

of data points. Those data points—the smirks and smiles and furrows and frowns—have become fodder for "scalable biometric research solutions" to presumably help the world become more productive, and, to the degree that all this data subscribes to some imagined or idealized state of accuracy and archivability, more controlled. This data—our data—can now be analyzed and aggregated and sorted and segmented and, most important, deployed for all sorts of purposes, from advancing consumer research to accessing security protocols to, frankly, policing the state. A paranoid assessment, or a pragmatic one? Typecasting, or totalitarianism? Who are the real "users" here? Who's using whom?

If language bootstraps us to the banal, it's equally a sublime tool in the hands of any number of gifted writers, whose imaginations steer us toward rather a different way of seeing our faces. From Aldous Huxley to H. G. Wells, Edwin A. Abbott to George Orwell, Ursula LeGuin to Ray Bradbury to the prolific Isaac Asimov, literature gives us countless stories of imagined human-technological hybridity—some, but not all, falling under the rubric of science fiction. In E. M. Forster's 1909 short story, "The Machine Stops," the main character is tied at once to an armchair and to a machine—the former a relic of the nineteenth-century parlor, the latter a pre-emptive nod to twenty-first century mobility—each its own allegory for a kind of social dislocation. (Forster, generally acknowledged to be a romantic, also turns out to have been something of a brilliant futurist.) In this story, he likens his protagonist

(the denizen of an underground habitat) to a mushroom; her skin sapped of blood flow, she is described as having "a face as white as a fungus."[2] Whiteness—a racial descriptor, to be sure, but also a rumination on a kind of eerie human erasure—hints at what happens when the face fails to thrive, the person literally ceasing to exist. "There warn't no color in his face, where his face showed," writes Mark Twain of Huckleberry Finn. "It was white; not like a nother man's white, but a white to make a body sick, a white to make a body's flesh crawl—a tree-toad white, a fish-belly white." Twain was not alone in crafting the nonperson through a kind of facial vacuum. "Ain't no color in her face and she ain't hardly breathin'," writes Ralph Ellison in *Invisible Man*. "She gray in the face." True, white and gray are machine colors, not human ones: and here, if color itself cues life, the pitch-perfect Octavia Butler moves beyond saturation to conjure an entire spectrum of sentience rendered in primary hues. "Red faces; blue faces; green faces," she writes. "Screaming mouths; avid, crazy eyes, glittering in the firelight."[3]

All of this is a far cry from "covariance pooling"—a method proposed by a group of Benelux researchers that captures the "regional distortions of facial landmarks."'[4] Their preferred algorithm starts with face detection to "get rid of the irrelevant information that is contained in the real-world images." Are we agreeing to let algorithms determine what is, or is not, relevant in our faces? (And why does "real-world" sound like such a dig?) If deft literary descriptions are to facial detection frameworks what caviar is to cardboard, it is in the gaping space between them that we find ourselves on particularly uncertain ground.

Above
Kodomoroid
2014

Kodomoroid combines the Japanese word *kodomo* (child) with the word android, and was designed to be a robotic newscaster on Japanese television.

Hiroshi Ishiguro Laboratories, ATR

Oral Simulator
RealDoll
2019

Does the presence of a complete face reduce sexual excitement? RealDolls offers a siphoned nose and mouth that provides a purely mechanical function—a feature that somehow requires red lipstick. In an interview with the *New York Times*, designer Matt McMullen said "the hope is to create something that will actually arouse someone on an emotional and intellectual level, beyond the physical."

Skin color, body type, breast size, nipple
shape, ankle width, elbow sharpness,
finger length—dialing an idealized robotic
specimen is now a reality.

As recently as 2015, *Fortune* senior editor Stacey Higginbotham looked at facial detection as a creepy protocol that cued what she termed the ick factor.[5] "Soon," she noted, "computers will be able to figure out whether you're happy, sad, or angry by merely watching the tiny involuntary muscle movements in your face." (The key word in that sentence might just be "involuntary.") True, you can content yourself with the idea that facial detection is good for society, that emotion-mapping is good for business, and that cyborgs are merely the stuff of science fiction (until they're not), but as artificial intelligence strives to mimic human attributes, these facial simulation protocols represent countless investments in a future that hardly seems to belong to you anymore. Being human is not now, nor has it ever been, a journey of temporal coherence. Welcome to the uncanny valley.

In his canonical 1919 work on the uncanny, Sigmund Freud examines the implicit tension between two seemingly oppositional words— *heimlich* and *unheimlich*—one "familiar and congenial," the other "concealed and kept out of sight." The very notion of uncanniness was, to Freud, borne of the natural reflex to resist the unknowable, the unfamiliar, the abhorrent. (Uncanniness "undoubtedly belongs to all that is terrible," he wrote, "to all that arouses dread and creeping horror.")[6] Yet while his argument may have been initially grounded in semantics, Freud also appreciated the aesthetic slippage between reality and simulation, noting the powerful feelings of repulsion that are triggered when we're presented with something that reads as alien. In his essay, he nods to a short work published in 1906 by the German

RealDoll
Magnetic Replacement Faces
2017

Matt McMullen's RealDolls come with
additional body parts, including magnetic
swappable faces, a more affordable option
than replacing the doll's entire head.

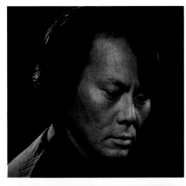

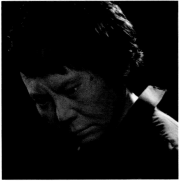

Sonzai Kan
Geminoid (Synthetic Self-Portrait)
2014

The Japanese phrase sonzai-kan roughly
translates as the idea of "presence."

Hiroshi Ishiguro Laboratories, ATR

psychiatrist Ernst Jentsch in which he describes, rather poetically, the emotional pull of the habitual, the visual power of the familiar, and the unsettling psychic tensions between that which is perceived to be animate versus inanimate.

Both Jentsch and Freud gasped this essential cognitive divide, which has since come to be known as the uncanny valley—a phrase that originates in the work of Masahiro Mori, a Japanese roboticist who published a study in 1970 in which he noted that the human tendency toward revulsion was piqued by seeing "humanoid" replicas that were too close for comfort.[7] ("Humanoid"—as perfect a synonym for creepy as one might find—is mostly used today as a positive thing.) Mori describes, for example, a robot implanted with twenty pairs of artificial muscles in its face—the same number as a human being—whose expression turns "creepy" when the speed of muscular movement is adjusted by half. But synchronizing speed was hardly the only issue, or even the main offender, here, and Mori's words of caution barely stemmed the tide. If anything, the next few decades would witness a massive surge in the race to simulate the "real-world" human.[8]

Consider the social-humanoid robot known as Sophia, touted as a great triumph when she debuted in 2016 because she could allegedly "see people's faces, process conversational and emotional data, and use all of this to form relationships with people."[9] Mask-bot—a collaborative venture between a group of German and Japanese engineers—would later introduce emotion synthesis software, projecting a transparent plastic mask onto a so-called realistic head, and delivering a series of "visible emotional nuances" to indicate, for example, when someone might be happy, sad, or angry. Meanwhile, shoppers at the Mitsukoshi department store in Japan have been greeted since 2015 by an android called Aiko—Toshiba's "meet-and-greet robot"—who is described as "quiet" and "happy to help people." Aiko's engineers claim that she is the first robot to actually "react to physical stimuli" and "mimic pain." (One imagines that she did all of this quietly and happily.) Hiroshi Ishiguro's "Geminoid" robots go even further toward a presumed kind of social assimilation: Erica, for example, is characterized as a "conversational robot" with forty-four degrees of freedom in her face. With a plastic skull, silicone skin, configurable features, and subdermal pneumatic actuators to create the illusion of breathing, Erica—who has her own YouTube channel—can perform for all of us, but mostly she performs to the preordained expectations of her team of engineers. In a fascinating example of modern technological audacity, Ishiguro unabashedly proposes that what's next for Erica is a proper personality, claiming that with the right engineering, "the soul can exist in anything."[10]

This is where the uncanny thrives, where the real ick factor truly lives—trapped somewhere between humanism and hubris—and here, Ishiguro is hardly alone. Over a decade ago, when Hasbro partnered with iRobot to introduce a digikinetic doll called My Real Baby, it boasted four different stages of laughter, three different stages of excitement, seven different simulated facial muscle groups, and

Face: A Visual Odyssey

fifteen "human-like emotions."[11] As Ishiguro proposed with his own synthetic creation, Erica, Hasbro later claimed that this was a doll with the makings of a central nervous system.

Which brings us back to that cognitive gap, that unsettling fissure separating character from code. In the forty years since Mori's study was first published, we've witnessed immense advances in technological achievement, but that essential divide—between human and, yes, humanoid—inevitably persists. Is it locked in a struggle of semantic intent? A battle between aspiration and achievement? And why must we continue to ape human form in pursuit of the mechanical—because it mirrors it all back, reinforcing the fabric of the familiar? Familiar, it bears saying, does not mean uniform. We are not users, but people: people with faces that mark us as individuals, with word choices that enable us to express ourselves with nuance, with souls that can neither be coded nor uploaded at will. The idea that we might bridge that divide is not just a function of the uncanny: it's vain.

Below
Dan Chen
Robotic Intimacy Device
2018

Dan Chen's Robotic Intimacy Device combines a physical embrace with a live video feed of the other person's face. The artist suggests that this device could also be used for long-distance intimacy.

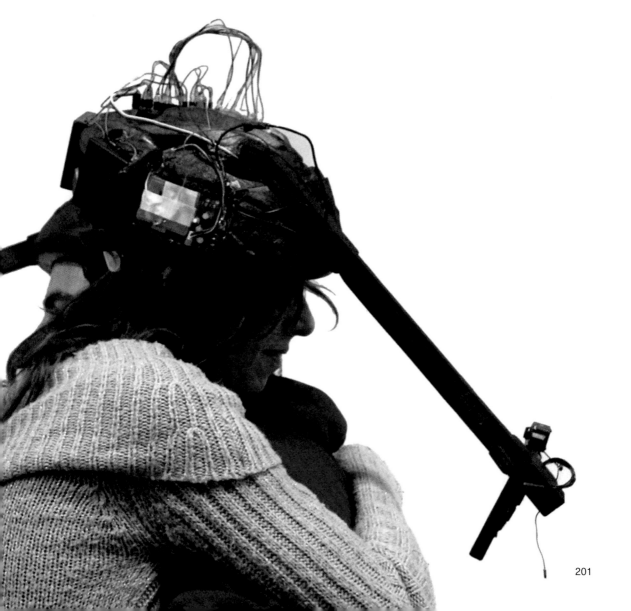

Sophistication

V | Vanity

A fashionable woman sits in a New York City hair salon, facing her reflection in a mirror. Her stylist faces the mirror, too. Their conversation, if it can be called that, happens sporadically: there is some pointing and posing, the essential directions duly transmitted and received, but any relative reciprocity here is minimal. Their eye contact is triangulated, impersonal, and oblique.

> Phyllida's hair was where her power resided. It was expensively set into a smooth dome, like a band shell for the presentation of that long-running act, her face.
>
> **Jeffrey Eugenides**

Sitting woman is speaking into some kind of Bluetooth-enabled mouthpiece, watching her own reflection and examining her every movement as she does so. She studies, with considerable attention, how her face changes dimension as she talks. She explains, in considerable detail, how a bidding war has begun on her house. And she narrates, at considerable volume, the multiple six-figure sums on offer. It's an odd dynamic—watching someone addressing an invisible person, talking on an invisible phone, completely ignoring her very present, yet seemingly invisible, stylist—and the resulting scene is nothing less than a travesty of tone-deaf privilege. Vanity, in the absolute, takes no prisoners: it just makes the rest of the world vanish.

The word itself has a rich literary and liturgical history, and to chart its essential trajectory—from bible to allegory, satire to consumerism—is to witness a boldly shifting target, veering from the desire for self-awareness (a moral conceit) to the display of self-idolatry (a physical one). In Christianity, vanity presents as one of the Seven Deadly Sins, lyricized in the book of Ecclesiastes ("Vanity of vanities / saith the Preacher / vanity of vanities / all is vanity") and allegorized in John Bunyan's seventeenth-century novel, *Pilgrim's Progress*, where

Top
Jan Miense Molenaer
Allegory of Vanity
1633

Toledo Museum of Art.

Above
Charles Allen Gilbert
All Is Vanity (detail)
1892

stories of Christian principle play out against the vicissitudes of social martyrdom.[1] The action here takes place in the city of Vanity Fair, defined by Bunyan as a "place or scene of ostentation or empty, idle amusement and frivolity" and thus aptly named. (His characters are equally metonymic, including, among others, Ignorance, the Flatterer, and Mrs. Know-Nothing.) A century later, William Thackeray would write a satirical novel by this title,[2] and by 1913, it would spawn a successful monthly publication that endures today as a media staple for the glitterati. If consumer magazines are to modern-day vanity what mirrored palaces once were to the aristocracy, glossy pages might just provide the perfect visual metaphor for the vain. Shiny objects have always favored social nearsightedness.

Vanity—once known as "vainglory" and sometimes used interchangeably with pride—is also code for valuelessness. (The Latin *vanitas* actually means worthless.) Vanities are also synonyms for trifles, and up until the fourteenth century, the word itself was a euphemism for futility, a reminder that life itself was transient. Medieval works of art favoring still-life displays came to be known as "vanitas" paintings and were meant to represent the futility of life: by conjecture, they served equally as keen graphic admonitions for the certainty of death. These images often included symbolic elements—

Wax Vanitas
Eighteenth–nineteenth century

Wellcome Collection.

a fragile butterfly, a rotting apple, a waning candle—and skulls, sometimes featured prominently and other times, placed as hidden, almost trompe l'oeil elements within a frame. The American illustrator Charles Allan Gilbert's classic 1892 drawing *All Is Vanity* shows a woman seated at her dressing table (her "vanity") in such a way that the resulting image forms a skull. Both the Spanish baroque painter Antonio de Pereda and the Dutch golden age painter Jan Miense Molenaer's produced paintings entitled *Allegory of Vanity* that feature listless women, disengaged from their surroundings, posed like inert statues alongside globes, jewelry, and skulls. In Molenaer's painting from 1633, a woman sits with a mirror on her lap, ignoring everything around her, including (and especially) her child. It's a stunningly modern composition: she could be sitting today in a hair salon. (That mirror could be an iPad.) Mrs. Know Nothings aren't just fictional characters: they're social archetypes, and we all know them.

If vanities were once believed to be expressions of personal sin, it was because they were seen as indulgent and boastful: one should not be prideful, but penitent, sooner virtuous than vain. Long before it was a novel by Tom Wolfe or an action role-playing video called *Assassin's Creed*, the original "bonfire of the vanities" was a fifteenth-century event in Florence in which objects believed to promote indulgent activities were publicly burned. These included books, art, clothing, and jewelry, but also targeted cosmetics and mirrors—

Diana Scheunemann
Behind My Face
1999–present

The Swiss/German photographer Diana Scheunemann has been taking a self-portrait every day since 1999. As an editorial and advertising photographer, Scheunemann has undertaken a vanity project that is anything but vain: rather than primp for her camera, she captures herself as a documentarian might do. The resulting visual diary is as much a portrait of time's passage as it is a portrait of the artist herself.

trifles of self-love, perhaps, but also precursors of portability. Today, of course, vanity has never been more mobile. Wearable devices track our physical output. Digital platforms extend our social reach. Smartphones function as robotic concierges but serve equally as court jesters, at once armed with services and primed for 24/7 entertainment. Emojis—the iconic deputies of the lazy correspondent—may not reflect vanity so much as laziness, but our ability to fine-tune their skin tone suggests that we want them to look as much like us as possible: is that not an expression of vanity, too, to map everything in your own likeness, even dingbats intended to simulate your feelings?

The smartphone's most seductive feature is undoubtedly its embedded camera, on high-alert at all times, lest we miss something that demands to be recorded. To take a selfie is to participate in precisely this dance: private moment to public display, you as the star of your own imagined show, capturing the instant, *carpe*-ing the *diem*, routinely reinforcing your own arguably infinitesimal presence in the world. Holding that camera in your hand, pointing it back at yourself, tilting your chin up, capturing the best light, favoring your good side— all to take a picture of yourself, and another, and another, and why not take a few hundred more, because what does it matter in a world where the display space before you is boundless? With the advent of virtual reality, what we even consider to be boundless is boundless. Doesn't that much opportunity breed its *own* kind of vanity?

Currently, our physical engagement with virtual space is a clunky affair, requiring a giant step into hardware—which is to say headgear—which means that our faces are proffered as willing components in a strange new kind of social choreography. Virtual reality is time travel, but it's also space travel, not so much on a planetary level as a perceptual one. It's a new kind of manifest destiny, relatively undeveloped and uncharted and raw (for now), with novel opportunities for invention, creation, and the acquisition of all kinds of knowledge. But just as virtual reality introduces new models for visual exploration, it obliges us to consider radical, even revolutionary new ways to embed ourselves in alternative kinds of engagement. It's all about seeing, even if, paradoxically, this essential transaction currently obliges you to conceal your eyes. Where augmented reality is concerned, eye contact is with the virtual, not the actual (reciprocity is between the person and the device) and while it is easy to imagine that the physical apparatus itself will shrink, perhaps even one day becoming invisible, the VR process itself is, at present, rather socially isolating—and perhaps intentionally so.

Arguably, if we define vanity by our worship of earthly possessions and pursuits, we are no less vain for shifting the coordinates to these kinds of alternative landscapes. The things we want may no longer qualify as "earthly" but are no less desirable. (They might even be more desirable.) As long as our participation in these maneuvers requires headgear to ensure complete psychic immersion—our eyes behind goggles, our attention diverted from our fellow human beings—social dislocation migrates to an entirely new level. Consider the brave new

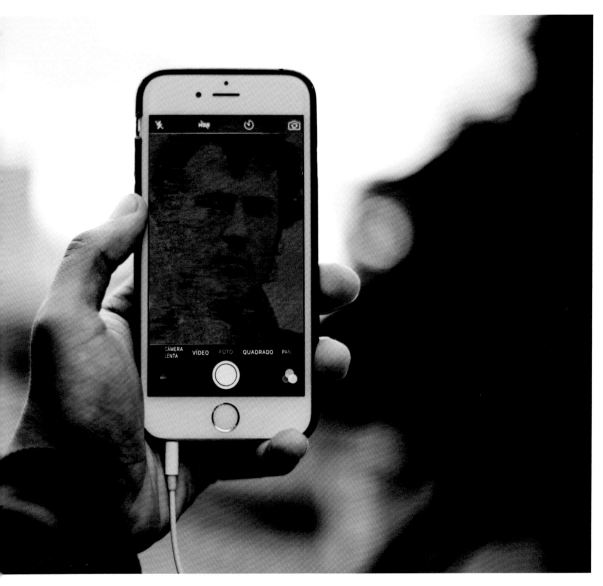

Insert
Robert Cornelius
Daguerreotype
1839

Robert Cornelius, one of the earliest
American studio phorographers, is widely
believed to have taken the first photographic
self-portrait, which he did by removing
the lens cap and then running into the
frame, sitting still for several minutes,
and then rushing back to cover the lens
once again. This was made possible by
the long exposure times required by early
photographic chemicals.

world of teledildonics, where sex is more a function of playing pilot
than embracing intimacy. (Or, if you are craving intimacy, it's an
environment where sex is as easily found with a cartoon character
as with a physical companion.) What do we (or don't we) see in each
other's faces and what are we giving up by reaching out in this way,
the mirror skewed to participate in some elliptical relationship with a
virtual plaything? Teledildonics may seem less an evocation of vanity
than an expression of voyeurism, but the root cause remains largely
the same: you see what you want to see, on you timetable, at your
command. "There comes a time when you look into the mirror and
you realize that what you see is all that you will ever be. And then you
accept it. Or you kill yourself," wrote Tennessee Williams. "Or you stop
looking in mirrors."

W | Wit

I never forget a face,
but in your case, I'll be glad
to make an exception.

Groucho Marx

In 1925, Carey Orr, a Pulitzer-prize winning political cartoonist, created a game for children he called Ole Million Face. Comprising a set of sixteen blocks, each six-sided component contained a different feature, making it possible to mix and match a total of 67,108,864 different facial combinations—a daunting, yet doable achievement if you did the math. Working at the rate of one change per minute, eight hours per day, six days per week, and fifty-two weeks per year, it was estimated that you could produce each possible combination over the course of exactly 28 years, 8 hours, 58 minutes, and 48 seconds.[1] Later versions included Changeable Charlie (4,194,304 faces), Fair Faces (1,048,576 variations) and Toon-a-Vision (65,688 possibilities), which was issued in the late 1950s, and came with a central screen and tiny knobs labeled as channels, in an effort to simulate (and by conjecture, compete with) that new staple of every middle-class living room, the television set.

Labeling did not stop there. The idea of naming characters replaced the entropy of Changeable Charlie with kind of pointed specificity that slyly nodded to facial—and gendered—typologies. (Gossip Gertie! Honey Heartbreak!) Hasbro would later introduce Let's Face It, a board-game variation of Mr. Potato Head in which players took turns completing the faces of "archetypal" Americans: a fireman, a cowboy, and someone rather mysteriously called the Dude. Faces may have been mixable, but packagers helped kids play by suggesting how to play, in some cases, by including a visual index of preordained examples. The 1933 souvenir game Face Fun Felt-O-Grams was one of a number of toys that included precut shapes and surfaces as well as a booklet showing variations, all of which were allegedly sent in by

Jeu des Portraits
Illustrations by Georges Tcherkessof
Published by Flammarion
1934

Tcherkessof (1900–1943) was a Russian
painter, set designer, and illustrator whose
stylized portraits of French nobility are
featured in this mix-and-match game
that features the kings Charlemagne and
Louis-Philippe, Napoleon Bonaparte, and
Catherine de Médicis, among others.

Patricia Martineau Collection.

the public where, oddly, they appear to have been produced not by
children, but by adults. (They're included in this book as endpapers.)

If American toy manufacturers produced mix-and-match face
games populated by the stereotypes embedded within their own
vernacular, foreign publishers did the same. Metamorphosis—or
transformation games, as they are sometimes known—all operated
from the same premise, but the illustrations reflect the cultural milieu
in which each game was produced. The 1930s British parlor game
Hoozitlike offered costumes that included a top hat and a monocle.
Flammarion's 1934 Jeu des Portraits favored the classic demeanor of
French nobility, with faces framed by wigs and hats, lacy collars, and
twirled hair. French metamorphosis games had more rules (some were
Lotto games, with clear winners and losers) and German games were
even more disciplined: many were marketed as puzzles, with notes
explaining that there was only one way to complete them correctly.
Cutout paper toys populated newspapers in the US and abroad, some
accompanied by instructional cut and fold lines for at-home play.

The Japanese game of Hanetsuki dates back to the Muromachi
period (1333–1568) and is not a face game, per se (with paddles and

a shuttlecock, it more closely resembles badminton) yet the rules of play call for the loser to have his or her face smudged with black ink to impede vision (or lose face). Indeed, to have a "game face"—sometimes called a poker face—is to have a neutral expression, lest you give yourself away to your opponents. And on that topic, games and toys featuring disguises have, by definition, long focused on the face as the prime locus for play. As extensions of dress-up, props for Halloween, masks in magic kits, and spy-play diversions, such toys typically mirrored the looks of their era and were marketed as creative playthings. (The seminal toy disguise—a pair of spectacles attached to a heavy mustache, nose, and eyebrows—dates back to the 1940s and is commonly known as Groucho glasses.)

If the face served the toy, it also offered a physical platform for shifting narratives. If today's face-changing apps invite users to morph and modify the face at will, they owe some modest debt to inventors like Charles M. Crandall, a nineteenth-century American toy manufacturer who introduced his face-matching Masquerade Blocks in 1870. They nod, too, to German cartoonist Lothar Meggendorfer's 1898 book *1536 Grimaces*—a so-called slice, or mix-and-match book—

Above
Funny Face Game No. 403
Child Welfare Publishers, Inc.
1912

With each piece cut from heavy cardboard
with the same die (so as to ensure a snug
fit of the interchangeable features), the
publishers of this jigsaw game included
often inappropriate verses to accompany
each image. ("Happy people dark and light,
Want their features put in right.")

Right
Danish DIY Puppet Maker
Circa 1915

Face: A Visual Odyssey

that turned viewers into players into costumers into directors into tiny armchair psychologists. Some thirty years earlier, a series of moveable "novelty" books called the Dame Wonder's Transformations Series was published in Britain, operating on a simple premise:

> The mechanism involves a round hole in the same position in each of the pages, through which a face is seen illustrated on the final page, which is left uncut. The pages are illustrated on the recto only (versos blank) with a central character lacking a face. As the pages are turned, the characters, or their dress, change, but the face, visible through the page holes, remains the same.[2]

Over time, these so-called flexible face books expanded to include other variations. An empty space meant that parents could add a photograph of their child's face, for example, thus firmly embedding his or her likeness into the book's central narrative. (A nod to relatability, perhaps.) A reflective surface produced a similar effect: the mid-century series Mirror Books for Girls/Boys operated on precisely this premise, appealing to vanity as a method of social engagement. Social media-supported apps and games subscribe to the same idea: you can take a selfie, adapt it at will, and lock yourself in at the center—and as the star—of every story.

This page, Clockwise from top
Marble Muggins
American, 1930s

Hoozitlike
English, 1930s

Face et Pile
French, 1930s

M —F	—BAD-TEMPERED —	M —F
EYES	= Large, but fullness, which is normally above upper eyelids, droops over to the outer half of eyes.	
NOSE	= Long, narrow ridge. Crude or bony in appearance.	
MOUTH	= Thin, straight lips on narrow mouth.	

F	—PLEASANT—CHEERFUL —	F
EYES	= Upper and lower lids cover part of the iris at the top and at the bottom. Eyes are bright, wide apart. Very thin, delicate eyebrows.	
NOSE	= Finely skinned. Short, showing holes of nostrils.	
MOUTH	Full, smiling lips, showing the teeth. Dimple at corner of the mouth.	

Books and blocks, which were typically elaborate (and sometimes costly) were not the only options for such interactive play, however. There were die-cut faces on interchangeable cards, "roundabout" cards, often distributed as advertising premiums, with faces chopped onto concentric wheels, and newspaper illustrations that comically shifted facial perspective into caricature. Head-turning games were likely intended less for children than for their elders: here, the idea was that a 180-degree rotation could turn a horse into a man into a horse again, a villain into an angel, a lady into a gentleman. (These date back to the sixteenth century.) One of the more famous of these, a 1558 illustration by the Flemish engraver Theodor de Bry called *Conceit and Insanity*, featured a head of the pope that inverted to reveal the devil.

Just as these kinds of two-dimensional illustrations served as affordable diversions, handheld toys inviting facial play easily appealed to broad audiences and could be manufactured cheaply, from paper dolls published in newspaper tabloids to pocket toys, advertising premiums, and party favors. (Inexpensively produced chain face games typify the mid-century toy giveaway.) Slightly more nuanced (but no less affordable) were faces made up of metal shards that were "painted" with a magnetic wand on the reverse. Wooly Willy, first introduced in the mid-1950s, spawned a subsequent series of alliterative variations including Hairdo Harriet, Modern Mom, Patient Pop, and Pesky Pup. Dexterity puzzles—popular with soldiers during World War I because they were small, portable, and, for the most part, silent—favored faces with buildable objectives, including one that challenges the player to replace individual teeth into a tiny mouth. Colorforms—a collage-like game based on precut vinyl that adhered easily to a plastic-coated board—was introduced in the early 1950s, and sported a logo designed by Paul Rand based on a Colorforms-constructed face of geometric bits.

Physogs
Jacques Penry for Waddy Productions
1934

Penry's game instructed on the finer points of facial identification. His hope was that better readings would help cleanse society of "criminals, mental deficits, neurasthenics and vocational misfits."

Face: A Visual Odyssey

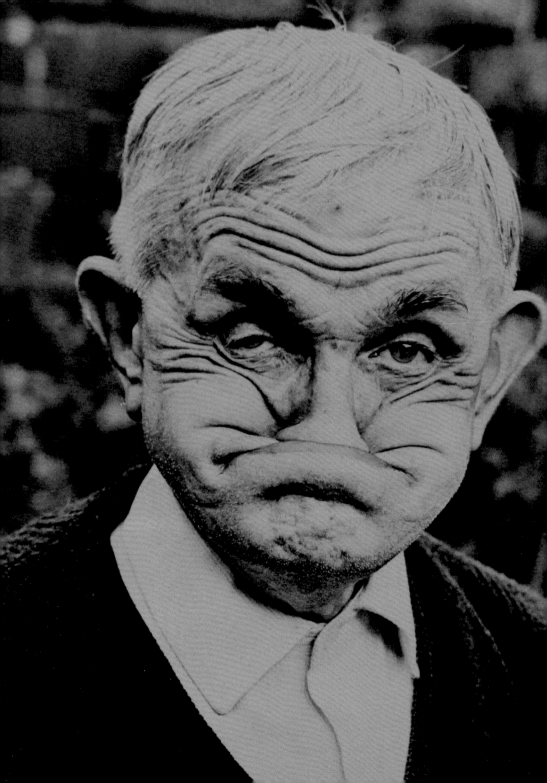

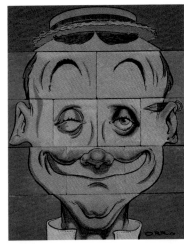
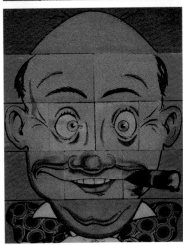
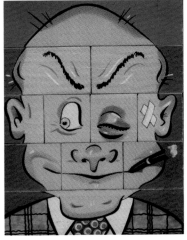
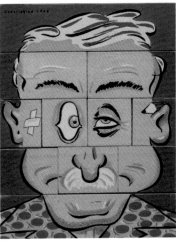

Above
Changeable Charlie
Halsam Products, Co.
1948

Opposite
Dai Llewellyn
Welsh Gurning Champion

Famously described as the "Master of Make Believe," Llewellyn could twist his face into extreme contortions. In between gurning competitions, he made appearances at carnivals where he was often asked to impersonate Popeye.

Today, a range of apps address this niche market for kids: Face Party is one of many mobile games that merges selfies with add-ons, allowing kids the chance to both customize and personalize faces at will.

But wit wants an audience. If you make funny faces, you typically do so to make someone else laugh. (Though perhaps not a parent: one is reminded of the classic motherly admonition to not go too far, "lest your face stay like that.") The idea of twisting your face into laughable contortions goes back some eight millennia to the reign of Henry III, when, during a crab-apple fair in a Cumbrian village in England, the fruit was so bitter that people made faces while biting into it—and grimacing itself became sport. Called "gurning"—a possible play on "grinning"—the game here is to willfully contort your facial features while your head is encircled by an oversized horseshoe-like collar, called a braffin.[3] Gurning takes skill and flexibility, though there are certain biological predispositions that favor the competitor: it has been said that the best gurners are toothless ones. One of the UK's most celebrated gurners, a five-time champion named Peter Hackman, had his own teeth deliberately removed to improve his chances at success.

If the willful distortion of the face has endured as a form of social entertainment, it is a practice hardly limited to toothless overachievers, to England, or, for that matter—to men. One British Pathé silent film shows female contestants warping their faces for prizes in Latvia in 1926. The plot of the 1914 silent film entitled *Daisy Doodad's Dial* is entirely based on a face-pulling competition.[4] (*Try Not to Laugh* is a contemporary Japanese game show that operates on a similar premise). Face contortion itself has long thrived in entertainment, particularly in cartoons. James Stuart Blackton's 1906 short *Humorous Phases of Funny Faces*—considered by many to be the first animated film[5]—chose faces as its subject, demonstrating a harmless exploration of caricature by way of that most primitive of visual means: chalk on a blackboard.

But not all face-pulling is so harmless. *Oenanthe crocata*, or hemlock water dropwort, is a poisonous herb resembling a carrot that possesses a unique toxin—called oenanthotoxin—that relaxes the muscles around the mouth, obliging you to smile even as you are dying. Strychnine poisoning produces a similar effect: both cause torqued eyebrows, bulging eyes, and evil-looking smiles referred to as death, or sardonic, grins (*rictus sardonicus*).[6] The idea of delightful derision as a form of evildoing dates back to Homer, who wrote about ritualistic killings in Sardinia by way of a potion tinged with precisely this herb. The "sardonic smile" is not so much a smile as a spasm: ironic, involuntary, and typically lethal. (No villain better exemplified the sardonic grin than Batman's Joker, and if that didn't label him as "bad" enough, he was also envy-colored-green, like the Seussian Grinch.) Both grinned as a form of disguise, which is its own kind of game.

Long before apps, videos, and video games would seamlessly integrate facial disguise, concealed identity was a curious feature in games and toys, particularly in the 1970s, after television had entered the living room but before "gaming" had become a staple of modern entertainment. These ranged from the cryptic (the popular game of *Guess Who* invites players to discover characters through a series of yes/no questions that hinged on discovering a series of concealed faces) to the creepy; *Hugo: Man of a Thousand Faces* was a bizarre bald (and

Face: A Visual Odyssey

white) hand puppet who shipped with a suite of false noses, chins, glasses, wigs, scars, mustaches, moles, and a nontoxic glue stick. (Many of those who remember Hugo claim to still have nightmares.)

The idea that a game might serve to reinforce gender and racial imbalance may speak to the inadequacies of tone-deaf toy manufacturers, but over time, gestures to the far more insidious persistence of inequity. The original version of Guess Who included only one nonwhite character (who was later redrawn as white) and a two-to-one male to female ratio.[7] (They were hardly alone: all of Toon-a-Vision's characters were Caucasian, too.) Of course, there are outliers in this category, like the card came Buffalo, which challenges and subverts players' expectations of social norms through the words used to described them, a kind of Guess Who for cultural theorists. There are video games that cue questions of nationality through facial identity—Papers, Please (2011) and Not Tonight (2018) are both dystopian dramatizations in which players with foreign identities struggle against the normative pull of authoritarian regimes.[8] Video games themselves have been famously criticized for the reinforcement of such stereotypes, "fun" framed as a set of binary opposites: winning versus losing, beauty versus beast, the progressive pitted against the puritanical. Wit—a synonym for cleverness, a euphemism for intelligence, an outlet for inventiveness, even irreverence in pursuit of humor—can also be tricky, controversial, and mean. Resistance to that which does not resemble you is not funny at all. It's just wrong.

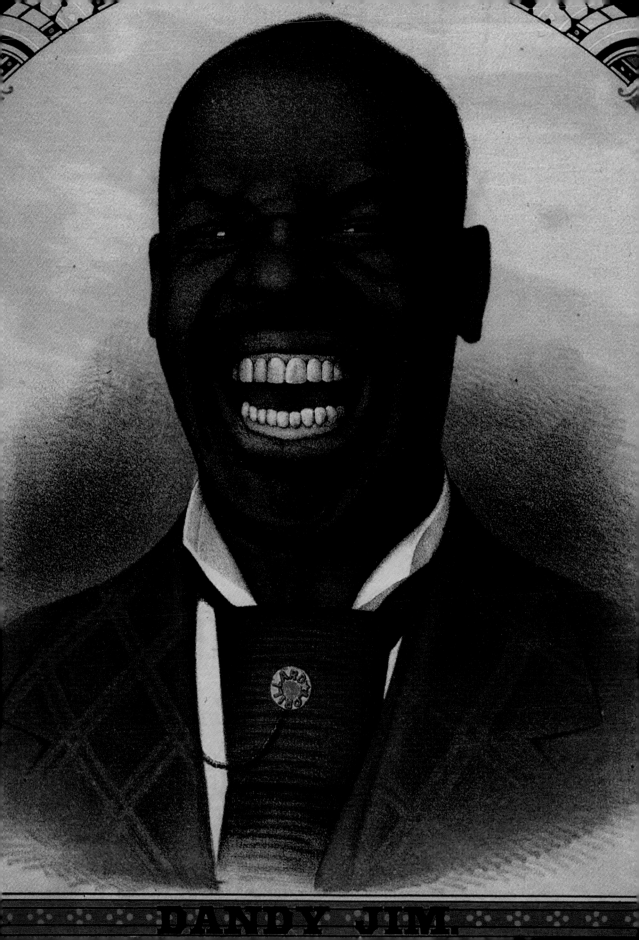

DANDY JIM

X | Xenophobia

It is 1993. Czechoslovakia ceases to exist. *Wired* magazine debuts. Thurgood Marshall dies, and Ariana Grande is born. Apple ships its first Newton, Intel releases its virgin Pentium microprocessor, and the World Wide Web is a massive, monochromatic sea of gray, powered by a browser called, somewhat improbably, Mosaic. Yet while the notion of the internet as a kaleidoscopic riot of color was far from a reality in those halcyon days of what we then called cyberspace, a different kind of mosaic was slowly coming into focus.

In November of that year, *Time* published a cover story on multiculturalism—*The New Face of America*—leading with an image that was at the time born of a comparatively novel experiment in picture-making: novel not because it was composited, but because it was *computationally* composited. ("TIME chose a software package called Morph 2.0," explain the editors, "produced by Gryphon, to run on a Macintosh Quadra 900.")[1] The resulting facial amalgam—the New Eve, as she was dubbed—was approximately 15 percent Anglo Saxon, 17.5 percent Middle Eastern, 17.5 percent African, 7.5 percent Asian, 35 percent Southern European, and 7.5 percent Hispanic.[2]

Gestated by a machine, New Eve became the poster child for a kind of blandly attractive, if racially ambiguous, human prototype: she represented everyone, which is to say that she resembled no one. The resultant image wasn't so much a cumulative portrait as an indexical sampler, a data-driven conflation of harvested ethnicities. If it was statistically accurate, it was also emotionally inept: in retrospect, *Time* produced a face that virtually nullified the very cultural variance they'd hoped to reveal. As a visual model for a kind of wishfully progressive cultural pluralism, New Eve was the opposite—a flatland of ethnic erasure.

August Sander
Village Schoolteacher (1921) and
Young Farmers (1914)

© Die Photographische Sammlung/
SK Stiftung Kultur
August Sander Archive, Cologne
ARS, New York, 2019.

It is 2013, twenty years (nearly to the day) since New Eve graced the cover of *Time*—and embryonic human cells can now be cloned. Scientists are able to culture a living ear from collagen. Artificial intelligence is now a reality, and "selfie" is declared the word of the year. (Three years later, that word will be *xenophobia*.) Ethnic conflicts continue to surge everywhere from Afghanistan to Pakistan, Syria to Sudan. In America, the Department of Homeland Security continues to shelter citizens of the homeland, but for countless numbers of migrants, refugees, immigrants, and asylum-seekers, where exactly is that home, that land, that protection from hate?

In October, *National Geographic* runs its own cover story— "The Changing Face of America"—featuring portraits by the German photographer Martin Schoeller, and a thoughtful essay by the American journalist Lise Funderburg, who writes about what it means to self-identify as multicultural, a descriptor that, at the time, had only been acknowledged by the US Census Bureau for about a decade. Funderburg describes multiculturalism as a factor of self-determination, what she calls a "step toward fixing a categorization system that, paradoxically, is both erroneous (since geneticists have demonstrated that race is biologically not a reality) and essential (since living with race and racism is),"[3] Schoeller's accompanying portraits serve here as tokens of shifting difference, testaments to transparency and tolerance. Blended families, bright-eyed children, bespoke identifiers—Blaxican, Juskimo—a stab, perhaps, at an actual mosaic of diversity and difference.

But whose story is this? America's? *National Geographic*'s? Who gets to tell it? Who benefits—from the telling of these stories, from the showing of these faces? ("What a strange thing is 'race,'" writes the American poet Elizabeth Alexander, "and family, stranger still.")[4] Who is to say who belongs, or who doesn't, and what belonging even means if we're relying on facial determinants as both biological and cultural markers?

Published in 1929, August Sander's photographs of Germans— *Face of Our Time*—was a catalogue of "types" that reflected the social order of its people, indeed, of its moment. A survey of cultural life during the late Weimar Republic, Sander parsed his photos into seven categories—The Farmer, The Skilled Tradesman, The Woman, Classes and Professions, The Artists, The City, and The Last People— labeling them individually but also grouping them in a manner at once empirical and prescriptive. The historian Wolfgang Brückle has observed that this book was as much a collective portrait as it was a training manual, faces meticulously coded as categorical specimens. (He also rightly notes that Sander was not the only photographer to try to codify people as cultural referents.)[5] Although the book itself was seized in 1936 (and the plates were destroyed by the Nazis), the idea that a photographic record can and will endure—virtually cementing the valences of an entire cultural moment—remains a powerful idea, and a tricky one. To bequeath to our faces the story of a generation inevitably involves participation in some kind of

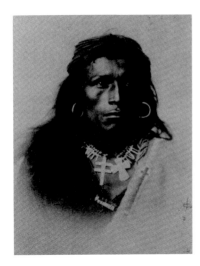

Above
Tom Torlino, Navajo
Photographs taken upon arrival (1882) and departure (1886) from Carlisle Indian School.

Beinecke Rare Book and Manuscript Library, Yale University.

Right
Redskin
Starring Richard Dix
Directed by Victor Schertzinger
1929

After an East Coast education, Navajo-born Wing Foot returns to his tribe and renounces their customs, becoming an outcast among his own people before restoring his honor and finding love. This film poster evokes a common photographic trope featuring the before-and-after portraits of Native Americans who were forced to attend colonial schools.

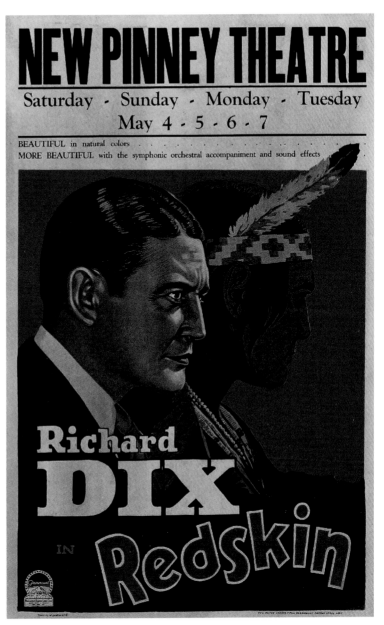

performance. Whether we frame those narratives as statistical composites or publish them as nationalistic showcases is, in a sense, immaterial: what results in either case is a kind of pictorial extremism, a sensibility that may contribute more to the xenophobic inclination than any of us care to admit.

If the line between that which is foreign and that which is familiar is uncanny, the line separating xenophobia from racism is unsettling. The word itself comes from the Greek—a combination of *xenos* (stranger, guest) and *phobos* (fear, panic)—a rather misleading notion, given that foreigners, spied through the xenophobic lens, are sooner

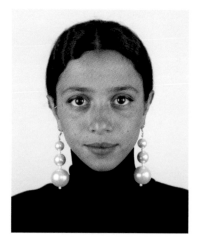
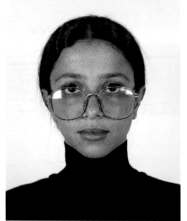
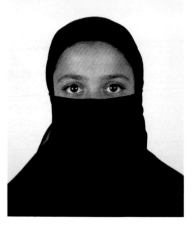
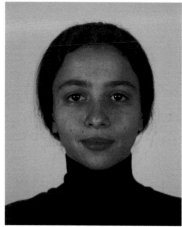

Nadia Gohar
Passport Don'ts
2017

Modeled on the photo specifications required to obtain a passport or visa, Gohar creates "flawed" passport photos, each conveying one of the "don'ts" for a headshot taken for bureaucratic purposes.

By restaging the mistakes that would result in a passport application being rejected, the artist questions silent notions of fear and prejudice in our display of national identity and self-fashioning.

Face: A Visual Odyssey

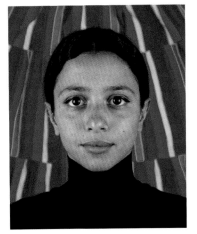

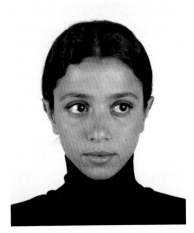

This series was exhibited at The Queens Museum in New York (January 2019) and the Arab Women Artists Now (AWAN) festival in London, UK (March 2018).

viewed as intruders than "guests." In an age in which terrorism and hate present as monolithic threats to civil liberties, resistance to that which is foreign is not only a xenophobic conceit: it's a barbarous one.

Barbarous—a word blessedly now-retired from active duty—was used for generations as a vituperative anthropological descriptor. ("While most barbarous races disappear, some, like the negro, do not," Francis Galton wrote in 1904.)[6] The considerably more enlightened Renaissance philosopher Michel de Montaigne noted some three centuries earlier that we tend to call "barbarous" anything contrary to our own habits. ("Why barbarous," he wondered, "because they are not French?")[7] If the image conjured by that sentence is one of a beret-wearing, baguette-carrying man on a bicycle, must we be confronted with the Frenchman to see ourselves in him, to resist or exile him to the role of the outsider, labeling him at a distance as a foreigner to be feared? To the extent that our faces telegraph our origin stories, none of this is inescapable, none of it is heterogeneous, and all of it—particularly if you find yourself on the other side of it—is real.

The promise of true cultural assimilation has a long and discomfiting history in Western society. Boosterism, frontierism, territorialism, exceptionalism—all are behaviors fueled by the misguided perspectives of exalted privilege, behaviors that successfully marginalized those who were routinely perceived as foreign, often by virtue of their faces. The very presumption of manifest destiny that fueled westward expansion in the United States during the nineteenth century is a fundamentally xenophobic story that resulted in forced migration, imposed dislocation, unwarranted occupation, and social exile. We know, for example, that indigenous Americans were, for generations, coercively removed from their own land by imposed colonial rule. (The American historian Bernard Bailyn calls these *The Barbarous Years* for good reason.)[8] We know that the Chinese Exclusion act of 1882 prohibited the immigration of Chinese laborers, banned Chinese women from entering the United States, and required those attempting to gain entry to memorize their own family legacies—literally reciting their own provenance—before being grilled by US border agents. And we know that Americans of African American descent were sold as chattel, lynched in public, publicly denied citizenship, and segregated within their own communities simply because of the color of their skin.

Blackface—a cultural aberration that emerged in the years following the Emancipation Proclamation and persisted throughout much of the early twentieth century—was a popular form of entertainment that merged comedy with spoofery and was exclusively aimed at black people. Mocked for their facial features, their skin color, their hair, teeth, and more, "minstrelsy"—or the minstrel show—was a burlesque exposition that combined skits and songs with references to American folklore. As if that were not objectionable enough, the performers themselves were all white. (A regrettable truth of

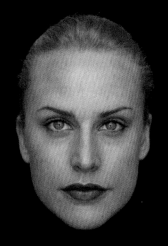

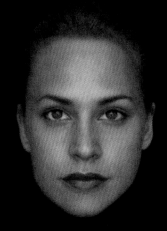

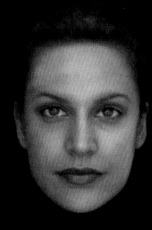

There Is No

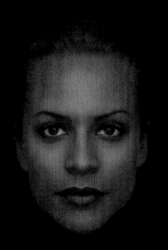
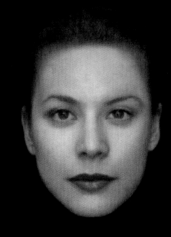
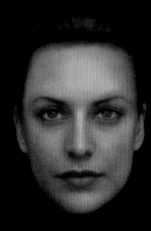

Gene For Race

Nelson Sizer
How to Study Strangers by Temperament, Face, and Head
1895

antebellum culture: before the Civil War, blacks were rarely allowed on the public stage.)[9] That grinning, coal-black face would become a divisive symbol of racial difference, and the idea that blackface was an accepted form of public spectacle further distanced African Americans from any hope of cultural assimilation, both on and off the stage.

Consider the language used to describe those whose faces do not telegraph what was, for generations, labeled as "mainstream," and at the unforgivably dehumanizing ethnic slurs that have, likewise, taken root over time. Redskins. Feathers. Coons. Coolies. Consider the branding: the Indian maiden on the Land-o-Lakes butter box, the Washington Redskins' "Chief Wahoo" logo. Think of Aunt Jemima and Uncle Remus and Mammy, of Speedy Gonzales and buck-toothed caricatures representing the face of the "Yellow Peril." True, xenophobia is not the same as racism, but to the extent that our reactions are triggered by visual difference, Native American faces, Asian faces, and African faces are not the same as white faces. History does not lie—and branding, all too often, does not help.

The United States Census now estimates that Caucasians will become a minority by 2043[10]—a full fifty years after New Eve made her virgin *Time* debut. These were also years during which American citizens

managed to elect a president who threatened to cut off aid to Central American nations by erecting a wall separating the United States from Mexico, thus advancing a partisan agenda that one *Washington Post* reporter recently described as a "xenophobic stew of fear, exaggeration and blatant lies."[11] The campaign promise to "Make America Great Again" served, if nothing else, to reassert a dogma of us versus them. If behavior is promoted by perception, how is xenophobia not a tacit form of racism? Visual evidence is racial evidence, and racial perception often begins with how we perceive the face.[12]

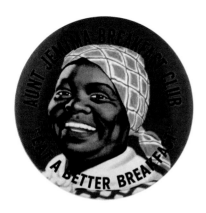

If that face is foreign to you, consider your own origin story, not so much from a genealogical perspective as an atomic one. Does wearing an Islamic veil make you a terrorist?[13] (Does wearing a red baseball cap make you a Republican?) In Daniel Defoe's classic novel *Robinson Crusoe*, his title character—the proverbial castaway—is adrift in his own personal odyssey. And how are any of us any different, adrift from our own narratives, seceding ever so gradually from our own centers of gravity, indeed, from one another? "Since scarce one family is left alive / Which does not from some foreigner derive."[14] Defoe wrote that in 1701. How is it that an Englishman writing more than three centuries ago understood so clearly what so many still may not: that resistance to the other is simply a denial of the self? That's not a political issue. It's a human one.

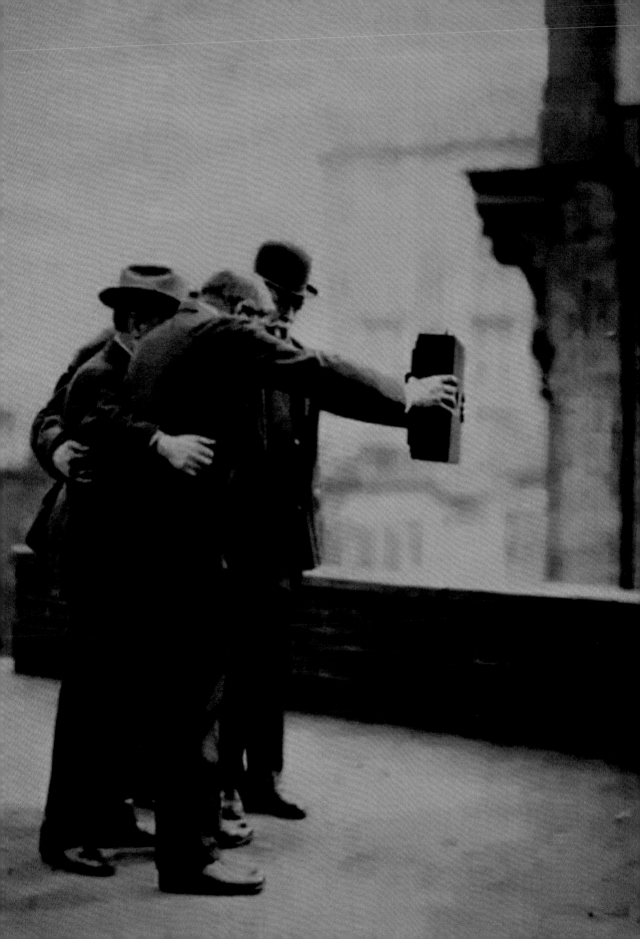

Y | You

For however dutifully we record what we see around us, the common denominator of all we see is always, transparently, shamelessly, the implacable "I."

Joan Didion

I am looking at a photograph of my family taken some years ago, at a friend's dinner table, early on a summer evening. My daughter, then about twelve, is looking at me. My son, two years older, is looking at my daughter. And I am looking at my son. It is a candid photo, neither planned nor premeditated, a random slice of a day that could so easily have been forgotten. And yet it is a remarkable picture— not because it tells a story, but because it tells a thousand stories— a cryptic, if melancholic, portrait of our little family at a particular moment in time.

My husband, who is also father to these children, is notably absent from this photo—not because he was the photographer (although wouldn't that have been a touching part of the story?) but because he is simply *not there*. He is not there most likely because he was working (something that pulled him away from us most of the time), yet his absence strikes me now, only a handful of years later, as eerily prescient. Within a few months, he would be diagnosed with an unforgiving illness that would colonize our lives with precipitous fury. He would die soon after, leaving the three of us to improvise on our own. In this photograph, we are doing just that: a trifecta in training.

The story here is as much about who is there as who is not there. The mysterious photographer. The missing parent. Images like these are like shuttlecocks, buoyant and airborne one moment, beacons of searing emotional power the next. "The trouble is that I don't see my face—or at least not at first," wrote Jean-Paul Sartre. "I carry it in front of me like a secret I am unaware of, and it is, on the contrary, the faces of others which teach me about my own."[1] In our pictures as in our memories, we see ourselves reflected in the faces of others.

On Christmas Day in 2006, *Time* magazine published its annual "person of the year" issue, with a strange twist: they didn't actually select a person. Instead, the cover featured a photo of a computer, on top of which lay a small, reflective paper rectangle—a makeshift mirror floating above a single, captivating word: *You.* "You control the information age," its cover proudly proclaimed. "Welcome to your world." The year 2006 was also when Facebook became available to anyone with an email address,[2] a scant year after YouTube was invented. (The selfie-stick was invented that same year.) Five years later, Apple introduced the iPhone 4 (the first to include a front-facing camera), and Instagram was launched. With mobility came opportunity, an enhanced, powerful desire for visual (and virtual) connectedness, and arguably, a new social order. This new *terra firma* was comprised of an archipelago of public platforms upon which to share and be shared, a shift that soon gave rise to a remarkable surge in self-portraiture. By 2014, every third photograph taken by an eighteen-to-twenty-four-year-old was of themselves. The age of "You" had arrived.[3]

As it happens, there turns out to be some curious historical precedent to all this. In 1902, the American sociologist Charles Horton Cooley published a book in which he described the concept of what he called the "looking glass self," the idea that the self grows out of our social interactions with others. (He called the self the citadel of the mind.) The thing that moves us to shame or pride, Cooley wrote, is not the mechanical reflection of ourselves, but "an imputed sentiment, the imagined effect of this reflection upon another's mind." [4] That idea of an imputed sentiment—transferring your shame onto someone else, or assuming that what you feel is what someone else feels equally— ascribes a kind of implicit performance to social interaction, readying the "you" for consumption and critique. ("To prepare a face to meet the faces that you meet," wrote T. S. Eliot of J. Alfred Prufrock.)[5] The idea of an imagined reflection, too, is a kind of adumbration—a word that comes from the Latin *adumbrare,* which in turn comes from *umbra* the word for "shadow"—nodding to the question of the shadow self, something both Freud and Jung explored in their work. (Like Cooley, both Carl Jung and Jacques Lacan each wrote about mirrors in relation to the unconscious, and questioned the degree to which we navigate, inevitably, by reflection.)[6]

If we see ourselves in the faces of others, that essential reciprocity is imbued with a kind of performative expectation: in-person, such response mechanisms may take the form of watching for facial cues, but virtual expression-seeking is no less penetrating, indeed, no less powerful. Writing in the 1960s, the Canadian-American social anthropologist Erving Goffman looked at attachment and avoidance, politeness and posing, and using theatrical metaphors—performance, staging, and, long before our current age of media saturation, something he called "frame analysis"—he defined "face" as "an image of the self which depends on both the rules and values of a particular society and the situation the social interaction is embedded in." [7]

Franklyn Swantek
Self-Portraits
1940s–1960s

The owner of Michigan's Swantek Photo Service (which billed itself as that state's largest operator and distributor of Photomatics), Franklyn Swantek took hundreds of photos of himself over the course of multiple decades of servicing the machines he apparently loved.

Donald Lokuta + Melissa Tomich Collection.

Jessica Dimmock
Still from *The Convention*
2015

Even before school I knew I was different but I just didn't know what it was. I hated playing football, although my size was such that I should have been good at it. But I hated it. Later in life I tried to suppress it and hide it. Most of my family knows. Those that matter to me know. There are some who would never understand, and if I ever come out to them, I'll lose them. There are still some people in my life who don't need—don't really need—to know.

Fran, 65

Opposite
Wedding Portrait
Paris
1935

Monique de Lasteyrie du Saillant, aged nineteen, taken before her wedding to Geraud de Miramon.

Private collection.

(Goffman also wrote thoughtfully, and rather unsentimentally, about racial perception and social stigma.) He helped to inaugurate what the now formally recognized sociological subdiscipline known as "face work," predicated on the notion that different societies retain particular ways of seeing and being seen, which raises curious questions about bigotry, tolerance, perspective—and habit.

In contemporary Western society, the "you" of habit is, increasingly, the "you" of the selfie—and what is a selfie but a love letter to yourself?[8] Quite a bit more, as it turns out: the notion of the highly mediated you—socially distributed, serially renewable—is the you of truth as well as the you of fiction. It's the you of social aspiration (bragging, posing) and the you of cultural assimilation (positioning, embedding). It's the you of psychic uncertainty (where you bravely battle your of demons of body dysmorphia) and the you of physical migration (where you boldly assert your capacity to venture beyond your own corporeal reality) and all the demonstrative "I was there" incarnations of you that circumnavigate your daily odysseys, all rendered photographically as proof of your own tour of duty here on earth. Harmless? Hubristic? Is the selfie an evidentiary kind of you, proof that our citadels deserve, even demand an audience?

We can say that taking pictures of our faces is a response to contemporary social demands, a method of reliably boosting our flagging self-esteem; that it tethers us to a bigger world by reinforcing our fleeting interconnectedness; or that we are just biologically hardwired to navigate through the density of the unknown by seeking faces that appeal to us, indeed, that resemble us. (By conjecture, we are equally prone to distancing ourselves from the opposite.) We can say that the selfie is myopic and vain, a reflection of soulless and superficial narcissism, or conversely, that it is reaffirming and

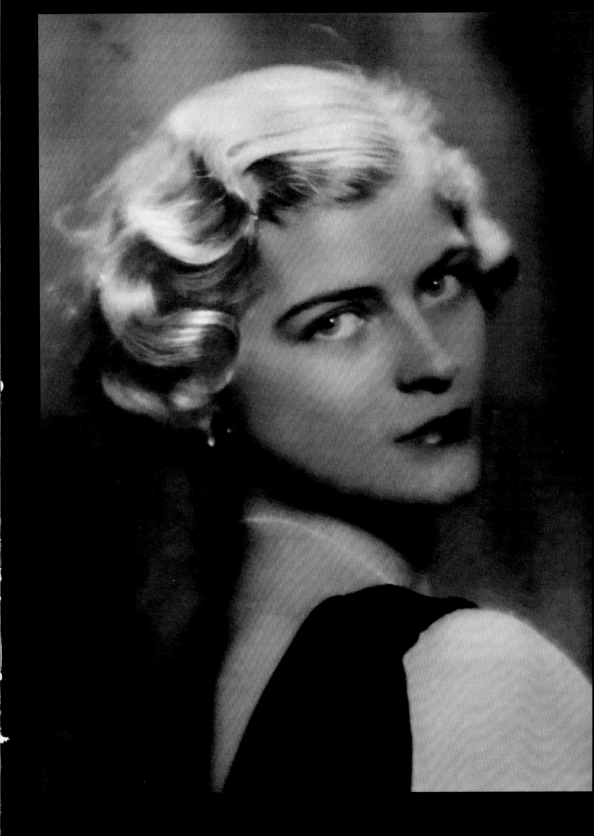

Every Man a Poster
Camp Hood, Texas
1943

Can glimpses of one's face function as public service announcements, even as cautionary tales?

Attributed to one Private Ivan A. Smith, who was then editor of the Camp Hood *Panther*, this poster was placed above mirrors in the latrines at Camp Hood, thus insinuating every soldier's face into the messaging. Together, the poster and mirror proved an effective system for reinforcing discretion.

Library of Congress.

powerful, a reclamation of agency for the socially marginalized. (It is likely a little of both.)

But if the you of the selfie is the you of agency, then why does it result in negative feelings? As a performative practice, it can be coded or cryptic, competitive or creative. As a social construct, it can make us feel jealous, flirtatious, prurient, or just lonelier. And as a booming industry, it drives everything from software development to plastic surgery to both the real and virtual cosmetics market. At once a behavior and a language, an economic driver and a cultural framework, that "love letter to yourself" is part of far more complex social apparatus that takes the distributed you and injects its own tags, prejudices, judgments, replications, distortions, meanings, and multiple points of micro-harvested data, thereby potentially subverting the you of your own bespoke narrative. Selfies may be intentional, but they're also impermanent. Just as young Dora Abravaya's details were sloppily misrecorded on her report card more than a century ago, so, too, will all those selfies randomly spray out across the multiple platforms of a future that remains, as yet, unseen.

While selfies may be defined as photographs one knowingly takes of oneself, they are also "created, displayed, distributed, tracked, and monetized through an assemblage of non-human agents,"[9] which raises critical questions about the relationship between you (read "agency") and the world (read "authority"). And here, finally, is perhaps the greatest irony of our media-obsessed age. How is it we have come this far, our handheld devices granting us the freedom to self-document, while the implicit gesture—uploading all those pictures, sharing all that data—means that we are, at the same time, willfully contributing to the very authority from which we've allegedly seceded? The you of any selfie endures only because of the sentiment that accompanies it, the narrative within which it is personally embedded, the memory and feeling that are summoned, like a deep intake of breath, to the human mind.

I am little, perhaps five years old, and there is a carnival in town. My mother has handed me a ticket to use—for a ride, a game, the choice, somewhat miraculously, is mine to make—when my red-headed, freckle-faced friend Colleen takes my hand and leads me to a man selling cotton candy. We give him our tickets. He gives us our cotton candy. We walk away, together and happy and free. I am drunk on independence, high on sugar, adrift in the delights of five-year-old heaven. I am unstoppable.

Until I am stopped. Suddenly, above the billowing pink cloud clutched in my tiny hands, the face of my mother appears—furious, reprimanding, resolute. Ours was a candy-free household and even here, even now, her rules are my rules, the rules I have so conveniently chosen to forget. She takes me by one hand, removes my cotton candy from the other hand, and returns it to the seller, or dumps it in the trashcan—I'm not sure—because here, my memory has dimmed with time. But the feeling has not dimmed in the least. (Nor has the memory of her adult face towering over me: the face of rebuke.) I remember the stinging pain of remorse, the embarrassment, the regret. I remember the shame, and most of all, I remember that I had witnesses: my friend, my mother, the world.

The story here is as much about who I was as who I wanted to be. The adventurous carnival-goer. The wannabe rule-breaker. It is moment I can never forget, for which I have no image of my own: yet an image of two girls clutching their own confections sends me, half a century later, into an emotional tailspin. (Those little faces! That steely determination!) You see yourself in pictures because they proffer themselves, like talismanic bits of treasured evidence, telegraphing a story about who you were. You see yourself in everyone's faces—and that is the entire point: not the posed you of the selfie, or the extracted you of the perfect data set, but the real and unedited you, the you that bears witness. "My God, such faces," writes Miranda Popkey, describing the casting choices in the television adaptation of Elena Ferrante's *Neapolitan Quartet*. "Sloppier and saggier, more wrinkled and more weathered and more crooked than many American readers will have imagined for these characters."[10] The real you is the you released by the wonders of the human imagination, where your face embeds itself in the untold mysteries of all that you are, and were, and ever will be.

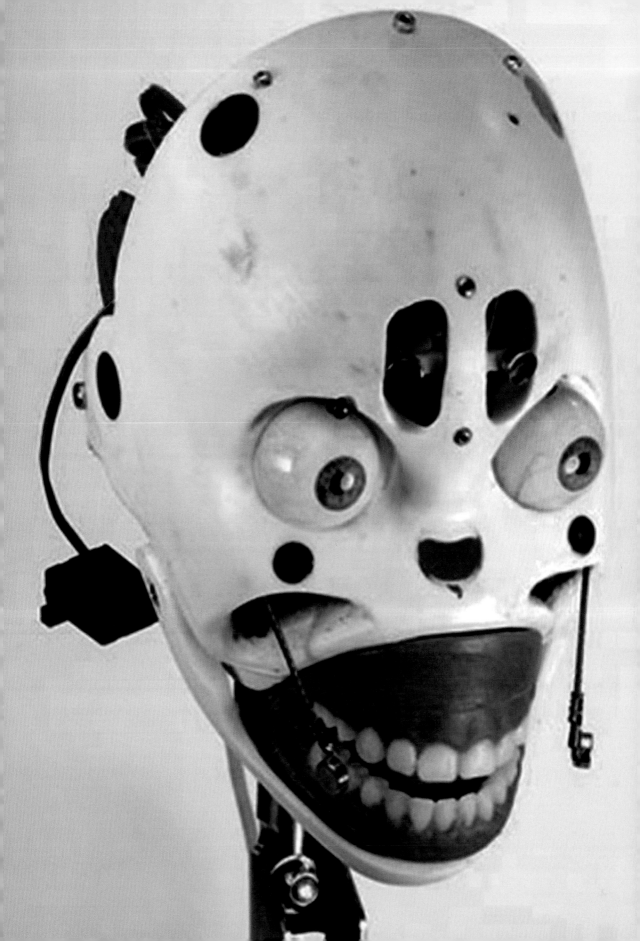

Z | Zeitgeist

The human face, ornamental as well as useful, is the self's finishing touch.

Dorothy Donelly

Today, in an age of multiple-frequency processing, where your pulse strives for vigilant contact with your wristwatch, the five senses you were born with seem nothing if not quaint. Our voices exiled to devices, our emotions cued by emojis, our faces dispersed across a myriad of platforms, services, systems, circuits, networks, frameworks and vast oceans of data—where's the "we" in all of that?

While the authority of the bloodline may be incontestable, our agency in the dissemination of our likenesses has ceased to be so simple. Our faces tell stories that are personal and anecdotal, visual and often irrepressibly viral, but those stories—and the methods by which they are both crafted and consumed—are also increasingly and insistently mercurial. True, mirrors reflect, but they also refract, changing direction and flaking off into particles you can neither capture nor control. Fake Instagram accounts (Finstas, for short) enable our faces to participate in more than one reality at a time. Such splintered self-representation is perhaps a uniquely modern condition: it bears saying that there's no particular penalty for such deceit (nor are there consequences for having multiple accounts) but as a public-facing expression of agency, there's still something fundamentally disingenuous about the entire proposition. Today's faces are highly mediated, freely distributed, chameleon-like, and fungible. What you think you see is not necessarily what you are going to get. Not anymore.

We live in an age of human annexation. Transhumanists subscribe to the belief that science and technology can (and will) override the limitations of the human race. Bioconservatives argue that artificial attempts to control augmentation will compromise human dignity.

Jamie Diamond
Jesus Heads,
From *Mother Love*
2014–2015

In collaboration with the Reborners—a group of self-taught female artists who hand-make, collect, and interact with hyper-realistic dolls—Diamond explores the ambiguity between reality and artifice, human and doll, artist and artwork.

Facial recognition protocols challenge our core definitions of what constitutes human privacy (the very practice essentially annexes your head) while the promises of augmented reality propose new immersive experiences that locate themselves at the very boundaries of optics, experience, perception, and space. When Emily Dickinson wrote "I feel physically as if the top of my head were taken off,"[1] she was describing poetry—not fakery—but today you can have both. There are tools (Emoji Me, Memoji) to let you venture forth with your own pictorially simulated proxy self, and apps (MSQRD, FaceApp) that let you retrofit your face into different gender, age, and even race representations. If those endeavors still seem too remote, Pitter Patter lets you "heartlink" your friends' heartbeats, in real time, on your Apple Watch. (The heart wants what it wants—even if it wants someone else's heart.)

We live in an age of decentralized presence. Our God-given faces—evocations of immediacy they might once have been—now present as portals into different dimensions, escape hatches to parallel worlds where authenticity itself is called into constant question. The adoption of the term "neural"—a word that once referred to the body's central nervous system—is now a prefix (and a premise) for a network that supports both the production and distribution of impeccable face forgeries. The enterprise known as the Deepfake (a portmanteau of "deep learning" and "fake") uses image synthesis and artificial-intelligence modeling techniques to engineer pitch-perfect face swaps. Shadowed by a subsidiary population lurking at the precipice of all that is seemingly real, the boundaries between these realities begin to seem startlingly unclear, and the language we use to describe it all is equally unsettling, borrowed from the body, annexed to the machine. If biomimicry apes the organic apparatus of the natural world, technology has begun to colonize the cognitive vocabularies of the mind. Will neural networks lead to cortical or vascular networks, limbic or arterial networks? (Neural networks, for the record, detect patterns in things: they're not capable of inference, or subtlety, or

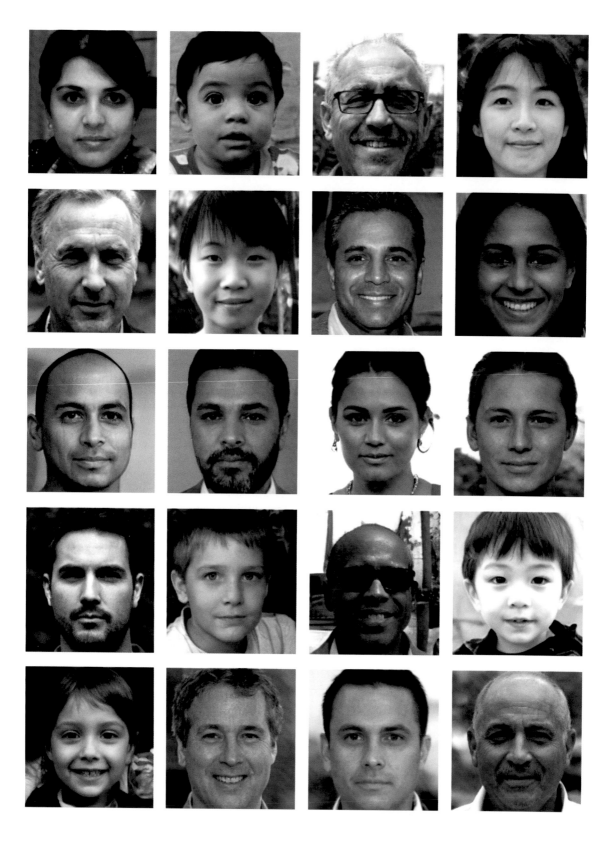

Phillip Wang
This Person Does Not Exist
2017

Using open source data and a generative
(GAN) algorithm developed by the graphics
card manufacturer Nvidia, Wang created a
site that randomly loads realistic images of
people who do not actually exist.

reasoning—like humans are.) [2] Our centers of gravity, once grounded
in the soul, are beginning, perhaps irrevocably, to shift.

We live, too, in an age of mechanical surrogacy. Simulated
humanoids—called love dolls or sexbots—come with optional fittings
including, but not limited to pelvic thrust motors, disposable vaginas,
nipple options, and interchangeable faces and heads. Facial spasms
that might (or might not) simulate sexual climax can be timed and
programmed, heat sensors can warm silicone-sculpted genitalia,
and apps can be customized to switch sexual orientation. Simulated
babies—called Reborns—come with optional fittings including, but
not limited to, rubbery umbilical cords, gurgle-enabled voice boxes, and
fairly convincing birth certificates. (You "adopt," rather than purchase,
a Reborn: their provenance demands paperwork.) Reborns ship with
powdery scents and pliable limbs, and can include eyes that tear, chest
cavities that breathe, and deftly engineered hair follicles that can
accommodate individually woven strands of (often human) hair. Like
sexbots, they're built from vinyls and polymers and other synthetic
materials, with chips and sensors designed to "humanize" them even
further. Both can be remarkably costly to customize. Neither requires
any actual social reciprocity. They're bloodless, emotionally inert—
and drama-free.

We live, too, in an age of scientific slippage. Where we once
measured the body with calipers, we can now rewrite genetic code.
Where we once imagined the face as a permanent fixture, we can now
envision a host of new and arguably progressive procedures that can
restore health, reassert youth, even reverse (or reaffirm) gender—but
can just as easily be deployed to curate (or for that matter, corrupt) an
embryo. Can you rework a gene sequence to anticipate, even eliminate
a congenital abnormality, or is that immoral, a eugenicist conceit? As
technology supersedes science, and as science struggles to keep up, the
ability to shape genetic sequences means we can edit for disease, but

it also means we can modify genetic data to gestate designer babies. The fall of 2018 saw the birth of the Crispr twins—the world's first gene-edited humans—a pioneering spectacle that immediately set off a firestorm of controversy over the ethics of genetic intervention. Among other vexing choices, the physicist in charge chose to only *partially* edit some of the genes, and why? Did he forget? Run out of time? Did he think that the embryo would just fill in the blanks, auto-completing the picture on her own, just like the half-baby gracing the cover of this book?

In the end, we live, always, in the age of the relational. What's visual is emotional, and what's emotional is human. What's beautiful is personal, and what's personal is, by definition, unequivocally authentic. Can authenticity be adjudicated as a measure of external authority? Are we defined by our metrics, valued by what can be siphoned, harvested, quantified? Hardly. Ours are the faces of poetry and literature, of adventure and war, of transnational identity and transitional gender. That we are all delineated by the involuntary fallout of the gene pool tells only part of the story. In the end as in the beginning, our faces offer the procreative proof of prior unions. We are all biological palimpsests, vessels of ancestral truth, carriers of our own genetic indices. From blood type to body type, biotype to phenotype, the study of human evolution tells a kaleidoscopic story of stunning physical, cultural, and emotional diversity, and it is across that remarkable spectrum that we persist. Surrogacy is a measure of stewardship, not a substitute for agency. (We breathe on our own.) Intelligence is a sentient gift, not a construction of artifice. (We think for ourselves). Optics are perspectival capabilities, not marketing tools. (We see because we can.) We are people—not promissory notes—and if our faces make us who we are, it is because they connect us to our past and to our future, but more than anything, they connect us to each other. Humanity is not now, nor should it ever be, a zero-sum game. The heart may want many things, but it should certainly want that.

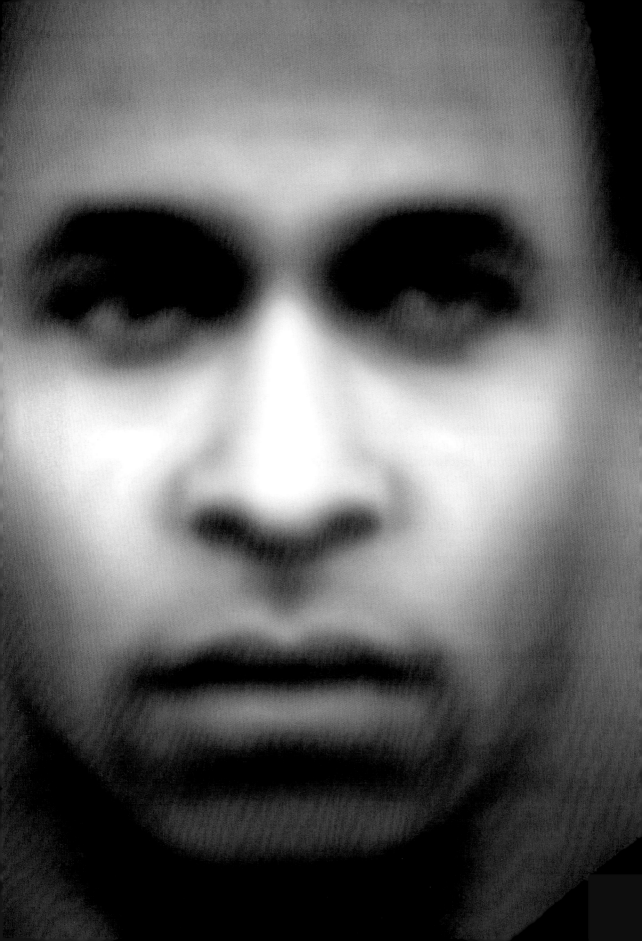

Notes

Prologue | The Mirror Is a Civil War

Carl Sandberg, "Prologue," *The Family of Man*, ed. Edward Steichen (New York: Museum of Modern Art, 1955; Thirtieth Anniversary Edition 1986), 4.

1. Béla Balázs, *Theory of the Film: Character and Growth of a New Art*, trans. Edith Bone (London: Dennis Dobson, 1952), 40.

2. American Academy of Facial Plastic and Reconstructive Surgery, "Social Media Makes Lasting Impact on Industry— Becomes Cultural Force, Not Fad," news release, January 29, 2018, https://www.aafprs.org/media/stats_polls/m_stats.html.

3. Italo Calvino, "The Adventure of a Photographer," in *Difficult Loves* (San Diego: Harcourt Brace Jovanovich, 1984), 228.

A | Anthropometry

1. The Health Insurance Portability and Accountability Act of 1996, or HIPAA, was enacted by the United States Congress and signed by President Bill Clinton in 1996.

2. The Greek term *kalokagathia* referred to the idea that being physically beautiful was the same as being ethically good, and a perfect face meant a perfect spirit. See Will Storr, *Selfie: How We Became So Self-Obsessed and What It's Doing to Us* (New York: Overlook Press, 2017), 54.

3. Galton's contributions to the study of the face will be examined in subsequent chapters, but it bears mention here that he specifically chose *not* to measure the head, claiming that it would be troublesome to perform on most women "on account of their bonnets, and the bulk of their hair." See Francis Galton, *"On the Anthropometric Laboratory at the late International Health Exhibition,"* *Journal of the Anthropological Institute of Great Britain and Ireland* 14 (1885): 210.

4. Bertillon published several lengthy books describing his methods, including *Instructions For Taking Descriptions for the Identification of Criminals and Others, by Means of Anthropometric Indications* (1889) and *Identification Anthropometique* (1893) which is available for free download on archive.org. For more on the ethics and imagery surrounding Bertillon's work, see "Decomposing Bodies," Visual Media Workshop at the University of Pittsburgh.

5. Quetelet's seminal contributions to measurement include the Quetelet Index, which has since become known as the body mass index, or BMI. See Adolphe Quetelet, *Sur l'homme et le développement de ses facultés* (Paris: Bachelier, 1835), and Kevin Donnelly, *Adolphe Quetelet, Social Physics and the Average Men of Science,*

1796–1874 (London: Pickering & Chatto, 2015).

6. Bertillon published *Identification anthropométrique: Instructions signalétiques* in 1885. It was translated into English two years later as *Signaletic Instructions Including the Theory and Practice of Anthropometrical Identification* and continued as the dominant criminal identification method both in the United States and Europe for almost three decades. For more on the evolution and adaptation of Bertillonage, see "Bertillon System of Criminal Identification," National Law Enforcement Museum, accessed December 20, 2018, http://www.nleomf.org/museum/news/newsletters/online-insider/november-2011/bertillon-system-criminal-identification.html.

7. Originally published in 1876, *Criminal Man* went through five editions during Lombroso's lifetime. A scholarly English translation was published in 2006. See Cesare Lombroso, *Criminal Man*, trans. with new introduction by Mary Gibson and Nicole Hahn Rafter (Durham: Duke University Press, 2006).

8. Quoted in Richard Farebrother and Julian Champkin, "Alphonse Bertillon and the measure of man: More expert than Sherlock Holmes*," Significance* 11 (April 2014): 36.

9. Joy Buolamwini founded (and leads) the Algorithmic Justice League at MIT as part of an ongoing effort to fight bias in machine learning. For more, see http://facethegaze.com.

B | Biometrics + Bias

1. Stefanos Zafeiriou et al., "The Photoface database," *CVPR WORKSHOPS* (Colorado Springs, CO, 2011), 132–139.

2. Murad Al Has et al, "Beyond the Static Camera: Issues and Trends in Active Vision," in *Visual Analysis of Humans: Looking at People*, ed. Thomas Moeslund, Adrian Hilton, Volker Krüger, and Leonid Sigal (London: Springer-Verlag, 2011), 13.

3. Jesse Davis West, "A Brief History of Face Recognition," *FaceFirst* (blog), August 1, 2017, https://www.facefirst.com/blog/brief-history-of-face-recognition-software.

4. Christopher Robbins, *The Invisible Air Force: The Story of the CIA's Secret Airlines* (London: McMillan, 1979), 65.

5. Bledsoe's first report, dated 30 January 1963, was called *A Proposal for a Study to Determine the Feasibility of a Simplified Face Recognition Machine*; this second, *Facial Recognition Project Report*, was published in March of the following year. Both are available for free download on archive.org.

6. Jennifer Tucker, "How Facial Recognition Technology Came to Be," *The Boston Globe,* November 23, 2014.

7. When the Senate Judiciary committee met in 2012 to examine facial recognition in light of protecting civic liberties, the panel

was led by former actor-turned-Senator Al Franken, prompting one journalist to observe at least one implicit irony. "The man with the most recognizable face in Congress is worried about the citizens of America being as easily recognized as he is, thanks to facial recognition technology." Kashmir Hill, "Sen. Al Franken Grills Facebook and the FBI Over Their Use of Facial Recognition Technology," *Forbes*, July 18, 2012.

8. Charles Darwin, "A Biographical Sketch of an Infant," *The Mind* 2, no. 7 (July 1877): 285–294. Beside Darwin and Lacan, Carl Jung also wrote about the mirror and the archetype with regard to the reflected self. The American sociologist Charles Horton Cooley's contributions to the study of human reflection—what he called "the looking glass self"—will be explored in a subsequent chapter.

9. Leslie A. Zebrowitz and Robert G. Franklin, "The Attractiveness Halo Effect and the Babyface Stereotype in Older and Younger Adults: Similarities, Own-Age Accentuation, and Older Adult Positivity Effects," *Experimental Aging Research* 40, no. 3 (May/June 2014): 375–393. More recently, simple facial width-to-height ratios offered researchers ways to to optimize and predict character traits, and good-looking Airbnb hosts appear more trustworthy to consumers (and may charge higher rental fees as a result). Bastian Jaeger, Willem W.A. Sleegers, Anthony M. Evans, Mariëlle Stel, Ilja van Beest, "The effects of Facial Attractiveness and Trustworthiness in Online Peer-to-Peer markets," *Journal of Economic Psychology,* published ahead of print, November 22, 2018. https://doi.org/10.1016/j.joep. 2018.11.004. See also Alexander Todorov, *Face Value: The Irresistible Influence of First Impressions* (Princeton: Princeton University Press, 2017), 178.

10. Like algorithmic bias, biometric data can misrepresent, malign, or even ignore accurate information about people of color. In her excellent book, *Dark Matters: On the Surveillance of Blackness*, the American scholar Simone Browne argues for a critical reassessment. "My suggestion here," writes Browne, "is that questioning the historically present workings of branding and racializing surveillance, particularly in regard to biometrics, allows for a critical rethinking of punishment, torture, and our moments of contact with our increasingly technological borders." Simone Browne, *Dark Matters: On the Surveillance of Blackness* (Duke University Press, 2016), 128.

11. Mary Bergstein, "Photography in the Szondi Test: 'The Analysis of Fate,'" *History of Photography* 41, no, 3 (2017): 217–240. See also John T. Hamilton, "Social desirability and the perception of faces in the Szondi test" (PhD diss., University of Ottawa, 1961).

C | Caricature + Close-ups

Henri Bergson, *Laughter: An Essay on the Meaning of the Comic*, trans. Cloudesley Brereton and Fred Rothwell (New York: MacMillan, 1911), 26.

1. Harvard Professor emeritus David Perkins has noted that portrait caricature strives for a balance between individuation and exaggeration, thus ensuring efficient recognition in the viewer. David A. Perkins, A Definition of Caricature and Caricature and Recognition," *Studies in the Anthropology of Visual Communication* 2, no. 1 (Spring 1975): 10.

2. Calling them pre-humanitarian, Jones writes: "The grotesque heads of Leonardo are some of the strangest, most unassimilable objects in world art—and one of the oddest things about these gurning prodigies is that many are owned by the British royal family." Jonathan Jones, "The Marvellous Ugly Mugs," *The Guardian*, December 4, 2002.

3. Leonardo da Vinci, *Leonardo on Painting: An Anthology of Writings by Leonardo da Vinci,* edited and translated by Martin Kemp and Margaret Walker (New Haven: Yale University Press, 2001), 220. More extensive scholarship into the relationship between Leonardo's work in art and science can be found here. http://faculty.virginia.edu/Fiorani/NEH-Institute/essays/resources/leonardos-writings/manuscripts-a-m.

4. Werth writes brilliantly about the face in the context of modernity in the early twentieth century. "During this period, she writes, "questions were being raised about the universality of facial expression, the normative and deviant models of facial morphology, and how the face might be pictured." Margaret Werth, "Modernity and the Face," *Intermédialités* 8 (Autumn 2006): 94. See also Jacques Aumont, *Du visage au cinéma* (Paris: Éditions de L'Étoile, 1992), 68, and Georg Simmel, "The Aesthetic Significance of the Face [1901]," trans. Lore Ferguson, in *Essays on Sociology, Philosophy and Aesthetics,* ed. Kurt H. Wolff (New York: Harper & Row, 1965), 278–279.

5. "A real close-up of an actor is about going in for an emotional reason that you can't get any other way," writes film critic Paul Schrader. Paul Schrader, "Game Changers: The Close Up," *Film Comment* 50, no. 5 (September/October 2014): 58.

6. Stage-trained method actors in Lee Strasberg's Actor's Studio were trained precisely for this purpose: to communicate silently, resulting in a powerful kind of psychological realism. Strasberg stressed, above all, the centrality of the face in the actor's craft. Lee Siegel, "On The Face of It," in *Striking Resemblance: The Changing Art of Portraiture,* ed. Donna Gustafson and Susan Sidlauskas (Munich: Prestel Verlag, 2014), 60–61.

7. Michael Kimmelman, "Mementos of a Revolution Repressed," *New York Times,* June 13, 1997.

8. "For Walter Benjamin, the close-up was one of the significant entrance points to the optical unconscious, making visible what in daily life went unseen." Mary Ann Doane, "The Close-Up: Scale and Detail in the Cinema," *Differences* 14, no. 3 (2005): 90.

9. Walter Benjamin, "The Work of Art in the Age of Mechanical Reproduction," in *Illuminations* (New York: Schocken Books, 1978), 217–241 and Jean Baudrillard, *The Ecstasy of Communication* (Los Angeles: Semiotext(e), 2012), 43.

D | Diagnosis

Carson McCullers, *The Heart Is a Lonely Hunter* (Boston: Houghton Mifflin, 1940).

1. Walter Benjamin, "Little History of Photography," in *Walter Benjamin: Selected Writings,* vol. 2, part 2, 1931–1934, ed. Michael W. Jennings, Howard Eiland, and Gary Smith (Cambridge: The Belknap Press of Harvard University Press, 1999), 508–530.

2. G. B. Duchenne de Boulogne, *Mechanism of Human Facial Expression,* ed. and trans. R. Andrew Cuthbertson (Cambridge: Cambridge University Press, 1990), 36.

3. Duchenne de Boulogne, *Mechanism of Human Facial Expression,* 43.

4. Georges Guillain, *Jean-Martin Charcot: Sa vie, son oeuvre* (Paris: Masson, 1955), 54.

5. Jean Martin Charcot, "A Science Odyssey: People and Discoveries," Public Broadcasting Service (PBS), 1998.

6. Why the face, Didi-Huberman asks? "Because in the face the corporeal surface makes visible something of the movements of the soul, ideally. This also holds for the Cartesian science of the expression of the passions, and perhaps also explains why, from the outset, psychiatric photography took the form of an art of the portrait. Georges Didi-Huberman, *Invention of Hysteria: Charcot and the Photographic Iconography of the Salpêtrière* (Cambridge: MIT Press, 2003), 3, and Andrew Scull, *Madness in Civilization: A Cultural History of Insanity, from the Bible to Freud, from the Madhouse to Modern Medicine* (Princeton: Princeton University Press, 2015), 49.

7. Mesmer himself, the Viennese physician and father of hypnosis, influenced not only Charcot but another Viennese physician, Sigmund Freud, who trained under Charcot as well.) Alain Lellouch, "Charcot, Freud et l'inconscient," *Histoire des sciences médicales* 38, no. 4 (2004): 411–418.

8. André Parent, Martin Parent, and Véronique Leroux-Hugon, "Jules Bernard Luys: A Singular Figure of 19th Century Neurology," *Canadian Journal of Neurological Sciences* 29, no. 3 (August 2002): 285.

9. Hugh Diamond, "On the Application of Photography to the Physiognomic and Mental Phenomena of Insanity," read before the Royal Society of London, May 22, 1856, in Sander Gilman, *The Face of Madness: Hugh W. Diamond and Psychiatric Photography* (New York: Bruner/Mazel Publishers, 1976), 20.

10. Caroline Alexander, "The Shock of War," *Smithsonian Magazine* (September 2010) https://www.smithsonianmag.com/history/the-shock-of-war-55376701. The French scholar Antoine Prost estimates that these numbers may have been considerably higher. See Antoine Prost, "The Dead," in *The Cambridge History of the First World War,* vol. 3: *Civil Society,* ed. Jay Winter (Cambridge: Cambridge: Cambridge University Press, 2014), 561–591, https://doi.org/10.1017/CHO9780511675683.

11. Jonathan W. Marshall. *Performing Neurology: The Dramaturgy of Dr. Jean-Martin Charcot* (New York: Palgrave Macmillan, 2016), 53.

E | Evolution, Expresion + Eugenics

Ludwig Wittgenstein, *Remarks on the Philosophy of Psychology,* ed. G. E. M. Anscombe and G. H. von Wright, trans. G. E. M. Anscombe (Oxford: Basil Blackwell, 1980).

1. Amy Ione, review of *Darwin's Camera: Art and Photography in the Theory of Evolution,* by Phillip Prodger, *Leonardo* 44, no. 1 (2011): 78–80.

2. Charles Darwin, *The Expression of the Emotions in Man and Animals* (New York: D. Appleton & Co., 1873), 236.

3. P. Ekman and W. Friesen, *Facial Action Coding System: A Technique for the Measurement of Facial Movement* (Palo Alto: Consulting Psychologists Press, 1978).

4. Allan Sekula, "The Body and the Archive," *October* 39 (Winter 1986): 47.

5. Francis Galton, "Eugenics: Its Definition, Scope, and Aims," *American Journal of Sociology* 10, no. 1 (July 1904): 1.

6. Alexandra Minna Stern, "Making Better Babies: Public Health and Race Betterment in Indiana, 1920–1935," *American Journal of Public Health* 92, no. 5 (2002): 742–752.

7. "Table of sterilizations done in state institutions under state laws up to and including the year 1940," The Harry H. Laughlin Papers, Truman State University. See also Mark A. Largent, *Breeding Contempt: The History of Coerced Sterilization in the United States* (New Brunswick: Rutgers University Press, 2008).

8. "One of Batut's principal interests seems to have been in using his technique to demonstrate physical characteristics, and he expressly states that his composite portraits are a form of virtual reality or 'images of the invisible.'" Peter Hamilton and Roger Hargreaves, *The Beautiful and the Damned: The Creation of Identity in Nineteenth Century Photography* (London: National Portrait Gallery, 2001), 99.

9. Melissa Percival, "Johann Caspar Lavater, Physiognomy and Connoisseurship," *Journal for Eighteenth-Century Studies* 26, no. 1 (2003): 77–90. See also August Sander, *Citizens of the Twentieth Century: Portrait Photographs, 1892–1952* (Cambridge: MIT Press, 1986), 24.

10. Susan Sontag, *On Photography,* electronic ed. (New York: Farrar, Straus & Giroux, 1973; New York: Rosetta Books, 2005), 26.

F | Facsimiles + Fragility

Walter Benjamin, "The Work of Art in the Age of Mechanical Reproduction" (1935).

1. Sarah Jeong, "Appeals Court Blasts PETA for Using Selfie Money as 'An Unwilling Pawn,'" *The Verge*, April 24, 2018, https://www.theverge.com/2018/4/24/17271410/

monkey-selfie-naruto-slater-copyright-peta.

2. Claudia Schmölders, writing about Hitler, describes the face as having a kind of "visible everyday legitimacy." See Claudia Schmölders, "The Face That Said Nothing: Physiognomy in Hitlerism," in *Unmasking Hitler: Cultural Representations of Hitler from the Weimar Republic to the Present*, ed. Klaus L. Berghahn and Jost Hermand (Oxford: Peter Lang Publishers, 2005), 30.

3. Galton was afraid of the inevitable errors of subjective judgment, and therefore entrusted a 'machine' to make the ultimate judgment. Bernadette Wegenstein and Nora Ruck, "Physiognomy, Reality Television and the Cosmetic Gaze," *Body & Society* 17, no. 4 (December 2011): 37.

4. Polaroid's SX-70 Land Camera, Laurence Olivier, advertisement, NBC Evening News, August 8, 1974.

5. Sharrona Pearl, *Face/On: Face Transplants and the Ethics of the Other* (Chicago: University of Chicago Press, 2017), 52.

G | The Gaze

Marcel Proust, *Swann's Way*, trans. C. K. Scott Moncrieff (New York: Henry Holt and Co., 1922), 242.

1. Each of these writers has written at length about the face and the gaze. See Yvonne Vera, quoted in Teju Cole, "On Photography," *New York Times Sunday Magazine*, February 10, 2019, p. 16; Ann E. Kaplan, *Looking for the Other: Feminism, Film and the Imperial Gaze* (New York: Routledge, 1997); bell hooks, "The Oppositional Gaze: Black Female Spectators," in *The Film Theory Reader: Debates and Arguments* (New York: Routledge, 2010), 229–242; Marianne Hirsch, *The Familial Gaze* (Hanover: University Press of New England, 1999); Joy Buolamwini, "When the Robot Doesn't See Dark Skin," *New York Times*, June 21, 2018; and Bernadette Wegenstein and Nora Ruck, "Physiognomy, Reality Television and the Cosmetic Gaze," *Body & Society* 17, no. 4 (December 2011): 27–55. Wegenstein expands upon her theory of the moralizing gaze in the essay "Mechanic Sutures: From Eighteenth-Century Physiognomy to Twenty-First Century Makeover," published in *Throughout: Art and Culture Emerging with Ubiquitous Computing*, ed. Ulrik Ekman (Cambridge: MIT Press, 2013), 371.

2. Victor Burgin, "Work and Commentary," in *Situational Aesthetics: Selected Writings by Victor Burgin*, ed. Alexander Streitberger (Leuven: Leuven University Press), 29.

3. Laura Mulvey, "Visual Pleasure in Narrative Cinema," *Screen* 16, no. 3 (October 1975): 6–18.

4. Jacques Derrida, "There Is No *One* Narcissism (Autophotographics)," In *Points . . . Interviews, 1974–1994* (Stanford University Press, 1995), 200–201.

5. John Urry, "Tourism, Culture and Social Inequality," in *The Sociology of Tourism: Theoretical and Empirical Investigations*, ed. Yiorgos Apostolopoulos, Stella Leivadi, and Andrew Yiannakis (New York:

Routledge, 1996), 115–133.

6. Michel Foucault. *The Birth of the Clinic: An Archaeology of Medical Perception* (New York: Vintage Books, 1994), 120. The quantification and measurement of the gaze has become a far more computational enterprise in recent years. See Andrew Gee and Roberto Cipolla, "Determining the Gaze of Faces in Images," *Image and Vision Computing* 12, no. 10 (December 1994): 639–647.

7. In contemporary terms, the predictive gaze is defined as a psychological function of that which is attention-driven and directional. See Andrew P. Bayliss and Steven P. Tipper, "Predictive Gaze Cues and Personality Judgments: Should Eye Trust You?" *Psychological Science* 17, no. 6 (June 2006): 514–520.

H | Heredity, Headshots + Hypocrisy

Thomas Hardy, "Heredity," in *Moments of Vision and Miscellaneous Verses* (London: MacMillan and Co., 1917), 15.

1. Aileen Kwun, "How the Alexandria Ocasio-Cortez campaign got its powerful design," *Fast Company*, June 29, 2018, https://www.fastcompany.com/90180561/how-the-alexandria-ocasio-cortez-campaign-got-its-powerful-design. As Ocasio-Cortez says in her powerful campaign video, calling for more diverse racial, cultural, generational, and ideological representation in the face of monied, career politicians: "This race is about people versus money. They have money, we have people." Alexandria Ocasio-Cortez, "The Courage to Change," video, 2:08, May 30, 2018, https://youtu.be/rq3QXIVR0bs.

2. Sontag, *On Photography*, 30.

3. John Shaffer et al., "Genome-Wide Association Study Reveals Multiple Loci Influencing Normal Human Facial Morphology," *PLoS Genetics* 12, no. 8 (August 25, 2016).

4. Carmen Emilia Lefevre et al., "Facial Width-To-Height Ratio Relates to Alpha Status and Assertive Personality in Capuchin Monkeys," *PLoS ONE* 9, no. 4 (April 4, 2014).

I | Identity

Ralph Waldo Emerson, "Behavior," in *Ralph Waldo Emerson: The Complete Works,* vol. 6: The Conduct of Life, 1904.

1. Jane Caplan and John Torpey, *Documenting Individual Identity The Development of State Practices in the Modern World* (Princeton: Princeton University Press, 2001), 124.

2. Martyn Lyons, *Napoleon Bonaparte and the Legacy of the French Revolution* (London: Macmillan, 1994), 119. For more on the history of the French ID card, see Pierre Piazza, *Histoire de la Carte Nationale D'Identité* (Paris: Editions Odile Jacob, 2004).

3. Peter Hamilton and Roger Hargreaves,

The Beautiful and the Damned: The Creation of Identity in Nineteenth Century Photography (London: National Portrait Gallery, 2001), 103.

4. "The pictures are unremarkable—which is, of course, the secret of their power."

Ralph Blumenthal, "The Holocaust Children Who Did Not Grow Up," *New York Times*, December 5, 1996. See also Serge Klarsfeld, *French Children of the Holocaust: A Memorial* (New York: New York University Press, 1996).

5. According to John Torpey's *The Invention of the Passport,* a man named Richebourg claimed in an article in the July 22, 1854, edition of *La Lumière* to have introduced the idea of the passport photograph. John Torpey, *The Invention of the Passport: Surveillance, Citizenship and the State* (Cambridge: Cambridge University Press, 2000), 62. For more origins of the passport, see Martin Lloyd, *The Passport: The History of Man's Most Travelled Document* (Stroud: Sutton, 2003).

6. Lily Cho, "Citizenship, Diaspora and the Bonds of Affect: The Passport Photograph," *Photography & Culture* 2, no. 3 (2009): 275–288.

7. Mary Oliver, *Our World* (Boston: Beacon Press, 2007), 71.

J | Judgment

Carl Gustav Jung, *Flying Saucers: A Modern Myth of Things Seen in the Sky* (1959), trans. R.F.C. Hull (Princeton University Press, 1979).

1. Plato, *Phaedrus*, trans. Benjamin Jowett, 360 B.C.E., http://classics.mit.edu/Plato/phaedrus.html.

2. Blaise Pascal, *Pensées* (1670; London: Penguin Classics, 2003), 535.

3. Satoshi Kanazawa and Mary C. Still, "Is There Really a Beauty Premium or an Ugliness Penalty on Earnings?" *Journal of Business Psychology* 33, no. 2 (April 2018): 249–262.

4. M. P. Haselhuhn, M. E. Ormiston, and E. M. Wong, "Men's Facial Width-to-Height Ratio Predicts Aggression: A Meta-Analysis," *PLoS One* 10, no. 4 (2015): e0122637, published April 7, 2015, doi:10.1371/journal.pone.0122637.

5. Five-factor model of personality. Available from https://www.researchgate.net/publication/264476432_Five-factor_model_of_personality, accessed July 26, 2018.

6. Alexander Todorov, *Face Value: The Irresistible Influence of First Impressions* (Princeton: Princeton University Press, 2018).

7. The "not" face is defined as a "grammaticalization of facial expressions of emotion shows that "people from different cultures expressing negation use the same facial muscles as those employed to express negative moral judgment." C. Fabian Benitez-Quiroza, Ronnie B. Wilbur, and Aleix M. Martinez, "The Not Face: A

Grammaticalization of Facial Expressions of Emotion," *Cognition* 150 (May 2016): 77–84.

8. Havelock Ellis, the nineteenth century British physician and writer on human sexuality, eugenics, and psychedelic drugs wrote of this medieval law. Havelock Ellis, *The Criminal* (New York: Scribner & Welford, 1890), 94.

9. Dr. Joseph Kahn, *Catalogue of Dr. Kahn's Anatomical Museum.* (London, 1851), 50.

10. Lauren Musu-Gillette et al., *Indicators of School Crime and Safety: 2016* (Washington: National Center for Education Statistics, U. S. Department of Education, and Bureau of Justice Statistics, Office of Justice Programs, US Department of Justice, 2017), 170.

11. Sameer Hinduja and Justin W. Patchin, "Bullying, Cyberbullying, and Suicide," *Archives of Suicide Research* 14, no. 3 (July 2010): 206–221.

12. Shahak Shapira is an Israeli-German writer whose controversial online project (in which he combined selfies from the Holocaust Memorial in Berlin wiuth actual footage from the camps) entitled Yolocaust was visited by more than 2.5 million people before he took it down. For more, visit https://yolocaust.de.

K | Keepsakes

Walter Benjamin, "The Work of Art in the Age of Its Technological Reproducibility" (second version), in *Walter Benjamin: Selected Writings*, vVol. 3, 1935–1938, ed. Howard Eiland and Michael W. Jennings (Cambridge: The Belknap Press of Harvard University, 2002), 108

1. Thierry de Duve, "Time Exposure and Snapshot: The Photograph as Paradox," in *Photography Theory*, ed. James Elkins (New York: Routledge, 2013), 110.

2. For more on the social history of the school portrait, see Catherine Burke and Helena Ribeiro de Castro, "The School Photograph: Portraiture, and the Art of Assembling the Body of the Schoolchild," *History of Education* 36, no. 2 (March 2007): 213–226. Also Claudia Mitchell and Sandra Weber, "Picture This! Class Line-ups, Vernacular Portraits and Lasting Impressions of School," in *Image-based Research: A Sourcebook for Qualitative Researchers*, ed. John Prosser (New York: Routledge, 1998): 197–213.

3. Shiry Ginosar et al., "A Century of Portraits: A Visual Historical Record of American High School Yearbooks," *IEEE Transactions on Computational Imaging* 3, no. 3 (September 2017): 421–431.

4. Sarah Maslin Nir, "No Boo-boos or Cowlicks? Only in School Pictures," *The New York Times,* November 19, 2010. For the British context see Lucy Ward, "Embarrassing Old School Photos Are History: Smile for a Smart Studio Shot," *The Guardian*, March 12, 2013.

5. Oliver James, *Office Politics* (London: Vermillion, 2014).

6. Lorna Roth. "Looking at Shirley, the

Ultimate Norm: Colour Balance, Image Technologies, and Cognitive Equity," *Canadian Journal of Communication* 34 (2009): 111–136.

7. For more on the evolution of the machinery and its popularity across a global spectrum, see Mark Bloch, "Behind the Curtain: A History of the Photobooth," http://www.panmodern.com/photobooth.htm.

8. Brian Dillon, "Forget Me Not: An Interview with Geoffrey Batchen," *Cabinet Magazine* 14 (Summer 2004).

L | Likenesses + Lies

E. H. Gombrich, "The Mask and the Face: The Perception of Physiognomic Likeness in Life and Art," in E. H. Gombrich, Julian Hochberg, and Max Black, *Art, Perception and Reality* (Baltimore: Johns Hopkins University Press, 1973), 13.

1. Hippocrates, *Prognostic 1*, in *Hippocrates*, vol. 2*,* trans. W. H. S. Jones (Cambridge: Harvard University Press, 1923), 9.

2. Milan Kundera, *Immortality*, trans. Peter Kussi (New York: Grove Weidenfeld, 1991), 12.

3. Davide Stimilli, *The Face of Immortality: Physiognomy and Criticism* (Albany: State University of New York Press, 2005), 65.

4. Johann Caspar Lavater, *Essays on Physiognomy: For the Promotion of the Knowledge and the Love of Mankind* (London: G. G. J. & J. Robinson, 1804), 25.

5. Toi Derricotte, "A Note on My Son's Face," in *Captivity* (Pittsburgh: University of Pittsburgh Press, 1989), 66.

6. Philip Larkin, "This Be the Verse," in *Collected Poems*, ed. Anthony Thwaite (London, Faber and Faber, 1988), 180.

7. William Shakespeare, Sonnet 20

8. Quoted in Evan Charteris, *John Sargent* (New York: Charles Scribner's Sons, 1927), 157.

9. Gertrude Stein, "Sugar," in *Tender Buttons*, 1914, Corrected Centennial Edition (San Francisco: City Lights Books, 2014).

10. "The Face of the Future Rears Its Head," University of Cambridge, March 19, 2013, https://www.cam.ac.uk/research/news/face-of-the-future-rears-its-head.

11. William Shakespeare, *Hamlet*, act III, scene I.

M | Masks + Mirrors

Peter Davison, "Sacrificial Mask," *Poetry* 98, no. 4 (July 1961): 210.

1. Rod Sterling, "The Eye of the Beholder," *The Twilight Zone*, season 2, air date: November 11, 1960:

2. Frederich Nietzsche, *Human, All Too*

Human: A Book for Free Spirits, 2nd ed., trans. R. J. Hollingdale (Cambridge: Cambridge University Press, 1996), 152.

3. Of his friend Cesare Pavese, Calvino sees a "mask of bashfulness" as a misleading facade concealing his friend's depression and subsequent suicide at the age of 42. "The Letters of Italo Calvino, Day II," *New Yorker*, May 14, 2013. In a more contemporary Italian story of facelessness, Elena Ferrante, the pseudonymous author of the bestselling Neapolitan novel series published in 2017 has famously refused to show her face in public: masking as identity protection. Rachel Donadio, "An Open Letter to Elena Ferrante—Whoever You Are," *The Atlantic*, December 2018.

4. Michael Ondaatje, *The English Patient* (New York: Vintage International, 2011), 48.

5. "Haudenosaunee (Iroquois) False Face Society Masks," *Theirs or Ours? Exploring the Repatriation of Individuals and Objects* (blog), Vassar College, March 7, 2017, https://pages.vassar.edu/theirsorours/2017/03/07/haudenosaunee-iroquois-false-face-society-masks/

6. Lucretius, *De Rerum Natura*, III. 58.

7. Katherine Feo, "Invisibility: Memory, Masks, and Masculinities in the Great War," *Journal of Design History* 20, no. 1, Spring 2007): 17.

8. Caroline Alexander, "Faces of War," *Smithsonian Magazine*, February 2007thttps://www.smithsonianmag.com/arts-culture/faces-of-war-145799854.

9. Alexander.

10. E. H. Gombrich, "The Mask and the Face: The Perception of Physiognomic Likeness in Life and Art," in E. H. Gombrich, Julian Hochberg, and Max Black, *Art, Perception and Reality* (Baltimore: Johns Hopkins University Press, 1973), 17.

11. Mark Pendergast, *Mirror, Mirror: A History of the Human Love Affair with Reflection* (New York: Basic Books, 2003), 259.

N | Narcissism

1. Sabine Melchior-Bonnet, *The Mirror: A History* (New York: Routledge, 2002), 180.

2. Gemma Aldridge and Kerry Harden, "Selfie addict took two hundred a day—and tried to kill himself when he couldn't take perfect photo," *The Mirror*, March 23, 2014, https://www.mirror.co.uk/news/real-life-stories/selfie-addict-took-two-hundred-3273819.

3. Ovid, *Metamorphoses* in The Oxford Anthology of Roman Literature, ed. Peter E. Knox and J. C. McKeown (Oxford: Oxford University Press, 2013), 280.

4. Graham Davies, Hadyn Ellis, and John Shepherd, "Wanted: Faces That Fit the Bill," *New Scientist,* no 1456 (May 16, 1985): 28.

5. Seamus Heaney, "Mount Helicon," in *Death of a Naturalist* (London: Faber and Faber, 2006).

6. Paul Barolsky, "A Very Brief History of Art from Narcissus to Picasso," *The Classical Journal* 90, no. 3 (February-March 1995): 255–259.

7. Theodore Dreiser wrote this in his diary in 1902. See Mark Pendergast, *Mirror, Mirror: A History of The Human Love Affair with Reflection* (New York: Basic Books, 2004), 5.

8. Daniel Boorstin, *The Image: A Guide to Pseudo-Events in America* (New York: Vintage Books, 2012), 257.

9. Italo Calvino, "The Adventure of a Photographer," in *Difficult Loves* (San Diego: Harcourt Brace Jovanovich, 1984).

10. Steven Millhauser, "Miracle Polish," *New Yorker*, November 14, 2011.

O | Othering

Susan Sontag, *On Photography*, electronic ed. (New York: Farrar, Straus & Giroux, 1973; New York: Rosetta Books, 2005), 27.

1. Arthur Lubow, *Diane Arbus: Portrait of a Photographer* (New York: Ecco, 2017), 241.

2. Lubow, 243.

3. John C. Moffitt, *Kansas City Star,* February 21, 1932.

4. Alexa Wright, *Monstrosity: The Human Monster in Visual Culture* (London: I. B. Tauris Books), 77.

5. In August 1966, one thousand copies of this book were distributed without charge to legislators, mental health commissioners, university professors, and leaders in the parent movement in mental retardation. The book was later republished by Human Policy Press in 1974. Burton Blatt and Fred Kaplan, *Christmas in Purgatory: A Photographic Essay on Mental Retardation* (Syracuse: Human Policy Press, 1974).

P | Physiognomy

1. Sharrona Pearl, *About Faces: Physiognomy in Nineteenth-Century Britain* (Cambridge: Harvard University Press, 2010), 149.

2. In Book Two of Aristotle's *Rhetorc*, his list of emotions includes anger, calm, friendship, enmity, fear, confidence, shame, shamelessness, kindness, unkindness, pity, indignation, envy, and emulation.

3. Sir Thomas Browne, *Sir Thomas Browne's Works: Including His Life and Correspondence,* vol. 2 (London: William Pickering, 1835), 88.

4. William Hazlitt, ed., *The Works of Michael de Montaigne* (London: John Templeton Publishers, 1845), 491.

5. Faces bothered Thoreau—he rarely looked people in the eye. For more on his anecdotal observations, see Henry David Thoreau*, The Journal of Henry David Thoreau 1837–1861* (New York: New York Review of Books, 2009), ix.

6. Oscar Wilde, *The Picture of Dorian Gray* (New York: Dover Publications; reprint edition, 1993), 109.

7. Johann Caspar Lavater, *Essays on Physiognomy* (London, 1840), 113. See also Dror Wahrman, *The Making of the Modern Self: Identity and Culture in Eighteenth-Century England* (New Haven: Yale University Press, 2004), 297.

8. Georg Christoph Lichtenberg, "Notebook B: 1768–1771," in *Georg Christoph Lichtenberg: Philosophical Writings,* ed. Steven Tester (Albany: SUNY Press, 2012), 43.

9. Camper's work influenced generations of anthropologists whose work informed the controversial study of scientific racism, including Ernst Haeckl, Samuel George Morton, and Étienne Geoffroy Saint-Hilaire, among many others.

10. Graham Davies, Hadyn Ellis, and John Shepherd, "An Investigation of the Use of the Photo-Fit Technique for Recalling Faces," *British Journal of Psychology* 66, no. 1 (February 1, 1975): 29–37. Some accounts have named an American detective, Hugh McDonald, as the inventor of Identikit in the late 1950s. For more on McDonald, see http://identikit.net/company.

11. Ludwig Wittgenstein, *Zettel* (41) (Berkeley: University of California Press, 1967). In addition to its illustrative roots in language, Wittgenstein also believed a facial expression could be compared to the reinterpretation of a chord in music. For more on Wittgenstein and the face, see Bernard J. Rhie's excellent dissertation, "The Philosophy of the Face and 20th Century Literature and Art" (University of Pennsylvania, 2005).

12. Maurice Merleau-Ponty, *The Merleau-Ponty Aesthetics Reader: Philosophy and Painting, trans. Michael B. Smith* (Evanston: Northwestern University Press, 1994), 132.

13. Michel de Montaigne, *The Essays of Michel de Montaigne,* vol. 3 (London: George Bell and Sons, 1908), 313.

Q | Quackery

John Ashbery, "Self-Portrait in a Convex Mirror," *Poetry* 124, no. 5 (August 1974): 247–261.

1. "Tomorrow's Daughter," *Vogue* 93, no. 3 (February 1, 1939): 60, 61.

2. "Global Cosmetics Market to Reach $390 Billion by 2020—Rising Demand for Natural Cosmetics—Research and Markets," *Business Wire,* May 24, 2017 https://www.businesswire.com/news/home/20170524005627/en/Global-Cosmetics-Market-Reach-390-Billion-2020.

3. For more on the ethics of surgical interventions with regard to the face, see Sharrona Pearl, *Face On: Face Transplants and the Ethics of the Other* (Chicago: University of Chicago Press, 2017).

4. Sanford Bennett, *Exercising in Bed: The Simplest and Most Effective System*

of Exercise Ever Devised (San Francisco: The Edward Hilton Co., 1907), 189.

R | Relatability, Resemblance, Reassurance, Reflection + Rhetoric

Jill Lepore, "The Prism: Privacy in an Age of Publicity," *New Yorker,* June 24, 2013.

1. "Here you see the lepers of the great television industry. Men without faces. Why, they even slide our paychecks under the door so they can pretend we're not here." *A Face in the Crowd,* script by Budd Schulberg, 1957.

2. Budd Schulberg, *Some Faces in the Crowd* (New York: Random House, 1953).

3. Emmanuel Levinas, *Totality and Infinity,* p. 198. The actual brain circuitry that enables facial recognition happens in a region called the fusiform gyrus, a cortical reason located right behind the ears. For more on how the social brain processes the face, see Bruce Hood, *The Self Illusion: How the Social Brain Creates Identity* (Oxford: Oxford University Press, 2012), 37.

4. W. J. T. Mitchell, "What Is an Image?" *New Literary History* 15, no. 3 (Spring 1984): 503–537.

5. Sontag spoke those words at a rally of support for Poland's Solidarity movement in late winter, 1982. See James Lardner, "Susan Sontag into the Fray," *Washington Post,* March 16, 1982.

6. Rebecca Mead, "The Scourge of Relatability," *New Yorker,* August 1, 2014.

7. Italo Calvino, *The Adventure of a Photographer,* 1985.

8. Tim Wu *The Attention Merchants: The Epic Scramble to Get Inside Our Heads* (New York: Alfred A. Knopf, 2016), 290.

9. Evan Osnos, "Can Mark Zuckerberg Fix Facebook Before It Breaks Democracy?" *New Yorker,* September 17, 2018.

S | Surveillance + Spectatorship

Hannah Arendt, *The Life of the Mind* (New York: Harcourt, 1977/1978).

1. Kaya Yurieff, "Facebook under Fire for Storing Facial Recognition Data without Consent," CNN Business, April 17, 2018, https://money.cnn.com/2018/04/17/technology/facebook-lawsuit-facial-recognition/index.html?iid=EL.

2. In Beijing's Temple of Heaven, a UNESCO World Heritage site, facial scanners have been installed in the public toilets to catch paper thieves. For more on China and social surveillance, see Simon Denyer, "China's Watchful Eye," *Washington Post*, January 7, 2018; and Rob Schmitz, "Facial Recognition in China Is Big Business As Local Governments Boost Surveillance," NPR, April 3, 2018.

3. Xiaolin Wu and Xi Zhang, "Automated Inference on Criminality Using Face

Images," *AI Technology & Industry Review*, November 13, 2016.

4. Teju Cole, "There's Less to Portraits Than Meets the Eye, and More," *New York Times Magazine*, August 23, 2018.

5. Georgetown Law, Center on Privacy and Technology, "The Perpetual Line-Up: Unregulated Police Face Recognition in America," October 18, 2016.

6. Aaron Pressman and Adam Lashinsky, "Data Sheet—How to Fight the Growing Scourge of Algorithmic Bias in AI," *Forbes*, September 14, 2018.

7. Privacy Multistakeholder Process: Facial Recognition Technology. A Report Published by the National Telecommunications and Information Administration, United States Department of Commerce, June 17, 2016, https://www. ntia.doc.gov/other-publication/2016/ privacy-multistakeholder-process-facial-recognition-technology.

8. Jennifer Finney Boylan, "Will Deep-Fake Technology Destroy Democracy?" *New York Times*, October 17, 2018.

T | Typecasting

1. Malvina Reynolds, "Little Boxes and Other Handmade Songs" (New York: Oak Publications, 26ADAD, 1957).

2. Denise Grady, "Anatomy Does Not Determine Gender, Experts Say," *New York Times,* October 22, 2018.

3. For more on first impressions and the role of the visual cortex in reading faces, see Mary A. Peterson and Gillian Rhodes, eds., *Perception of Faces, Objects, and Scenes: Analytic and Holistic Processes* (Oxford: Oxford University Press, 2003), and Gregory J. Feist, *The Psychology of Science and the Origins of the Scientific Mind* (New Haven: Yale University Press, 2006), 240.

4. In 2013, Harvard researchers published a study in which they noted shifting patterns of neural activity in the brain when people look at black versus white faces, and at male versus female faces. See Peter Reuell, "What's in a Face?" *Harvard Gazette*, October 11, 2013.

5. Nathan Jurgenson, *The Social Photo: On Photography and Social Media* (New York: Verso Books, 2019).

6. Riz Ahmed, "Typecast as a Terrorist," *The Guardian*, September 15, 2016.

7. Bastian Jaeger, Willem W.A. Sleegers, Anthony M. Evans, Mariëlle Stel, and Ilja van Beest, "The effects of Facial Attractiveness and Trustworthiness in Online Peer-to-Peer Markets," *Journal of Economic* Psychology, published ahead of print, November 22, 2018, https://doi. org/10.1016/j.joep. 2018.11.004.

U | Users + The Uncanny

Marcel Proust, *Swann's Way*, trans. C. K. Scott Moncrieff (New York: Henry Holt and Co., 1922).

1. Kevin Robins, *Into the Image: Culture*

and Politics in the Field of Vision (London: Routledge, 1996), 118.

2. E. M. Forster, "The Machine Stops" (1909), in *The Machine Stops and Other Stories* (London: André Deutsch Limited, 1997).

3. Mark Twain, *The Adventures of Huckleberry Finn* (1885; London: Collector's Library, 2004), 28; Ralph Ellison, *Invisible Man* (1952; New York: Vintage International), 65; and Octavia Butler, *Parable of the Sower* (New York: Warner Books, 1993), 154.

4. Dinesh Acharya, Zhiwu Huang, Danda Pani Paudel, and Luc Van Gool, "Covariance Pooling for Facial Expression Recognition," 2018 IEEE/CVF Conference on Computer Vision and Pattern Recognition Workshops (June 2018), doi: 10.1109/ CVPRW.2018.00077.

5. Stacey Higginbotham, "Computers That Understand Your Emotions Are Coming Next Year," *Fortune*, December 23, 2015, http://fortune.com/2015/12/23/computers-understand-emotions. The "ick" factor is not unlike the "yuck" factor. Patricia Cohen, "Economists Dissect the Yuck Factor," *New York Times*, January 31, 2008, https://www. nytimes.com/2008/01/31/arts/31gross.html.

6. Sigmund Freud, "The Uncanny."" First published in *Imago* 5 (1919); reprinted in Sammlung Fünfte Folge, trans. Alix Strachey, p. 1; Ernst Jentsch, "On the Psychology of the Uncanny" (1906), trans. Roy Sellars, *Angelaki: Journal of the Theoretical Humanities* 2, no. 1 (1997): 7–15.

7. Masahiro Mori. "The Uncanny Valley," *Energy* 7, no. 4 (1970), reprinted in *IEEE Robotics & Automation Magazine* 19, no. 2 (June 2012): 98–100.

8. "What, if any, are the ethical implications of creating 'emotional' robots?" Verena Nitsch and Michael Popp, "Emotions in Robot Psychology," *Biological Cybernetics* 108, no. 5 (October 2014): 621–629.

9. Zola Ray, "Saudi Robot Sophia Now Wants to Have a Baby," *Newsweek*, November 28, 2017, https://www. newsweek.com/sophia-saudi-robot-baby-future-family-725254.

10. For more on Hiroshi Ishiguro's laboratory of robots, visit http://www. geminoid.jp/en/index.html. See also Gertie Goddard, "Uncanny Valley: Robots so Creepy They'll Haunt Your Dreams," *Science Focus/BBC,* October 31, 2018.

11. Sandra Kemp, *Future Face: Image, Identity, Innovation* (London: Profile Books, 2004), 51.

V | Vanity

Jeffrey Eugenides, *The Marriage Plot* (New York: Farrar, Straus & Giraud, 2011).

1. John Bunyan, *Pilgrim's Progress*, 1678.

2. William Makepeace Thackeray, *Vanity Fair*, 1848.

W | Wit

1. optical toys.com

2. Joseph Edmonds and Ian Alcock. *A Head of Its Time: Early Toy Books with Hole Effects*, 2017 (unpublished).

3. People living in the Cumbrian village have celebrated crab apple time since 1267 when King Henry III granted a Royal Charter for a weekly market and an annual crab For more on the history of the Egremont Crabapple Fair, see "Gurners Go for Gold," BBC News, September 2001.

4. Daisy Doodad, http://www.screenonline. org.uk/film/id/437622/index.html.

5. Jonathan Crow, "Watch *Humorous Phases of Funny Faces*: The First Animated Movie (1906)," *Open Culture*, September 2014, http://www.openculture. com/2014/09/watch-humorous-phases-of-funny-faces-the-first-animated-movie-1906. html.

6. Nick Squires, "Mystery of the 'Sardonic Grin' Solved," *The Telegraph,* May 18, 2009.

7. Adam Sherwin, "Guess Who's Sexist? Classic Board Game's Gender Bias Leaves Six-Year-Old Fuming," *The Independent*, Saturday, November 17, 2012.

8. Vicky Gan, "The Anti-Stereotype Party Game," *Citylab*, October 29, 2015.

X | Xenophobia

1. "The New Face of America," *Time* 142, no. 2 (November 18, 1993).

2. Loretta I. Winters and Herman L. DeBose, *New Faces in a Changing America: Multiracial Identity in the 21st Century* (Thousand Oaks, CA: Sage Publications, 2003), 305.

3. Lise Funderburg, "The Changing Face of America," *National Geographic*, October 2013.

4. Elizabeth Alexander, "Race," in *Antebellum Dream Book* (St. Paul, MN: Graywolf Press, 2001).

5. Helmar Lerski's *Everyday Heads* (*Köpfe des Alltags,* 1931), Erich Retzlaff's *German People* (*Deutsche Menschen,* 1931), and Erna Lendvai-Dircksen's *Face of the German People* (*Das deutsche Volksgesicht,* 1932), among others, sought to capture the German facial paradigm. Wolfgang Brückle, *Face-Off in Weimar Culture: The Physiognomic Paradigm, Competing Portrait Anthologies, and August Sander's Face of Our Time*, http:// www.tate.org.uk/research/publications/ tate-papers/face-weimar-culture-physiognomic-paradigm-competing-portrait.

6. Francis Galton, "Eugenics: Its Definition, Scope, and Aims," *American Journal of Sociology* 10, no. 1 (July 1904).

7. Michel de Montaigne, "Of Vanity," book 3, *The Essays of Michel de Montaigne*, vol. 3, 228.

8. Bernard Bailyn, *The Barbarous Years: The Peopling of British North America—The Conflict of Civilizations, 1600–1675* (New York: Alfred A. Knopf, 2012).

9. Robert C. Toll, "Behind the Blackface," *American Heritage Magazine*, April–May 1978.

10. Eric Kanye, "Census: White Majority in U.S. Gone by 2043," *NBC News*, June 13, 2014.

11. Jennifer Rubin, "Trump Plays the Xenophobia Card, Again," *Washington Post*, October 23, 2018.

12. T. A. Mok, "Getting the Message: Media Images and Stereotypes and their Effect on Asian Americans," *Cultural Diversity and Mental Health* 4, no. 3 (1998): 185–202.

See also Tiffany A. Ito and Bruce D. Bartholow, "The Neural Correlates of Race," *Trends in Cognitive Sciences* 13, no. 12 (2009): 524–531.

13. Neil Chakraborti and Irene Zempi, "The Veil under Attack: Gendered Dimensions of Islamophobic Victimization," *International Review of Victimology* 18, no. 3 (September 1, 2012): 269–284.

14. Daniel Dafoe, *The True Born Englishman*, 1701.

Y | You

Joan Didion, "On Keeping a Notebook," in *Slouching toward Bethlehem* (New York: Farrar, Straus, and Giroux, 1968).

1. Jean-Paul Sartre. "Faces," in *The Writings of Jean-Paul Sartre*, vol. 2, Selected Prose (Evanstown: Northwestern University Press, 1974), 69. Originally published as "Visages" in a special issue of *Verve* in 1939.

2. Sarah Phillips, "A Brief History of Facebook," *The Guardian*, July 25, 2007.

3. "And to get along and get ahead in this new you-saturated social media arena, you had to be better than all the other yous that were suddenly surrounding you." Will Storr, *Selfie: How We Became So Self-Obsessed and What It's Doing to Us* (New York: Overlook Press, 2018), 256. Several books have been written on the culture of the selfie that deserve mention. See also Alicia Eler, *The Selfie Generation: How Our Self-Images Are Changing Our Notions of Privacy, Sex, Consent, and Culture* (New York: Skyhorse Publishers, 2017).

4. A self-idea of this sort seems to have three principal elements: the imagination of our appearance to the other person; the imagination of his judgment of that appearance, and some sort of self-feeling, such as pride or mortification. Charles Horton Cooley, "The Looking Glass Self," in *Human Nature and the Social Order* (New York: Charles Scribner's Sons, 1902), 152.

5. Thomas Stearns Eliot, "The Love Song of J. Alfred Prufrock," in *T. S. Eliot: Collected Poems, 1909–1962* (Orlando: Harcourt Brace Jovanich, 1963), 4.

6. Jung's examination of the collective unconscious may provide greater insight into the cognitive aspects of judging ourselves and each other. For more on how the ego manifests in dreams, and how those ancestral archetypes come to frame our understanding of who we are, see Carl G. Jung, *Psychology and Alchemy* (Collected Works of C. G. Jung, vol. 12), 2nd ed. (Princeton: Princeton University, Press, 1980).

7. Erving Goffman, "On Face-Work: An Analysis of Ritual Elements in Social Interaction," *Psychiatry* 18, no. 3 (1955): 213–231.

8. "Selfies are little visual diaries that magnify, reduce, dramatize—that say, 'I'm here; look at me.'" Jerry Saltz, "Art at Arm's Length: A History of the Selfie," *New York Magazine*, 2014.

9. "When people pose for political selfies, joke selfies, sports-related selfies, fan-related selfies, illness-related selfies, soldier selfies, crime-related selfies, selfies at funerals, or selfies at places like museums, we need more accurate language than that afforded by 19th-century psychoanalysis to speak about what people believe themselves to be doing, and what response they are hoping to elicit." Theresa M. Senft and Nancy K. Baym, "What Does the Selfie Say? Investigating a Global Phenomenon," *International Journal of Communication* 9 (2015): 1590.

10. Miranda Popkey, "The Faces of Ferrante," *Paris Review*, December 10, 2018.

Z | Zeitgeist

Dorothy Donnelly, "Faces," *Poetry* 141, no. 1 (October 1982): 7–9.

1. Emily Dickinson, "Selected Letters, 1870," in James Reeves, ed., *Selected Poems of Emily Dickinson* (Poetry Bookshelf, 1959), 104.

2. Ava Kofman, "How Facial Recognition Can Ruin Your Life," *The Intercept*, October 13, 2016.

Notes

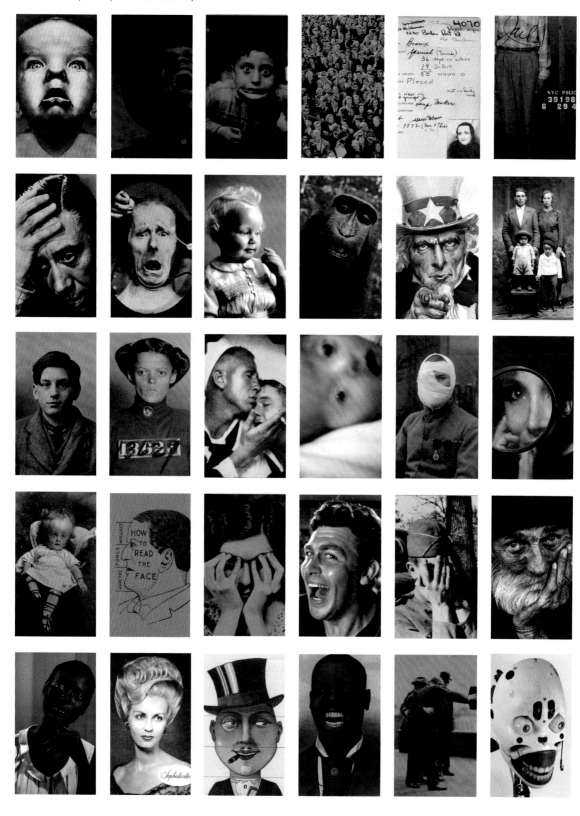

Front Cover	Back Cover	Title Page	Prologue	A \| Anthropometry	B \| Biometrics + Bias
John Seven The Sheer Infantilising Disbelief of Pain When the Drugs Don't Work. 2011	Photobooth image set, featuring two unidentified white men and one unidentified African American man. *University of Kentucky Archives.*	Public domain photograph. Circa 1950	Public domain photograph. Circa 1935	Dora Abravaya's 1930s school attendance card revealed her multiple absences and addresses during her high school years. *Paul Lukas Collection.*	New York City police line-up that included a set of twin brothers. 1944 *Mark Michaelson Collection.*

C \| Caricature + Close Ups	D \| Diagnosis	E \| Eugenics	F \| Facsimiles + Fragility	G \| The Gaze	H \| Heredity
Fernandel Born Fernand Joseph Désiré Contandin, Fernandel was a French character actor for more than forty years. *Patricia Martineau Collection.*	Duchenne de Boulogne, *Experiments in physiology.* (Terror.) *Wellcome Collection.*	Found photo of unknown child, Johannesburg, South Africa. Circa 1943	Self-portrait of a female Celebes Crested Macaque (*Macaca nigra*) in North Sulawesi, Indonesia, using a camera belonging to the British nature photographer David Slater. 2010	**James Montgomery Flagg** *I Want You for U.S. Army* Poster. 1917	Anonymous family by the Romanian photographer Costică Acsinte. Circa 1940.

I \| Identity	J \| Judgment	K \| Keepsakes	L \| Likenesses + Lies	M \| Masks + Mirrors	N \| Narcissism
Found photo of unknown child, Paris. Circa 1930.	Alvina Hoots, arrested with her husband for stealing by the Police Department, of Cincinnati, Ohio. 1914 *Mark Michaelson Collection.*	Anonymous sailors in Photobooth. Early 1940s *San Diego Air and SpaceMuseum.*	**Nancy Burson** Untitled. 1990–1993	**Anna Coleman Ladd** Studio for Portrait Masks, Paris. Circa 1918 *Library of Congress.*	Photograph of a woman shot through a magnifying glass. Circa 1955

O \| Othering	P \| Physiognomy	Q \| Quackery	R \| Relatability	S \| Surveillance + Spectatorship	T \| Typecasting
Hydrocephalic child exhibited at a state fair, White River Junction, Vermont. 1922 *Robert Bogdan Disability Collection Yale University.*	**L.A. Vaught** Vaught's Practical Character Reader. 1902	Kathryn Murray System of Facial Exercises. 1920s	Andy Griffith as Larry "Lonesome" Rhodes in *A Face in the Crowd.* 1957	Anonymous soldier concealing his face. Early 1940s *Robert E. Jackson Collection.*	Found photograph. Undated

U \| Users + The Uncanny	V \| Vanity	W \| Wit	X \| Xenophobia	Y \| You	Z \| Zeitgeist
Laurie Simmons How We See / Ajak (Turquoise). 2015	An undated hairdressing advertisement for a bouffant coif.	Mix and match face game. 1930s	*Dandy Jim, From Caroline* was a minstrel song mocking an African American man for dressing up and putting on airs. *Duke University Libraries.*	Joseph Byron and Ben Falk hold a camera together for a comparatively early "selfie." 1920 *Museum of the City of New York.*	The actual robotic face behind the simulated face of a Realbotix "RealDoll." 2018

Index

Page references for illustrations appear in *italics*

7 x 3 (portraits), *87*
9/11, 92, 108
23andMe, 86
1536 Grimaces (Meggendorfer), 213, *215*

Index